To Ruth -

Best +

Great

Picture-Making !

Festival
of
the
Cranes.
11/17/99

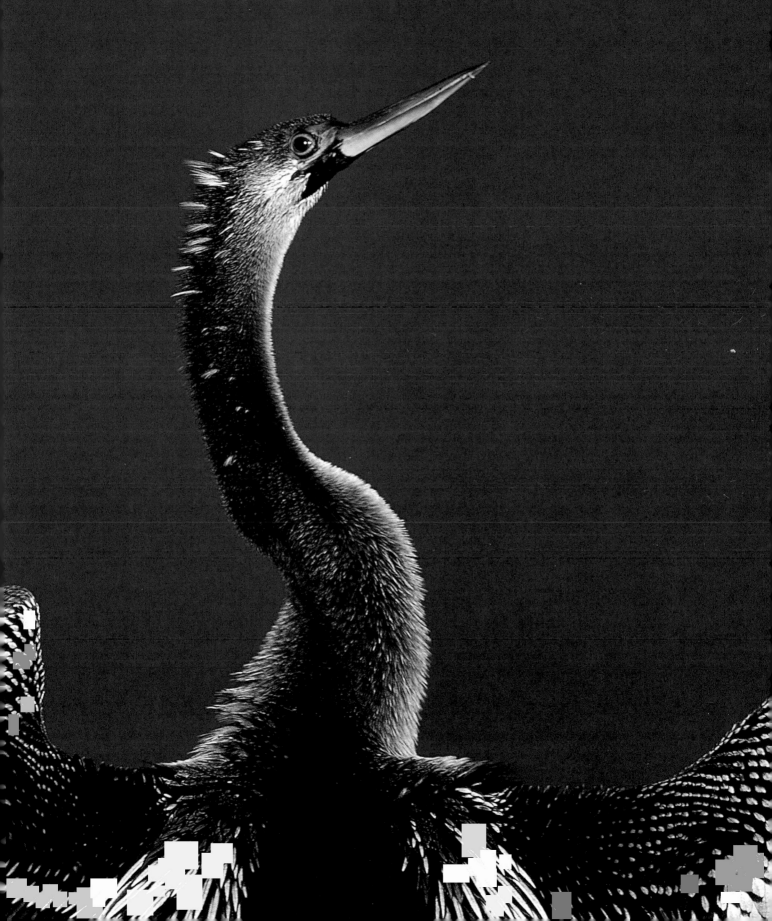

The Art of
BIRD PHOTOGRAPHY

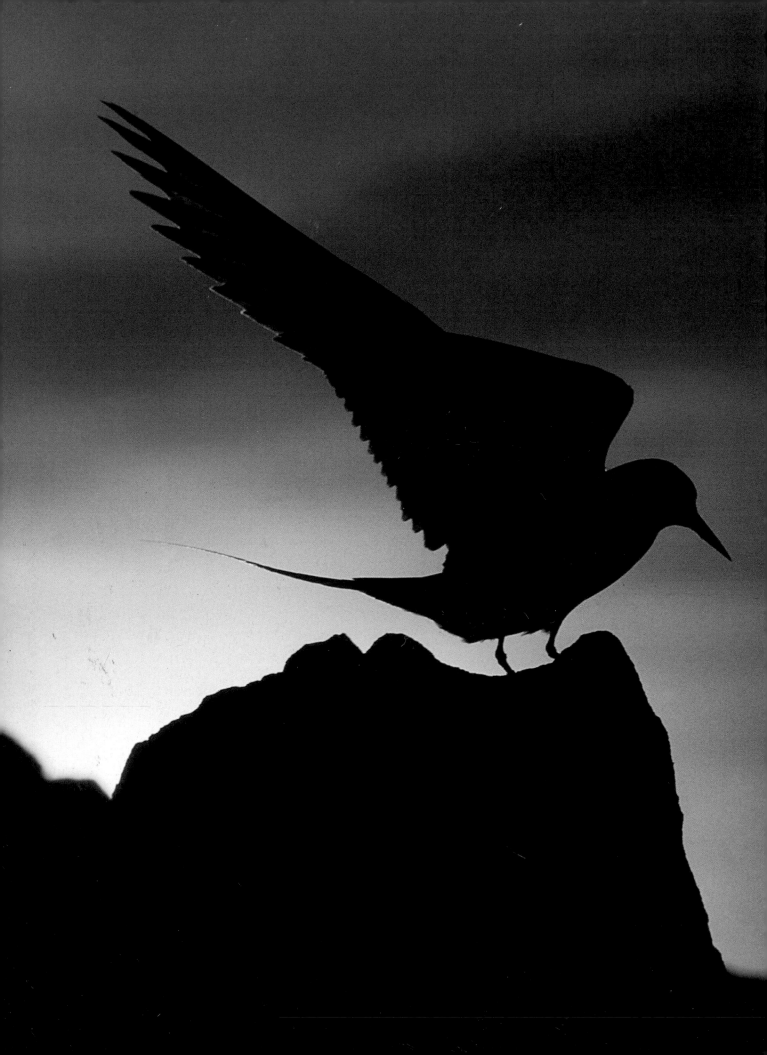

The Art of
BIRD PHOTOGRAPHY

The Complete Guide to Professional
Field Techniques

Arthur Morris

AMPHOTO BOOKS
An imprint of Watson-Guptill Publications/New York

Page 1: **FEMALE ANHINGA,** Everglades National Park, Florida
Pages 2–3: **ROSEATE TERN AT SUNRISE,** Great Gull Island, New York
Page 5: **HEERMAN'S GULL DISPLAYING,** La Jolla, California
Pages 6–7: **BLACKBURNIAN WARBLER,** Point Pelee National Park, Ontario

Note: Unless otherwise indicated, all the photographs in this book were made with either Gitzo 320, 341, or 410 tripods, and with the camera set in aperture-priority mode.

Editorial concept by Robin Simmen
Project Editor: Alisa Palazzo
Designer: Areta Buk
Production Manager: Hector Campbell

Text and illustrations copyright © 1998 Arthur Morris

First published in 1998 in New York by Amphoto Books,
an imprint of Watson-Guptill Publications,
a division of BPI Communications, Inc.,
1515 Broadway, New York, NY 10036

Library of Congress Cataloging-in-Publication Data
Morris, Arthur, 1946–
 The art of bird photography / Arthur Morris.
 p. cm.
 Includes bibliographical references (p.) and index.
 ISBN 0-8174-3303-1 (hc)
 1. Photography of birds. I. Title.
TR729.B5M657 1998
778.9'328—DC21 97-46935
 CIP

Printed in Singapore

1 2 3 4 5 6 7 8 9 / 06 05 04 03 02 01 00 99 98

ACKNOWLEDGMENTS

Over the course of my career, I've received a great deal of help from a great many people, and I would like to acknowledge them here. When I became serious about birding in the late seventies, Max and Nellie Larsen helped me hone my field identification skills. Tony Manzoni and the late Thomas H. Davis, Jr., inspired me with their photographs, and it was Tom who instilled in me his love of shorebirds.

In the mid-eighties, I spent hundreds of hours photographing birds at Jamaica Bay Wildlife Refuge (JBWR) in Queens, New York, with friends Rob Villani, Johann Schumacher, and Kevin Karlson. We all learned a great deal from one another. Don Riepe of JBWR was always supportive and allowed us to improve photographic conditions at Big John's Pond. In the early nineties, I spent a lot of time on Long Island with Tom Vezo, photographing beach birds from the back of his utility vehicle.

At Visual Resources for Ornithology (VIREO), at the Academy of Natural Sciences in Philadelphia, director Doug Wechsler and collection manager Bill Matthews have both marketed many hundreds of my images and become good friends, as well, as has David Tipling at Windrush Photos in the United Kingdom.

At *Bird Watcher's Digest,* William and Elsa Thompson, and son Bill III (now the editor), had enough faith in me to publish my first photo-illustrated article and, in 1992, my booklet *Bird Photography Basics.* Longtime editor Mary Beacom Bowers edited more than 15 of the articles that I wrote for *Bird Watcher's Digest;* her support, guidance, and praise gave me confidence as a writer.

Eldon Greij, founder and editor of *Birder's World,* and photo editor Gordon Van Woerkom have both graciously published many of my images and articles, and former *Birder's World* editorial staff members Julie Ridl and Mary Katharine Parks were also instrumental in helping me develop as a writer.

I also want to acknowledge Jill Crane, formerly at *The Living Bird Quarterly* (now *Living Bird*); Helen Longest-Slaughter at *Nature Photographer;* Diane Jolie at *Ducks Unlimited;* Paul Konrad at *Wildbird;* and the staffs of *Petersen's PHOTOgraphic* and *Wildfowl Carving and Collecting.* They have all used my work regularly for years, and I thank them all.

In addition, it was a supreme pleasure working with Robert L. Dunne, former executive editor—and a photographer's photo editor—at *Ranger Rick.* He was creative, sincere, helpful, supportive, and appreciative. And, no one in the industry returned your outtakes faster than Bob.

Sheetal Kumar at Chelsea Professional Color Labs in New York City has handled all of my processing and duplicating needs for the past five years in fine fashion. Since 1995, Canon USA has been exceedingly generous with its support. And, Dave Metz and Michael Newler of Canon's Pro Markets department in Lake Success, New York, have been remarkably helpful and supportive as well.

Joanne Williams, Bryan Geyer, Ned and Linda Harris, B. Moose Peterson, and John Nash (technical advisor at M&M Photo Source) reviewed portions of early drafts of this work. Ralph Paonessa read two late drafts; his thoughtful comments, questions, and suggestions were invaluable. Peter Burian did a technical edit, and Alisa Palazzo at Amphoto Books skillfully edited the final draft. Jeanette Davia, who has brought love and happiness back into my life, helped with the proofreading. The responsibility for any errors, however, lies with the author.

To all those above, and to those I have inadvertently forgotten, I offer my sincerest thanks. My biggest thank you, however, goes to Robin Simmen at Amphoto Books; without her vision, support, and guidance, you would not be holding this book in your hands today.

This work is dedicated to the memory of my late wife,

Elaine Belsky Morris,

who was my love, my best friend, and my biggest supporter.

Her wonderful smile was lost to the world on November 20, 1994.

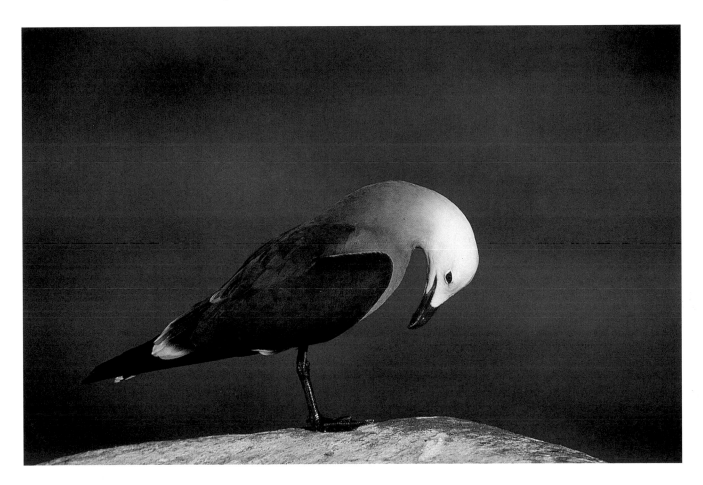

CONTENTS

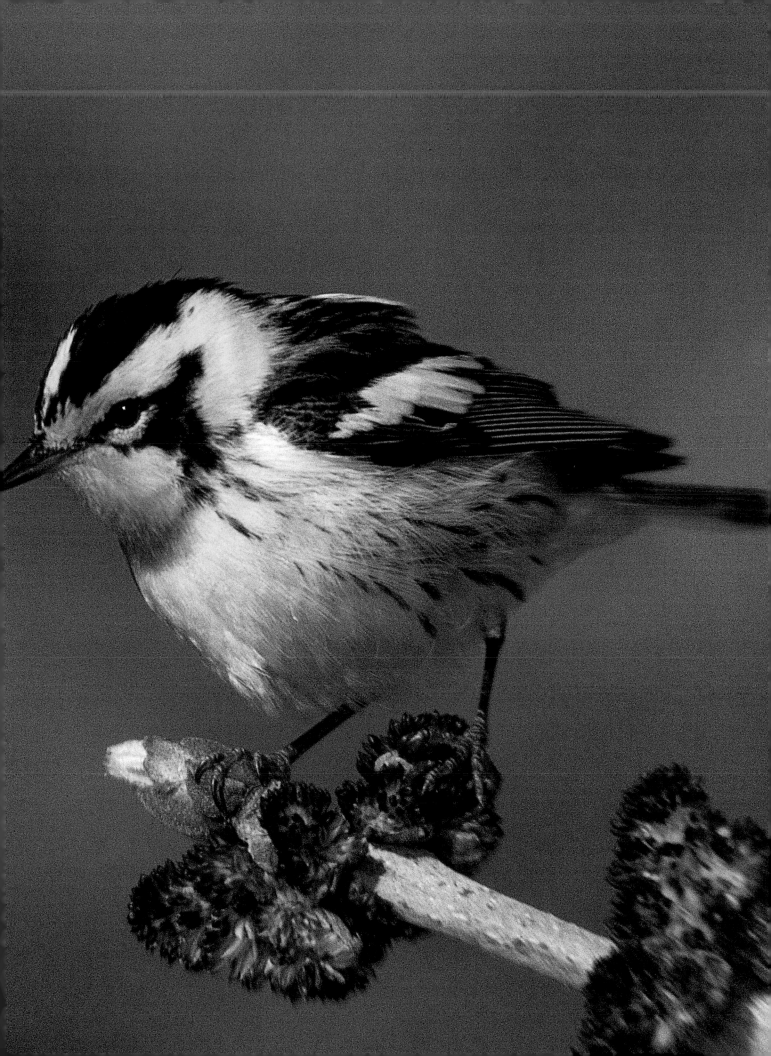

Preface

In the late winter of 1997, I stood in the parking lot at Anhinga Trail, Everglades National Park, proudly showing off a set of 70mm duplicate transparencies to a group of Belgian nature photographers. The apparent leader of the group let out a hearty laugh of approval whenever he saw an image that moved him. He laughed a lot.

After viewing all the images, he shook his head and said, "Dit is meer dan vogels, dit is kunst!"

"What did you say?" I asked.

After yet another hearty laugh, he answered emphatically, "This is more than birds, this is art!"

His words thrilled me; they meant more to me than any photo credit—even a *National Geographic* credit.

I don't shoot to sell. I don't shoot with specific markets in mind. When I venture afield with a tripod-mounted super-telephoto rig slung over my shoulder, I shoot simply to make art—to make photographs that please me and inspire others with their beauty. My style is simple; most times, I strive to design images that consist only of a bird, its perch, and a background of pure color. I make every effort to eliminate distracting background elements. I believe that in nature photography, less is often more.

For the past 15 years, photographing birds has been the driving passion in my life. The thought of waking early and going out with a long lens excites me even more today than it did in August 1983, when I purchased my first telephoto, the Canon FD 400mm F4.5 lens. I can remember getting back that first roll of semipalmated sandpipers and thinking, "Those dots on the slides, are they birds?" They were, and realizing that I'd have to get much closer to my subjects, I began applying the knowledge that I'd gathered during seven previous years of intensive birding. In other words, I began crawling through the mud.

As for determining the correct exposure, I didn't have a clue. And though I searched through countless books and magazines, I was unable to come up with any information that made sense to me. Relying only on my in-camera meter, I found many of my slides to be well over- or underexposed. When the meter in my Canon AE-1 began malfunctioning severely, all my images were four to five stops overexposed.

This, however, turned out to be a blessing in disguise. I noted that the information in the film box recommended exposing Kodachrome 64 at 1/60 sec. at *f*/16 for subjects in full sun. When working in sunny conditions, I began setting the equivalent exposure, 1/500 sec. at *f*/5.6, *manually* and, without realizing it, had begun, in part, using the "sunny *f*/16" rule. I was on the road to gaining a complete understanding of exposure theory, but as it turned out, it was a very long road.

TURKEY VULTURE ALIGHTING, Anhinga Trail, Everglades National Park, Florida. Canon EF 400mm F5.6L lens and A2 body (handheld), Fuji Velvia pushed one stop, evaluative metering +1/2 stop: 1/500 sec. at *f*/5.6

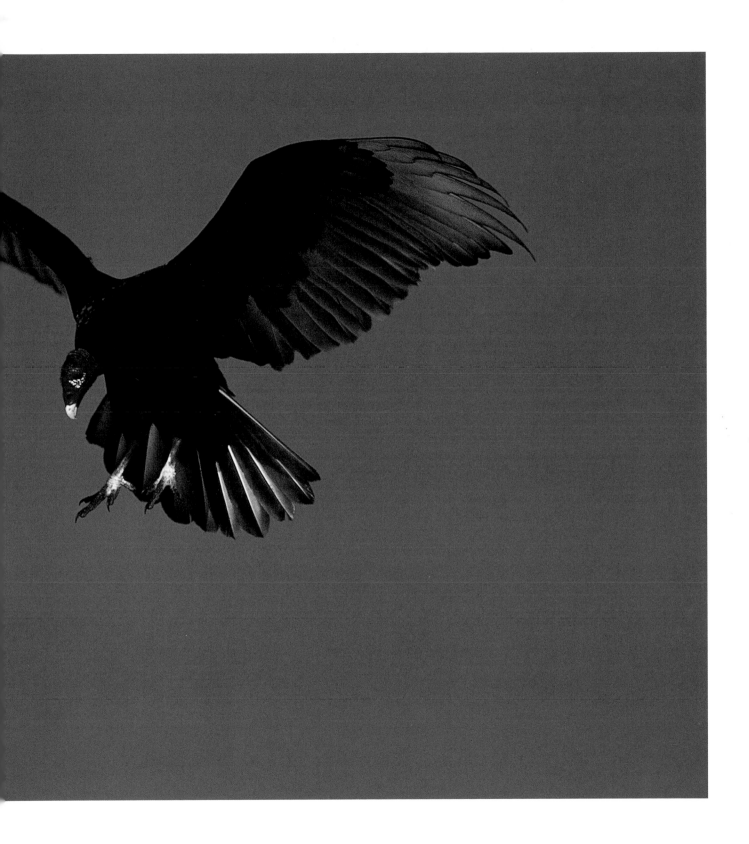

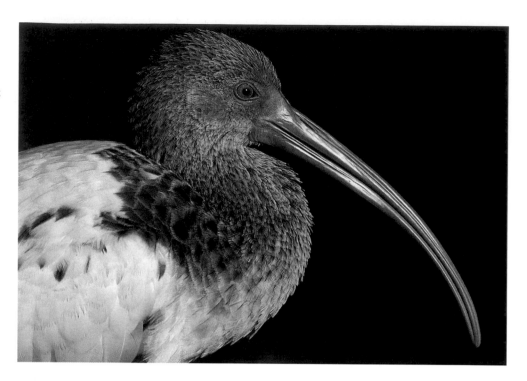

IMMATURE WHITE IBIS, Anhinga Trail, Everglades National Park, Florida. Canon EF 500mm F4.5L lens with 2X teleconverter and EOS 1N body, Fuji Velvia pushed one stop, evaluative metering at zero: 1/320 sec. at *f*/6.7

With the focal length of my longest telephoto lens being only 400mm, I had to work very hard in order to produce some satisfactory images. Good opportunities were few and far between. After seven years, though, I had met with some success. Early on, my photograph of a preening anhinga graced the cover of *The Living Bird Quarterly.* Then, several of my images appeared on Audubon wall calendars, and I sold photo-illustrated articles to both *Bird Watcher's Digest* and *Birder's World.*

In the late eighties, all the bird photographers whom I encountered afield were using 400mm lenses. In January 1989, a photographer using a 600mm lens at Ding Darling National Wildlife Refuge in Florida invited me to take a peek through his lens. The cormorant looked so large in the frame that I was utterly amazed. Never having realized that a moderate increase in focal length would result in such a dramatic increase in image size, I remember thinking that I'd been wasting my time. I planned to save up enough money to buy the Canon FD 500mm F4.5L lens, but in May 1989, I ran into Art Wolfe in Cape May, New Jersey. He was photographing red knots, ruddy turnstones, and sanderlings with the Canon FD 800mm F5.6L lens; My eyes were opened once again. And, when I learned that the FD 800mm cost just $300 more than the FD 500mm, my decision—though made in ignorance—was an easy one.

I can remember being scared stiff while unpacking my new lens. What had I done? I had spent $3,800 on a long, heavy lens that I had absolutely no idea how to use. How ludicrous it seems now that I proudly mounted it on my lightweight Slik U-212 tripod. I immediately realized that additional investments would have to be made and purchased a heavy-duty tripod and ball head. The big lens made life a lot easier; doubling the focal length from 400mm

to 800mm resulted in images that were four times larger. The number of good photo opportunities increased vastly. I often was able to simply get out of my vehicle, mount the 800mm outfit on my tripod, and begin shooting. And, the longer focal length allowed me to concentrate more on designing artistic images.

In the early nineties, I began selling more and more photographs to a variety of markets, but after expenses, the bottom line revealed that I was still losing many thousands of dollars a year. My wife Elaine and I were still teaching in New York, so we easily remained solvent. I had, however, become obsessed with photographing birds. On sunny mornings, I'd arrive at Jamaica Bay Wildlife Refuge at dawn, shoot for an hour, then rush home, pick up Elaine, and barely make it to school by 8:40 A.M. Afternoons were spent at the refuge or on the Jones Beach strip, which can be productive at any season. Weekends allowed us to travel farther afield, and during winter and spring breaks, we'd visit either Elaine's folks in Florida or mine in San Diego. The national wildlife refuges at Merritt Island and Lake Woodruff offered excellent photographic opportunities in central Florida, as did many locales around San Diego. Our summers were spent either traveling in North America or photographing at Jamaica Bay and on Long Island.

Also in the early nineties, I attended a George Lepp workshop in Tampa, Florida. After viewing Lepp's razor-sharp images of flying birds and planes, and speeding race cars, I was convinced that autofocus cameras and lenses now worked! To me this was big news. After checking out the lenses at the Canon exhibit, I realized two things: that the longest autofocus lens I could afford was the Canon EF 400mm F5.6L, and that a light, handholdable 400mm autofocus lens would be ideal for photographing large

birds in flight. I purchased the lens and a Canon EOS A2 body and almost immediately began making superb images of herons, egrets, gulls, terns, and raptors both in flight and in action. I extolled the virtues of my new "toy lens" to Instructional Photo-Tour participants and seminar audiences and in "Deadly Duo," an article published in *Birder's World*. Pretty soon, bird photographers from coast to coast—even Nikon users—could be seen afield with Canon 400 F5.6s slung over their shoulders.

In 1992, having long since grown weary, after 23 years, of teaching in the New York City school system, I convinced Elaine that we should take travel sabbaticals, tour North America, and then leave teaching to work full-time at the business of bird photography. We knew that under the terms of a deal between the teachers' union and the board of education, we would not, as is customary, have to return to teaching when our sabbaticals were over. We bought a home (by phone) near Elaine's parents in Deltona, Florida, purchased a micro-mini motor home, moved in late July, and set out on our journey in mid-August.

Criss-crossing North America twice in 12 months, we visited many of the continent's great birding spots, a plethora of historical museums and societies, and countless old cemeteries. We dined royally in San Francisco, were rained on in Vancouver, experienced wave days at both High Island, Texas, and Point Pelee National Park near Leamington, Ontario, and photographed a pair of great gray owls in Yellowstone. We had fun each and every day and reveled in our love for each other. As our wonderful trip neared its end, we asked only for our health and joked that we needed only money enough for food, film, and gas.

We arrived home on June 30, 1993, and that night Elaine said, "We'd better watch out. Things are too perfect. Your career is taking off, and we don't have to go back to P.S. 106."

Two days later, she discovered a lump in her left breast, undetected by annual mammograms. After a last-wish trip to Hawaii in late September of 1994, she died peacefully at home of metastasized breast cancer on November 20, 1994. Losing my wife, my love, and my best friend was devastating. Without bird photography in my life, her loss would likely have destroyed me. Less than three weeks after her death, I visited Bosque Del Apache National Wildlife Refuge in New Mexico for the first time, began making art again, and started the long, difficult process of healing.

By 1996, I was making more money as a photo-journalist specializing in birds than I could ever have dreamed of. My photo-tour business was very successful, editorial sales (to books, magazines, and calendars) and the more lucrative advertising sales expanded continuously, and offers to speak to various groups around the country poured in. *Shorebirds: Beautiful Beachcombers* (North Word Press, 1996) and *Bird Photography Pure and Simple* (self-published through Tern Publishing Company, 1997) were both selling extremely well.

Having no formal training in ornithology, photography, or art, I feel privileged and extremely lucky to be able to make the wonderful living that I do. While on the road more than 250 days in both 1996 and 1997, my passion for bird photography continued to grow; each day in the field seemed more exciting than the last. Elaine, however, was rarely out of my thoughts for long, and to this day, I miss her.

Still, whether photographing Atlantic puffins on a remote island off the coast of Maine, being frustrated by flitting warblers at Point Pelee National Park, Ontario, or making images of spectacularly beautiful brown pelicans on the cliffs of La Jolla, California, I, like all serious bird photographers, spend many hours at my task and come to know my subjects intimately. And it is this intimacy that enables the knowledgeable, prepared photographer to make not only artistically designed, technically perfect portraits, but images that depict spectacular action or private moments in the daily lives of his or her subjects. In this book, I strive to share with you the knowledge that I've acquired and the techniques that I've used and developed, so that you, too, may become that photographer.

John Shaw, speaking on the business of nature photography at the North American Nature Photography Association's 1997 Annual Forum in Corpus Christi, Texas, said, "There are no secrets." I couldn't agree more. I'll share everything that I know about bird photography in an effort to help you make better images. If we meet in the field, however, and you find me doing things differently from the way I've described them here, don't be surprised. If you're not learning every day you're in the field, you're wasting your time; I'm continually trying new methods and techniques, adding those that work and discarding those that don't. I hope this book inspires you to make beautiful pictures and to continue learning.

A Note from the Author

As is evident and necessary, throughout the text I mention the brand names of the equipment I've used and relied on for years. Though I strive to be fair and honest, readers should know that in April 1995—after 12 years of using and loving Canon equipment—I became a Canon contract photographer and continue in that role at the time of publication. My first contract was part of their "Special Way of Seeing" program, and my work was featured in two books published by Canon, *Explorers of Light* and *EF Lens Work II*. I've also made a television commercial for Canon EOS equipment and was featured in two episodes of the "Canon Photo Safari" television show that aired on ESPN in November of 1997.

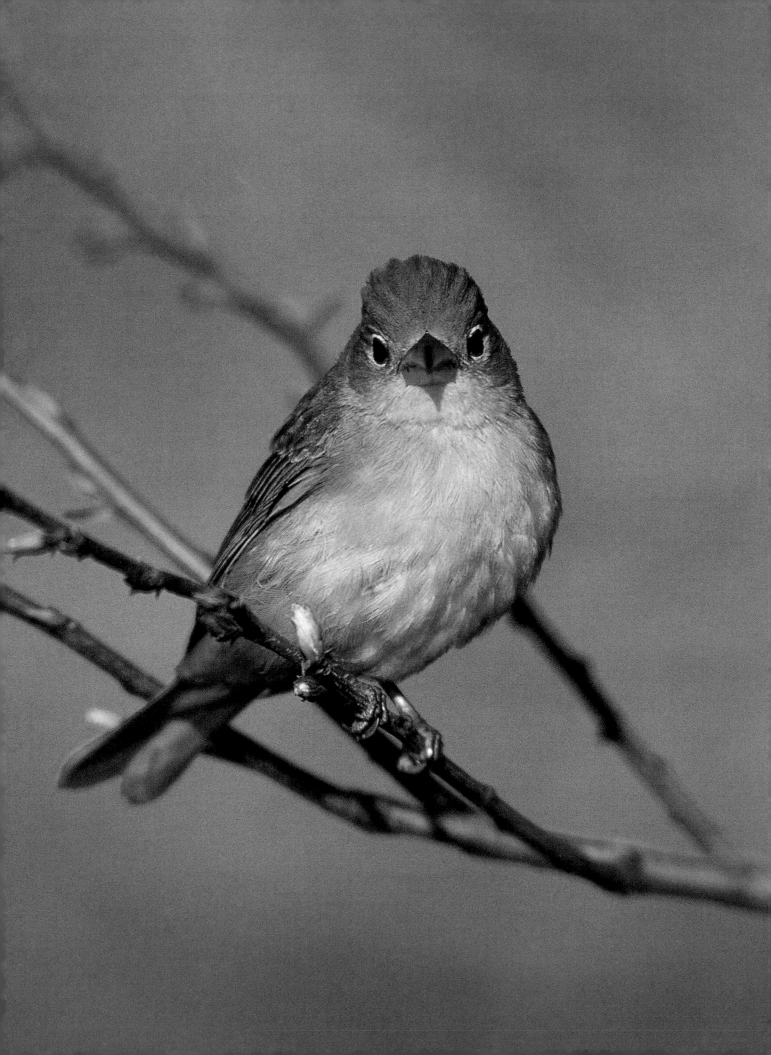

INTRODUCTION

Why photograph birds? Birds are beautiful creatures. If you've ever seen a purple gallinule, a scarlet tanager, or a male Cape May warbler, you need no further explanation as to why they are such popular photography subjects. Laughing gulls in breeding plumage feature velvety, jet black hoods, white eye crescents, and wine-red bills, while great egrets feature lime green lores. Snowy owls are white and black with piercing, bright yellow eyes. But even the subtle beauty of earth-toned sparrows and shorebirds—studies in browns and buffs—cannot be denied. And, birds come in a variety of shapes, as well. Plovers are plump, gannets are pointed at both ends, terns are elegant, and falcons are sleek.

Birds are also interesting creatures. Most wear two distinct sets of feathers each year, and their appearance varies as a result of feather wear and bleaching, as well. About 650 species breed regularly in North America, and well over 200 other types have visited the continent. There are eight or nine thousand species in the world, depending on who's counting, so photographers will never be lacking for new subjects.

Birds lead fascinating lives. They rarely stay still for long and perform a variety of interesting behaviors each and every day. They feed, drink, preen, sleep, walk, run, swim, dive, perch, defend, squabble, fight, build nests, court, mate, and incubate, protect, and raise their young. Best of all, they fly. (Modern autofocus equipment has opened up a new era in flight photography.) Even if photographers chose to photograph only a single family of birds, such as the owl family, or perhaps just a single species of bird, such as the great blue heron, their life's work would never be done, their photographic collection never complete.

FEMALE SUMMER TANAGER, Point Pelee National Park, Leamington, Ontario. Canon EF 600mm F4L lens with 1.4X teleconverter plus 25mm of extension and EOS 1N body, Fuji Velvia pushed one stop, evaluative metering +1/3 stop: 1/640 sec. at f/5.6

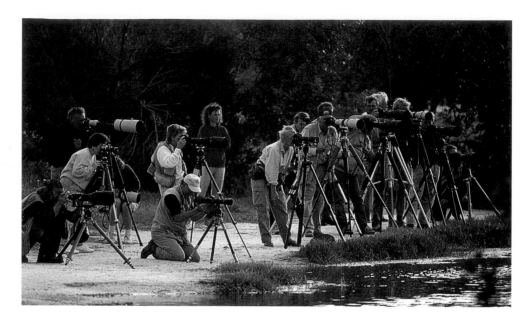

BIRD PHOTOGRAPHERS,
Ding Darling National Wildlife
Refuge, Sanibel Island, Florida.

Birds can be difficult subjects, so photographing them is a great challenge. They're usually fearful of humans—especially humans carrying big telephoto lenses—and, as a result, are often difficult to approach. They rarely remain still, or in one spot, for long. In addition, some live in inhospitable or inaccessible locations, such as swamps and treetops. Often, as I approach a particularly rare or beautiful bird, I'll whisper to the bird, begging it to stay put, telling it in endearing terms how lovely it is, saying, "Don't fly beautiful baby." I assure it that I mean no harm and let it know that I only wish to capture its beauty on film. Sometimes the bird listens, sometimes it doesn't. When it doesn't, I despair.

Photographing birds is also educational. Birders often visit several productive sites in a single morning, checking off their sightings as they proceed and wondering, "How many different species can I see today?" Bird photographers, on the other hand, often spend an hour or more with a single bird or group of birds. In doing so, they unavoidably learn a tremendous amount about their subjects. They witness a variety of behaviors and interactions, and they learn to interpret a bird's actions and anticipate its next move. In photographing a single species of bird over the course of several years, one can accumulate a vast amount of knowledge with regard to both the subject's life history and to changes in its plumage and appearance. I really do need to do a herring gull book!

Why photograph birds? It is fun, exciting, and rewarding. Or, as I say often, it's a tough job, but somebody's got to do it. Getting the shot in difficult circumstances is a huge thrill. I can remember nailing a speeding bufflehead in flight with my 600mm autofocus lens off the footbridge at Bolsa Chica Lagoon in Huntington Beach, California, and whooping for joy. Being outdoors is a big plus; spending a day in a beautiful, natural area is great, even if you don't get to make any good photographs at all. And, having an

unexpected bird land right in front of you for no reason at all can be a mind-blowing experience.

Recently, I was photographing a winter-plumage glossy ibis at close range in Jamaica Bay Wildlife Refuge. As this species is usually very wary, I was quite excited. I noticed a female blue-winged teal circling around in flight, as if looking for a place to land, but had no expectation at all of photographing her since this bird is always extremely skittish in the northeast; I was standing in plain sight in the shallow water. But, I *was* standing very still, and the next time I looked up, the teal had landed nearby and was floating right in front of me. Though stunned by my good fortune, I was able to make several nice images before she sensed me and paddled away. The tale of this experience alone perfectly answers the question, "Why photograph birds?"

Be aware, however, that in bird photography the results are often disappointing and the experiences often frustrating, even for seasoned photographers. Don't be discouraged. Look at as many quality photographs as you can in books, magazines, and calendars. Read and reread this book—especially the chapter on exposure—until the information becomes familiar; your work will improve dramatically. Understand, also, that this book is about the way *I* photograph birds. For the most part, I simply take my equipment, go for a walk, approach free, wild, and unrestrained birds with care, and try to create artistic images. I rarely work from blinds, photograph songbirds at the nest, or make hummingbird images with multiple high-speed flashes. I've got a bad back and very little patience, so blinds—especially cramped ones—are not my favorite places. I firmly believe that photographing nesting landbirds can only harm the birds. And, as for electronic flashes, one is more than enough for me.

I have no problem at all with photographers who work around feeders; the birds are free and wild. Setting up attractive perches in these or other similar situations is equally

fine with me. Photographing legally held, captive birds is not a problem either, but I firmly believe that such images must be honestly labeled by photographers and accurately captioned by publishers. To my mind, those who photograph animals at zoos, raptor rehabilitation centers, or game farms, and then attempt to pass these images off as real (often, for example, by labeling them "Mountain lion, Montana"— Montana being the game-farm location) are simply lying to the viewer. The same goes for those who dramatically alter or create images on the computer. Unfortunately, the days when the viewing public could believe that each published image depicted a free and wild creature as seen through the lens of a photographer are gone. This saddens me.

It has long amused me that all nature photographers profess only the highest ethical standards but, in practice, apply their strict standards to everyone but themselves. I will admit to (very rarely) stepping a short distance off the path to get a great shot, to photographing migrant raptors responding to my decoy owl, and to occasionally flushing (inadvertently scaring) a bird or birds that I had been attempting to photograph. I realize that there are many who would have serious problems with all of these actions. I do not, however, ascribe to the theory that if a bird you're approaching stops what it is doing and looks up at you, then you're guilty of harassing wildlife. All in all, I do try to minimize my impact on both the creatures I photograph and the environments they inhabit.

Having been in bird photography for many years, I've learned of many practices that must be considered—by any ethical standards—disturbing, despicable, and abhorrent. Landbirds are very hard to photograph, so some photographers resort to capturing the birds either legally, under federal banding permits, or illegally, and then restraining them or placing them in natural enclosures to be photographed at close range. Such practices are in all cases illegal. If you see a huge-in-the-frame songbird image, especially a vertical one, be wary, and examine it carefully. Often, the bird's wing coverts will be disheveled, indicating that it has just been taken from a mist net. The bird may also exhibit a crouched posture, its crown flattened and its eyes bulging. All these signs are dead giveaways that the bird in the image is terrified. Lastly, look at the toes; if they are misplaced on the branch, it is another sure sign of a truly frightened bird.

I know of one top professional photographer who moved a family of *unfledged* baby owls to a more attractive perch, and of another who sawed the branch from which an oriole nest hung to bring it closer to the ground, and of yet another who swung an unfledged grosbeak chick about his head several times before placing the dizzy,

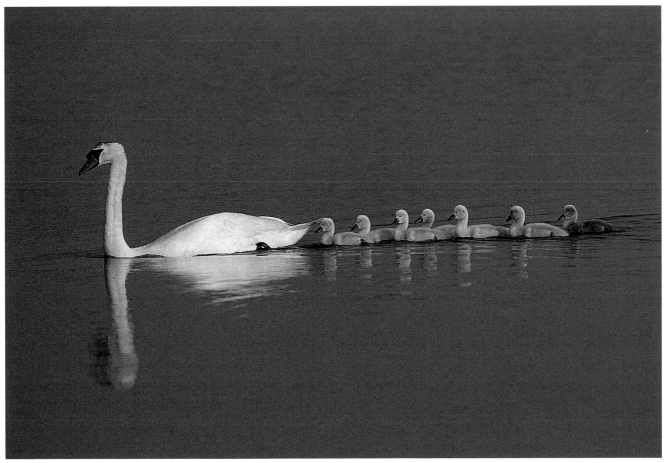

MUTE SWAN WITH CYGNETS, Lighthouse Pond, Cape May, New Jersey. Canon EF 400mm F5.6L lens and A2 body (handheld), Fuji Velvia pushed one stop, evaluative metering -1/2 stop: 1/1000 sec. at *f*/5.6

dazed bird on a clean perch for portraits. Years ago, one highly respected natural history magazine featured an unfledged warbler on its cover. The baby bird was tethered to a log by a clearly visible thread around its leg. And, after seeing a gorgeous great horned owl image on the cover of one of the top birding magazines, my envy turned to dismay after learning that the owl was a rehabilitated bird brought into the woods and then posed in an attractive natural setting.

Another well-known bird magazine featured an adult penguin and a cute-as-could-be chick against a background of blue ice on the cover. When I complimented the editor on his choice of cover art, he proudly stated that it was *he* who had created the image on a computer from *three* separate images, all made by a very famous photographer. No mention of the computer manipulation was made in the magazine. Amazingly, the editor couldn't understand my objections at all. It is unfortunate that today the validity of all spectacular natural history images is questioned, whether they are phonies or not. How sad for those who work hard—and ethically—at the art of bird and nature photography. In my mind, it is generally best to take your equipment, go for a walk, and strive to create artistic images.

Some bird species have done well as humans have drastically changed the face of the planet over the past two centuries. Blue jays and American robins thrive in the disturbed habitats of residential areas. These birds, as well as chickadees, titmice, and northern cardinals, also flourish in the second growth of abandoned farm fields, and millions of blackbirds, grackles, and brown-headed cowbirds roam the continent's extensive farms and croplands. Red-winged blackbirds now nest in hay and alfalfa fields, as well as in their more traditional marshes. In addition, other species, whose populations

BROWN PELICAN, La Jolla, California. Canon EF 600mm F4L lens and EOS 1N body, Fuji Velvia pushed one stop, evaluative metering at zero: 1/800 sec. at ƒ/5.6

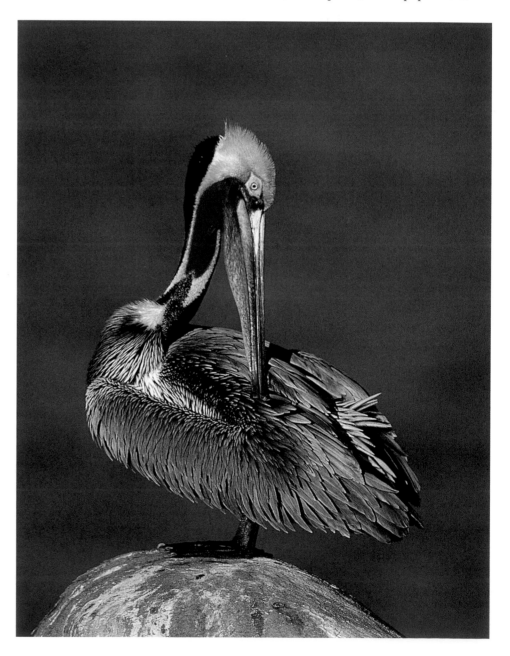

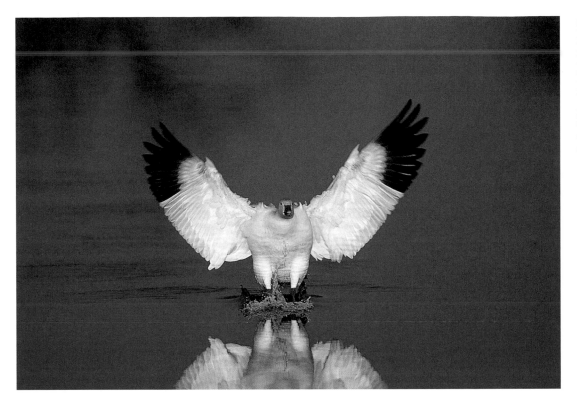

SNOW GOOSE,
Bosque Del Apache
National Wildlife
Refuge, New Mexico.
Canon EF 600mm
F4L lens and EOS 1N
body, Fuji Velvia
pushed one stop,
evaluative metering
at zero: 1/800 sec.
at *f*/5.6

have been threatened or endangered, are, after receiving extraordinary attention and protection, rebounding nicely. Examples include the osprey and peregrine falcon; populations of both birds have recovered well in many areas from the eggshell-thinning depredations of DDT, although the chemical is still widely used in South America.

Many shorebirds have also rebounded well after market hunting was banned early in the 20th century, but populations of some species, such as American golden-plover and Hudsonian godwit have never recovered fully. And, the Eskimo curlew, at best, teeters on the brink of extinction. Even more disturbing are the unexpected declines of some shorebird populations; sanderling numbers, for example, are down 60 to 80 percent over the past quarter of a century. These globe-trotting sandpipers breed worldwide above the Arctic circle and winter on the beaches of six continents, yet no scientist has a clue as to the reasons for their continuing dramatic decline.

Most disturbing of all, however, are the apparent alarming declines in numbers of neotropical migrant passerines (perching birds). While many birders (myself included) and scientists sense that there are far fewer songbirds than there were in the seventies, breeding bird surveys, banding data, and other studies confirm that declines of 50 to 75 percent are real. Studies along the Gulf Coast show just a trickle of birds heading north on spring evenings, while just several decades ago torrents of migrating birds blipped their way across radar screens on many late April evenings. Here, the reasons for declining populations are obvious. In North America, the destruction and fragmentation of forests continues unabated; nesting

landbirds are exposed to cats and other predators, and also to brood parasitism by the brown-headed cowbird. Still others are simply denied the large unbroken woodland tracts that they require to breed successfully.

On the South American wintering grounds, habitat destruction proceeds at an even faster rate. Factor in industrial and agricultural pollution on both continents, and the recipe for disaster is complete. Wood thrush, ovenbird, cerulean warbler, and Baltimore oriole are just a few examples of neotropical migrants that have suffered greatly at the hands of humankind.

Populations of grassland breeding species are in even worse shape. Large declines in the number of Henslow's and grasshopper sparrows, upland sandpiper, loggerhead shrike, and even eastern meadowlark have been documented over the past two decades. And, beach nesters such as piping and snowy plover and least tern are not faring much better. These birds are under pressure from both continued development and increasing numbers of beachgoing humans, including fishermen who believe it is their constitutional right to drive their beach buggies through tern colonies and over piping plover chicks.

It has been understood for some time that birds are accurate indicators of environmental degradation. It is also understood that species that fail to adapt to environmental changes (no matter what the cause) are headed toward extinction. Many people today think that the human species exists above and beyond the earth's ecosystem and that when things get very bad environmentally, we (because of our supposedly high intelligence) will be able to execute a quick fix. In addition to habitat destruction

and pollution, the problems of available energy and human overpopulation rule out the quick-fix idea. We fail to realize that declining bird populations are trying to warn us that we're trashing the planet, and though we're causing most of the problems, we must understand that *we are part of the planet's ecosystem.* The birds are trying to warn us that we, too, as a species, are rapidly headed toward extinction.

Even if there are birds for us to photograph well into the next century, nature photographers may well be out of luck anyway. As more and more of us enjoy both birding and photography each year (the vast majority in an ethical and unobtrusive manner), many refuge, wildlife, and land managers respond by closing some venues, restricting access to others, reducing hours of operation, introducing senseless regulations, and allowing travel only by crowded trams or tour buses running on severely limited schedules. While closures and other changes at famous locales like Denali National Park in Alaska have drawn great opposition and storms of protest from the nature photography community, it is the great number of closings and restrictions at many other lesser known sites that concerns me most.

Fifteen years ago, several nearby locations made San Diego, California, a bird photographer's paradise. Today, however, pickings are slim indeed. Birders and photographers visiting Imperial Beach used to be allowed to walk along the Tijuana River to its mouth, where American avocets, long-billed curlews, and elegant terns fed and rested. For a few years, the area was closed for several months each year to protect the endangered snowy plover, but now the estuary is closed 365 days a year. The

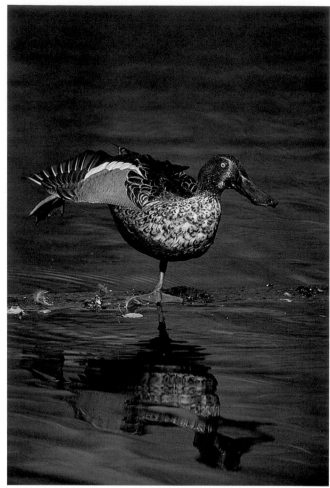

MALE NORTHERN SHOVELER, Big John's Pond, Jamaica Bay Wildlife Refuge, Queens, New York. Canon FD 800mm F5.6L lens with 25mm extension tube and T-90 body, Fuji Velvia pushed one stop, center-weighted average metering -1/3 stop: 1/180 sec. at *f*/5.6

SANDHILL CRANES, Bosque Del Apache National Wildlife Refuge, New Mexico. Canon EF 600mm F4L lens and EOS 1N body, Fuji Velvia pushed one stop, evaluative metering +2/3 stop: 1/180 sec. at *f*/4

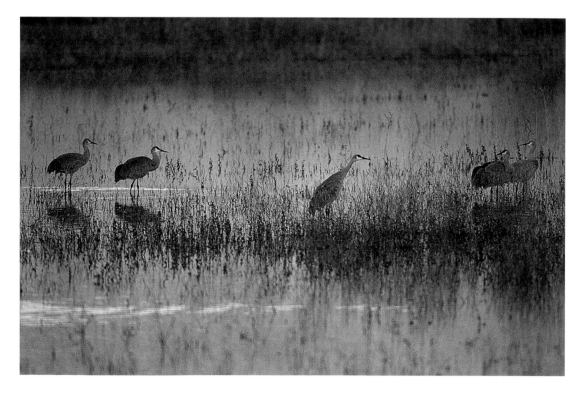

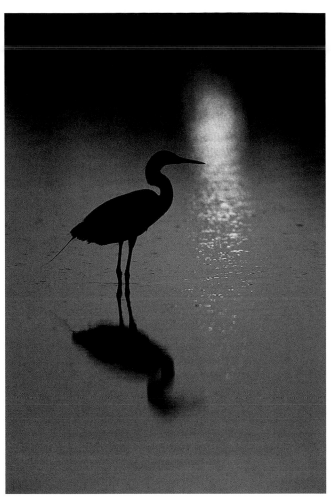

REDDISH EGRET, Ding Darling National Wildlife Refuge, Sanibel Island, Florida. Canon EF 600mm F4L lens with 1.4X teleconverter and EOS 1N body, Fuji Velvia pushed one stop, evaluative metering +1/3 stop: 1/500 sec. at ƒ/5.6

blue and white signs with the flying goose logos read "National Wildlife Refuge/Unauthorized Entry Prohibited." When I visited the headquarters of the Tijuana River National Estuary and inquired as to how to secure authorized entry, I was told that there were no provisions for authorized entry.

Nearby, Border Field State Park has been closed for years, as I understand, because of pollution. You can visit Chula Vista National Wildlife Refuge only by taking a tram from I-5 to the visitor center after 10:00 A.M. But don't bring your camera, wildlife observation is permitted only from a single viewing tower. Several formerly productive coastal lagoons north of San Diego are now completely encircled by chain link fences. How natural. And, in 1997, the world's very best location for photographing brown pelicans—the cliffs above the main cove at La Jolla, California—was closed to all access to keep out late-night beer guzzlers and vandals!

Though an internationally renowned bird photography hot spot, the Ding Darling National Wildlife Refuge on Sanibel Island, Florida has seen similar deterioration in recent years, as well. The refuge, like most in the National Wildlife Refuge system, formerly opened at sunrise but now opens at 7:30 A.M. In April, the sun has been up for more than an hour and a half and the golden light is long gone before vehicle entry is permitted, and though early pedestrian entry is permitted, the two best photography spots are more than two miles from the entrance.

Presently at Ding Darling, long lines of cars wait eagerly in early morning for the automated gate to open. On some weekends, the line is so long that the traffic on Sanibel-Captiva Road is impeded. When the gate does open, many cars race through the refuge (disturbing wildlife as they go) to reach the mud bar, the traditional roseate spoonbill roost. Photographers have been photographing spoonbills from the muddy beach below the limestone road for decades, yet in 1997, new, more restrictive signs were employed. Placement of the new signs limited photographers to the bank *behind* the muddy beach. Instructed to shoot from the bank, rather than from the narrow beach, photographers trampled native vegetation. Additionally, "to reduce disturbance of birds and other wildlife," the refuge is now closed on Fridays. When well-known birders Don and Lillian Stokes asked me what I saw for Ding Darling in the year 2000, I answered, "Open Saturday through Monday, 10:00 A.M. to 2:00 P.M., admission on tram only."

At Ding Darling, seeing long lines of photographers just yards from spectacular feeding aggregations that include hundreds of wading birds is a common sight; the great majority of birds at this location are totally unafraid of humans. In more than a decade of photographing at Ding Darling, I can scarcely recall seeing a single bird scared by an approaching photographer (point-and-shoot camera–toting tourists excluded). On one still morning, however, I did see several dozen birds fly off in fear of the approaching brush hog, a roaringly loud mowing machine designed to clear roadside vegetation.

Astoundingly, wherever and whenever I complain about restricted park access—which is often—I'm told that I'm the only one who has voiced concern. If we, as birders and bird photographers, don't band together to exercise our political voice, we can only look forward to more closures, more shortened refuge hours, and little or no access to our favorite hot spots.

The aforementioned problems aside, viewing your images on a light box is almost always a great thrill and is a big part of why I photograph birds. Picking the very best photograph from a long sequence or finding a single great image among 16 boxes of junk makes me feel like a kid with a big bowl of ice cream. And, sharing my work with others, whether as prints, in slide shows, or on the published page, is like adding hot fudge and cherries. As you read this book, I hope that you enjoy your ice cream sundaes.

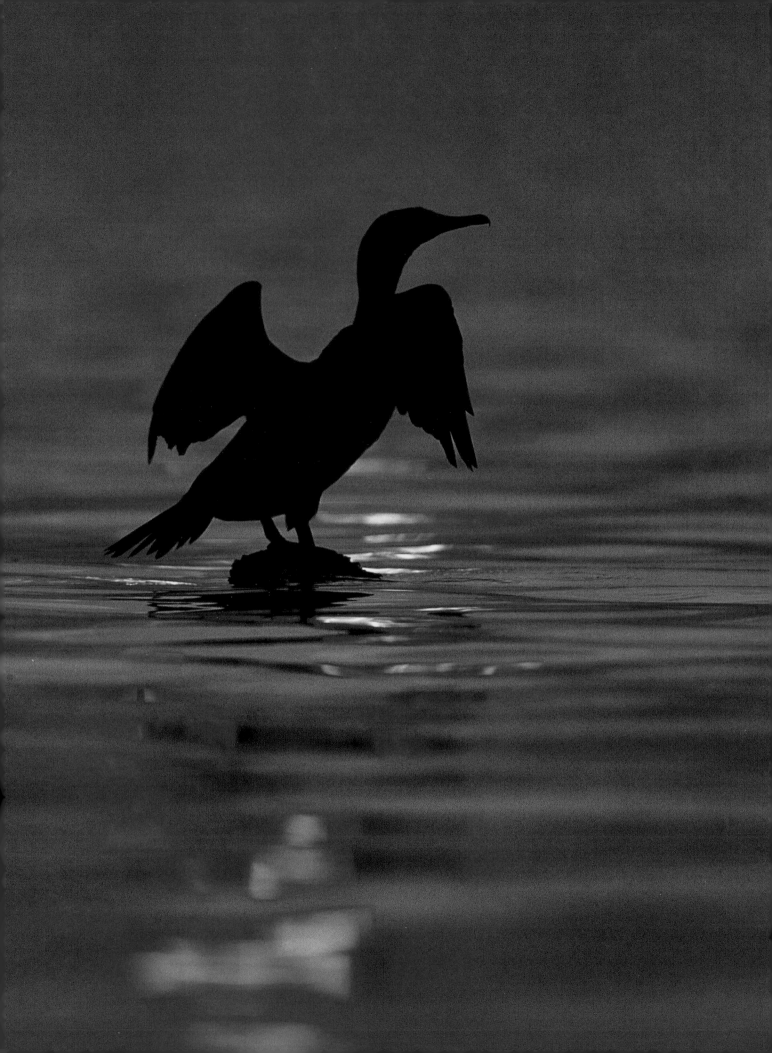

Chapter One

CHOOSING THE RIGHT EQUIPMENT

Choosing and purchasing a camera system and a telephoto lens today is a daunting and expensive proposition. There are many questions to consider. What is the best focal length? Should you buy autofocus (AF) or manual? New or used? Which is the best system, Nikon or Canon? How do Pentax, Minolta, Olympus, Contax, Leica, and independent-brand lenses compare? Is high quality glass worth the additional investment? Should you change systems if you already have equipment? Surely, you'll want to research and test various brands before purchasing a telephoto lens.

Read, but also be wary of, the product reviews in various photography magazines. (My favorite lens, the Canon EF 400mm F5.6L, was trashed in a review by one of the top photography magazines.) On the other hand, be wary of glowing reports. Consult knowledgeable camera store personnel. Speak to other bird photographers. If at all possible, field test equipment before plunking down your credit card. You can often rent both lenses and camera bodies from large camera stores, borrow them from other photographers, or take instructional photo-tours on which a variety of lenses may be available for loan or rent. After doing some research, buy the best equipment that you can afford.

In recent years, a quick look at the photo credits in prestigious wildlife calendars and magazines reveals that the great majority of nature images taken in North America are made with Canon or Nikon equipment. These systems are favored by nature photographers because of their reputations for quality and durability, the availability of a wide range of focal length lenses and system accessories, and because they employ the latest in metering and autofocus technology.

Since Canon was the first to develop a superbly effective autofocus system (EOS), a look along the sidelines at many major athletic events worldwide during the last decade often reveals primarily Canon telephoto lenses (the white ones), with very few Nikon lenses (the black ones) in evidence. Nature photographers wishing to photograph birds in flight and action have basically the same equipment needs as sports photographers. In spite of Canon's great technological advances in the nineties, however, Nikon has maintained the market share among nature photographers. In addition, Nikon recently joined the autofocus fray with a vengeance, offering a superb line of autofocus equipment that includes the F5 body and several AF-S telephoto lenses.

DOUBLE-CRESTED CORMORANT, North Channel Bridge, Jamaica Bay Wildlife Refuge, Queens, New York. Canon FD 800mm F5.6L lens and T-90 body, Fuji Velvia pushed one stop, center-weighted average metering +2/3 stop: 1/500 sec. at ƒ/5.6

Long lenses make a bird photographer's job easier.

Essential Camera Features

Virtually all bird photographers use 35mm single-lens-reflex (SLR) camera bodies as the basis for their photographic systems because of their light weight and the ease and speed of operation that they provide. While it is true that a camera is just a black box that lets in light, today's modern bodies offer a wide range of features, many of them essential to nature photographers specializing in birds. The following are several features that I consider indispensable and some that, while not essential, can often be very helpful.

ACCEPTANCE OF INTERCHANGEABLE LENSES

Point and shoot 35mm SLR cameras with fixed lenses are virtually useless for photographing birds, especially since the longest focal length generally available is 135mm (on some zooms). Bodies that accept interchangeable lenses are a necessity for both bird and general nature photography. Being able to switch lenses quickly allows a photographer complete control of both the framing of a scene and the magnification of the subject.

INTERCHANGEABLE FOCUSING SCREENS

The split-image focusing screens that are standard in many older camera bodies will drive you nuts if you photograph birds or other moving subjects; avoid these screens at all costs. Bright, fine matte screens are your best choice; they make focusing easier. Some photographers install Beattie Intenscreens for even brighter viewing (and, therefore, easier focusing). Others choose grid screens (offered by most camera manufacturers) to ensure that their horizons are level and their subjects square to the world.

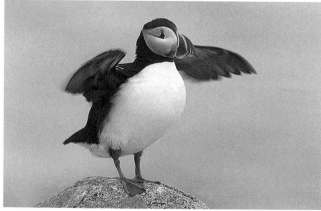

ATLANTIC PUFFIN, Machias Seal Island, Maine. Canon EF 500mm F4.5L lens with 1.4X teleconverter and EOS 1N body, Fuji Velvia pushed one stop, evaluative metering +2/3 stop: 1/320 sec. at *f*/6.7

Power winders are an essential camera feature for bird photography, especially when the action is fast and furious, and your time with the birds is limited. Logistics usually limit your time in the blind on Machias (where I made this picture) to well under two hours, so you'd better be able to shoot fast!

THROUGH-THE-LENS METERING

Through-the-lens (TTL) metering is fast, practical, and fairly accurate. It also makes life easy when lighting conditions are changing rapidly, such as when the sun is at full strength one moment and then blocked by a cloud the next. Additionally, the amount of light lost when using extension tubes (the hollow spacers that fit between the camera and lens to allow for closer focusing) and teleconverters (devices used to increase the effective focal length of lenses) need not be calculated. Through-the-lens metering measures the light coming *through* the lens so that it is not necessary to compensate for the light lost due to the use of extension tubes or teleconverters. Handheld light meters may be great for landscape and close-up photography, but birds usually don't remain still as long as mountains or flowers (on calm mornings) do.

AUTOMATIC EXPOSURE MODE WITH APERTURE PRIORITY

With these features, standard on most current camera bodies, you select a lens opening (which, when photographing birds, is usually the widest one), and the camera selects a shutter speed. You can work quickly at the fastest possible shutter speed while taking advantage of today's sophisticated metering systems (see chapter 3). I work in automatic exposure (AE) mode in aperture priority more than 99 percent of the time. You will, however, need to learn when and how to override your camera's meter.

MANUAL EXPOSURE MODE

This feature, used extensively by many experienced amateur and professional photographers, allows you to select and set both the aperture (lens opening) and the shutter speed. Though I almost never work in manual mode, I find it useful when the light on the subject is constant but the brightness of the background is changing from moment to moment, such as when photographing sunlit birds in flight against a changing background of white and dark clouds, or blue skies and clouds. I also use manual mode, at times, when I'm working in extreme lighting conditions.

POWER WINDER

A power winder, or motor drive, which advances the film instantly and automatically after you make an exposure, is an absolute necessity for bird photographers. With one, you'll always be ready for the next shot and be able to capture long behavioral or flight sequences. The speed at which the film advances varies from one or two frames per second (fps) to as high as six or eight fps. The faster the film advances, the more in-camera originals you can produce and the more complete your action sequences

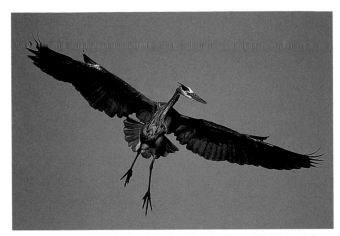

GREAT BLUE HERON, South Venice, Florida. Canon EF 600mm F4L lens and EOS 1N body, Fuji Velvia pushed one stop, evaluative metering +1/3 stop: 1/640 sec. at f/5.6

When using good autofocus equipment, it is important to select your camera's fastest drive mode so that you can make several images after focus has been acquired.

will be. Today, most camera bodies have built-in power winders. As a general rule, the fastest power winders are offered on the most expensive bodies.

OPTIONAL DRIVE MODES

No, this feature has nothing to do with golf, automobiles, or your desire to succeed. *Drive* simply refers to the film winding mode. Most modern camera bodies offer the following drive choices: single frame, continuous low, and continuous high. In single-frame drive mode, you can only make one image at a time; you must release the shutter button completely before you can make a second exposure.

On my photo-tours, I encounter many photographers, especially beginners, who choose this mode to "avoid wasting film." To me, this represents false economy. In bird photography, spectacular opportunities are few and far between. When they occur, you should strive to make as many images as you can in as little time as possible. Aside from having a series of in-camera original similars (similar original images), one photo in a series will almost always stand out as the best because of minor changes in the bird's posture or head position. Having to release the shutter button between frames cuts down significantly on the number of images you can make in a given time. In addition, when using autofocus, letting up on the shutter button even momentarily will require you to reacquire focus.

I usually have no trouble convincing these photographers to switch at least to continuous-low drive mode. Set to continuous low, the camera will fire one frame after another at a speed somewhat slower than its maximum speed. I'm sure that you won't be surprised to learn that I always set all my camera bodies on continuous-high drive mode (the fastest firing speed). I do, however, try to remember to switch to single-frame mode when shooting close-ups or scenics to, you guessed it, avoid wasting film.

VERTICAL GRIPS

Vertical grips are either standard equipment or optional accessories on most top-of-the-line camera bodies and on a limited number of other models, as well. The ideal vertical grip offers a shutter button and the several key camera controls necessary to make shooting in vertical format convenient. Some high-end camera bodies feature power winders that serve as functioning vertical grips. Before I owned a camera with a good vertical grip, shooting verticals was difficult, but now, with my EOS A2s and 1Ns, it is as easy as shooting horizontals.

DIAL-IN EXPOSURE COMPENSATION

When working in any automatic exposure mode, the dial-in exposure compensation feature allows you to do just what its name suggests—dial in exposure compensation, usually in 1/3- or 1/2-stop increments—as follows: plus (+) for lighter exposures, minus (-) for darker ones. I prefer bodies that offer exposure compensation in 1/3-stop increments because of the fine control that they afford. Avoid camera bodies that have exposure compensation mechanisms that require you to use two hands or take your eye from the viewfinder. Canon bodies feature easy-to-use exposure compensation features.

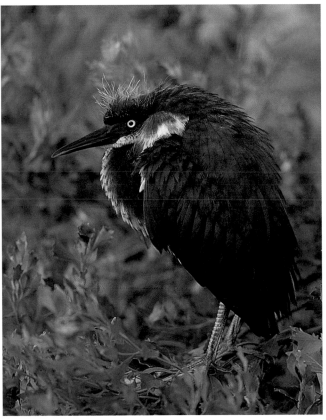

TRICOLORED HERON, St. Augustine Alligator Farm, St. Augustine Beach, Florida. Canon EF 500mm F4.5L lens and EOS 1N body, Fuji Velvia pushed one stop, evaluative metering at zero: 1/250 sec. at f/4.5

Almost all vertical grips offer a shutter button and several other important camera controls that make shooting vertical compositions a snap.

Self-Timer

This camera body feature, while not entirely essential, can sometimes be extremely helpful in specialized situations. At slow shutter speeds with tripod-mounted systems, a self-timer helps eliminate the vibrations caused by depressing the shutter button manually, and sharper images result. (Using a cable release would have the same effect.) Most self-timers have either 2- or 10-second delays; so, if the bird flies away (or changes position significantly) during the delay, you're out of luck.

Mirror Lock-Up

This feature, currently available on only a few cameras, allows you to make photographs of static subjects at very slow shutter speeds by raising the mirror before the exposure is made, thus eliminating vibration due to mirror slap. (During normal operation, the mirror is raised just an instant before the shutter begins to open.) For best results, use a cable release or the camera's self-timer in conjunction with mirror lock-up to avoid the vibrations caused by depressing the shutter manually.

Depth-of-Field Preview

This is another desirable, but not entirely essential, camera body feature. Depth of field is the zone of front-to-back sharpness in a photograph. To allow for accurate focusing, all modern camera bodies offer wide open viewing; even if you have chosen a small aperture, the image you see in the viewfinder appears as it would if the image were being viewed at the lens' widest aperture, that is, wide open. By activating the depth-of-field preview feature, the smaller aperture that you have chosen is set. After giving your eye a moment to adjust to the darker image, you'll note that more of the image is in sharp focus; you can actually *see* the depth of field.

SNOW GEESE AT SUNRISE, Bosque Del Apache National Wildlife Refuge, New Mexico. Canon EF 28–105mm F3.5–4.5 zoom lens at 28mm and A2 body, Fuji Velvia pushed one stop, evaluative metering +1 stop: 1 second at *f*/11

After setting a custom function on the Canon A2 body, mirror lock with two-second delay is available with the push of a single button. I always use mirror lock when shooting at very slow shutter speeds well before dawn.

To check an image for sufficient depth of field, simply set smaller and smaller apertures while activating depth-of-field preview. This feature is especially helpful when photographing resting flocks of birds with long lenses. Additionally, using depth-of-field preview often helps reveal distracting background elements by bringing them into sharper focus. This feature is offered only on a relatively few camera bodies, so check a camera's specifications carefully before buying if you'd like a body with depth-of-field preview.

Autofocus

The ability of the best modern autofocus equipment (Canon and Nikon) to track moving subjects and attain accurate focus at the instant of exposure is science fiction-like; for photographing birds that are flying, swimming, walking, or running, it performs superbly. For photographers with poor vision, it can be a godsend. (For photographing birds at rest, or other static subjects, autofocus offers no great benefits at all to those with good vision.) If you do opt for an autofocus system, make sure you choose one with the focusing motor *in the lens*; focusing motors that are built into the camera body were engineered to drive short lenses and just are not powerful enough to focus long telephoto lenses quickly.

Auto-Rewind

This feature rewinds the film automatically after the last frame on a roll is exposed. It allows you to get back into the fray quickly. Several modern bodies give you the option of choosing auto or manual rewind, as well as the option of choosing a fast or slow rewind speed. For normal shooting, I choose high-speed auto-rewind. The slower rewind speed, though, is quieter and uses less battery power.

100-Percent Viewfinder

Being able to view the entire image allows you to make sure that no distracting elements creep in along the frame edges. Virtually all professional camera bodies feature 100-percent viewing. Most, if not all, of the less expensive bodies offer only 92- or 93-percent viewing, as do my Canon A2 and A2E bodies. (The A2E body offers eye-control focus; it works, but has virtually no advantages for nature photography.)

For most bird photography, and particularly for shooting birds in flight, using a camera with a 92-percent viewfinder is no great handicap at all. It is important to remember that the inside dimensions of a slide mount are slightly smaller than a 35mm transparency; thus, a small portion along the edge of an image will be obscured by the mount.

Autoexposure Bracketing

After making a series of images at what you believe to be the correct exposure, it is often a good idea to ensure success by making additional, similar images at different exposures.

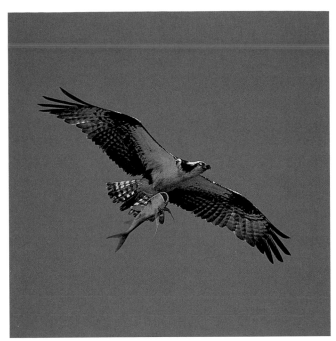

OSPREY CARRYING GAFF-TOPSAIL CATFISH, Sanibel Island, Florida. Canon EF 400mm F5.6L lens and EOS 1N body (handheld), Fuji Velvia pushed one stop, evaluative metering +1/2 stop: 1/640 sec. at *f*/5.6
The days when using autofocus meant listening to the "zzz, zzz, zzz" of a hopelessly searching system are over. Modern autofocus lenses and bodies are quiet and deadly accurate; they're incredibly effective when photographing birds in flight.

This is especially true when traveling to distant locations. While it is a fairly simple matter to vary the exposure by using your compensation dial, it is faster and easier to use your camera's autoexposure bracketing (AEB) feature.

To do this, first set the AEB compensation (usually at +/-1/3 or +/-1/2 stop). Next, focus and reframe the image as necessary, then depress the shutter button and hold it down. A series of three images will be made, each at a different exposure. If you've chosen +/-1/2 stop, an image will be made at the metered exposure, another 1/2 stop lighter, and another 1/2 stop darker. Depending on your camera body, the order in which the exposures are made may vary. If you have an option, it is best to have the first image made at the metered exposure; that way, if you begin a series with an action shot, it will be made at the exposure you thought best.

You may enter exposure compensation first and then auto bracket around that. For example, if you add 2/3 stop to the exposure and then set AEB to +/-1/3, the images will be made at +2/3, +1, and +1/3 (though not necessarily in that order). As you get better and better at determining the correct exposure, you'll often be positive that either one of two exposures is correct. You might, for example, be sure that either the metered exposure or +1/2 stop will be perfect. Currently, the Nikon F5 is the only camera body I know of that offers AEB *in only one direction.* This is a valuable feature—one that other manufacturers would be wise to include on future models.

Another advantage of using AEB rather than setting an exposure compensation occurs in the following situation: If you've added 1/2 stop to what you believe is the correct exposure and the bird strikes an extraordinary pose—a dramatic wing stretch, for example—all your images may wind up overexposed. By using AEB and keeping the shutter-button depressed, you'll be assured of coming up with at least one perfect exposure. This brings up one final point. Some AEB features don't allow continuous firing (beyond three frames). This is a problem, especially when autofocusing, because when you let up on the shutter button so that you can fire another burst, you'll need to reacquire autofocus. At present, continuous AEB firing is offered only on the Nikon F5. It is a feature that other camera manufacturers would be wise to include on future models.

VIEWFINDER SHUTTER

There are instances when it is best to make an image with your eye away from the viewfinder. By closing the viewfinder shutter (which is standard equipment on some high-end bodies), you prevent all direct and stray light from entering the viewfinder, where it could influence the in-camera meter and cause underexposure (when you're working in any automatic exposure mode). When I'm working with slow shutter speeds and mirror lock-up, for example, I'll often view the birds through binoculars and use a cable release to make the exposure when things look perfect. In this and similar circumstances it is necessary to block extraneous light from entering the viewfinder. (If your camera doesn't have a viewfinder shutter, you can shade the viewfinder with a hat or your hand, or simply work in manual mode.)

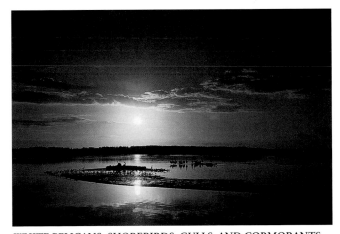

WHITE PELICANS, SHOREBIRDS, GULLS, AND CORMORANTS AT SUNSET, Ding Darling National Wildlife Refuge, Sanibel Island, Florida. Canon EF 28–105mm F3.5–4.5 zoom lens at 45mm and A2 body, Fuji Velvia pushed one stop, evaluative metering +1/2 stop: 1/125 sec. at *f*/11
When shooting spectacular sunrises and sunsets, I often autoexposure bracket around +1/2 stop exposure compensation, as these scenes are, on average, lighter than middle-tone ones. In this instance, I preferred the middle of the three exposures. Working with a short zoom lens allowed me to compose the image so that the island dominated the foreground.

Comparing Camera Bodies

When using Canon FD (manual focusing) equipment, which I did for many years, I relied on T-90 bodies almost exclusively. They were rugged and dependable, had built-in power winders, and featured easy-to-use exposure compensation. They lacked a 100-percent viewfinder, autoexposure bracketing, and mirror lock-up. With Canon's EOS (autofocus) system, I regularly use both EOS 1N (with 100-percent viewing) and EOS A2 and A2E (with 92-percent viewing) bodies. The 1N— the pro body—is fast (6.3 frames per second with the optional Power Drive Booster E1), extremely rugged and dependable, and offers a great variety of features, as well as a set of custom functions that can be set by the user. In addition, it autofocuses superbly on both flying birds and foraging warblers. The Power Drive Booster is an absolutely essential accessory; it takes either AA batteries or, better yet, Canon's rechargeable nicads. Today, many top nature shooters—including Carl R. Sams II, George Lepp, Konrad Wothe, William Neill, Erwin and Peggy Bauer, Adam Jones, Darrell Gulin, Henry Holdsworth, and Brian K. Wheeler—all rely on the EOS 1N.

Although it is my favorite everyday body, the 1N does have some shortcomings. It is expensive. Without the Power Drive Booster or the BP-E1 battery (AA-size) pack you are forced to depend on the expensive and somewhat inadequate (especially in cold weather) 2CR5 batteries. The viewfinder in the 1N could be brighter. Plus, autoexposure bracketing doesn't permit bracketing in one direction only, and the 1N will fire only three-frame AEB bursts.

The Canon A2 and A2E bodies are lightweight and far less expensive than the 1N. As in the 1N, autofocus performs superbly. The A2 and A2E viewfinders are actually brighter than that of the 1N. The optional vertical grip makes a superb addition. And, both A2 series bodies are quieter than the 1N, so I use an A2 series body when attempting to photograph hawks that perch below my decoy owl; at close range, the birds would be scared away by loud camera noises.

On the other hand, film advance with the A2 series bodies isn't nearly as fast as with the 1N, and the command dial on the top left of the camera is a weak link in the construction; take care to turn this dial slowly. I've seen several A2 and A2E bodies (including two of my A2s) on which the command dial's ratchet mechanism failed. The A2 and A2E rely on the less desirable 2CR5 batteries. (The BP-5, a heavy, cumbersome battery pack that takes four D-cell batteries and clips to your belt, is available, but you'll most likely want to resort to it only when shooting in very cold weather.) The most annoying aspect of the A2 series bodies is that when you use them with a teleconverter on many of Canon's EF L lenses, there's a glitch in the metering program. Compensation, in varying degrees of underexposure, needs to be added to null the meter (bring it to a true zero value).

I've had my hands briefly on the Elan II, a Canon body similar to, but less expensive than, the A2 series bodies, and had it not been for the slow film advance, I'd have been very impressed. The command dial has been redesigned, and there are three AF sensors instead of five—I consider this an improvement, since the outside sensors on the A2 series bodies don't perform very well. The optional vertical grip enables the camera to be powered by AA batteries. And, most importantly, the metering glitches encountered when using teleconverters have been eliminated.

My experience with Nikon bodies is extremely limited, but I've learned about them from friends, colleagues, and BIRDS AS ART Instructional Photo-Tour participants. The F4s was *the* Nikon pro body for more than eight years and enjoys a reputation as a rugged workhorse body. Many top professionals including Tom Mangelsen, John Shaw, Art Wolfe, Frans Lanting, Ron Austing, Tom Vezo, Donald M. Jones, Kevin Schafer, B. Moose Peterson, and Charles Krebs have used the F4s to produce many of the outstanding natural history images of our time. Though the very expensive F4s is an autofocus body, the AF system is so poor as to be practically useless for photographing birds in flight. The N90s (*not* the N90) was the first Nikon body to feature a functional autofocus system that worked fairly well for flight photography (with AF-I or AF-S lenses).

In spite of Nikon's reputation for durability, many of my tour participants have had problems with Nikon N90, N90s, and F4s bodies—problems that often involved jammed shutters. Nikon's new pro body, the tremendously expensive F5, was supposed to be light-years ahead of all modern camera bodies; it features color matrix RGB metering and a five-point dynamic autofocus system. It is the first camera body with autofocus sensors not limited to the horizontal centerline. (Wake up, Canon!) However, despite claims that the F5 yields a perfect exposure every time even in the most difficult lighting situations, the F5 overexposes brilliant white subjects in bright sunlight against dark backgrounds and underexposes dark birds flying against white skies just as any other camera would.

Still, the F5 metering system does produce a higher percentage of excellent exposures than any camera body currently in production. Some users have complained that the autofocus system has trouble picking up light- to middle-tone subjects against light- or middle-tone backgrounds.

Others note that battery life is ridiculously short, and still others have had problems when using the F5 with Nikon teleconverters (the body shuts down at times when electrical contact between the body and the multiplier are lost).

Be assured, however, that in spite of its minor shortcomings and its extremely high price, the Nikon F5 is—with its blazing speed (8 frames per second) and superb metering and autofocus systems—one of the premier camera bodies in the history of 35mm photography. Whichever camera body and system you choose, however, understand that the major manufacturers will continue to make significant technological advances in the near future. Today's best high-tech cameras will be obsolete in less than a decade, and often much sooner than that.

Regardless of which camera you choose, if you're serious about bird photography, you'll want and need a second body as a backup. After investing in equipment, film, and travel, the cost of a backup body is almost insignificant. If you own only a single camera body and it malfunctions or is damaged, you'll be out of luck. To avoid this, you can mount a second, shorter lens on your backup body and carry it into the field with you so that you'll have it immediately at hand should a problem arise with your number one body. Some photographers feel that both camera bodies should be identical so that, in the event of a mishap or malfunction, you're equally familiar with both your main and backup camera bodies. Others economize somewhat by owning a pro body as their number one body and using a less expensive body as the backup.

CAMERA BODY ERGONOMICS
When deciding which camera body to purchase, you should always consider the following: How good does a camera body feel in your hands? How easy is it to reach the various buttons and dials that control the functions? How easy is it to press those buttons and turn those dials? How easy is it to work these controls with gloves on?

The science that deals with these matters is called *ergonomics*. A camera body's "feel" and its ease of operation go a long way toward determining how useful a tool it will be in your hands. The best way to learn about a camera body's ergonomics is to grab hold of one in a camera shop, in a friend's living room, or in the field. If it seems that the grip is made for your hands, and that the controls are easy to reach and use, it may just be the perfect camera body for you.

KNOWING YOUR CAMERA BODY
There is one oft-neglected and invaluable accessory that comes with all camera bodies—the instruction booklet. Even if your camera body is the most expensive one on the market and offers every imaginable feature, it will be worthless unless you know how to use it. After you purchase your camera, study the instruction manual carefully. With the booklet open and no film in the camera, load a battery and mount a lens. Practice the various operations until they become second nature to you. Set and change the film speed. Switch from mode to mode, try different metering patterns, and enter exposure compensations. Learn to access and set the various custom functions that your camera offers.

In bird photography, time is of the essence. A moment spent fiddling with an unfamiliar control, or even an instant of confusion wasted searching for a familiar one, can cause you to miss a once-in-a-lifetime photographic opportunity. In addition to your camera's instruction booklet, there are also other sources of information. Many instructional guidebooks published by Hove and a very few videos are available for many popular camera bodies.

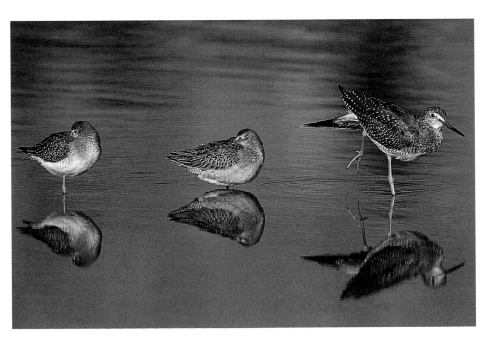

JUVENILE SHOREBIRDS, Jamaica Bay Wildlife Refuge, Queens, New York. Canon 600mm F4L lens and EOS 1N body, Fuji Velvia pushed one stop, evaluative metering at zero: 1/60 sec. at f/16

Being intimately familiar with my camera body controls enabled me to quickly change the aperture from f/5.6 to f/16. This ensured more than adequate depth of field.

Lenses for Bird Photography

There is, of course, no single best lens for all situations in bird photography. Serious bird (and wildlife) photographers need a varied complement of lenses to help them capture on film the images that they create in their mind's eye. Let's take a close look at the different classes of single-lens-reflex (SLR) lenses, their uses in bird photography, and the factors that determine lens choice.

WIDE ANGLE (17–35MM) AND STANDARD OR NORMAL (50MM) LENSES

Short lenses have limited uses in bird photography, but like bad little children, when they're good, they can be very, very good. You can use them to capture scenic shots with birds in the frame (birdscapes, if you will) and for photographing sky-filling flocks of waterfowl or smaller groups flying directly overhead at low levels. And, if your standard lens is a macro lens (designed to take close-up images of tiny subjects such as flowers or insects), you can use it to photograph bird footprints in the sand or mud.

To obtain sharp close-up photographs without using a tripod, lie flat on the ground, brace yourself on your elbows, and choose a shutter speed between 1/30 and 1/60 sec.; the smaller *f*-stops that result from using slow shutter speeds will yield adequate depth of field. Except when hand-feeding gulls, opportunities for photographing wild, unrestrained birds at point-blank range with short lenses are usually few and far between— or far from civilization, where the birds may be unafraid of humans.

SHORT TO MEDIUM (70–300MM) TELEPHOTO AND ZOOM LENSES

Like wide-angle and standard lenses, the lightweight lenses in this class can, at times, be useful for photographing birds, but they don't provide enough magnification to serve as everyday bird photography lenses. However, for photographing finches, sparrows, or hummingbirds at a window feeder, a tame owl in tight quarters, or a bossy pelican on a fishing pier, short telephoto lenses can be ideal. You can also use them to make flock shots of birds (either in flight or at rest) and images of individual birds at point-blank range.

Some nature photographers, especially those photographing birds and mammals, choose a 300mm F2.8 lens as their everyday workhorse lens. The addition of a 1.4X or 2X teleconverter increases the effective focal length of such lenses to 420mm and 600mm respectively.

LONG TELEPHOTO LENSES (400MM AND 500MM)

Many serious bird photographers choose their everyday lenses from this group, most opting for either a 400mm or 500mm focal length. These lenses offer enough magnification to obtain satisfactory image sizes after a reasonably close approach is made. Additionally, when used wide open, long telephoto lenses produce lovely, soft, out-of-focus backgrounds; their narrow angles of view inherently eliminate many distracting background elements. You can handhold the lenses in this class— especially the lighter 400 F5.6s—for flight photography.

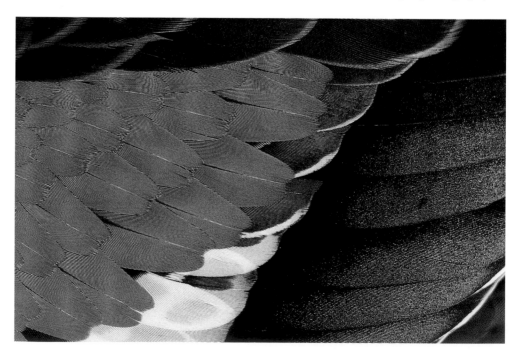

WING DETAIL OF BLUE-WINGED TEAL, Jamaica Bay Wildlife Refuge, Queens, New York. Canon FD 50mm F3.5 macro lens and A1 body (handheld), Kodachrome 64, center-weighted average metering at zero: 1/60 sec. at *f*/11.

I no longer carry a macro lens, opting instead to use the Canon 100–300mm zoom with an extension tube or a 6T two-element diopter, or both. Low-angled afternoon sunlight gave this image a digitized look.

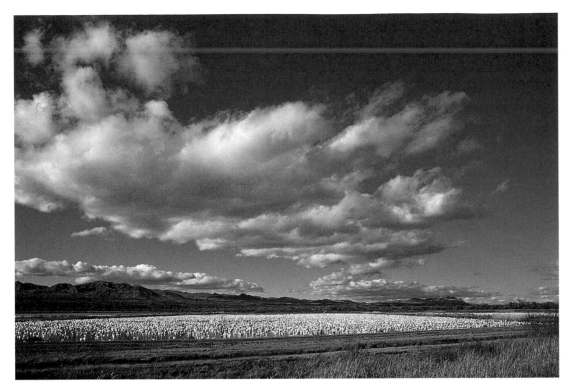

SNOW GEESE IN IMPOUNDMENT, Bosque Del Apache National Wildlife Refuge, New Mexico. Canon EF 28–105mm F3.5–4.5 zoom lens at 28mm and A2 body (handheld), Fuji Velvia pushed one stop, evaluative metering at zero: 1/350 sec. at *f*/9.5

I chose a wide-angle lens for this birdscape so that I could include the expanse of both the birds and sky, which seemed almost to be reflections of each other.

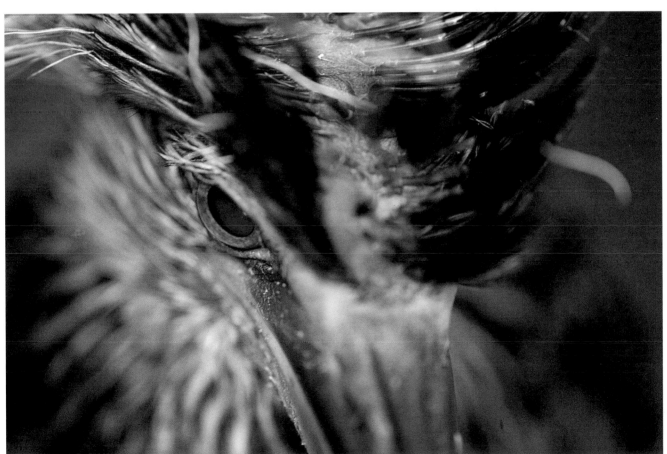

YELLOW-CROWNED NIGHT-HERON, Jamaica Bay Wildlife Refuge, Queens, New York. Canon FD 200mm F4 macro lens, Fuji Velvia pushed one stop, center-weighted average metering at zero: 1/125 sec. at *f*/5.6

This nearly fledged chick fell out of its nest and was placed on a perch by refuge personnel. I was captivated by the creature's eye, so I grabbed my 200mm macro and got really close to the young bird, which seemed totally unafraid.

However, the fast 400mm and 500mm lenses (as well as the 300mm F2.8s) are long and heavy enough to demand the use of a tripod at all other times. Even when mounted on sturdy tripods, they're light enough to carry around for a full day in the field. Resting the outfit on your shoulder and snaking your arm around the tripod's lower legs will make this task easier.

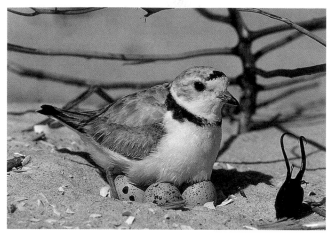

MALE PIPING PLOVER ON EGGS, Lido Beach, Long Island, New York. Canon FD 400mm F4.5 lens with 25mm extension tube and A1 body, Kodachrome 64, sunny *f*/16 -1/2 stop: 1/125 sec. at *f*/13

The 400mm F4.5 was my first telephoto lens, and it served me well. Today, a good used, manual-focus 400mm lens might make an ideal first lens. As more and more photographers switch to autofocus, you should be able to find a variety of good used, manual focus lenses.

Some very good photographers prefer shoulder stocks or "gun-stock" mounts (shoulder mounts placed on the shoulder to steady the camera), which are lighter than tripods and far easier to maneuver, but I recommend against them for general shooting. Positioning a tripod-mounted telephoto lens in a dense thicket while a yellow-breasted chat sings its heart out just 30 feet away can be extremely difficult, but the increased sharpness that comes with using a heavy-duty tripod and slow, fine-grained slide film should never be sacrificed if you're striving to produce high-quality images of birds. Shoulder stocks may help some photographers attain sharper flight shots by steadying the entire rig, but I prefer handholding my 400mm F5.6 lens.

SUPER TELEPHOTO LENSES (600MM AND 800MM)
These lenses cost many thousands of dollars. They're ponderously heavy and difficult to maneuver, yet fragile and delicate, and at times, need costly repair. Some cannot focus on nearby birds without the use of light-sapping extension tubes and others have hard-to-master rack and pinion focusing mechanisms at the rear of the lens. All require the use of heavy-duty ball heads and tripods. And, while ball heads may look easy to use, simply locating the bird in the camera's viewfinder is a formidable task at first due to these lenses' extremely narrow angles of view.

My Favorite Lenses

The Canon EF 400mm F5.6L lens is my absolute favorite. Using it is fun. It is light enough to be handheld and is absolutely superb for photographing birds in flight and in action. I love taking long walks down secluded beaches carrying only this lens and seeing what images I can create.

If limited to a single lens for bird photography, however, I would, without batting an eyelash, choose the Canon EF 600mm F4L lens (with matching teleconverters). I'd use the 1.4X teleconverter with this lens more than 90 percent of the time; in bird photography, the longer your lens, the more chances you have to make good images.

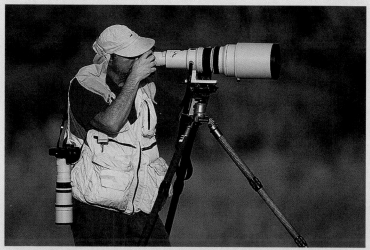

You'll usually find me afield carrying the tripod-mounted Canon EF 600mm F4L lens with the EF 400mm F5.6L and A2 camera body combination on my shoulder. Note the sun protective hat (I cover my arms thoroughly with sunblock), the full pockets of the L. L. Rue vest, the carrying strap on the 600mm lens, and the lightweight Gitzo 1548 carbon fiber tripod. (Photo courtesy Joanne Williams)

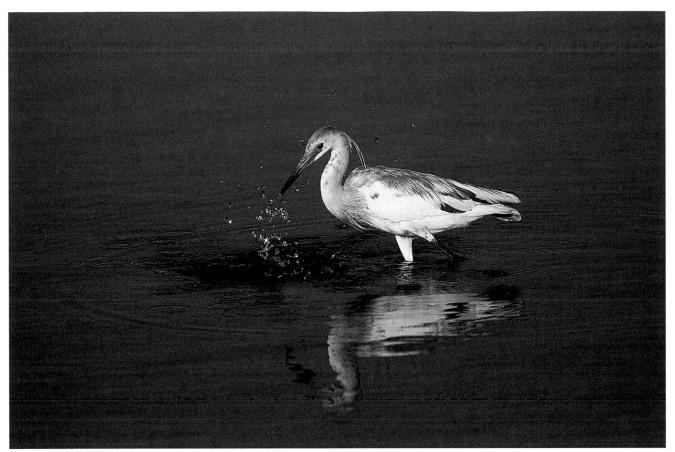

IMMATURE LITTLE BLUE HERON, Merritt Island National Wildlife Refuge, Titusville, Florida. Canon EF 500mm F4.5L lens and A2 body, Fuji Velvia pushed one stop, evaluative metering at zero: 1/1250 sec. at *f*/4.5

Scrambling quickly through the brush down to the water's edge with this relatively lightweight autofocus outfit made it possible to capture this striking image. To my mind, 500mm should be the minimum focal length used by serious bird photographers as their everyday lens.

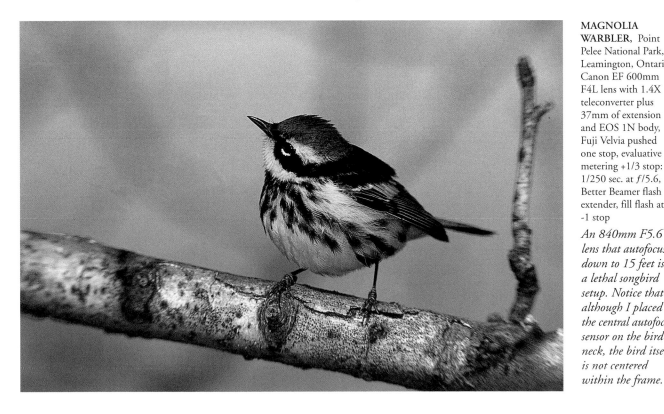

MAGNOLIA WARBLER, Point Pelee National Park, Leamington, Ontario. Canon EF 600mm F4L lens with 1.4X teleconverter plus 37mm of extension and EOS 1N body, Fuji Velvia pushed one stop, evaluative metering +1/3 stop: 1/250 sec. at *f*/5.6, Better Beamer flash extender, fill flash at -1 stop

An 840mm F5.6 lens that autofocuses down to 15 feet is a lethal songbird setup. Notice that although I placed the central autofocus sensor on the bird's neck, the bird itself is not centered within the frame.

In spite of these and other disadvantages, relatively fast super telephoto lenses are awesome tools in the hands of experienced bird photographers. Their incredibly powerful magnification allows photographers to stay well back from the birds and to expose roll after roll without disturbing them. The lenses bring distant birds within range, and even more so than with the long telephotos, super telephotos produce pleasingly out-of-focus backgrounds. By virtue of their narrow angles of view (that range roughly from three to four degrees), these lenses can help photographers eliminate distracting background elements and isolate their subjects.

By mounting an extension tube (or tubes, depending on the lens' minimum focusing distance) behind a super telephoto lens to allow for closer focusing, most songbirds will fill half the frame (after a reasonably close approach), and head-and-shoulders portraits of large, cooperative birds, such as gulls, are a snap. In addition, those heavy-duty tripods, so difficult to lug around in the field, make

it possible—if the subject remains perfectly still—to produce sharp results when using shutter speeds as slow as 1/60 sec., provided that you use an adequately strong and sturdy tripod head and perfect technique.

My Canon FD (manual focus) 800mm F5.6L lens (just under nine and a half pounds), purchased in 1991, quickly became my everyday bird lens—the "monster." After using it for several weeks, I found it hard to imagine how I ever took any pictures without it. For years, I used the Gitzo 320 Studex Performance Model Tripod for all my bird photography. Now that I've retired the FD 800mm in favor of the nearly 14-pound Canon EF (autofocus) 600mm F4L lens, I've been using only the heavier Gitzo 410R Pro Studex tripod. When I recently went back to using the Gitzo 320 for a day's shooting with the Canon EF 500mm F4.5L lens, it seemed as if the lighter tripod's legs were, by comparison, made of toothpicks.

Extension Tubes

An extension tube is used to reduce the minimum focusing distance of a lens. Extension tubes come in various sizes, including 12mm, 25mm, and 50mm. Be sure to get autoexposure- and autofocus-compatible extension tubes as needed, especially when buying independent brands. As always, purchasing the manufacturer's matched accessories is best. (Unfortunately, and almost amazingly, Nikon does not currently offer matching automatic extension tubes for its autofocus system.)

There are a number of advantages to using extension tubes. They allow photographers to get closer to their subjects than do prime lenses alone. They can be stacked to enable even closer approach. (The closer you can get, the larger the image size.) And, adding an extension tube when you're *outside* of the lens' minimum focusing distance provides small, but significant, increases in magnification.

Of course, there are disadvantages, too. When using an extension tube, the lens can no longer focus at infinity or on distant subjects. There is also some light loss, which varies inversely with lens length (the longer the lens, the less light lost) and averages from 1/6 to 2/3 stop with a single tube on a telephoto lens. In these instances, it is best to use through-the-lens metering so that the light lost due to extension is measured through the lens. Avoid using the sunny *f*/16 metering rule or an incident meter when using extension tubes as both will, at best, require complicated calculations.

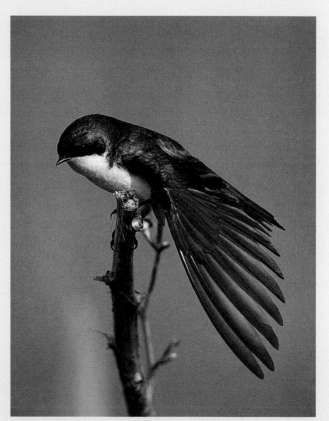

TREE SWALLOW, Jamaica Bay Wildlife Refuge, Queens, New York. Canon FD 400mm F4.5 lens with 25mm extension tube and T-90 body, Kodachrome 64, center-weighted average metering +1/3 stop: 1/350 sec. at *f*/5.6
A 25mm extension tube mounted between the camera body and the FD 400mm lens reduced my minimum focusing distance from about 12 to just inside 9 feet.

Buying Long Lenses

There are no bargains when purchasing lenses of 300mm or longer; you get what you pay for. As stated earlier, Canon and Nikon are the overwhelming popular choices of North American nature photographers. Other top manufacturers, such as Olympus, Minolta, and Pentax, offer competitively priced, high-quality telephoto lenses and camera bodies.

Sigma, Tamron, and Tokina now offer mid-priced good-quality lenses, as well; in some cases, these lenses are offered in a variety of mounts with the cost roughly half of that of comparable Nikon and Canon lenses. Though I've never shot a single frame with lenses from any of these manufacturers, word is that the best of the 400mm F5.6 lenses is the Sigma 400mm F5.6 APO Tele-Macro. The Nikon-mount model doesn't have the focusing motor in the lens, so, although the lens is sharp, don't expect great autofocus performance. Only the new Canon EF-mount model, designated "HSM" for *hypersonic motor,* has a focusing motor in the lens, and autofocus performance is reportedly satisfactory. Both these lenses have improved tripod mounts (previous models had tripod mounts that were inadequately secured with tiny screws). The Sigma 500mm F4.5 APO has also received good reviews for sharpness, performance, and durability.

Michael Frye, a skilled professional nature photographer from California, has made a living shooting wildlife with the manual focus 300mm F2.8 Tamron LD (IF) lens. I've seen many wonderful images made by him with this lens; it isn't necessary to own a ten thousand dollar lens to be a good nature photographer. Beware, however, of off-brand telephoto lenses that cost only a few hundred dollars. These cheaper lenses are often manufactured especially for camera dealers. Due to their inferior optics, most just aren't capable of producing sharp images. And, many are very slow lenses with minimum focusing distances of 60 or 70 feet.

If you're using extension tubes to allow for closer focusing, vignetting (when the corners of the photograph are darkened considerably) may occur, especially with slower lenses. Don't buy any telephoto lens until you're positive that you can use extension tubes without causing vignetting. Lastly, lenses other than those of the highest quality will not produce acceptably sharp images when used with teleconverters.

Today, there's a huge market in used photographic equipment; many used telephoto lenses are bought and sold each week. An increasing number of used manual focus lenses and bodies are becoming available as more and more photographers switch to autofocus. It is amazing how well top-quality telephoto lenses keep their value;

used lenses, even manual focus models, often cost as much as or more than they did when purchased new 5 or 10 years ago. You can sometimes find excellent values by contacting individual photographers, especially those changing systems. Dealer prices are usually higher but often include some sort of warranty. *Shutterbug* magazine's classified advertisements list used equipment, as do various photography news groups on the Internet.

Lens Speed

By definition, a fast lens has a relatively large maximum lens opening. Conversely, a slow lens has a relatively small opening. Fast lenses, with their great light-gathering capabilities, allow photographers to utilize relatively fast shutter speeds and are extremely useful in the low-light conditions encountered at dawn or dusk. Today, the fastest long telephoto lenses have maximum apertures of $f/2.8$ or $f/3.5$. Moderately fast ones have maximum apertures of $f/4$, $f/4.5$, or $f/5.6$. With slower telephotos, the largest lens opening may be $f/6.7$, $f/8$, or smaller.

You may opt for a slower telephoto lens, even though a faster one is available, for two simple reasons: you'll avoid carrying extra pounds and save lots of dollars. A Canon EF 400mm F5.6L lens weighs less than three pounds, while the Canon EF 400mm F2.8L II lens weighs over thirteen. Plus, the latter costs roughly five times more than the former. As a general rule for bird photography, I recommend choosing a longer, slower lens over a faster, shorter one.

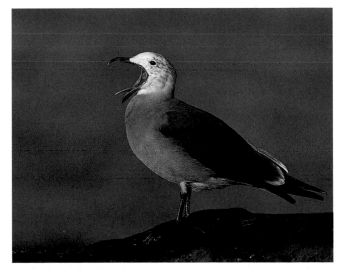

HEERMANN'S GULL, La Jolla, California. Canon EF 600mm F4L lens and EOS 1N body, Fuji Velvia pushed one stop, evaluative metering -1/3 stop: 1/1000 sec. at $f/4$

Fast lenses allow the use of action-stopping shutter speeds. Though overlooked by many photographers, gulls, which always seem to be doing something interesting, are among my favorite avian subjects.

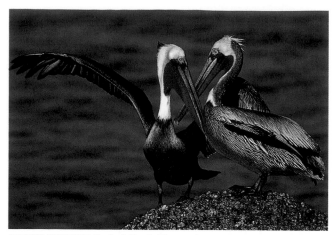

BROWN PELICANS, La Jolla, California. Canon EF 600mm F4L lens with 1.4X teleconverter and EOS 1N body, Fuji Velvia pushed one stop, evaluative metering at zero: 1/500 sec. at *f*/5.6

Canon super telephoto lenses are renowned for their edge-to-edge sharpness and brilliant color reproduction, even when used at wide open apertures with teleconverters. Clearly, these pelicans are thinking about something other than fish.

GLASS QUALITY

Not even fast shutter speeds and huge, rock-solid tripods can produce razor-sharp images if your telephoto lens has inferior optics. The type and quality of glass used in the manufacturing of a long lens is of utmost importance in obtaining critically sharp images. The best modern lenses are constructed of special glass elements, some impregnated with expensive minerals, including fluorite. Unlike lenses made with standard glass, these lenses, which are sometimes designated APO (apochromatic), are able to focus all three primary colors on a single plane, even at large apertures. Thus, the resulting photographs are sharper and don't exhibit chromatic aberration (a distortion of color), especially toward the edges of the image. Ultra-low dispersion (UD) and low

dispersion (LD) glass elements are also used to improve the performance of super telephoto lenses. Other designations for lenses made from high-quality glass include L (luxury), ED (extra-low dispersion), and SD (super-low dispersion).

While choosing a telephoto lens made with high-quality glass adds several thousand dollars to its cost, the difference in sharpness may be apparent only to those with highly trained eyes and powerful loupes (the magnifying devices used for viewing slides on a light box). Depending on focal length and aperture, some lenses made with standard glass are capable of producing sharp images; however, when used with teleconverters, they'll never perform as well as the more expensive models.

ZOOM LENSES

Zoom lenses can be adjusted to provide a continuous range of focal lengths. From the 17–35mm wide-angle zooms that fit in the palm of your hand to massive 150–600mm telephotos, zoom lenses can replace two, three, or more lenses. They're especially useful when working from fixed positions, such as permanent blinds or parked vehicles. In all instances, they make it easy to frame a scene or subject properly. With recent improvements, modern zoom lenses are able to produce images as sharp as, and almost indistinguishable from, those taken with fixed focal length lenses. However, zooms are, in varying degrees, larger, heavier, and slower than their fixed focal length counterparts. My favorite short zoom is the inexpensive Canon EF 28–105mm F3.5-4.5 lens.

MIRROR LENSES

Mirror (or cadiotropic) lenses are usually less costly, far more compact, and lighter in weight than straight telephoto lenses of the same focal length. They feature close focus

GREAT BLUE HERON AT SUNSET, Ding Darling National Wildlife Refuge, Sanibel Island, Florida. Canon EF 28–105mm F3.5–4.5 zoom lens at 105mm and A2 body (handheld), Fuji Velvia pushed one stop, evaluative metering at zero: 1/125 sec. at *f*/4.5

Photographing this very tame individual with a short zoom lens allowed me to try a variety of framing options; the color was so spectacular that I liked all of them.

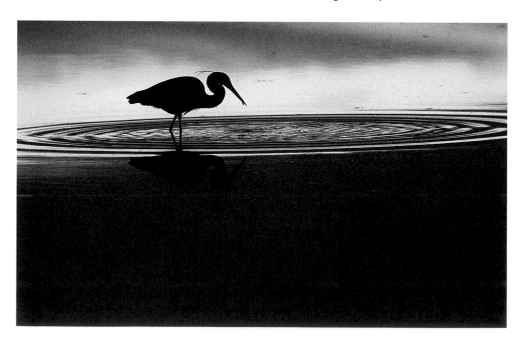

capability, can be easily handheld, and produce images of acceptable sharpness. The most popular mirror lenses among wildlife photographers are the 500mm F8s. However, because of several limitations, few top-notch bird photographers use them. Most are relatively slow (f/8 or slower), necessitating the use of slow shutter speeds or fast film. All have fixed f-stops, so creative control of depth of field isn't possible. Furthermore, points of reflected light in the background will appear on the slide as a series of circular doughnuts.

TELECONVERTERS

Also referred to as tele-extenders or multipliers, teleconverters are optical devices for increasing the effective focal lengths of telephoto lenses. Unlike extension tubes, teleconverters contain glass elements. They provide great increases in magnification at a very low price when compared with the cost of a longer lens. For most camera systems, there are two teleconverters available: 1.4X and 2X. The 1.4X teleconverter increases the focal length of the main lens by 40 percent, the 2X by 100 percent. With the former, you lose one full stop of light; with the latter, you lose two full stops. A 1.4X teleconverter transforms a 400mm F4 lens into a 560mm F5.6 lens; a 2X teleconverter changes a 500mm F4 lens into a 1000mm F8 lens. Note that the loss of light demands the use of slower shutter speeds or faster (grainier) film and that it is best to use TTL metering so that light loss is measured through the lens.

For nature photographers specializing in large mammals, a 400mm F2.8 telephoto is often the lens of choice. To photograph birds, a 2X teleconverter is used to transform these lenses into 800mm F5.6 lenses. By stacking the 1.4X and 2X teleconverters (if they can be physically mated) behind a 600 or 800mm lens, it is possible to produce huge images of the sun at dawn and sunset; to protect your eyes, try this only when the sun is well muted by haze or by a layer of clouds.

Note that whenever you place a piece of glass between your quality telephoto lens and the film, image quality will suffer. Additionally, with the increase in effective focal length comes an increase in the effects of camera shake and equipment vibration. Therefore, slides taken with teleconverters can, theoretically, never be as sharp as those taken with your main lens alone. Years ago, with my Canon FD (manual focus) equipment, I had mixed results when using teleconverters—lots of soft slides with an occasional sharp image. Many other photographers, especially Nikon users, swore by them, though. With my new Canon EF (autofocus) lenses, however, I'm routinely able to make razor-sharp images with both my 1.4X and 2X teleconverters. And, by using a cable release and mirror lock-up, I've made images with the EF 1.4X and 2X teleconverters stacked around an EF 12mm extension tube that are so sharp under a 4X loupe as to be scary.

The optical quality of the EF teleconverters is absolutely superb. Realize, however, that all camera manufacturers recommend *against* stacking teleconverters. In the Canon EOS system, the 12mm extension tube is needed for the teleconverters to be connected. To stack the Nikon autofocus teleconverters, you must file down the flange on the nose end of the 1.4X that prevents the teleconverters from coupling. (For details on doing this, try getting in touch with noted veteran bird photographer Ron Austing; Nikon will just tell you that it shouldn't be done.)

In general, the higher the quality of your prime lens, the sharper the photograph will be—as long as you use the manufacturer's matched teleconverter. (The optical quality of most independent-brand teleconverters ranges from fair to poor.) The increases in magnification and image size gained when using teleconverters are significant, so being able to routinely produce razor-sharp pictures with the 600mm F4 lens and both the 1.4X and 2X EF teleconverters is a huge plus.

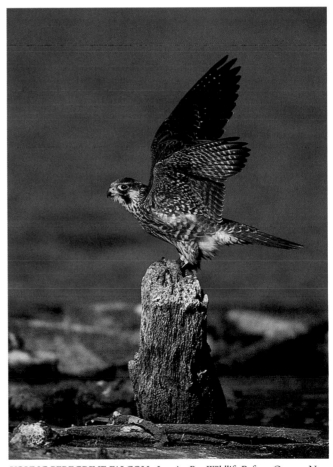

YOUNG PEREGRINE FALCON, Jamaica Bay Wildlife Refuge, Queens, New York. Canon EF 600mm F4L lens with 1.4X teleconverter and EOS 1N body, Fuji Velvia pushed one stop, evaluative metering +1/3 stop: 1/500 sec. at f/5.6

This is the image that convinced me that the 600 F4 could make razor-sharp images when used with the matched 1.4X teleconverter. As I was photographing this perched falcon, a flock of shorebirds streaked by; the falcon took off in pursuit an instant after I made this exposure.

Traveling with Your Equipment

Without a doubt, one of the biggest hassles in bird photography is traveling by air with big lenses, heavy tripods, and hundreds of rolls of film. However, by using common sense and following a few simple guidelines, you can get safely from point A to point B on an airplane and arrive with your gear and film in good condition and, if you're lucky, with your sanity.

First of all, I believe strongly that your camera should never be mounted to a long lens when you're traveling. Doing so may damage the lens mount (or wreak other unspeakable horrors on your gear). I once had an Instructional Photo-Tour participant open his luggage in Socorro, New Mexico, only to find that his Nikon 300mm F2.8 lens had been snapped in half while en route. He had packed his lens in soft-sided luggage with the camera mounted on it! The mounted camera body had supplied the leverage that enabled the baggage handler to break the lens in two with a well-placed toss of the suitcase.

Here's my advice for traveling with your equipment. As I said, never drive or fly anywhere with a camera body mounted to a telephoto lens. When flying, bring all essential photographic gear aboard as carry-on luggage. This includes your main lens, at least one camera body, a good supply of film, and a sturdy tripod and tripod head. Misrouted luggage may not catch up to you for a day or two, or even a week or more if you are traveling internationally, and while you can almost always buy clothing, replacing camera gear is more difficult. When forced to pack camera equipment in checked baggage, pad it well with clothing inside a rugged hard-sided case. (I own two large Delsey suitcases that have combination locks and can really take a pounding.)

A photographer's vest (see box below) can be your best weapon against zealous "carry-on baggage police" flight attendants. On most trips, I routinely pack the following items in my L. L. Rue vest: a 400mm F5.6 lens (in the vest's long back pocket), three camera bodies, my 28–105mm and 100–300mm zoom lenses, my 1.4X teleconverter, and three extension tubes, as well as the other small items I usually carry in the vertical pockets high on the chest. Since the packed vest is just an item of clothing, it doesn't count as a carry-on bag. It's a neat trick.

On some international trips, or on smaller aircrafts, you may be extremely limited as far as total weight or the number of bags allowed. There may be restrictions on both carry-on and checked bags. The only advice I can give in these situations is to limit the amount of clothing you pack so that you're able, if at all possible, to bring your longest lens and your heaviest tripod. Some photographers remove all but 20 rolls of film from their film canisters to reduce weight; exposed film is removed from the canisters and packed safely away while fresh rolls are inserted so as to be ready for the next day's field shoot. I prefer not to do

Vests and Fanny Packs

Photographers' vests and fanny packs are additional items that can help you in carrying your equipment. Vests come in small, medium, large, and extra large sizes, and can be used to carry extra lenses, accessories, and film into the field. They make it easy for bird photographers to carry teleconverters, extension tubes, short auxiliary zoom lenses, lots of extra film, lens cleaning tissue and fluid, and even a large clear plastic garbage bag (to cover your telephoto outfit when it rains). The vests' padded shoulders ease the pain of carrying 13-pound and heavier lenses, and the best models have binocular straps that eliminate neck strain. I've used the L. L. Rue Photographic Vest for nearly a decade, and I'm still finding pockets that I didn't know were there!

One disadvantage to the vests is that when fully loaded, they're heavy; even though the weight you are carrying is well distributed, you'll be glad to take your vest off at the end of a long day. If you'll be working in one spot for a while, taking off your vest and laying it on the ground provides a refreshing break. Also, unless you consistently place the same items in the same pockets, you may find yourself searching feverishly for something while a great bird flies off.

Fanny packs are one size fits all. You can use them to carry an extra lens, an accessory or two, and a few rolls of film. They're great for traveling light, and allow for packing a teleconverter, an extension tube or two, some film, and maybe a short zoom or standard lens. By putting a few items in your pants or shirt pockets, you can, at times, get by without a vest (and just a fanny pack). My favorite fanny pack for hot weather is part storage, part insulated canteen! Of course, the disadvantage to a fanny pack is that carrying capacity is limited. And, fanny packs don't have comfortable shoulder padding.

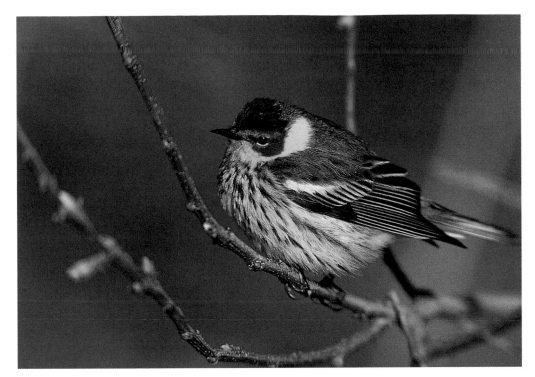

CAPE MAY WARBLER, Point Pelee National Park, Ontario. Canon EF 600mm F4L lens with 1.4X teleconverter plus 37mm of extension and EOS 1N body, Fuji Velvia pushed one stop, evaluative metering at zero: 1/250 sec. at *f*/5.6, Better Beamer flash extender, fill flash at -1 stop

A good vest lets you carry all manner of extension tubes, teleconverters, battery packs, extra lenses, and a more than adequate supply of film, which can really come in handy on a spectacular wave day during spring migration, when dozens of tired, hungry songbirds, such as this Cape May Warbler, can be found feeding or resting at eye level.

this as dust and grit invariably find their way into the loose film; long straight scratches often result.

As far as having carry-on film X-rayed, the machines in the United States and in most modern international airports are supposed to be safe; I've never had a problem. In fact, in my limited experience with foreign travel, I've found it easier to have film hand-checked in international airports than in domestic ones. In some countries, however, all carry-on baggage must be X-rayed.

When traveling with only one super telephoto lens (the 600mm F4), I carry it in a Lowepro Pro Trekker All-Weather Super-Telephoto Backpack (see Resources). Though it is legally a carry-on bag, you can pack lots more than a big lens in this sturdy, well-padded backpack. When traveling with both the 600mm F4 and the 500mm F4.5, I use a Travelpro rolling bag that is one inch larger than legal carry-on size (and I haven't been hassled yet, so please don't squeal on me). This case is unpadded, so I first place each lens in its own large (500/600mm size) padded Domke lens bag. The rolling bag fits into the overhead compartments of most large airliners, but I've had to check it at the gate when making short hops on tiny aircraft. You claim bags checked like this, when boarding, immediately upon deplaning. If, however, you send a soft-sided suitcase packed with camera equipment as regular checked baggage, you'll be inviting disaster.

IN THE FIELD

I'm sure that, by now, you're also wondering how to carry an assortment of lenses, accessories, film, and other equipment across fields, through marshes, and up and down steep and slippery slopes while photographing birds. Here's how I do it.

On long walks, I carry the Canon EF 600mm F4L (with mounted EOS 1N) by the heavy duty lens strap on my right shoulder and the EF 400mm F5.6 EF by the A2's strap on my left. I carry either the Gitzo 410 or the much lighter Gitzo 1548 carbon fiber tripod in my left hand. I do carry the tripod-mounted 600 F4 on my shoulder when walking short distances, most often with the 1.4X teleconverter in place; in this case, I'll have the 400mm F5.6 on my right shoulder where I can quickly grab it for in-flight or action shooting.

Three extension tubes (two 25mm and one 12mm), stacked together, fit neatly into one of the horizontal zippered pockets of my L. L. Rue Enterprise vest; the 2X teleconverter occupies the other. The EF 28–105mm and 100–300mm zoom lenses fit easily into the right main pocket and one of the side flapped pockets respectively. I stuff at least 10 rolls of film—mostly Fuji Velvia and a roll or two of Ektachrome 100SW—into the left main pocket. I also throw in a felt marking pen with the film (to indicate "pushed" or "normal" on each finished roll—see pages 79 and 81 for more on pushed film).

In the small zippered upper chest pockets, I also stow a blower brush, lens-cleaning fluid and tissue, Q-tips (for cleaning the viewfinder), a tiny cross-slotted screwdriver, and a Really Right Stuff 5/32-inch hex driver tool (to tighten or remove the hex socket head screws in mounting plates and flash arms). In addition, I keep two neatly folded, large, clear, thick plastic garbage bags in the side flapped pockets; I use them to protect my cameras and lenses in case of rain. I place exposed film either in a pants pocket or in one of the zippered upper chest pockets (where it is less likely to fall out than in one of the vest's main pockets).

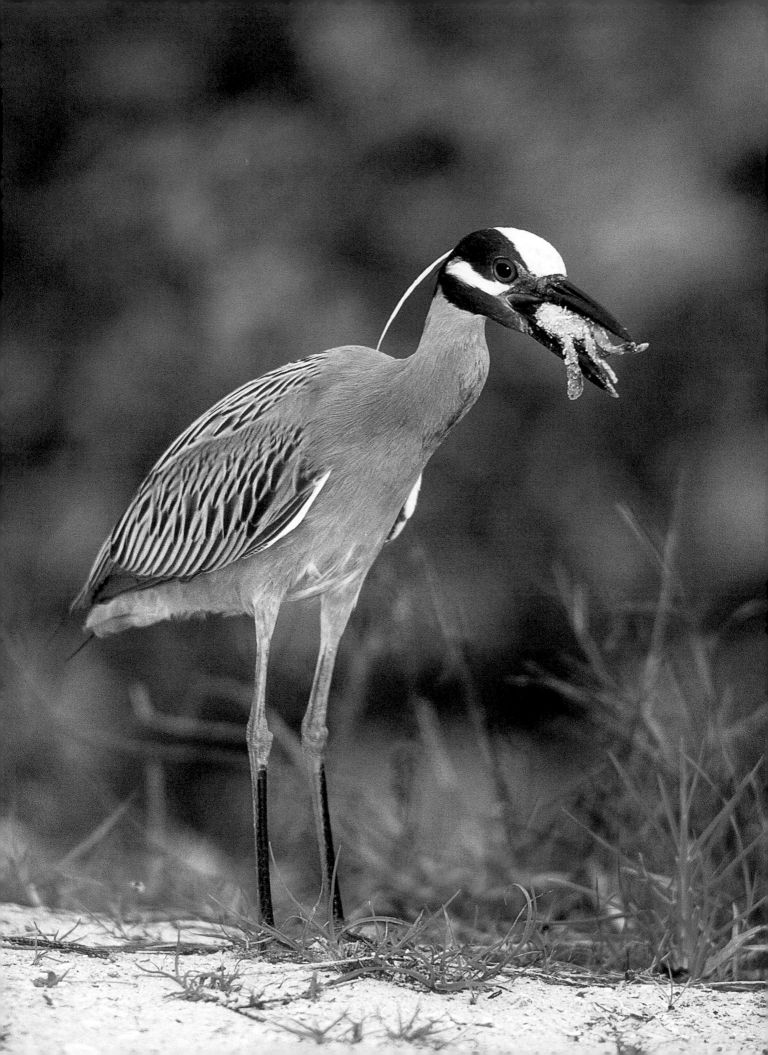

Chapter Two

THE AUTOFOCUS ADVANTAGE

For bird photography (and for general nature photography, as well), autofocus is a double-edged sword. The beneficial edge, however, is incredibly sharp; the ability of the best high-tech autofocus equipment to track birds in flight and attain accurate focus at the instant of exposure is science-fiction–like indeed. The disadvantages are few, though exasperating at times. With manual focusing equipment, getting just one sharp flight shot on a 36-exposure roll is a great accomplishment; however, with Canon EOS bodies and EF (autofocus) lenses—and to varying degrees with other modern autofocus equipment—making razor-sharp images of birds in flight is now routine.

For photographers with poor or failing vision, autofocus is, of course, a virtual necessity. Even photographers with perfect vision will find that for shooting soaring ospreys, speeding roadrunners, swimming loons, and foraging phalaropes, today's autofocus equipment produces superb results on a consistent basis.

All current autofocus systems offer a choice of two modes, one designed for photographing static subjects and the other for photographing moving subjects. In Canon's autofocus system, the mode for shooting still subjects is called "One-Shot"; in the Nikon system, it is "Single Servo"; and in other brands, the term "single shot" is often used. Autofocus is customarily activated by depressing the shutter button halfway.

YELLOW-CROWNED NIGHT-HERON WITH BABY BLUE CRAB, Ding Darling National Wildlife Refuge, Sanibel Island, Florida. Canon EF 600mm F4L lens and EOS 1N body, Fuji Velvia pushed one stop, evaluative metering at zero: 1/180 sec. at *f*/5.6, Better Beamer flash extender, fill flash at -1 stop

Focusing manually on static subjects can actually be faster than autofocusing. The Canon EOS 1N's electronic focus-confirmation beep tells you when you're accurately focused. For flying and swimming birds, however, autofocus is unbeatable.

Photographing Birds at Rest

During workshop critiques, I see countless slides of dead-centered birds, which, for the most part, are compositionally boring. When questioned about this, photographers invariably answer, "But I use autofocus." Many early autofocus (AF) systems featured only a single focusing sensor located in the center of the frame; this led to what I jokingly call ACS, or autofocus compositional syndrome—this involves just autofocusing on the bird's eye and settling for the resulting composition. The newest systems, however, offer somewhat more compositional latitude; top-of-the-line bodies now allow photographers to choose one of several autofocus sensors.

It is easy to avoid centering a stationary bird in single-shot mode with any current autofocus setup. To do this, autofocus on the bird's eye by depressing the shutter button halfway, then, while keeping light pressure on the shutter button, recompose and shoot. As long as you don't release the shutter button completely, you'll maintain accurate focus. With Canon EOS equipment, you can make a long series of pleasingly composed images, as long as the bird doesn't change its position significantly. With most Nikon, and many other brand, camera bodies, however, you must refocus after taking each frame. When in single-shot mode with the latest high-end SLRs, autofocus remains locked as long as the shutter button isn't released and continuous shooting occurs.

Additionally, most Canon EOS bodies offer a custom function that allows users to activate autofocus by pressing a conveniently placed button on the top right rear of the camera body with their thumb, rather than by pressing the shutter button with their index finger, as is customary. Many photographers rave about this function, but I do not. When taking flight shots, why should you have to do two things (activate autofocus *and* depress the shutter) instead of one?

Some photographers (including myself, at times) prefer to focus manually when photographing still birds. To do this, simply flip the switch on your lens from AF to M (for manual focusing), then focus on the bird's eye, recompose, and depress the shutter button. With Canon's EOS 1N camera, I select the focus-confirmation feature when I turn the camera on; an electronic beep sounds when I attain accurate focus manually. Focusing manually eliminates the need to keep the shutter button depressed halfway. In addition, when focusing manually, it is easier to fine-tune the focus in response to slight changes in your subject's position. Note that some autofocus systems do allow for manual focus override; in this instance, you can autofocus on a bird's eye and then tweak the focus manually, as long as the shutter button remains depressed halfway.

SNOWY EGRET, Sanibel Island, Florida. Canon EF 400mm F5.6L lens with 25mm extension tube and A2 body (handheld), Fuji Velvia pushed one stop, evaluative metering -1/2 stop: 1/1000 sec. at *f*/5.6

As a rule, it is best to avoid centering subjects in horizontal compositions. Rules, however, are made to be broken. I was using one-shot autofocus, so I could easily have recomposed this image, but the bird looked best in the center of the frame.

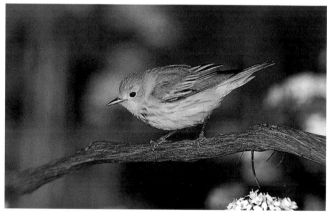

YELLOW WARBLER, Point Pelee National Park, Ontario. Canon EF 600mm F4L lens with 1.4X teleconverter plus 37mm of extension and EOS 1N body, Fuji Velvia pushed one stop, evaluative metering at zero: 1/180 sec. at *f*/5.6, Better Beamer flash extender, fill flash at -2 stops

I would have preferred placing the bird higher in the frame here and including the entire white flower that appears in the lower right portion of the photograph. Using AI Servo autofocus (Canon's AF mode for moving subjects), however, required that I keep the sensor on the bird. In this case, I was trapped by the technology.

When photographing distant subjects, focusing manually may be a necessity; autofocus sensors are often deceived by heat shimmer. And lastly, but most importantly, even the best autofocus systems will, on occasion, search or hunt for the subject *for several seconds*—especially if the subject is completely out of focus when AF is activated. At these times, it is possible to miss a great shot. In pressure situations, experienced photographers may, in the long run, get better results by focusing manually.

Autofocus for Flight and Action

The mode for photographing moving subjects is called "AI Servo" in the Canon system, "Continuous Servo" in the Nikon system, and "continuous focus" in most other brands. In this mode, you must pan with the moving subject—while keeping the (active) focusing sensor (or sensors) on the bird—and then depress the shutter button halfway to activate autofocus. To maintain autofocus, you *must* keep the sensor on the moving bird as you continue to depress the shutter button halfway. In certain modes, the very latest autofocus cameras will automatically change the active sensor in response to placement of the bird in the frame; however, even in these instances, it is usually necessary to keep one of the focusing sensors on your subject.

In any case, autofocusing on moving subjects against uncluttered, or clean, backgrounds sounds more difficult to do than it really is. After practicing on birds in flight—without film in your camera at first—you'll quickly get the hang of it. Handholding a lightweight 300mm or 400mm lens is ideal. And, you can take pictures at any time by fully depressing the shutter button; the camera will fire whether the subject is in focus or not.

When photographing moving birds against clean backgrounds, some modern systems will maintain focus even if the sensor drops off the subject momentarily. If your sensor loses the subject and begins to search for it, *release the shutter button and depress it again to re-acquire focus.* This is a far better approach than keeping the shutter button depressed and hoping that the system will find the subject again. When photographing birds in flight against backgrounds other than sky or water, or when capturing birds in action on the ground, however, locking and

maintaining autofocus is a difficult proposition at best. If you don't place and hold the sensor precisely on your subject, the camera will immediately and repeatedly attempt to focus on the background.

Current Canon EOS bodies offer a choice of either three or five autofocus sensors located across the horizontal centerline. I generally use the central sensor when photographing flying or swimming birds in AI Servo mode. If a bird fills about half the frame, I place the central sensor on the bird's head or neck; the bird will have lots of room to fly or swim into the frame. With smaller moving subjects, I manually select an outside autofocus sensor to avoid centering the bird in the composition.

EOS bodies with multiple autofocus sensors allow photographers to activate all the focusing sensors; in spite of the fact that camera body manuals refer to this as "automatic focusing point selection," it is best to acquire focus with the central sensor. The system will then hold focus as long as the subject (or one of the subjects) is covered by one of the sensors. When using Canon A2 series bodies, I light up all five sensors only when photographing flight or frantic action against clear backgrounds at close range, such as when shooting reddish egrets in their "drunken sailor" feeding mode. For flight shooting with the A2 bodies, I find that it takes longer to acquire focus with all five sensors lit than with only the central sensor activated. (With the EOS 1N body, initial focus acquisition with all five sensors activated is much faster than it is with the A2 series bodies.) Still, you should activate all the sensors when photographing birds that are fighting; the system will best be able to hold focus on the combatants.

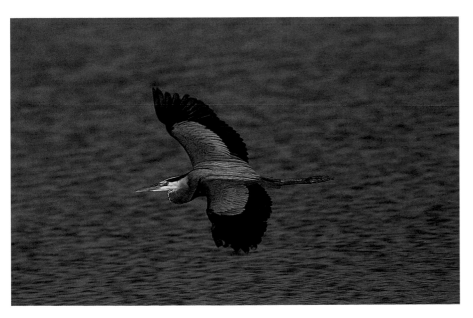

GREAT BLUE HERON, Little Estero Lagoon, Fort Myers Beach, Florida. Canon EF 400mm F5.6L lens and A2 body (handheld), Fuji Velvia pushed one stop, evaluative metering at zero: 1/500 sec. at ƒ/5.6

To photograph a bird in flight, frame the image and acquire autofocus while the bird is still some distance away, and then pan with the subject as it approaches. Strive to make an image or two while the bird is flying toward you, and stop shooting once the bird passes your position and begins to fly away.

The very best autofocus systems calculate the speed and direction of the subject while tracking it and predict exactly where the subject will be at the instant of exposure; focus is set for *that* spot. (There is a time lag, measured in milliseconds, between the instant the shutter button is depressed and the time that the shutter begins to open.) In due time, you'll find that tracking large, slow-flying birds that maintain a steady course has become routine. Small

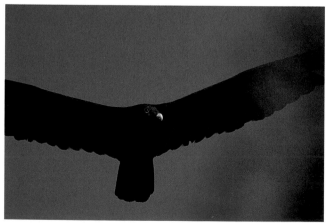

TURKEY VULTURE IN FLIGHT, Merritt Island National Wildlife Refuge, Titusville, Florida. Canon EF 500mm F4.5L lens and EOS 1N body, Fuji Velvia pushed one stop, evaluative metering at zero: shutter speeds unrecorded at *f*/5.6

With modern autofocus equipment, keeping your camera's AF sensor on the subject will enable you to make a series of sharp images.

birds, such as warblers and tanagers, and birds that fly erratically or at high speeds, such as ducks and falcons, are extremely difficult to photograph in flight, even with the best autofocus equipment. Today, however, the primary limiting factor is the skill of the photographer rather than the ability of the latest high-tech autofocus systems to track rapidly moving subjects; if you can keep the AF sensor on the bird, the camera will maintain and predict accurate focus.

Flight shooting is almost always best when the sky is blue and when the wind and the light are coming from the same, or nearly the same, direction. An east wind in early morning, or a west wind in the afternoon, will find most birds flying into the sun and, therefore, being well lit. With a west wind in the morning, or an east wind in the afternoon, you'll wind up photographing the rear ends of most flying birds. In general, shooting flight against white skies is, because of the dreariness of the background, less than rewarding. Plus, on white-sky or foggy days, autofocusing on white or light gray birds in flight may be difficult or impossible, even with the best autofocus systems; all AF systems need some visual contrast to be able to acquire focus.

FASTER FOCUSING

Many modern autofocus telephoto lenses offer a choice of two or three focusing ranges. If you select the range that most closely approximates your camera-to-subject distance, the lens won't have to search over its entire focusing range (from minimum focusing distance to infinity). The lens is, therefore, limited to focusing over a shorter range; as a result, focusing time is decreased. If, for example, you're photographing a single goose in flight, it isn't necessary to have your lens be able to focus down to 15 or 20 feet. Geese are large birds, and you'll usually be working at distances of 50 to 80 feet. So, by simply choose the "far-focusing" range, you'll narrow down the focusing from 25 to 45 feet or so (depending on the lens) to infinity, and you'll reduce the time needed for initial focus acquisition. If your lens offers a "close-focusing" setting, use this when photographing birds at point-blank range; since the lens won't have to search to infinity, it will focus much more quickly on nearby birds.

Several top-of-the-line Canon autofocus telephoto lenses offer a "focus preset" feature that instantly focuses the lens at a predetermined distance, which you can set according to the situation. Imagine that you're on a beach using Canon's 600 F4 autofocus lens to photograph juvenile sanderlings foraging roughly 25 feet from your position. You glance down the beach and see a migrant osprey flying right toward you. You point your lens at the large raptor, but the image is so out of focus that you're unable to perceive the bird in your viewfinder. (Unfortunately, the top-of-the-line Canon lenses don't allow you to prefocus manually when using autofocus.) You depress the shutter

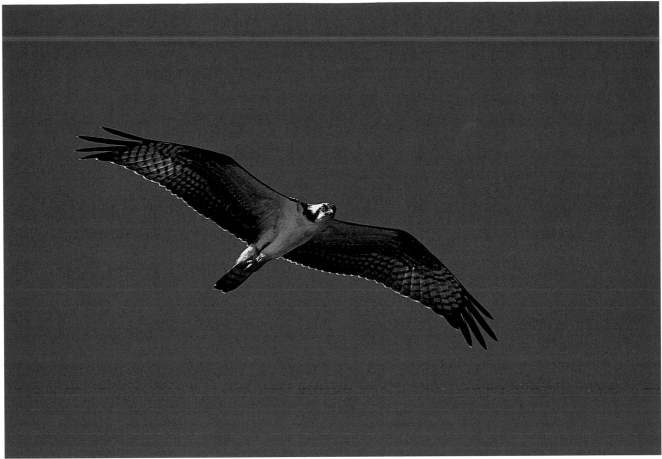

JUVENILE OSPREY, Cape May, New Jersey. Canon EF 500mm F4.5L lens and A2 body (handheld), Fuji Velvia pushed one stop, evaluative metering at zero: 1/750 sec. at ƒ/4.5.

Record numbers of ospreys migrated past Cape May Point in September 1996. I chose to photograph them at Sunset Beach, where the sand serves as a giant reflector, lighting the birds from below and permitting me to shoot at the metered exposure (rather than having to add 1/2 stop of light as is usual for an undersides shot).

button halfway as the bird approaches, but the autofocus system searches unsuccessfully for the subject.

What's the problem? Before pointing your lens at the osprey, you had been focused on the sanderlings at approximately 25 feet. Therefore, the osprey was so completely out of focus that you couldn't see it in the viewfinder, and your autofocus system was unable to acquire focus. If you use focus preset, you can solve this problem as follows: After seeing the first osprey (and expecting others to follow), autofocus on an object on the beach that is roughly the same distance away as the bird was when you initially saw it. Slide the focus preset button momentarily to the "set" position (this sets that desired greater distance into the lens' memory), and return to photographing the sanderlings. Then, when you see another osprey flying toward you, simply give the electronic focusing ring a quick twist. The lens will return instantly to the greater preset distance, and when you point it at the flying opsrey, the image will appear in your viewfinder in relatively sharp focus. Initial focus acquisition will be easily attained.

Top-of-the-line Nikon AF-S and AF-I telephotos offer an M/A (manual/autofocus) setting that makes much more sense than Canon's focus preset feature. By selecting the M/A setting (instead of just M or A), you can—with the shutter button depressed—prefocus manually and then activate autofocus by simply taking your fingers off the manual focusing ring. With a bit of practice, you'll be able to achieve focus acquisition easily and instantly.

The M/A feature also allows manual focus override after the image has been autofocused; to engage manual focus, simply touch the manual focusing ring. Other manufacturers would be wise to add a similar feature to their next generations of super telephoto lenses. A system that allows for manual focusing *before* you touch the shutter button would be absolutely ideal. Note that with those Canon autofocus lenses that *don't* have focus preset features (like the 400mm F5.6L), you can focus manually before engaging autofocus.

COMPOSITIONAL LIMITATIONS

When using the autofocus mode designed for moving subjects, you, as a photographer, become something of a compositional slave to the technology. You must keep an autofocus sensor (or the edge of a wide-area sensor) on your subject at all times. It isn't possible to hold focus and then recompose, as it is in single-shot mode. Since there is,

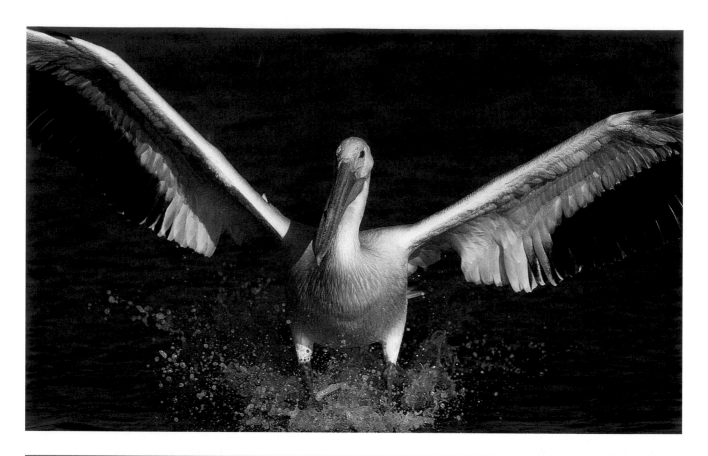

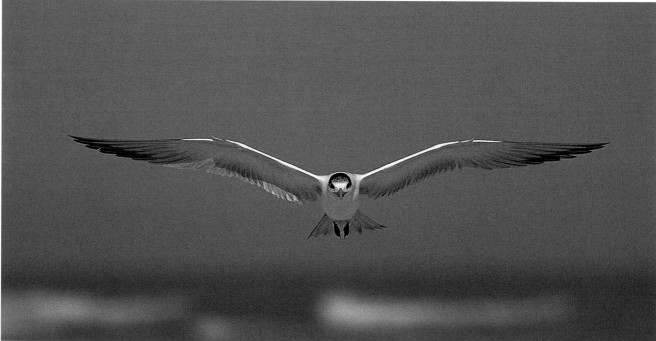

Top: **WHITE PELICAN,** Placida, Florida. Canon EF 400mm F5.6L lens and A2 body (handheld), Fuji Velvia pushed one stop, evaluative metering -1/2 stop: 1/750 sec. at ƒ/5.6
Bottom: **ROYAL TERN,** Captiva Island, Florida. Canon EF 400mm F5.6L lens and A2 body (handheld), Fuji Velvia pushed one stop, evaluative metering at zero: 1/1000 sec. at ƒ/5.6

With evaluative metering, the pelican image needed 1/2 stop of underexposure because of the dark blue water background, while the tern, against the light blue sky just above the horizon, was photographed at the metered exposure.

generally, only one convenient spot on a subject on which to place the sensor, it follows that there is, generally, only one possible composition. The technology, therefore, determines the composition.

The Nikon F5, currently the only body to feature an array of autofocus sensors *not* limited to the horizontal center line, offers some latitude in this area; however, Nikon would have done far better by *rotating* the array 45 degrees so that there was an autofocus sensor in each of the four "rule of thirds" positions (these are the four points that result when you divide the area in your viewfinder into nine boxes by evenly spacing two horizontal and two vertical lines across it). A camera body with an array of autofocus sensors that allows photographers to focus on subjects 1/3 of the way up or down the frame *and* that can handle off-centered subjects, as well, is sorely needed. I've been urging Canon to offer just that for several years; it was rumored at the time of publication that the Canon A3 body will be the first to offer photographers complete compositional latitude.

In any case, the placement of the focusing sensor on the subject is of critical importance, especially when you're shooting birds flying or swimming by at close range; however, the most obvious choice for sensor placement isn't always the best one. When photographing a flyby gull, for instance, placing the central sensor on the gull's body will result in the sensor autofocusing on the near wing when the near wing is on the downstroke. Consequently, the bird's eye will be out of focus because the near wing is

closer to the film plane than the bird's eye. A far better option would be to try to place and hold the autofocus sensor on the bird's head or neck; since the bird's head, neck, and eye are very close to being on the same plane, the eye will be sharp. In addition, a more pleasing composition will result; the off-centered bird will have room to fly into the frame.

For birds flying, swimming, walking, or running directly toward the camera (as in the photos opposite and below), simply place the central focusing sensor on the subject's head or neck and fire away; in nearly all cases, the resulting dead-centered composition will be just fine. With manual focusing equipment, attaining razor-sharp, head-on flight shots is just about impossible, even for the most skilled flight photographers. However, with today's continuous predictive autofocus systems, even beginning bird photographers can make such images.

When making tightly framed photographs of a bird and its mirror image reflection in water, it is often impossible to include the complete reflection in the image if you place the focusing sensor on the bird's head or neck. Try focusing on the water along the imaginary line separating the bird and its reflection; with a bit of practice this won't be at all difficult. If your camera offers a choice of focusing sensors, another option would be to choose one of the outer sensors and autofocus on the spot where the bird's near leg enters the water. Using either of these methods will allow for the inclusion of both the bird and its complete reflection in the composition.

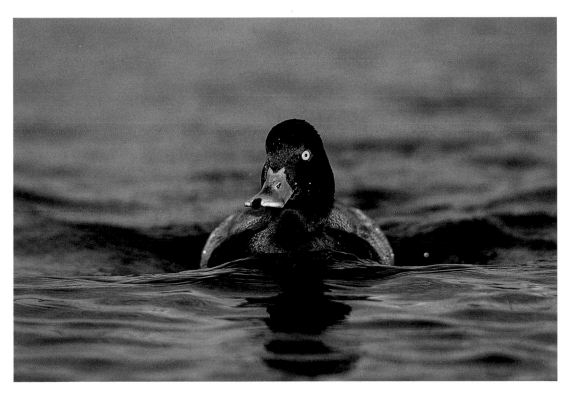

DRAKE LESSER SCAUP, Mission Bay, San Diego, California. Canon EF 600mm F4L lens and EOS 1N body, Fuji Velvia pushed one stop, evaluative metering +1/3 stop: 1/500 sec. at *f*/5.6

Photographing a duck swimming rapidly toward you is another instance in which the use of autofocus is practically mandatory. I made this image when the bird turned its head to the side and showed off its bright yellow eye.

Capturing Small Landbirds with Autofocus

When photographing small landbirds in brushy or grassy fields, open woodlots, or along woodland edges, modern autofocus technology can either save the day or cause you to miss a spectacular shot. Confused? Consider the following situation: A black-and-white warbler forages for insects, constantly spiraling up and down a nearby tree trunk. You prefocus briefly on the trunk so that you're able to follow the movement of the tiny bird (which will appear in relatively sharp focus). As it pauses for an instant, you place the central sensor on the bird's neck and depress the shutter button halfway. Instantly, the image snaps into focus. You fire the shutter and smile, knowing that without autofocus, you'd never have gotten the shot. Moments later, a dazzlingly beautiful male magnolia warbler stops in his tracks on a seemingly clear perch, alternately preening and posing. You frantically depress the shutter button time and again, but the autofocus system searches hopelessly for the bird. Taking your eye from the viewfinder, you notice a strand of vine a few feet from the front of your lens. You flip the autofocus switch to "M" and begin to focus manually, but an instant before the image would have snapped into sharp focus, the bird flies off.

To photograph small landbirds, I use my Canon EF 600mm F4L lens, EOS 1N body, EF 1.4X teleconverter, and two extension tubes (one 25mm and one 12mm). To maintain functioning autofocus, the teleconverter must be placed in front of the extension tubes. With 37mm of extension, the 600 F4's minimum focusing distance is reduced from 19.7 feet to 15.7 feet. On the advice of veteran bird photographer Ron Austing, I began using AI Servo AF (rather than one-shot AF or manual focus) for warblers at Point Pelee, Ontario, in May 1997. He reminded me of the importance of *prefocusing* on a leaf or branch at approximately the same distance as that of the subject, before attempting to autofocus on the bird's face or neck. Additionally, I'd wait until the bird hopped onto an unobstructed perch before I depressed the shutter button. In most cases, I achieved focus acquisition instantly; my warbler images from Pelee were superb. Thanks Ron.

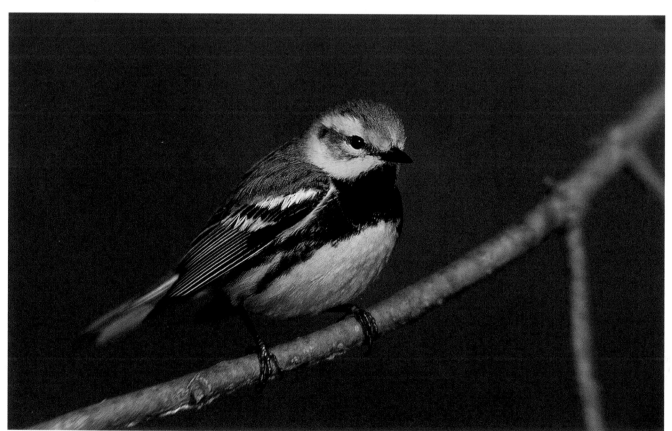

BLACK-THROATED GREEN WARBLER, Point Pelee National Park, Ontario. Canon EF 600mm F4L lens with 1.4X teleconverter plus 37mm of extension and EOS 1N body, Fuji Velvia pushed one stop, evaluative metering at zero: 1/180 sec. at ƒ/5.6, Better Beamer flash extender, fill flash at -1 stop

After years of frustration and disappointing results on my Point Pelee trips, I began using AI Servo autofocus in May of 1997 and succeeded beyond my wildest dreams. Learning to prefocus on a branch and follow the subject until it became clear made a huge difference. I'd then depress the shutter button to engage focus instantly and fire away.

Short Autofocus Lenses

When using wide-angle, standard, and short telephoto and zoom lenses to shoot birdscapes (scenics featuring a bird, or birds, as the main subject), I find autofocus extremely helpful. The shorter the lens, the more difficulty I have focusing manually; to me, everything looks in focus. So, for birdscapes with tripod-mounted outfits, choose the single-shot autofocus mode. Autofocus on the bird or flock of birds, turn autofocus off, recompose, and shoot. When handholding the camera, simply keep the shutter button depressed halfway after focusing, then recompose and shoot. To attain maximum sharpness at a given aperture when photographing large, resting flocks of birds, focus 1/3 of the way into the flock.

For shooting large flocks of ducks or geese in flight with shorter lenses, choose the continuous AF mode. Fill the frame with birds and fire away. Wide-angle lenses are especially effective when large flocks of birds fly directly overhead, but most zoom lenses, as well as short telephotos in the 80mm to 200mm range, can also produce satisfactory images in these situations.

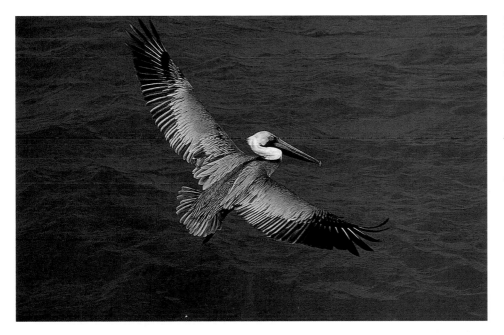

BROWN PELICAN, Sanibel Island, Florida. Canon EF 28–105mm F3.5–4.5 zoom lens at 40mm and A2 body (handheld), Fuji Velvia pushed one stop, evaluative metering at zero: 1/500 sec. at ƒ/4.5

Several brown pelicans were diving into the water right next to the fishing pier on the eastern end of the island and then turning back into the wind and lifting off; the short zoom was the best lens for the situation.

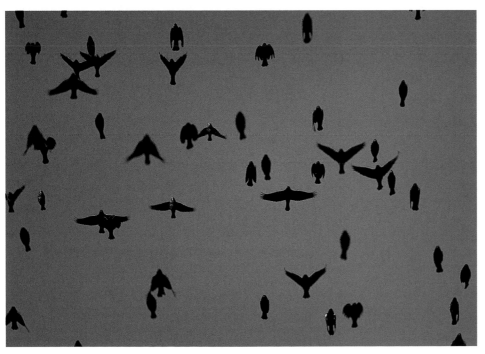

RED-WINGED BLACKBIRDS, Bosque Del Apache National Wildlife Refuge, New Mexico. Canon 300mm F2.8L lens and A2 body (handheld), Fuji Velvia pushed one stop, evaluative metering +1/2 stop: 1/500 sec. at ƒ/5.6

The 300mm F2.8 lenses are fairly heavy, but can be handheld for flight shooting by most photographers for at least short periods of time.

Mid-Range Autofocus Telephotos

Some bird photographers opt to use 300mm F2.8 autofocus telephotos as their everyday lenses, adding 1.4X teleconverters for handheld flight shooting, and 2X teleconverters for general bird photography. Others choose 300mm F4 lenses (often coupled with 1.4X teleconverters) for handheld flight shooting. A few serious bird photographers do choose the very best modern 400mm F2.8s as their workhorse lenses (in spite of their great size, weight, and expense), often using them with 2X teleconverters; the resulting 800mm F5.6 lenses offer minimum focusing distances in the very impressive 9- to 10-foot range. Photographer Ron Austing, for example, relies on the Nikon 400mm F2.8 AF-I lens, often with the Nikon TC20e (2X) teleconverter.

On sunny days, a relatively slow 400mm autofocus lens can be great for handheld flight or action shooting with 100 speed film. The performance of the Canon EF 400mm F5.6L USM lens (which I affectionately refer to as my "toy" lens due to its light weight) is unsurpassed. It is handholdable and features superb optics that yield consistently sharp images; in short, it is a superb lens for photographing birds in flight. My toy lens has paid for

itself many, many times over, and today, many serious bird photographers—even Nikon users—carry the Canon EF 400mm F5.6 lens with a lightweight Canon A2 series body for flight photography.

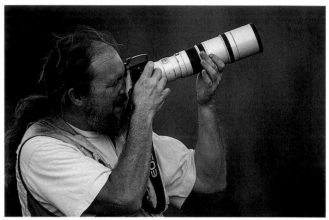

That's me handholding my favorite lens, the Canon EF 400mm F5.6L. It is so light and easy to use that anyone can begin making good flight shots with it the first time they pick it up. (Photo courtesy Erik Egensteiner)

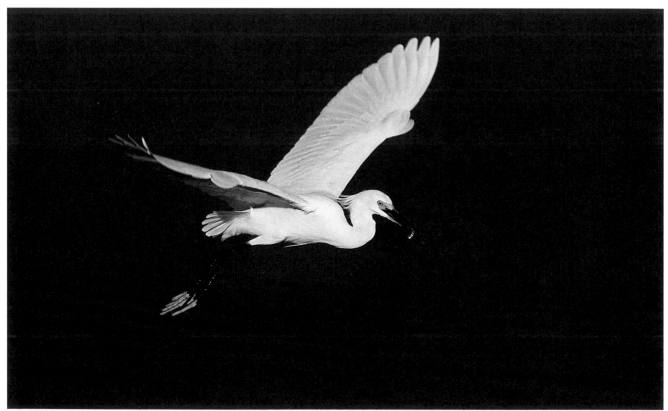

SNOWY EGRET, Ding Darling National Wildlife Refuge, Sanibel Island, Florida. Canon EF 400mm F5.6L lens and A2 body (handheld), Fuji Velvia pushed one stop, evaluative metering -1/2 stop: 1/1000 sec. at *f*/5.6

Before purchasing the 400 F5.6 lens (after attending a George Lepp workshop in Tampa, Florida), I'd stand by, frustrated, when I'd encounter a feeding spree at Ding Darling. With birds whirling and flying and fishing everywhere, I'd feel helpless and would rarely take a single frame. Now, with my "toy" AF lens, I'll often shoot 10 rolls in an hour.

Long Autofocus Telephotos

State-of-the-art 500mm and 600mm autofocus lenses, with their powerful magnifications (10X and 12X respectively), make ideal everyday bird photography lenses. When used with teleconverters, the lenses in this class are astonishingly powerful. The 600 F4 lenses, however, are extremely heavy—usually almost 14 pounds. Long autofocus lenses are great for shooting swimming ducks or foraging sandpipers, but due to the weight of these lenses, flight photography isn't as easy as it is with lenses in the intermediate class. Although you can handhold the 500mm lenses for short periods of time, you'll need a tripod for most flight shooting with the big lenses.

You can use any of the heavy-duty ball heads for flight shooting with long telephotos. Far better, however, especially with the nearly 14-pound lenses, is the heavy, gimbal-type Wimberley tripod head. When mounted on this head, huge lenses can be handled effortlessly. Tracking large birds that are flying slow, steady courses is, with some practice, easy. I've had great success recently making flight shots with the 600mm F4 mounted on the Wimberley head and, with the addition of a 1.4X teleconverter, also attained great results at 840mm. This tripod head may, in fact, be best for general bird photography with 400mm F2.8 and 600mm F4 lenses; it is currently my everyday tripod head.

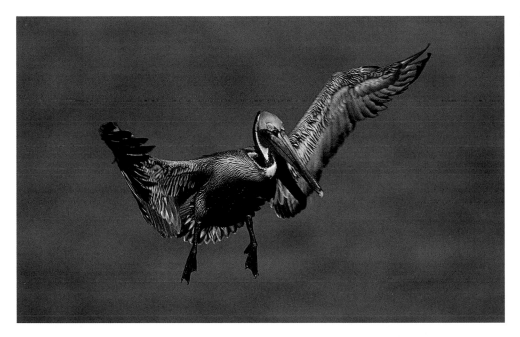

BROWN PELICAN, La Jolla, California. Canon EF 600mm F4L lens and EOS 1N body, Fuji Velvia pushed one stop, evaluative metering at zero: 1/640 sec. at *f*/5.6

With the tension set fairly loosely, it is possible to track large birds (like this brown pelican) in flight with large, tripod-mounted autofocus lenses supported by Arca Swiss B-1 ball heads.

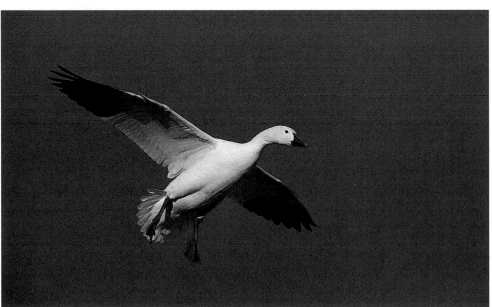

SNOW GOOSE, Bosque Del Apache National Wildlife Refuge, New Mexico. Canon EF 600mm F4L lens with 1.4X teleconverter and EOS 1N body, Fuji Velvia pushed one stop, evaluative metering -1/3 stop: 1/1250 sec. at *f*/5.6

I made this image using the tripod-mounted 600mm lens on a Wimberley tripod head. Until I began using this specialized head, I had mistakenly dismissed the possibility of routinely making sharp flight shots with this lens and the 1.4X teleconverter.

Autofocus with Teleconverters

Long autofocus telephoto lenses with high quality glass elements work extremely well with matching 1.4X and even 2X teleconverters. With a sturdy tripod and ball head, and proper technique, the results can be extremely sharp. Generally, when using teleconverters with autofocus telephoto lenses, autofocus will be maintained if the effective aperture is f/5.6 or larger, *but* autofocusing will be a bit slower due to light loss—a 300mm F4 lens with a 1.4X teleconverter (f/5.6 effective aperture) will *not* acquire focus as fast as a 400mm F5.6 lens. (With the former setup, you can improve AF performance by focusing manually before engaging autofocus.)

As with manual focusing equipment, a 1.4X teleconverter causes the loss of one stop of light, a 2X causes the loss of two stops. Mount a 2X teleconverter behind a 300mm F2.8 lens and you'll have an effective 600mm F5.6 lens; autofocus will function. However, put a 2X teleconverter on a 300mm F4 lens and the resulting 600mm F8 lens won't autofocus because the effective aperture (f/8) is smaller than f/5.6. (With some brands, autofocus will

function, even if the effective aperture is smaller than f/5.6, but performance will be poor at best.)

Putting a 1.4X teleconverter on Canon's EF 500mm F4.5 lens yields a 700mm F6.3 lens, but autofocus *won't* function because the effective aperture is smaller than f/5.6. On the other hand, Nikon's 500mm F4 AF-I or AF-S autofocus lenses *will* autofocus with 1.4X teleconverters— the effective aperture will be f/5.6. With the addition of 1.4X teleconverters, the huge 600mm F4s are transformed into 840mm F5.6 lenses with functioning autofocus and respectable minimum focusing distances in the 19- to 20-foot range.

I've even produced sharp images of stationary subjects by stacking the 2X and 1.4X teleconverters around a 12mm extension tube; the 2X should be in the front, mounted to the lens. In this instance, you should use mirror lock-up and either a cable release or the self-timer. (A cable release is practically mandatory if the bird is changing its head position at all; after the mirror is locked, you'll need to watch your subject and fire the shutter as desired. When

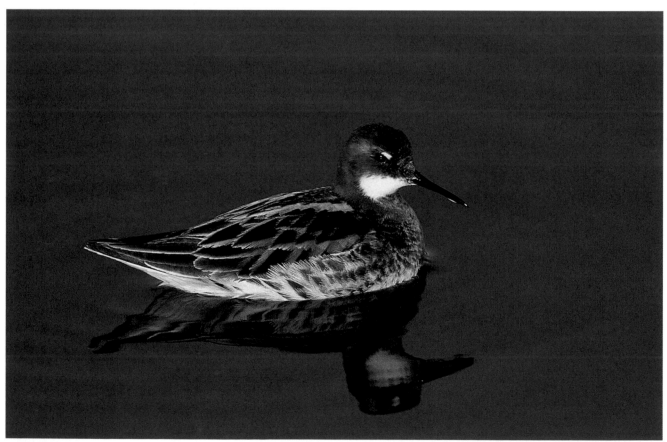

FEMALE RED-NECKED PHALAROPE, Churchill, Manitoba. Canon EF 600mm F4L lens with 1.4X teleconverter and EOS 1N body, Fuji Velvia pushed one stop, evaluative metering at zero: 1/640 sec. at f/5.6

These tiny, seagoing shorebirds seem as if they never stop moving and spinning; without autofocus, you'd have almost no chance of making a sharp image. And, with their dark eye masks, the head position and the angle of the light striking their faces needs to be perfect. Of the hundreds of images that I've made of this bird, this is the only really good one.

using either the 2- or 10-second delay, you'll be at the mercy of the bird, unless it remains absolutely still.)

You can also use a second tripod to increase image sharpness. I favor a Benbo tripod *(the* best for macro photography) with a Beanhead, which is a tripod head featuring a rectangular beanbag affixed to a mounting plate. I position the Benbo tripod under the camera body. The centerpost is raised until the Beanhead supports the camera body. Using this method, there's no need to use a camera body plate (see page 99); positioning the second tripod, even when working in vertical format, is easy.

When using a second tripod with an Arca Swiss mounting system, aligning the tripod and securing the plate can be either frustratingly difficult or just plain impossible, especially when you're shooting verticals. In any case, many of the images that I've made with stacked teleconverters are so sharp as to be beyond belief. It took me 14 months to wean myself off the Canon FD 800mm F5.6L (manual focus) lens. However, by January 1996, the Canon EF 600mm F4L lens (often with a 1.4X teleconverter) had become my everyday bird photography lens; the quality of my work has been increasing by leaps and bounds ever since.

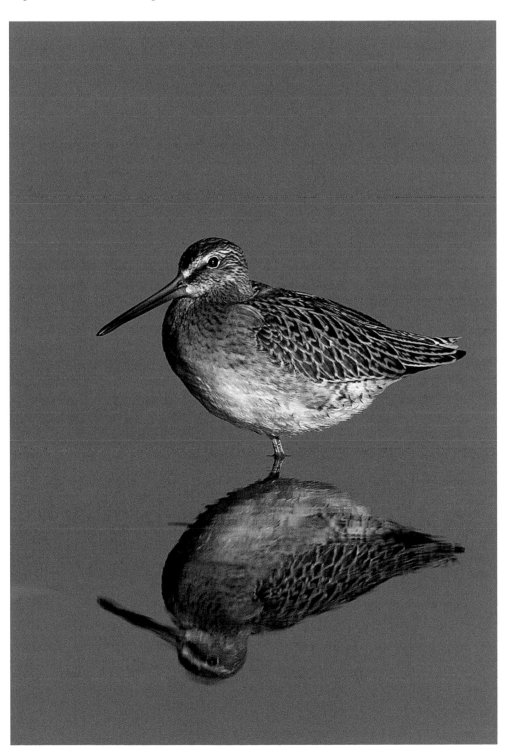

JUVENILE SHORT-BILLED DOWITCHER, Jamaica Bay Wildlife Refuge, Queens, New York. Canon EF 600mm F4L lens with 2X teleconverter, 12mm extension tube, 1.4X teleconverter, and EOS 1N body, Fuji Velvia pushed one stop, evaluative metering at zero: 1/15 sec. at ƒ/11

I made this image on an absolutely still August morning, with both teleconverters stacked around a 12mm extension tube, by using mirror lock and a cable release. I was blown away by the resulting sharpness of the image.

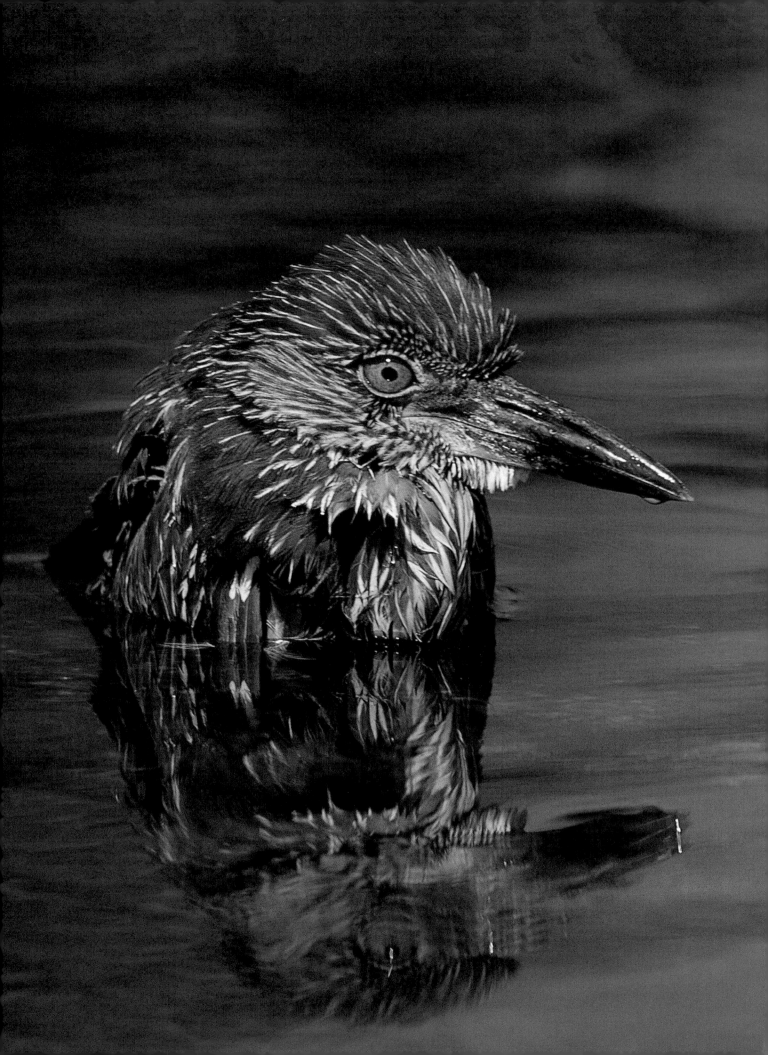

Chapter Three

MAKING GOOD EXPOSURES

You mount your long lens on a heavy duty tripod and approach a beautiful bird with painstaking care. You compose a pleasing image that depicts the bird in its natural habitat or against a background of pure color. You focus accurately and depress the shutter button. But does a great photograph result? Not necessarily. If your image is overexposed or underexposed, your slides will wind up in the discard pile. Exposure-wise, color slide film is quite unforgiving. Most slide films can tolerate a bit of underexposure—and my favorite, Fuji Velvia, a bit of overexposure—but in most cases, if your exposure is off by more than 1/2 stop, the results will be unsatisfactory.

To succeed as a nature photographer, you must learn the basics of exposure. You should practice judging the tonality of a variety of subjects and backgrounds. You need to understand the sunny $f/16$ exposure rule. You should study and learn exposure theory so that you can understand how to determine the correct exposure for white, light, dark, and black subjects relative *to the correct middle-tone exposure.* And, you must learn to use your camera's various metering patterns. When time permits, you can determine your exposure using the method that you most prefer and then cross check the results against other methods that you're comfortable with. Choose and stick with one type of film and learn its characteristics. In the beginning, take good field notes on your exposures, or use a mini tape recorder (and make sure to transcribe your comments daily). Soon, you'll be making satisfactory exposures on a consistent basis.

FIRST-WINTER YELLOW-CROWNED NIGHT-HERON, Ding Darling National Wildlife Refuge, Sanibel Island, Florida. Canon FD 800mm F5.6L lens with 50mm extension tube and T-90 body, center-weighted average metering at zero, 1/180 sec. at $f/5.6$

By learning the basics of exposure and exposure theory, understanding the way your camera's various metering patterns work, and choosing and using one film, you'll be able to consistently attain exposures that please you.

Measuring Light in Stops

Shutter speed and *aperture* together determine the amount of light that reaches the film. Both are measured in values, called *stops,* which indicate a doubling or halving of adjacent values. The shutter speed, usually measured in fractions of a second, is the length of time that the shutter remains open; the longer it stays open, the more light strikes the film. Shutter speeds that are commonly used in bird photography include 1/60 sec., 1/125 sec., 1/250 sec., 1/500 sec., and 1/1000 sec. Each shutter speed in the series lets in half as much light as the one preceding it and twice as much as the one following it. Most modern cameras offer shutter speeds in half-stop increments (in boldface) as follows: 1/30, **1/45**, 1/60, **1/90**, 1/125, **1/180**, 1/250, **1/350**, 1/500, **1/750**, 1/1000, **1/1500**, and 1/2000.

The aperture, or *f*-stop, is the opening that, when the shutter opens, allows light to strike the film. Most lenses have adjustable apertures. The larger the aperture, the more light strikes the film. Each full *f*-stop lets in twice as much light as the one it precedes, and half as much light as the one it follows. The *f*-stops commonly encountered in telephoto photography are *f*/2.8, *f*/4, *f*/5.6, *f*/8, *f*/11, and *f*/16. The *f*/2.8 aperture is the largest lens opening in this series; *f*/16 is the smallest. Many modern cameras allow settings in half-stop increments (in boldface) as follows: *f*/2.8, **f/3.5**, *f*/4, **f/4.5**, *f*/5.6, **f/6.7**, *f*/8, **f/9.5**, *f*/11, **f/13**, and *f*/16.

An exposure is simply the combination of a single shutter speed and a single aperture; together, they determine the amount of light that strikes the film. If the correct exposure in a given situation is 1/250 sec. at *f*/8, the same photograph could be made using an exposure of 1/500 sec. (half the exposure time) at *f*/5.6 (twice the light), or at 1/125 sec. (twice the time) at *f*/11 (half the light). Plus, there are many other shutter speed and aperture combinations that would let in exactly the same amount of light: 1/60 sec. at *f*/16 and 1/000 sec. at *f*/4 are two examples. Understand, also, that opening up the lens means changing to a larger lens opening (a lower *f*-stop number), and stopping down the lens means changing to a smaller lens opening (a higher *f*-stop number).

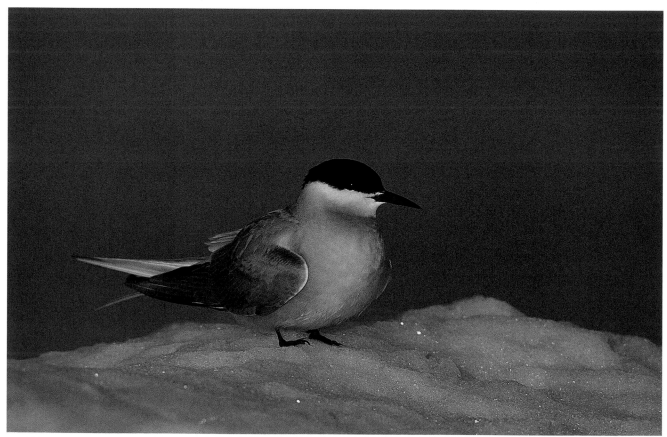

ARCTIC TERN, Churchill, Manitoba. Canon FD 800mm F5.6L lens with 25mm extension tube and T-90 body, Fuji Velvia pushed one stop, center-weighted average metering +2/3 stop: 1/500 sec. at *f*/5.6

With half a frame of light blue sky, a white breasted bird, and lots of highly reflective ice, 2/3 stop of extra light prevented the underexposure of this image. I made this photograph during the first week of July in early-morning light.

The Sunny Sixteen Rule

On clear, sunny days, two hours after sunrise and two hours before sunset, you can determine the correct exposure without using your camera's meter by following the "sunny $f/16$" rule: at the closest shutter speed equal to the fraction made by 1 over the film speed, an aperture of $f/16$ will give you the correct exposure for a front-lit middle-tone subject (against any background). Sunny $f/16$ = 1/ISO at $f/16$. Use the sunny $f/16$ exposure rule only to photograph front-lit, middle-tone subjects when the sun is at full strength. A middle-tone subject, by definition, is one that reflects 18 percent of the light that strikes it. A middle-tone gray is halfway between black and white.

While photographers often refer to shades of gray when talking about middle tones, it is important to understand that all colors have middle tones. A middle-tone blue is halfway between dark, navy blue and light, pastel blue. A middle-tone red is halfway between deep, fire-engine red and pale rose, and so on for each color in the spectrum.

The sunny $f/16$ rule is based on the assumption that the amount of incident light (the light striking the subject) is a predictable constant in given conditions. Sunny $f/16$ doesn't consider the amount of light *reflected by* the subject or scene. Therefore, when using the sunny $f/16$ rule, you must choose your camera's *manual exposure mode* and set the aperture and shutter speed manually. When using Kodachrome 64 on a sunny day, for example, you'd expose a middle-tone subject at 1/60 sec. (the closest shutter speed to 1/64) at $f/16$ (or an equivalent exposure, such as 1/500 sec. at $f/5.6$). For

Fuji Velvia, 1/ISO = 1/50. The nearest shutter speed (in half stops) to 1/50 is 1/45 sec. So, in theory, sunny $f/16$ for Fuji Velvia is 1/45 sec. at $f/16$ or 1/350 sec. at $f/5.6$.

If your camera doesn't offer shutter speeds in half stops, the theoretical sunny $f/16$ metering for Fuji Velvia would be 1/60 sec. with the aperture set between $f/11$ and $f/16$ (or an equivalent exposure). Likewise, in theory, the sunny $f/16$ calculation for pushed Velvia (see pages 79 and 81 for information on pushed film), and for other 100 ISO films, should be 1/750 sec. at $f/5.6$. This is, in fact, the value that I use for pushed Velvia in brilliant sun, but for other 100 speed films (such as Provia and Ektachrome 100SW), I use 1/1000 sec. at $f/5.6$ as my sunny $f/16$ value because I rate these films 1/3 stop faster than the manufacturer's recommended ISO value.

For brilliant white birds, stop down one full stop from the correct sunny $f/16$ exposure. For lighter than middle-tone birds, stop down 1/2 stop from the sunny $f/16$ exposure. For dark birds, open up 1/3 to 1/2 stop from the sunny $f/16$ exposure. For black birds, open up from 1/2 to 1 whole stop from the sunny $f/16$ exposure. When using the sunny $f/16$ rule to determine exposure, *you* make the calculations, not your camera's metering system; you make compensations by adjusting the sunny $f/16$ exposure and setting the resulting values manually. You can add or subtract light by changing either the shutter speed or the aperture (while working in manual mode). There's no need to refer to your in-camera meter when using the sunny $f/16$ rule.

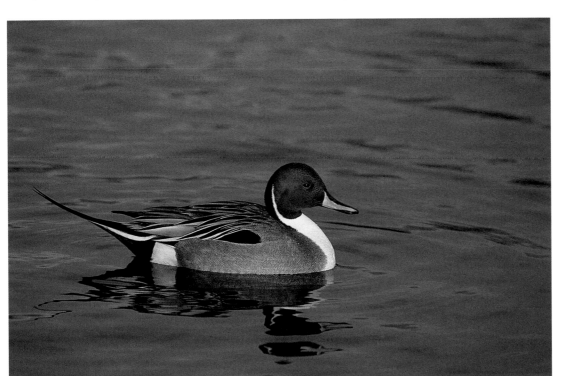

NORTHERN PINTAIL DRAKE, Freeport, Long Island, New York. Canon FD 400mm F4.5 lens and A1 body, Kodachrome 64, sunny $f/16$: 1/500 sec. at $f/5.6$

I made this image at 10:00 A.M. on a clear, sunny day. Since both the subject and the background averaged to a perfect middle tone, the sunny $f/16$ exposure rule worked perfectly.

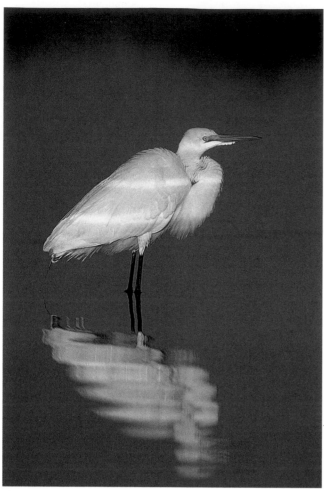

GREAT EGRET, Little Estero Lagoon, Fort Myers Beach, Florida. Canon EF 600mm F4L lens with 1.4 teleconverter and EOS 1N body, Fuji Velvia pushed one stop, evaluative metering at zero: 1/800 sec. at *f*/5.6

In early morning light, still, blue water is lighter than a middle tone. With a large, centered, white subject, evaluative metering stops down enough so that no (minus) compensation is needed.

When double-checking the exposures suggested by Canon's evaluative metering (which I depend on extensively), I've noted that I very often wind up shooting Fuji Velvia film at sunny *f*/16 values that are 1/2 stop lighter than the theoretical values. This ends up being 1/250 sec. at *f*/5.6 for middle tones and 1/500 sec. at *f*/5.6 for brilliant whites for Velvia shot at ISO 50, and double those values (1/500 sec. at *f*/5.6 for middle tones and 1/1000 sec. at *f*/5.6 for brilliant whites) for pushed Velvia. I rationalize by reasoning that the sun is, for a variety of reasons, not quite at full strength.

On days with less than full sun, you can determine a base exposure value by taking a reading off a gray card (18-percent reflective gray cards are available at most photography shops), or off any other object that you believe represents a middle tone—for example, luxurious green grass or tree bark that is neither dark brown nor light gray. Then, starting with the base exposure that you've calculated, compensate for light or dark subjects as described above. Remember that, when determining

exposure by the sunny *f*/16 rule or when using a base exposure on days with less than full sun, you—not the camera's metering system—determine the exposure (and you set it manually).

Another way to determine a base exposure value (in any lighting conditions, including full sun) is to use a handheld incident meter. Set the ISO, choose a shutter speed, point the sensor directly away from the subject, and push the button. The meter will indicate an aperture setting. An incident meter measures the light falling on the subject, not the light being reflected from it; therefore, as above, you'll need to *subtract light from the suggested exposure to keep from overexposing light subjects and add light to prevent underexposing dark or black subjects.* Though some photographers use incident meters for bird photography, I do not. Whenever I've been around photographers using them, it seems that no two incident meters ever agree. Additionally, you need to take a new reading each time the light changes. It is far simpler and faster to use your camera's through-the-lens metering system and one of its automatic exposure (AE) modes.

CHECKING YOUR CAMERA'S LIGHT METER
The light meters, shutter speed settings, and aperture settings in most modern (electronic) cameras are generally very accurate. Meters in older camera bodies, however, are often off by a stop or more. Now that you understand the sunny *f*/16 rule, you can check your in-camera meter on a sunny, cloudless, haze-free day as follows:

1. Mount a medium telephoto lens on your camera body.
2. Set the ISO to 125.
3. Select shutter priority and set the shutter speed to 1/125 sec., that is, to 1/ISO.
4. After making sure that your gray card is square to the sun, take a reading off it or off the clear, northern, blue sky 40 degrees up from the horizon. If your meter is accurate, the suggested aperture should be *f*/16 (as per the sunny *f*/16 rule). If your meter is off, you can calibrate it by changing the ISO setting until the meter correctly indicates an aperture of *f*/16. In this case, you'll need to make a corresponding change each time you load a fresh roll of film.

Following this method, if you had to increase the ISO by one stop (from ISO 125 to ISO 250) to get a reading of *f*/16 in your meter check, you'd need to increase the ISO one stop whenever you put a new roll of film in your camera. Likewise, if you needed to decrease the ISO by 1/3 stop (from ISO 125 to ISO 100), you'd need to decrease the ISO by 1/3 stop each and every time you load a fresh roll. Your only other option is to return the camera body to the manufacturer and have the meter recalibrated, repaired, or replaced.

Automatic Exposure Modes

With your camera in automatic exposure (AE) program mode, it is the camera that suggests and sets the exposure (the shutter speed and aperture). Other AE modes include shutter priority (TV) and aperture priority (AV). In TV mode, you select and set a shutter speed and the camera automatically suggests and sets the aperture. In AV mode, which is preferred for bird photography, you select and set the aperture (usually the widest) and the camera suggests and sets the shutter speed.

Nearly all in-camera meters assume that the image being metered averages to an overall middle tone, in other words, that it reflects 18 percent of the light that strikes it. When images average darker or lighter than middle tones, most in-camera metering systems will suggest incorrect exposures. With practice, however, you can learn how and when to override your camera's meter by making exposure compensations (by adding or subtracting light from the suggested exposures). Before you learn to make exposure compensations, it is vital that you understand the variety of reflective light metering patterns offered by your camera.

CENTER-WEIGHTED AVERAGE METERING
For years, the center-weighted average metering pattern was standard in most SLR camera bodies, and most current cameras offer it today, as well. Center-weighted average metering reads the light reflected by the entire image, placing an extra emphasis on the light reflected by the central and lower portions of the image because camera manufacturers realize that the average consumer will be taking pictures of their surroundings—with the earth below and the sky above. Center-weighted average metering

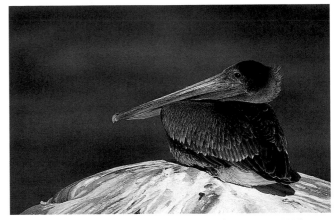

IMMATURE BROWN PELICAN, La Jolla, California. Canon EF 600mm F4L lens and EOS 1N body, Fuji Velvia pushed one stop, evaluative metering at zero: 1/640 sec. at f/5.6

Most segmented meters will recognize the contrast between a dark subject and a lighter background and suggest an exposure that will prevent underexposure of the subject. When working with center-weighted average metering, however, you'll need to add the light needed to prevent underexposing the subject; this is the case whether or not the sun is shining.

systems give extra emphasis to the lower portion of the image (the darker, earth part) so that the upper portion (the lighter, sky part) won't cause gross underexposure of the photograph.

SPOT METERING
Today, many, but not all, camera bodies offer spot metering as an option. Fine spot meters feature a tiny circle in the center of the viewfinder that usually comprises about three percent of the entire image. You simply point the lens so that the spot-metering sensor lies directly on the area of the image that you wish to meter. Many top professional and advanced amateur nature photographers use spot metering exclusively. They compensate for light or dark subjects and then set the resulting exposures manually. I primarily use evaluative metering, my camera's multi-segmented metering pattern, and rarely use spot metering at all.

MULTI-SEGMENTED METERING
The latest modern camera bodies offer a variety of multi-segmented metering patterns that go by a variety of names, evaluative (Canon), matrix (Nikon), honeycomb, and multi-pattern among them. These metering patterns take exposure readings off numerous sectors of an image and then attempt to match them as closely as possible to the exposure readings of preprogrammed images; they then suggest and set an exposure. Multi-segmented metering patterns are generally very accurate, but not a single one that I've tried is perfect.

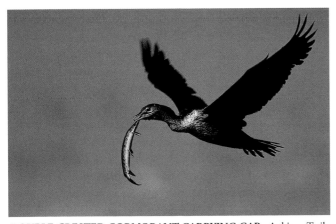

DOUBLE-CRESTED CORMORANT CARRYING GAR, Anhinga Trail, Everglades National Park, Florida. Canon EF 400mm F5.6L lens and A2 body (handheld), Fuji Velvia pushed one stop, evaluative metering +1/2 stop: 1/500 sec. at f/5.6

Though evaluative metering works well for flight shots on blue-sky days, I chose to add 1/2 stop to the suggested exposure to prevent underexposing this dark subject.

ROSEATE SPOONBILL, Ding Darling National Wildlife Refuge, Sanibel Island, Florida. Canon FD 800mm F5.6L lens and T-90 body, Fuji Velvia pushed one stop, center-weighted average metering at zero: 1/750 sec. at f/5.6

With large, light subjects against middle-tone backgrounds, simply shoot at the metered exposure; no exposure compensation is needed. This is true for both center-weighted and segmented metering. Large, light subjects will stop the lens down enough to prevent overexposure.

CENTER-WEIGHTED AVERAGE METERING WITH EXPOSURE COMPENSATION

The boxes below represent different exposure situations; the circled areas represent the subject, with the surrounding area being the background. Next to each box, I've provided the appropriate exposure compensation guidelines for metering medium-size, off-center subjects photographed on Fuji Velvia color slide film. You may need to fine-tune these exposure compensations for your own film choice and equipment.

This is a situation in which you have a dark or fairly dark subject on a dark background. Shoot at -1/3 or -1/2 stop. Use -2/3 or -1 for large black subjects.

When an entirely white or light subject, or a subject with white highlights, appears against a middle-tone background, use -1/3 or -1/2 stop compensation. Against a very dark or black background, opt for -2/3 or -1 stop.

If the subject is somewhat darker than its middle-tone background, compensate with +1/2 or +2/3 stop.

For a situation with a middle-tone subject on a middle-tone background, shoot at the metered exposure (or +1/3 stop).

When you have a large, light subject against a middle-tone background, shoot at the metered exposure.

With a large, brilliant white subject, spot meter the white and add 1 1/3 stops.

For a dark subject on a light background, shoot at +1 or +1 1/3. Use +2 when there is extreme contrast between the light and dark, or when one of the elements is extremely light or dark.

Here, you have a light or white subject against a light background, so you should compensate at +2/3 or +1.

Spot Metering with Compensation

Many professional and advanced amateur photographers determine their exposures by spot metering their subjects (and then compensating when necessary). I don't, preferring instead to choose a metering pattern that reads the light reflected by the entire image. My problems with using spot metering for bird photography are the following:

1. Birds are, on average, small subjects. Getting close enough to them to fill the spot metering circle with a uniform section of their plumage may be extremely difficult or impossible.
2. Spot metering different areas of a subject that appear to be of uniform tonality often yields dissimilar readings.
3. With many camera systems, you are—*after* making the desired exposure compensations—forced to either set your exposures manually or to use the AE lock feature when spot metering. Using a center-weighted or multi-segmented metering pattern with compensation is always faster.
4. When spot metering and compensating, you must execute several steps (both mental and physical); there's a lot of room for dumb mistakes. When working in an automatic exposure mode, you just dial in compensation and press the shutter button.
5. When spot metering, you must be able to judge tonalities accurately. This is far easier said (and described in writing) than done, and it is something that I find very difficult to do—even after 15 years of photographing birds.

Despite these problems, understanding spot metering with compensation will greatly increase your overall grasp of exposure and will give you a way to double-check the exposures that you determine in the field by other methods. For middle-tone birds, simply spot meter the bird (or a large middle-tone object in the same light) and make the photograph at the suggested exposure. For large, brilliant white birds, or for birds with extensive areas of white plumage, spot meter the white and *open up* 1 1/3 stops. Brilliant white reflects roughly 2 1/3 stops more light than a middle tone, so opening up 1 1/3 stops will result in a one-stop underexposure of the white, relative to the correct middle-tone exposure, and this is exactly what you want. Another option would be to spot meter a large middle-tone object and *subtract* one stop of light.

It is at this point that many photographers become confused. You're thinking, "First we're told to stop down one stop for whites, then we're told to open up 1 1/3 stops. What's going on?" It is simply a matter of considering the starting point. You stop down one stop for whites—when starting at the sunny *f*/16, gray card, base, or middle-tone exposure—to keep from overexposing them. In these cases, you're working with the *incident* light (the light falling on the subject). You do, however, open up 1 1/3 stops—when starting at the spot-metered exposure of a brilliant white—

WESTERN GULL, La Jolla, California. Canon FD 800mm F5.6L lens with 75mm of extension and T-90 body, Fuji Velvia, spot metering of white breast +1 1/3 stops: 1/500 sec. at *f*/5.6

Spot metering brilliant whites in direct sun and adding 1 1/3 stops of light will yield clean whites while maintaining good feather detail. If you spot meter the white and shoot at the suggested exposure, your gulls will have dingy gray breasts because your camera's spot meter will read the white and underexpose the image.

to prevent underexposure. Here, you're working with *reflected* light. Remember that your camera's basic reflective metering patterns want to make everything gray. For light subjects, open up from 2/3 to 1 stop from the spot metered exposure; for subjects just a bit lighter than a middle tone, open up from 1/3 to 1/2 stop.

For black subjects, you spot meter them and subtract 1 or 1 1/2 stops of light, or else your in-camera meter will make them gray and, thereby, overexpose them. Another option is to spot meter a large middle-tone object and then add from 1/2 to 1 full stop of light. For dark subjects, subtract 1/2 to 2/3 stop from the spot metered exposure; for subjects just a little darker than a middle tone, underexpose them by 1/3 to 1/2 stop from the spot-metered exposure reading.

Whether you spot meter the subject and compensate, or spot meter a large middle-tone object in the same light and work from there, the idea is to photograph middle-tone subjects at the suggested exposure, place subjects that

are lighter than a middle tone at the appropriate level of underexposure (relative to the correct middle-tone exposure), and place subjects that are darker than a middle tone at the appropriate level of overexposure (again, relative to the correct middle-tone exposure). The chart below details these concepts and ties together the entire exposure package.

Multi-Segmented Metering Patterns with Compensation

As I stated earlier, evaluative and matrix type metering patterns measure the light reflected by numerous sectors of an image and then attempt to match these readings as closely as possible to those of preprogrammed images. Most of these multi-segmented patterns have 6 to 8 segments, while others have as many as 14; the Nikon F5 has more than one thousand. In order to take full advantage of these highly sophisticated metering patterns, it is my feeling that photographers must first master the basics of exposure and exposure theory because each manufacturer's multi-segmented metering pattern will react differently to various lighting/subject/background combinations. Multi-segmented meter readings will even vary among *different* camera body models from the *same manufacturer*.

When I began using Canon's evaluative metering patterns (in both their A2 series and EOS 1N bodies), I had to learn how they reacted in different lighting situations with various subject/background combinations. I learned about my new metering patterns by comparing their performance to the performance of the metering pattern that I knew best: center-weighted average. I'd switch back and forth between center-weighted average (with compensation dialed in) and evaluative. If the exposure suggested by the evaluative system matched the exposure that I'd arrived at with center-weighted average metering and compensation, then I knew that the evaluative metering system was doing its job and that I could use it in that *one specific situation* without compensation. If, however, the readings didn't match, I knew that even the sophisticated evaluative system would need my help (in the form of exposure compensation) in that specific situation.

A Quick Guide to Correct Exposure

Below are the correct exposure levels, *relative to the correct middle-tone exposure,* for subjects that are lighter and darker than a middle tone. The actual difference in reflectance from the whitest white to the blackest black is 4.83 stops. Whitest whites reflect 98 percent of the light that strikes them; they reflect about 2 1/3 stops *more* light than a middle tone. Blackest blacks *absorb* about 92 percent of the light that strikes them, so they reflect about two stops *less* light than a middle tone.

When you spot meter a brilliant white and open up 1 1/3 stops, you end up with precisely the suggested correct exposure level for brilliant whites: a level that is one stop *darker* than the correct middle-tone exposure. When you spot meter the blackest black and subtract from 1 to 1 1/3 stops of light, you end up shooting in the range of correct exposure suggested for the blackest subjects: from about 1/2 to 1 stop *lighter* than the correct middle-tone exposure.

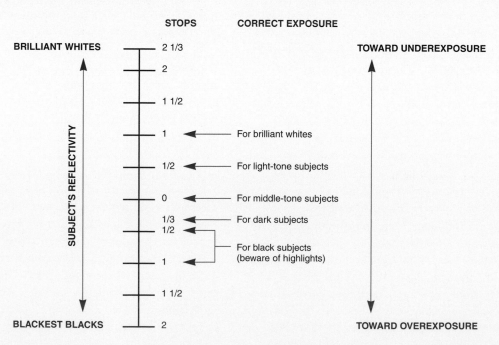

BLACK-CROWNED NIGHT-HERON, Shark Valley, Everglades National Park, Florida. Canon EF 600mm F4L lens with 1.4X teleconverter and EOS 1N body, Fuji Velvia pushed one stop, evaluative metering +1/3 stop: 1/45 sec. at ƒ/5.6, mirror lock with 2-second self-timer

In this low-light situation, I needed to add 1/3 stop of light to keep the light green reeds light green. In full sun, Canon's evaluative metering system would have opened up 1/3 stop, and no compensation would have been needed.

After using Canon's evaluative metering patterns for over two years, here's what I learned: When shooting Fuji Velvia with the sun at, or nearly at, full strength, you almost never need to compensate more than 1/3 or 1/2 stop from the evaluative meter reading. On sunny days, with light, middle-tone, or dark subjects against middle-tone, light, or very light backgrounds, Canon's evaluative metering system performs superbly; it knows when to open up in bright conditions, because it knows the film's ISO and its sunny ƒ/16 values, as well. When the incoming light reading is 1/2 to 2 1/2 stops (or more) *brighter* than the sunny ƒ/16 value for the film, the system adds from 1/3 to 1 stop (or more) of light. When the sun is shining, evaluative metering keeps overall light images light.

When photographed against dark backgrounds (in any light), subjects that are a middle tone or dark require from 1/3 to 1/2 stop of underexposure with Fuji Velvia, and from 2/3 to 1 stop of underexposure with most other color slide films. If these subjects have white or bright highlights, they'll need another 1/3 stop less light. When photographing large-in-the-frame light or white subjects against dark backgrounds with the Canon evaluative metering system, the metered exposure will usually come close to being correct. You can always double-check by spot metering the subject and adding light as needed.

In nearly all of these situations, when working in low light (with the sun at well less than full strength), you need to compensate *exactly as if using center-weighted average metering.* (The lone exception is that evaluative metering will open up a bit for dark subjects against light or middle-tone backgrounds in any lighting conditions.) If photographing on a light sand beach on a sunny day, you can photograph most subjects at the metered exposure *without* having to dial in any exposure compensation. But, if a cloud obscures the sun, you'll need to add from 2/3 to 1 full stop of light (just as if using center-weighted average metering).

For flight shots taken against a blue or light blue sky on clear, sunny days, evaluative metering performs superbly in nearly all situations. However, it is necessary to overexpose 1/3 or 1/2 stop for black or very dark birds and to underexpose 1/3 or 1/2 stop for brilliant white birds against dark blue skies (or waters). In both of these situations, though, no compensation is needed if the bird is very large in the frame. When the sun is out, but at less than full strength, you need to add from 1/2 to 1 stop of light for flight photographs against light blue skies.

All in all, I am very happy with my Canon evaluative metering system and use it now (with compensation) for nearly all my bird photography; it is rare that I have to compensate more than 1/3 or 1/2 stop.

Black-and-White Subjects

When photographing black-and-white birds, such as puffins, black-backed and black-hooded gulls, and bufflehead, the standard advice is to "expose for the highlights" (rather than for the blacks). If you do this, however, by placing the whites at a level of one full stop of underexposure (relative to the correct middle-tone exposure), the blacks will be underexposed and completely without detail. Even if the white area is extensive, you should place it at a level of only 1/2 stop (rather than one full stop) of underexposure so that there'll be some detail in the black. This is called "giving the white away," that is, overexposing it a bit to allow for enough light to bring out the details in the black.

Be forewarned that the evaluative metering system in Canon's EOS 1N body will grossly overexpose the whites on a black-and-white bird (such as a great black-backed or western gull) if the focusing sensor, which is linked to the metering system, falls on an extensive area of black plumage. In addition, when photographing black-and-white birds in bright sun, exposure problems are most difficult. On cloudy-bright days, though, contrast is reduced and shooting just a bit darker than the correct middle-tone exposure will result in properly exposed whites and blacks that show good detail.

For black birds with white or bright bills, such as American coots or double-crested cormorants, you cannot overexpose the blacks by the usual 1/2 to 1 stop; this will overexpose the highlights. To avoid burning the highlights, make the photo at the middle-tone exposure or at an even slightly darker level. You'll lose some detail in the black, but if the bird's bill is badly burned, you have to relegate the image to the trash barrel. If you are now thinking that determining the correct exposure for black-and-white subjects is tricky, you're entirely correct. If you regularly use Fuji Velvia, switching to a less contrasty film, such as Ektachrome 100SW, when you shoot black-and-white birds in full sunlight will help to some degree.

WILLET, Little Estero Lagoon, Fort Myers Beach, Florida. Canon EF 600mm F4L lens with 1.4X teleconverter and EOS 1N body, Fuji Velvia pushed one stop, evaluative metering at zero: 1/500 sec. at *f*/8

I find that when photographing most any bird against light to middle-tone backgrounds on sunny days, Canon's evaluative metering yields superb results.

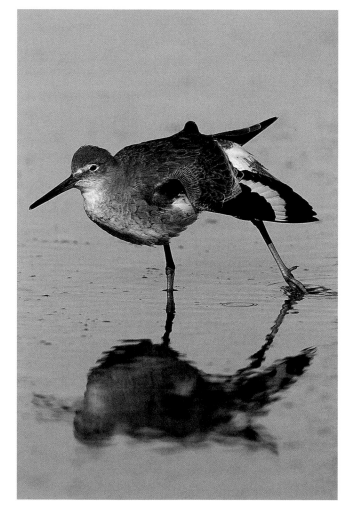

AMERICAN COOT, Mission Bay Park, San Diego, California. Canon EF 600mm F4L lens with 1.4X teleconverter and EOS 1N body, Fuji Velvia pushed one stop, evaluative metering -1/3 stop: 1/320 sec. at *f*/5.6

Coots, as in "You old coot," are supposed to be ugly birds, but in golden early-morning light, they can look downright handsome. When photographing birds with white or bright bills, however, you'll need to subtract 1/3 stop of light (or more) from the suggested exposure to keep from burning the highlights.

Bracketing

To bracket an exposure, first make an image at what you believe is the correct exposure, and then make another image at a lighter exposure and still another at a darker exposure. This is easiest to do by using your camera's automatic exposure bracketing feature, if it has one (see page 24 for more on this camera feature). With many top-of-the line cameras, you can bracket in 1/3-, 1/2-, 1-, or even 2-stop increments; however, when using color slide film, it is best to bracket in 1/3- or 1/2-stop increments (except in highly unusual lighting situations, such as when shooting high-contrast or strongly backlit images). Often, two of the three exposures will be acceptable, but one exposure will almost always stand out as best. When you're shooting sunrises or sunsets, all three exposures may be acceptable, each depicting a different mood.

Bracketing is like taking out insurance; you spend a little extra on film to ensure that you get one perfect exposure. So why not bracket all the time? Film is expensive; instead of wasting film on bracketed exposures, you could use it to make valuable in-camera original duplicate images—the highest quality and least expensive duplicates you'll ever come across. Also, bracketing can become a crutch; you won't ever learn to calculate the correct exposure if you just bracket all the time. Plus, when photographing birds,

you're always looking for that special action shot, that image of a bird grabbing a dragonfly from midair or gracefully stretching a wing; when you bracket, you risk losing these striking images due to an incorrect exposure.

I'm constantly asked if I bracket. My standard answer is that I bracket only occasionally, when photographing on foreign soil, when encountering difficult lighting conditions, when photographing an extremely rare bird, or when faced with a truly spectacular opportunity, such as a beautiful bird posing in great light against a soft, pleasing background. Yet even in these instances, I hold my breath and hope that the bird doesn't do something sensational while I'm bracketing exposures.

Sometimes, I use autoexposure bracketing, shooting 1/3 stop lighter and 1/3 stop darker than the exposure that I've set. However, in most situations, I'm so sure that I'm within 1/3 stop of the correct exposure that I vary the exposure in one direction only. I do this with the exposure compensation dial, but I wish that my Canon camera bodies offered automatic exposure bracketing *in one direction only,* thus making only *two* images in a series (like the Nikon F5). In any case, most of the times that I bracket my exposures, I do so in one direction only—to find out which of the two exposures will be best in a given situation.

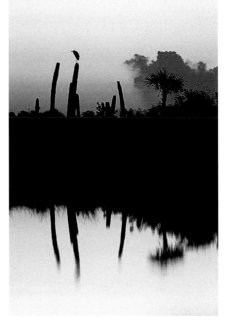

GREAT BLUE HERON ON CABBAGE PALM STUMP AT SUNRISE, Merritt Island National Wildlife Refuge, Titusville, Florida. Canon EF 400mm F5.6L lens and A2 body, Fuji Velvia pushed one stop, evaluative metering +1/2 stop, autoexposure bracketing +/-1/2 stop: 1/500, 1/350, and 1/750 sec. at *f*/5.6

Using autoexposure bracketing for sunrise and sunset birdscapes will yield images with different moods. Of these three, I prefer the darkest image; it is the most dramatic.

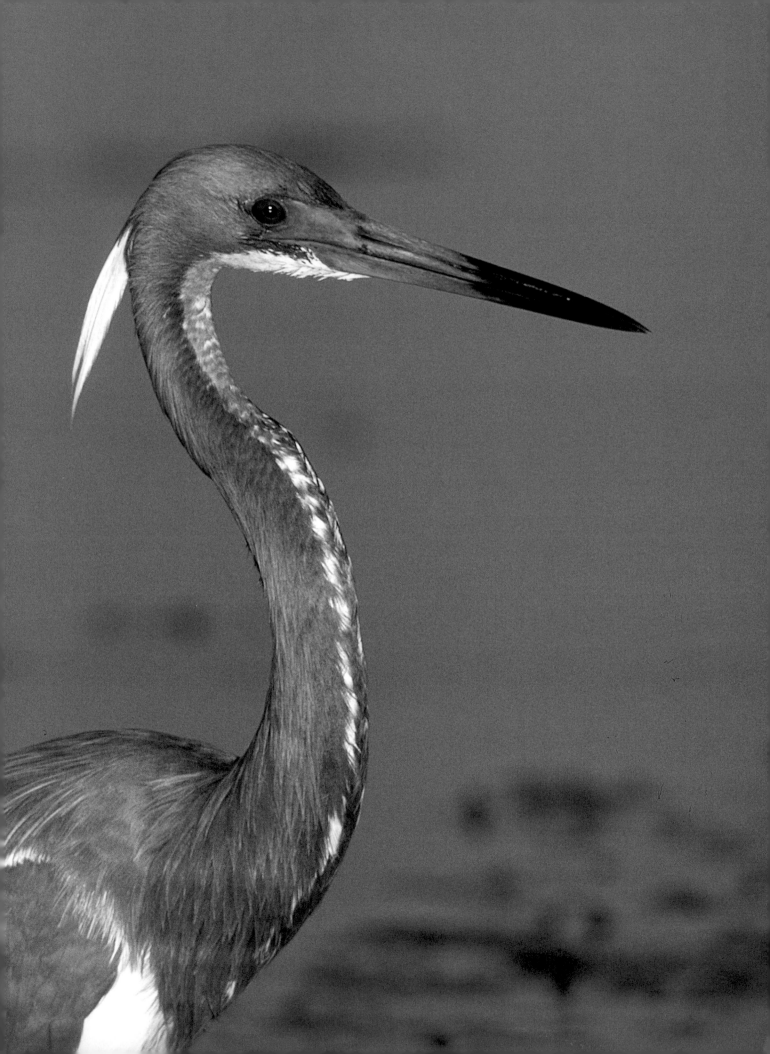

< removed>
Chapter Four

ON MATTERS OF LIGHT

On sunny days, the golden light of early morning and late afternoon, rich with red and yellow components, makes for wonderful bird photography. Colors are enriched and textures enhanced, and contrast is reduced, as well, when your subject is lit by sunlight that strikes it at a low angle. Since the sunlight of early morning and late afternoon is rich in red and yellow hues (colors that bring to mind fire and heat), it is often referred to as *warm* light; the light of midday, on the other hand, features fewer red and yellow tones and more blue ones (hues associated with ice and shadows) and is, therefore, sometimes referred to as *cool* light. It is generally best to avoid direct overhead midday sunlight, especially when photographing white birds; such light is very harsh and creates unpleasant shadows.

To create dramatically lit images of natural history subjects on clear, sunny days, you must be out in the field early in the morning and then again in the late afternoon. Showing up with your long lens at 11:00 A.M. on a bright sunny day just won't cut it. (All rules, however, are made to be broken; I photographed one of my best-selling images—of a singing common yellowthroat—at noon on a bright, sunny day.) With light-overcast or cloudy-bright conditions you can photograph birds all day long; the light is soft and even and contrast is reduced, as well. It is easier to produce images with detail in both the highlight and shadow areas under these lighting conditions than it is on bright sunny, days.

TRICOLORED HERON, South Cape May Meadows, Cape May, New Jersey. Canon FD 800mm F5.6L lens with 50mm extension tube and T-90 body, Fuji Velvia, center-weighted average metering at zero: 1/125 sec. at ƒ/5.6

Late afternoon sunlight enhanced the breeding plumage colors of this remarkably tame bird. Finding beautiful birds in beautiful light makes for remarkable photographic opportunities.

Orienting Yourself to the Light

The *direction* of natural light is at least as important as the qualities it exhibits. My very strong preference is for direct frontlighting, in which the light evenly illuminates the bird and my shadow points directly at it. In the field, I constantly change my position to ensure that my shadow points toward the bird I'm photographing. Ideally, when shooting standard portraits, your subject should be parallel to the film plane, that is, square to the lens axis. The direction that birds face

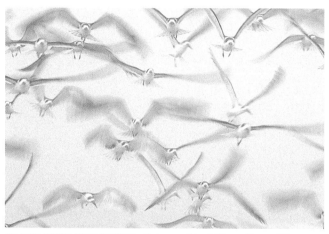

BLACK SKIMMERS IN FOG, Galveston Island, Texas. Canon EF 600mm F4L lens and EOS 1N body, Ektachrome 100SW pushed one stop (rated at ISO 250), evaluative metering +1 stop: 1/500 sec. at *f*/5.6

Photographing birds in fog can lend an ethereal air to your images. With most metering systems, adding one stop to the suggested exposure will give you just what you want—white fog.

is usually determined by the direction of the wind, even if only a slight breeze; birds will almost always face directly into the wind while roosting. If a bird isn't quite square to the lens axis, I'll move several steps to the right or left, as necessary, until it is. In these cases, the lighting will be frontal but not quite direct (my shadow will be pointing as much as 10 or 15 degrees away from the subject).

When shooting like this, with the sun at an angle to the lens axis, take care to shade your viewfinder with your hand or the visor of a hat. If you don't, stray light might enter the viewfinder and cause underexposure if you're working—as I almost always do—in an automatic exposure mode.

On cloudy days, when the light can be a bit cool (with strong blue components), an 81A warming filter will help restore color balance, as will fill flash (see page 75). I keep an 81A filter in my big lens at all times; it has little effect on images made on sunny days and warms things up a bit on cloudy ones. Realize, also, that the light on misty or foggy mornings can produce dramatic, somewhat ethereal results. As a general rule when shooting in fog, open up one stop from the in-camera meter reading.

It is important to remember that birds are ever-alert creatures that are constantly turning their heads from side to side, keeping an eye out for danger. As a bird does this, the effect of the light striking its face changes from moment to moment. You should depress the shutter button only when the feathers of the face are impeccably lit and when

COMMON YELLOWTHROAT SINGING, Brigantine National Wildlife Refuge, New Jersey. Canon FD 400mm F4.5 lens (resting on pillow on lowered car window) with 25mm extension tube and A1 body, Kodachrome 64, center-weighted average metering at zero: 1/500 sec. at *f*/5.6

Don't believe everything that you read about lighting in photography books and magazines. This image, which I made just before the stroke of noon on a bright, sunny day, has appeared on several book covers and in Natural History *magazine.*

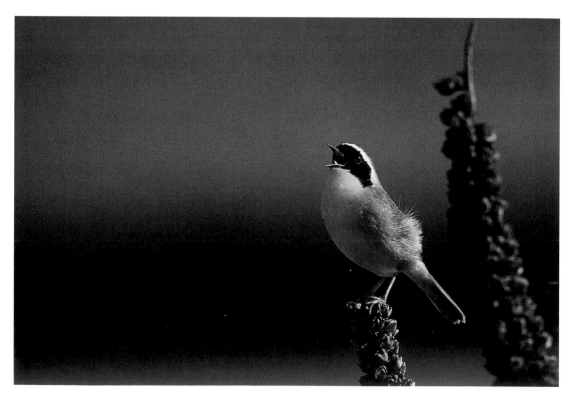

a catch-light (a highlight) appears in the eye. If the bird is looking toward your camera, strive to capture the instant when both of its eyes peer down the barrel of your lens; striking images will result.

As a general rule, I detest sidelighting. It usually works fine with furry mammals, but nearly all the sidelit images of birds that I've seen or taken have resulted in the sunny side of the bird being a bit overexposed and the shadow side necessarily underexposed. Direct backlighting (in non-silhouette situations) isn't my favorite either, but I will attempt to make some images when I encounter strongly backlit birds against dark backgrounds (see photo below). Using either center-weighted average or multi-segmented metering with a bit of underexposure in these situations will generally yield a good exposure with pleasantly accentuated rim lighting around the edge of the bird's form.

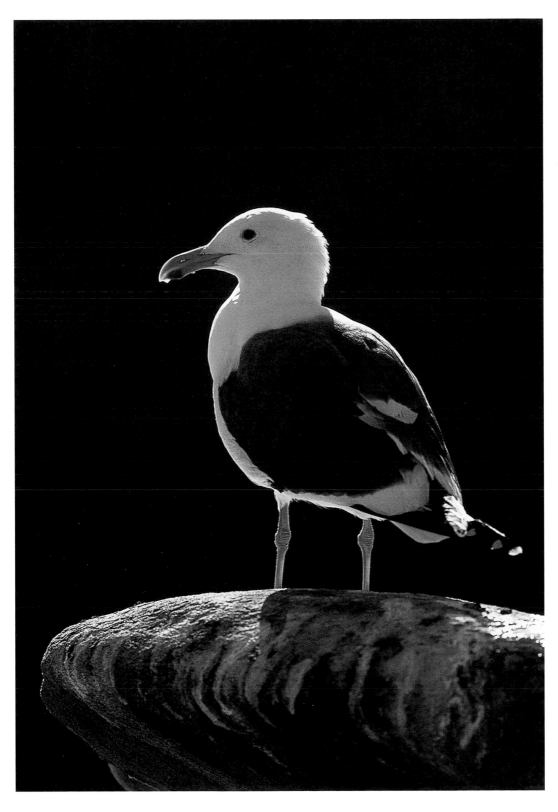

WESTERN GULL, La Jolla, California. Canon FD 800mm F5.6L lens with 25mm extension tube and T-90 body, Fuji Velvia pushed one stop, center-weighted average metering -2/3 stop: 1/125 sec. at ƒ/5.6

Although I prefer direct frontlighting, backlit images of birds can work well when the subject is set against dark backgrounds. The rim light on this gull's head and the tip of its bill caught my eye.

Shooting Silhouettes

More than two centuries ago in France, the controller general of finances cut likenesses of his friends from black paper and distributed them as gifts. His name was Etienne de Silhouette. Today, images of wild creatures photographed in silhouette are often seen gracing the pages of slick magazines, expensive coffee-table books, and prestigious calendars. It is easy to photograph strongly backlit subjects in silhouette. The yellow, orange, red, pink, purple, and violet skies at both sunrise and sunset create dramatic backdrops, as do their watery reflections.

While some successful photographs of silhouetted birds are taken on the spur of the moment, most are the result of careful planning, especially when it comes to site selection. Many waterbirds return to preferred perches day after day, season after season. Photographers must find spots like these, where, additionally, the birds will be positioned in front of the rising or setting sun—you must have strong backlighting in order to produce silhouetted images.

For a variety of reasons, you'll often find suitable silhouette shooting sites near sizeable bodies of water; the terrain surrounding bays, beaches, and even lakes and ponds, is generally more open than anything found in the woods. In addition, water provides a wonderful backdrop since it reflects both the sun's image and that of the brilliantly lit sky, as well. You can count on waterbirds, which are often content to occupy a perch for hours on end, to return to a given spot again and again, unlike landbirds, which are much more active and rarely alight on the same twig twice.

Once you've found a suitable silhouette locale, visit it as often as possible. Each sunrise and sunset is unique. Like

LAUGHING GULL PAIR AT SUNSET, Cape May, New Jersey. Canon EF 400mm F5.6L lens and A2 body, Fuji Velvia pushed one stop, evaluative metering +1/2 stop: 1/500 sec. at *f*/5.6

The 400mm lens provided perfect framing, and the muted sun made getting the right exposure easy. I visualized the shot and waited for the birds to swim into the frame and balance this rather simple composition.

artists selecting oil colors from their palettes, you'll get to choose your background from delicate rosy pinks and light blues, from dramatic golden yellows and royal purples, and from fiery combinations of red and orange. The first three impoundments on the left side of the tour road at Ding Darling National Wildlife Refuge on Sanibel Island, Florida, are traditional evening silhouette spots. The area from the viewing tower to the first left turn is my favorite; I took my very first Audubon calendar image there almost a decade ago.

Telephoto and super telephoto lenses in the 300mm to 800mm range are excellent for silhouette work; they enlarge the image of the bird (and the sun) substantially and, on partly cloudy days, allow you to zero in on small patches of brilliantly colored sky or water against which you can silhouette your subjects. And of course, the longer your

BLACKBIRDS AND GEESE AT SUNSET, Squaw Creek National Wildlife Refuge, Missouri. Canon EF 600mm F4L lens with 1.4X teleconverter and EOS 1N body, Fuji Velvia pushed one stop, evaluative metering +2/3 stop: 1/125 sec. at *f*/5.6

With more than a million blackbirds and geese wintering at Squaw Creek in an average year, there's always something to silhouette when there's some color in the sky.

lens, the greater your working distance; birds that you've scared away cannot be photographed, in silhouette or otherwise. You can also use your 1.4X or 2X teleconverters to effectively increase magnification.

Shorter lenses, however, can be useful when photographing silhouetted flocks that are either roosting or in flight. Consider using autoexposure bracketing (AEB) around +1/2 stop exposure compensation when photographing silhouetted groups of birds with short lenses. Since contrast is low, and the mood of sunset scenics is determined by the exposure, all three AEB images will often be pleasing. The darkest exposure usually looks ominous and foreboding, and the lightest often features pastel colors and an open, airy feeling. This shooting technique works especially well from one to a half hour before sunrise and from a half to one hour after sunset, when colors are often most intense (and when most photographers are either in bed or on the way home).

To produce razor-sharp silhouettes of birds in flight, landing, raising their wings, or taking off, use the fastest shutter speed that the film speed and lighting conditions allow. Since you're always shooting toward the sun to produce silhouettes, you will sometimes encounter relatively fast shutter speeds, even with slow, fine-grained slide film. By shooting wide open at the fastest possible shutter speed when photographing perched birds, you can achieve pleasing, soft, out-of-focus backgrounds.

When the sun is very low in the sky, just above the horizon, you must—because of low light levels—use relatively slow shutter speeds. At Lake Woodruff National Wildlife Refuge in central Florida, I once made over 20 images of a still great blue heron more than an hour after sunset at shutter speeds ranging from 15 to 30 *seconds.* All but three were sharp. When shooting long exposures, the use of mirror lock, a cable release or self-timer, and a sturdy tripod are all mandatory. To produce intentionally blurred photographs of silhouetted birds in flight, choose a shutter speed between 1/8 and 1/60 sec., and bring lots of film; the results when attempting to take intentionally blurred images are hit or miss.

DETERMINING THE BEST EXPOSURE

When silhouetting a bird or flock of birds against a vividly colored section of sky or water *without* including the sun or its brilliant reflection in the frame, take an exposure reading (without the bird or birds in the frame) off the background using center-weighted average metering. Then, add from 1/2 to 1 stop of light, depending on the brightness of the background; the brighter the background, the more light you add. Just before a muted sunset, you may judge the sky or water to be a middle tone. In these cases no compensation is necessary. Either way, set your exposure manually (or use AE lock if available), recompose, and make the photograph. The subject will appear as a jet black silhouette, and the sky will be properly exposed. You'll have overexposed a lighter-than-middle-tone background to keep it lighter than a middle tone. Remember: You add light to keep overall light scenes light.

Photographs that include the image of the sun in the frame can be spectacular, and with big lenses and stacked teleconverters, it is possible to practically fill the frame with the sun's image. It is vitally important that you attempt to make such images only when the sun is very low on the

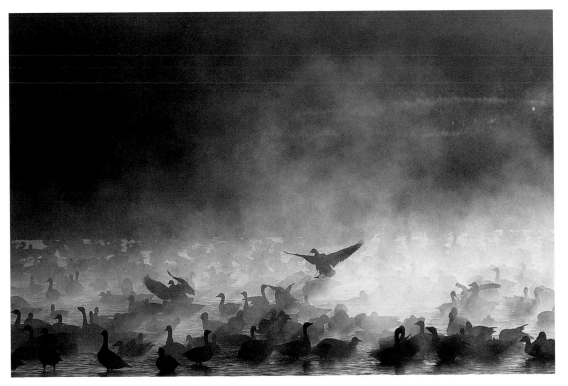

SNOW GEESE IN GROUND FOG, Bosque Del Apache National Wildlife Refuge, New Mexico. Canon EF 600mm F4L lens and EOS 1N body, Fuji Velvia pushed one stop, evaluative metering +2/3 stop: 1/320 sec. at ƒ/5.6

Because of low light levels, I needed to add exposure to keep this overall light image light. Despite having photographed in Bosque at dawn on more than 90 occasions, I've only encountered this situation, with the birds in ground fog and backlit by the rising sun, twice.

horizon, or is muted by haze, fog, or a light layer of clouds, otherwise you risk incurring serious eye damage. This point cannot be overemphasized. If you aim your long lens at the sun and the world looks purple to you when you take your eye from the viewfinder, you may already have sustained eye damage. If in doubt, pass up the opportunity to make this type of photograph.

When the sun's muted image does appear in your composition, determining the correct exposure is a tricky proposition. The brighter the sun's image, the more difficult it is to come up with a satisfactory exposure. So, aside from potential eye damage, this is another good reason to avoid pointing your long lens at a too-bright sun. Even a muted sun is bright enough to cause center-weighted average metering systems to underexpose the image, often by five or six stops. To prevent such underexposures, meter an area of sky adjacent to the sun, without including any part of the sun in the frame. Then, set the suggested exposure manually, recompose, and fire away. If you rate the sky as somewhat lighter than a middle tone, don't be tempted to add light, as you would normally; this will result in the sun's image being well overexposed. For skies that you rate as much lighter than a middle tone, add only 1/2 stop of light before proceeding. In all of the above examples, using your camera's spot meter instead of center-weighted average metering should yield the same—or very close to the same—results.

Another difficult exposure situation arises when you silhouette a bird against strongly backlit water sparkling with ever-changing highlights and reflected points of light. In these cases, use center-weighted average metering to meter the brightly lit water without the bird in the frame, and open up at least 1 or 1 1/2 stops. Then, set

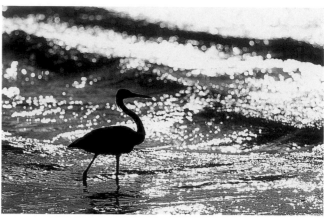

TRICOLORED HERON, Sanibel Island, Florida. Canon EF 400mm F5.6L lens and A2 body (handheld), Fuji Velvia pushed one stop, evaluative metering -1/2 stop: 1/500 sec. at *f*/8

There's just no substitute for knowing your camera's metering system and understanding how it works. Canon's evaluative metering does such a good job of opening up in bright, reflective situations that I actually needed to subtract *light to get the results I wanted. In this highly reflective situation, center-weighted average meters would have severely* underexposed *this image.*

the new exposure manually. Try to time each exposure so that there are no dark shadows directly behind the silhouetted subject. On very rare occasions, when you can silhouette a bird entirely against a bright sun or against its reflection in the water, you can achieve dramatic results by shooting at the exposure suggested by your center-weighted average meter. The sun will stop the lens down and so severely underexpose the image that everything in the frame goes black except for the sun and its reflection; the image of the silhouetted bird becomes "keyholed" (see the photograph opposite).

Using multi-segmented metering patterns for shooting silhouettes can be even trickier than using spot or center-weighted average metering, especially when the sun appears in the frame. Multi-segmented metering patterns vary greatly from manufacturer to manufacturer, so giving general advice is difficult. When shooting silhouettes against backgrounds of bright sky or water, multi-segmented metering patterns will do a fairly good job. When light levels are low, however, it becomes necessary to add 1/2 to 1 stop of light, just as you would when using center-weighted average metering. When the sun appears in the frame, it is important to remember that multi-segmented metering patterns will open up when faced with extremely high light levels (relative to the film's ISO).

Canon's evaluative metering does such a good job of opening up to prevent underexposure when the camera is pointed at the sun, or very bright adjacent sky, that it can at times actually *overexpose* the image by 1/2 stop or more. And, this is in situations in which center-weighted average metering would underexpose the image by five or six or more stops! With multi-segmented metering,

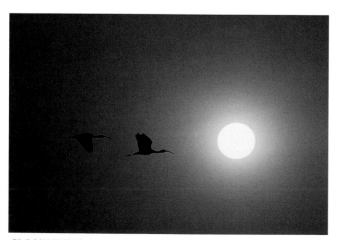

GLOSSY IBISES, Jamaica Bay Wildlife Refuge, Queens, New York. Canon FD 400mm F4.5 lens and A1 body (handheld), Kodachrome 64, center-weighted average metering of sky adjacent to sun: 1/500 sec. at *f*/5.6

I made this image many years ago with a manual focus lens just days after reading an article on how to get the right exposure when the sun is included in the frame. I guess it pays to be a quick study.

therefore, it is sometimes necessary to subtract 1/2 stop or more of light when shooting silhouettes that include the sun in the frame. Becoming familiar with how your camera's multi-segmented metering pattern handles various silhouette exposure situations requires time and experimentation. Once you've learned what your multi-segmented metering pattern will do, however, it may be the best metering pattern to use when photographing birds in silhouette.

These guidelines should yield satisfactory exposures, but you should understand that there is no single "correct" exposure for each individual silhouetted image. (Of course, if the silhouetted bird is lost in a sky that's too dark, your exposure is, indeed, incorrect.) Images that are somewhat lighter or darker than the ones obtained by following the techniques described above may also be equally pleasing and may evoke a completely different moods, as well.

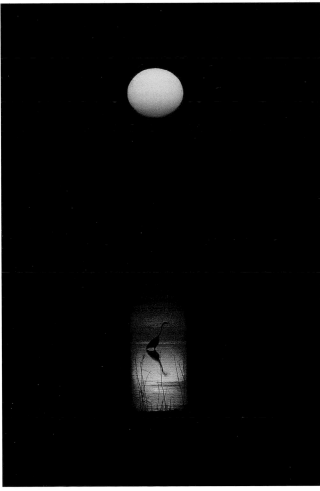

GREAT BLUE HERON AT DAWN, Brigantine National Wildlife Refuge, New Jersey. Canon FD 800mm F5.6L lens and T-90 body, Kodachrome 64, center-weighted average metering at zero: 1/2000 sec. at ƒ/5.6

Sometimes it pays to experiment. After making a series of images at the "correct" exposure (by metering the sky adjacent to the sun), I made a single image at the metered exposure with the sun in the frame and discovered the "keyhole" technique!

COMPOSING SILHOUETTED IMAGES

The size of the bird in the frame and the shape of both the bird and its perch will help determine your choice of either a horizontal or vertical format. A cormorant, or any tall bird on a piling or cactus, will fit naturally in a vertical composition, while a gull sitting on the edge of a dock will almost always look best when photographed in horizontal format.

When silhouetting a bird against the sun, or when including the sun in the frame as one of the compositional elements of your photograph, precise positioning of your tripod is an absolute necessity. Position the sun in relation to the bird's silhouetted image by carefully moving your tripod either sideways (by lifting it up and setting it down) or up and down (by adjusting the legs or center post elevator). Because the sun is 93,000,000 miles away and your subject is just 10 or 20 yards away, such adjustments are often matters of only a fraction of an inch. You may wish to position the sun behind the bird, or to balance the composition by placing the sun elsewhere in the frame. Be careful to avoid placing the subject against any dark or shadowed areas; the resulting "merges" will be horribly distracting. You can often eliminate them by moving left or right, or up or down.

The most dramatic lighting conditions are usually those encountered in the field at sunrise and sunset. As it is impossible to tell whether a photograph was taken at sunrise or sunset, there is no best time to shoot silhouettes of birds. Photographers who shoot only sunsets get to sleep late, but they always miss at least half of the opportunities. In the morning, it is best to be in position at least an hour before sunrise, because the deepest colors often occur 45 minutes to an hour before the sun touches the horizon, and even earlier on some days.

In addition, many birds are ridiculously tame before sunrise and remarkably skittish thereafter. As long as you're working on a heavy-duty tripod, you may be able to get some spectacular images well before the sun comes up. Once the sun peeks above the horizon, be prepared to work quickly; lighting conditions often change dramatically from moment to moment, and the whole show usually lasts less than 10 minutes—and often well less than that.

When hoping to shoot silhouettes late in the day, be out an hour before sundown; low clouds on the horizon often create favorable conditions well before the sun sets. And don't be too quick to head home on cloudy afternoons; when there's a window of clearing just beneath the lowest layer of clouds, the sun often bursts through with a vengeance, creating intense colors and breathtaking sunsets. So, since nature offers bird photographers these spectacular silhouetting conditions twice each day (weather permitting), carry a long lens, plan on breakfast at five and supper at nine, and enjoy the gift of light.

Electronic Flash

In nature photography, electronic flash has two basic uses: as main light and as fill. In bird photography, a flash is used as the main light source most often in dark situations. In these cases, it is the flash entirely that illuminates the subject. Because the light from the flash falls off so rapidly, using flash as main light frequently results in black backgrounds that most photographers find objectionable. In addition, since the flash eliminates contour shadows on a subject, birds photographed with flash as the main light often appear flat and one dimensional. And, there are often hard, black, shadows along the edge of the bird's belly, as well.

When flash is used properly as fill, the results are far more pleasing. In these situations, it is the ambient light (the available natural light) that primarily illuminates the subject, with just a splash of flash added for effect. As a result, the background—lit by the ambient light—appears natural. When using fill flash, your best images will look as if you haven't used a flash at all.

In either case, using electronic flash for bird photography is a pain in the neck, and for many years, I resisted using it. A decade ago, using flash correctly required a knowledge of complex formulas. In addition, using flash, even today, means that you have to carry around more equipment, thereby adding weight to already heavy outfits and making them more awkward to carry. The flashes themselves are fragile and can be easily snapped off at the hot shoe (the mount) by innocent tree branches or ravaged by moisture on drizzly days. In spite of the fact that they devour batteries, flashes take much too long to recycle (to get ready to make the next flash). In low light, when mounted directly on-camera, flash causes red-eye in owls, steel-eye (an objectionable silver crescent in the eye) in small landbirds, and green-eye in some mammals; after passing through wide open irises, the light from the flash reflects off the animals' retinas.

Today's flashes, when used with high-tech SLR cameras, are much simpler to use than the flashes of a decade ago. Flash exposure is read automatically off the film plane by "smart" flashes and is easily controlled with the push of a button or two. Rechargeable battery packs decrease recycling time, often to less than a second. And, you can use flash brackets and remote cords to eliminate steel-eye and red-eye. However, today's flashes still make your equipment more difficult to carry and are still very delicate. In addition, when shooting sequences, the first frame may be perfect, but those that follow may be too dark, because the flash did not have time to recharge completely.

Despite the drawbacks, I use flash now more than ever. Color slide film is balanced for sunny daylight (roughly

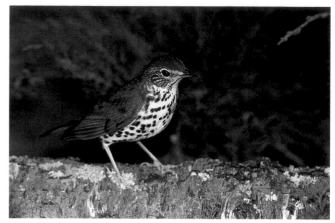

WOOD THRUSH, Rio Grande, New Jersey. Canon EF 600mm F4L lens with 1.4X teleconverter plus 25mm extension tube and EOS 1N body, Fuji Velvia pushed one stop, ambient exposure set manually at a level of 2 stops of underexposure: 1/60 sec. at ƒ/5.6, Better Beamer flash extender, flash as main light at -1/3 stop

I photographed this bird from a friend's bathroom window in extremely low light. Unfortunately, the image displays many of the characteristics of a photograph made using flash as main light. Most objectionable to me is the dark background. However, despite the "flashed" look, I've been able to sell this image several times; wood thrushes are difficult birds to photograph.

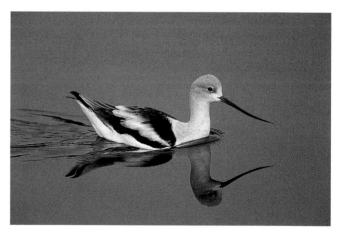

AMERICAN AVOCET, Newport Back Bay, California. Canon EF 600mm F4L lens with 1.4X teleconverter and EOS 1N body, Fuji Velvia pushed one stop, evaluative metering +2/3 stop: 1/250 sec. at ƒ/5.6, Better Beamer flash extender, fill flash at -1 1/3 stops

Adding 2/3 stop of light to the ambient exposure kept this overall light image light; fill flash brightened the whites and brought the image to life.

two hours after sunrise and two hours before sunset); the color temperature in such conditions is roughly 5500 degrees Kelvin. When photographing birds in the shade or on cloudy days, the light is cooler (with more blue and less red and yellow components) and the color temperature ranges between 8000 and 12000 degrees Kelvin. (At sunrise and sunset, the light is warmer—richer in reds and yellows—

and the color temperature is between 3000 and 4000 degrees Kelvin.) Birds photographed in light with strong blue components often appear dull and lifeless, their colors displaying an unnatural bluish cast. Using just a splash of flash restores the color balance, and the resulting images are far more pleasing. Note, also, that flash never scares birds away from an area, so you can use it without fear of traumatizing your subjects.

USING FLASH AS FILL

When working in the shade and on cloudy days, using fill flash is practically a must if you want to avoid producing dreary images. To use fill flash, first set the correct exposure for the ambient light *as if you weren't using flash at all.* Then, set your flash compensation at -1 1/3 or -1 2/3 stops for middle-tone subjects, -2 or -2 1/3 stops for white or bright yellow birds, or -2/3 or -1/3 stop for black birds (which absorb a great deal of light from the flash). Note that only very few cameras or flash units have dial-in exposure compensation capabilities; among them are the Canon 430 and 540 EZ Speedlites and the Nikon SB 24, SB 25, and SB 26 Speedlights.

If you study the technical captions for the fill flash images in this book, you'll note that the compensation settings are different from the ones I've recommended above. This is because Canon's EOS bodies are programmed for fill flash in all modes, even manual mode. With programmed fill flash, the camera automatically reduces the flash output to some degree, depending on the light level. With the EOS 1N, you can set a custom function to cancel flash reduction, but for simplicity's sake, I choose not to do so. Therefore, the minus factor that I enter on the 540EZ Speedlite is *in addition to* the flash reduction programmed by the camera body. When I fill at -1 on the flash, I'm actually filling at

somewhere around -1 2/3 or -2. With my Canon EOS 1N, I use dial-in flash exposure compensation as follows: -1 for middle-tone subjects, -2 for white or bright yellow subjects, and zero for dark or black subjects.

Some modern cameras offer programmed fill flash only in a single mode (usually program mode); when this is the case, choose that mode and, if possible, set your ambient exposure as you would normally. The flash output will be automatically reduced (depending on the light level). Canon EOS cameras, as mentioned above, have programmed fill flash in all modes. With these bodies you may want to cancel the automatic flash reduction so that you have complete control over the level of flash reduction when using flash as fill. In either case, you must study both the camera body and the flash instruction manuals carefully so that you have a full understanding of how your flash works.

Using fill flash properly on dark, cloudy days will add a highlight to a bird's eye, restore color balance, and bring "dead" images to life. In bright sunlight at midday, using fill flash at -1 2/3 stops will fill in the shadows and warm up the scene a bit. The light supplied by most flashes has more blue in it, and less red and yellow, than sunny daylight and, therefore, is a bit cooler than sunny daylight, so some photographers tape a rectangular, cut-to-size section of a polyester warming filter (Rosco Cinegel 1/8 CTO) on the front of the flash-head to warm the light from the flash.

Ideally, the use of fill flash won't be obvious in the resulting photograph. It is important to realize that if you're using fill flash properly, and for some reason the flash doesn't fire, the exposure will be correct. This is because you've set the correct exposure for the ambient light and are adding just a splash of flash to brighten the image. Therefore, if the flash fails to fire, the exposure should be correct anyway.

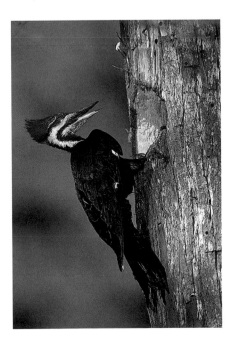 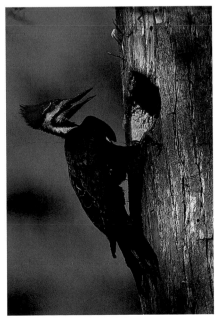

PILEATED WOODPECKER, Loxahatchee National Wildlife Refuge, Florida. Canon EF 600mm F4L lens with 1.4X teleconverter and EOS 1N body, Fuji Velvia pushed one stop, evaluative metering +1/3 stop: 1/180 sec. at *f*/5.6. Left image: Better Beamer flash extender, fill flash at zero; right image: no flash.

Comparing these two images shows how fill flash can bring up detail in the feathers of black birds. In these examples, I used fill flash in the left image and no flash in the right image. When photographing black birds, it is best to use a very high fill flash ratio, especially with Fuji Velvia, a high contrast film on which the blacks tend to block up, that is, be rendered without detail.

USING FLASH AS MAIN LIGHT

If you're in a situation in which the ambient light forces you to use a shutter speed in the range of 1/45 to 1/8 sec. or slower (at the wide open aperture), you'll need to use flash as main light. Photographing birds at such slow shutter speeds will almost always result in blurred images due to subject movement, equipment shake, or both.

The simplest way to use today's high-tech flashes as main light in extremely low-light situations is to use your camera in program mode. Just point and shoot. The shutter speed won't drop below 1/60 sec, and the flash will light the subject and be turned off automatically when the exposure, as measured off the film plane, is correct. Some flashes have a confirmation light that comes on if the flash was powerful enough to properly expose the subject; others have a warning light that comes on if the flash illumination was insufficient. However with others, you're left in the dark, so to speak.

When using flash as main light, most photographers opt to have more control over both shutter speed and aperture by working in manual mode. In very low light, there's a glitch in the Canon EOS 1N's program mode when shooting flash as main light with long telephotos; the camera will suggest an exposure of $f/45$ at 1/60 sec. The resulting photographs, of course, would be black, so I shoot in manual mode to avoid this.

When using flash as main light, it is generally best to select a shutter speed at least as fast as 1/90 sec.; you cannot, however, choose a shutter speed that's faster than the camera's *synch speed* (the fastest shutter speed that can be used with flash). When using a shutter speed faster than the synch

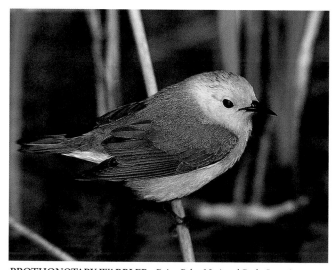

PROTHONOTARY WARBLER, Point Pelee National Park, Leamington, Ontario. Canon EF 600mm F4L lens with 1.4X teleconverter plus 37mm of extension and EOS 1N body, Fuji Velvia pushed one stop, ambient exposure set manually at a level of one stop of underexposure: 1/90 sec. at $f/5.6$, Better Beamer flash extender, flash as main light at -2/3 stop

The bird was large enough in the frame so that the flash turned itself off when a correct exposure was read off the film plane. I killed the flash 1/3 stop because of the dark background and an additional 1/3 stop because of the bird's bright orange-yellow feathering. This prevented overexposure.

speed, the rear shutter curtain begins to shut before the front curtain has opened fully. As a result, the flash (which is of extremely short duration—measured in microseconds) will be unable to light the entire image when it fires. The latest high-tech cameras have synch speeds of 1/200 or 1/250 sec. Unfortunately, some older models have synch speeds as slow as 1/60 sec.; in these instances, you're always forced to use the slow synch speed.

Generally, when using flash as main light, you'll be working at the largest available aperture, but when photographing birds at point-blank range, you may be able to stop down to $f/8$ or even $f/11$. Be sure to check and see if your flash output was sufficient after making the first image by checking either the confirmation or warning light (if your flash has either of these features). Again, the flash will light the subject and, theoretically, be turned off automatically when the exposure as measured off the film plane is correct. However, birds are often small in the frame, and therefore, the flash may try to light the background. When shooting small birds at close range with flash as main light, I generally get best results by dialing in -1/3 stop flash exposure compensation.

While the chosen shutter speed and aperture don't affect the exposure of the *subject* with TTL flash, they do affect the exposure of the *background;* the faster the shutter speed and smaller the aperture, the darker the background. Another factor that influences the exposure of the background is the proximity of the background to the subject. When photographing a bird on a perch at close range, with the background vegetation well beyond the subject, the background will be rendered black due to flash fall-off, unless your chosen exposure is only a stop or so darker than the correct ambient exposure. If your chosen exposure is three or more stops darker than the correct ambient exposure, as is often the case, the background will be black. If, however, you're photographing a bird on the ground, or against a background of foliage that's only a few inches behind the subject, the flash will light both the subject and, to varying degrees, the background.

In cases in which the background will be lit by the flash, the settings you choose will have little or no effect on the exposure of the background. However, when photographing birds with flash as main light against distant backgrounds, you can, at times, get some additional light on the background by working wide open and choosing as slow a shutter speed as you dare, but almost never slower than 1/60 sec.

For photographing birds in flight in low light by using flash as the main light source, try the following. (Intermediate autofocus telephoto lenses are ideal for this application, when birds are flying by at fairly close range.) With your most powerful flash and a flash extender in place, set your exposure manually two to three stops darker than indicated by your in-camera light meter; you'll generally be working with an aperture between $f/8$ and $f/11$. Fire the shutter

when a sharp, pleasing image appears in the viewfinder; the flash will illuminate the subject and turn itself off when the exposure is correct. If your flash has a confirmation or warning light, check if you had sufficient flash power. If not, choose a larger aperture (or try to reduce the subject-to-camera distance).

Photographs made using this technique will be extremely sharp, because they're made at stopped-down apertures and because the short flash duration will freeze the action. The bird's underwing surfaces will be dramatically lit, providing detail that simply cannot be revealed when using only natural light. The backgrounds will be somewhat (to considerably) underexposed, but in many cases, this adds even more drama to the images.

ELECTRONIC FLASHES AND ACCESSORIES

Throughout the nineties, Nikon flashes were (please excuse the pun) light-years ahead of their Canon counterparts. The SB24, with automatic daylight-balanced fill flash and TTL flash metering, set the standard for modern, easy-to-use, smart flashes. Canon has, to some degree, caught up in recent years, first with the 430EZ Speedlite and then with the 540EZ, the flash I currently use. Both of these, when used with Canon EOS bodies, offer programmed fill flash in all modes and allow the photographer complete and independent control over both the ambient light and flash exposures.

Really Right Stuff's B91 flash arm, a sturdy flash bracket for large telephoto lenses with rotating tripod collars, is an integral part of my flash system. Although it raises the flash only a few additional inches above the lens axis, it virtually eliminates steel-eye in small landbirds. And, the flash arm allows you to shoot vertical compositions without having to turn the flash on its side, a problematic procedure at best. By means of two steel bolts, the B91 mates to the lens-specific, superbly machined Arca Swiss-type lens plates produced by Really Right Stuff.

Canon's Off-Camera Shoe Cord 2 (or your system's TTL extension cord) is used to connect the flash, which is mounted atop the flash arm, to the camera's hot shoe. The hot shoe at the distal end of Canon's remote cord is so poorly designed that the flash begins to wobble around just moments after it is mounted. To combat this, I jury-rig the connection between the flash and the faulty hot shoe with an inch-long piece of broken tree branch and some gaffer's (or duct) tape. I use the rechargeable Quantum Turbo Battery to augment flash power and to provide extremely short recycling times. Whichever rechargeable battery you choose, make sure to get the matching connecting cord for your system.

Whether using flash as main light or as fill with lenses of 300mm or longer, I use a fresnel flash multiplier called the Better Beamer/Walt Anderson Flash Extender. A flash extender concentrates the light from a flash. The Better Beamer folds flat for storage, is sturdy yet extremely lightweight, easily assembled, and very effective: it increases

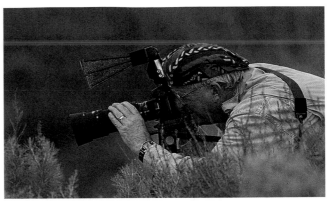

Photographers around the world are now using the Better Beamer/Walt Anderson fresnel flash extender (seen here attached to the flash head) with lenses of 300mm or longer. It substantially increases flash output.

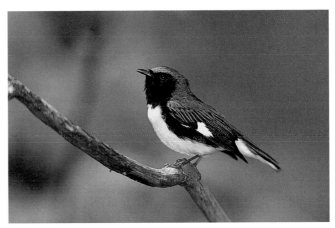

BLACK-THROATED BLUE WARBLER, Point Pelee National Park, Ontario. Canon EF 600mm F4L lens with 1.4X teleconverter plus 37mm of extension and EOS 1N body, Fuji Velvia pushed one stop, evaluative metering +1/3 stop: 1/250 sec. at *f*/5.6, Better Beamer flash extender, fill flash at - 1/3 stop

Using a higher than normal fill flash ratio to light this bird's black face mask and neck required lots of battery power. The Better Beamer flash extender enabled me to rip off two images of this singing warbler with just about zero recycling time, but on the third frame, the flash did not have time to recharge fully and that image was underexposed.

flash output by about two stops (three stops from a flash's 50mm setting). This saves battery power, allows for the use of a smaller aperture, or enables you to use flash as main light or as fill at greater distances.

When I visit Point Pelee each spring for two weeks to photograph migrant songbirds, I use flash most of the time; 80 percent of my slides go directly into the trash. I lose many images due to subject movement and cluttered backgrounds, and I discard many taken in low light because of incorrect flash exposures. By continuing to use my flash in low-light situations, I hope to better understand my flash system and come up with acceptable exposures on a more consistent basis. Even though today's smart flashes are far easier to use than their predecessors, utilizing electronic flash to photograph birds is still a big-time hassle. But, despite the problems and frustrations, I find myself relying on flash more and more each season. It enables me to bring my images to life on dark, dreary days.

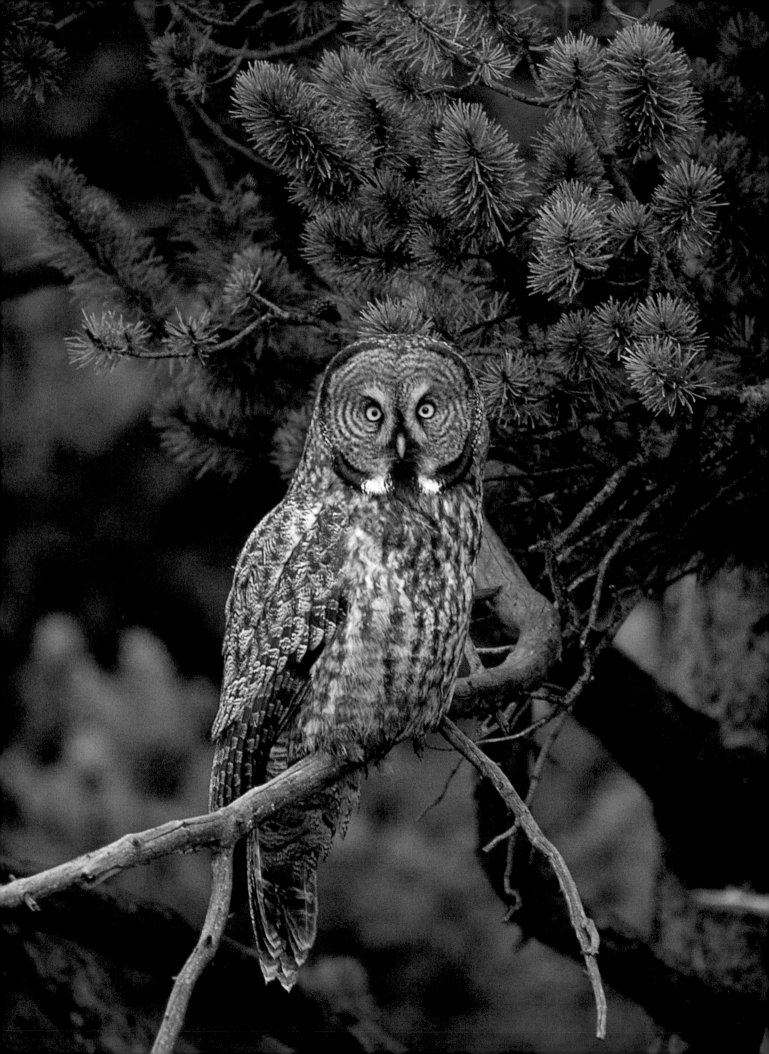

Chapter Five FILM CHOICE

Choosing a film is a personal decision, and there are lots of good films available today, so the choice is a difficult one. If you're just starting out, you need to learn the basics and then do some homework. Among the color slide films that are used regularly by professional and serious amateur photographers today are the Fujichromes—Velvia, Provia, and Sensia (the less expensive, amateur version of Provia); the Kodak films—Kodachrome 64 and Ektachrome 100S (saturated), 100SW (saturated/warm), and Elite II (a less expensive Ektachrome 100 film with a color balance between that of 100S and 100SW); and Agfachrome RSX.

I make a living shooting Fujichrome Velvia (an ISO 50 film), almost always pushing it one stop to exposure index (EI) 100. The term *pushed* refers to the practice of intentionally underexposing film to allow for the use of faster shutter speeds; the photo lab or developer must compensate for this underexposure by extending the processing time. Since film's actual ISO is an international standard that can never be changed, the term exposure index is used to indicate the *effective* ISO number when film is pushed. My 200 speed film is Kodak's Ektachrome 100SW pushed one stop.

If you're a nature photographer in search of an everyday film, my advice is to take a careful look at the various color slide films available today. Since magazine reproductions don't accurately depict a film's qualities, examine original slides if at all possible. An even better approach would be to shoot a few test rolls of the films you're considering, being sure to bracket and take accurate notes, and compare the results. Then, pick the film with the qualities you like and stick with it exclusively for at least one year. By doing so, you'll learn that film's characteristics and idiosyncracies. Knowing and understanding your film will better enable you to express your individual photographic style and vision.

GREAT GRAY OWL, Yellowstone National Park, Montana. Canon FD 800mm F5.6L lens and T-90 body, Fuji Velvia pushed one stop, center-weighted average metering -1/3 stop: 1/45 sec. at *f*/5.6

Fuji Velvia, almost always pushed one stop, has been my everyday film for the past seven years. Its vivid colors, its performance in low light, and its exceptional sharpness are unequaled.

Basic Facts about Film

A film's speed, which indicates its sensitivity to light, is, like aperture and shutter speed, measured in stops. This speed, or sensitivity to light, is indicated by an ISO (International Standards Organization) rating. For example, ISO 100 film is twice as sensitive to light as ISO 50 film, and half as sensitive as ISO 200 film. Readily available films whose ISO numbers fall on full stops include ISO 25, 50, 100, 200, and 400. The lower the ISO number, the slower the film and the more light necessary to properly expose an image (at a given aperture). The slowest films, ISO 25, 50, and 64 (ISO 64 film is 1/3 stop faster than ISO 50 film), offer extremely fine grain. The faster films, ISO 200 and 400, allow the use of relatively fast shutter speeds, even in low light, but show considerably more grain. ISO 100 films offer a fine middle ground and are the choice of many nature photographers today.

At a given aperture, an image that is properly exposed at 1/500 sec. on ISO 100 film would be properly exposed at 1/250 sec. on ISO 50 film, which is one stop slower than ISO 100 film. An image made at 1/30 sec. on ISO 50 film should be exposed at 1/125 sec. when using 200 speed film, which is two stops faster than ISO 50 film. The images on the ISO 200 film would, however, be grainier than those on the slower, fine-grained film.

WHAT FILM SPEED SHOULD YOU USE?

Do you want action-stopping shutter speed? Then, choose a fast film, such as ISO 200 or 400. Do you want fine grain? Choose a slow film, such as ISO 50 or 64. Want both? Sorry. However, ISO 100 film does offer a fine compromise. For bird photography, I find that ISO 100 film (in my case, Fuji Velvia pushed one stop) is fast enough in all but extremely low-light situations. The sunny $f/16$ exposure for pushed Velvia is 1/90 sec. at $f/16$; the equivalent, 1/750 sec. at $f/5.6$, is fast enough to freeze most action.

In all but very low light situations, pushed Velvia is fast enough to combat the light lost due to the use of teleconverters and extension tubes. However, in late 1997, I had a chance to test a new Kodak film, E-200, and of course, I pushed it one stop to EI 400. I was amazed by the results; the color was very good and the grain was barely evident.

COLOR SLIDE FILM VS. COLOR PRINT FILM

Most, but not all, nature photographers choose a relatively slow color slide film as their workhorse film for a variety of reasons. To start, films in the ISO 50 to 100 range have an ultra-fine grain that allows for successful enlargement (without exhibiting objectionable graininess), and offer enough speed to shoot on sunny and cloudy-bright days. Also, since birds are colorful creatures, most photographers choose color film over black-and-white film, although the results with the latter can be quite artistic. In addition, the cost of color *slide* film and processing is less than that of color *negative* (or print) film processing and printing, and most bird photographers—professionals included—throw away at least 1/3 to 1/2 of everything they shoot. Prints (and color separations for publication) can easily be made from color slides or transparencies.

Though more expensive, color print film does offer far more exposure latitude than color slide film, and is better able to handle contrast. High speed color print films are also less grainy than their slide film counterparts. Some nature photographers prefer color print film. When I encounter them on my tours and ask why, I almost always get one of two answers: Either, "I don't sell my work, and my goal is to make large quality prints, so why should I shoot slide film?" Or, "I like to have something to show my friends; small prints give me pleasure from my photography." Often, even after I've explained the many benefits of using slide film, they'll still stick with print film.

Color slide film can tolerate a bit of underexposure, but a bit of overexposure can be fatal, because details in the highlights will be lost. Images that are slightly underexposed can be duplicated by custom labs with the exposure adjusted to your specifications. When working with color print film, however, the opposite is true. To produce perfect negatives, you must guard against underexposure or the detail in the dark areas will be lost. If in doubt when working with color print film, lean toward overexposure.

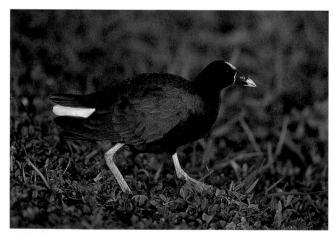

PURPLE GALLINULE, Anhinga Trail, Everglades National Park, Florida. Canon EF 600mm F4L lens and EOS 1N body, Fuji Velvia pushed one stop, evaluative metering at zero: 1/320 at $f/5.6$
Fuji Velvia's ability to reproduce brilliant colors in low light is unsurpassed by any other slide film. And, no 100 speed slide film is anywhere near as sharp as Velvia (ISO 50) pushed one stop.

My Film Preferences

For more than eight years I used Kodachrome 64, long the standard color slide film for nature photography. Kodachrome 64 is a relatively slow film that offers subtle, fairly accurate colors, fine grain, and remarkable archival storage properties (when stored properly). In the summer of 1991, I tried several rolls of Fujichrome 50 and Fujichrome 100 (for a bit more speed) but wasn't thrilled with the results. (Though used successfully by many top nature professionals, neither of these films is in production today.) In September of 1991, I shot a few rolls of Fujichrome Velvia (ISO 50) and was amazed by its incredibly rich and vivid colors, its ability to capture countless shades of green and brown, its sharpness (which rivals or exceeds that of Kodachrome 64), and its incredible performance in low light.

By this time, many professionals had already jumped on the Fuji Velvia bandwagon, in spite of its slow speed (and possibly poorer archival storage properties). Many were thrilled that E-6 film processing, usually on a same- or next-day basis, was available in most cities. Kodachrome 64 requires the more complex and environmentally unfriendly K-14 processing that is currently offered by only a relatively few labs. (Note that Kodak now has a KR mini lab with less problematic chemicals; K-14 processing may become more available in coming years.)

PUSHING FILM

Fuji Velvia quickly became my everyday film and remains so to this day. I push almost every roll of Velvia that I

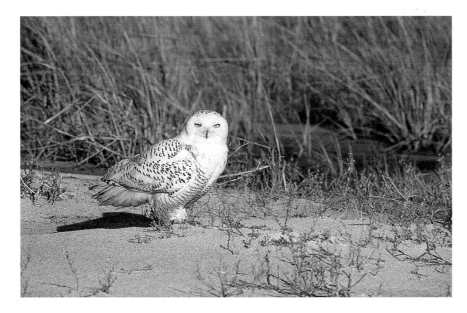

SNOWY OWL, Jones Beach State Park, Long Island, New York. Canon FD 400mm F4.5 lens and AE1 body (on shoulder stock), Kodachrome 64, base exposure -1/2 stop: 1/125 sec. at f/11

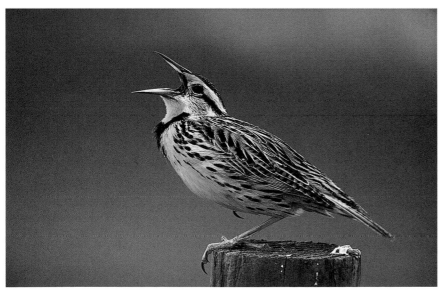

EASTERN MEADOWLARK, Old Venus, Florida. Canon FD 800mm F5.6L lens with 50mm extension tube and T- 90 body, Kodakchrome 64, center-weighted average metering at zero: 1/60 sec. at f/5.6

I made both the snowy owl image above and the eastern meadowlark image below on Kodachrome 64, which, for several decades, was just about the only film used by serious nature photographers. With their more saturated colors, the early Fujichrome films took a chunk out of Kodak's ISO 64 market. And though a handful of loyalists still use Kodachrome 64 today, the introduction of Fuji Velvia pretty much put the last nail in the coffin.

shoot one stop to exposure index (EI) 100 to gain one full stop of shutter speed. The only time I shoot Velvia at its normal, rated ISO (50) is when I'm shooting in bright, sunny conditions during midday hours with fast lenses. At all other times, I push it one stop to EI 100. To push film one stop, you lie to the camera by doubling the ISO, then tell the truth to the lab. Be sure to mark each pushed roll "Push +1" with a felt-tipped marker the instant that you unload it. Film shot at its rated ISO should be labeled "normal".

I cancel the automatic film speed setting feature, which works with DX-coded film, on all my camera bodies. If you ever push film and your camera offers this feature, you should do the same so that you get in the habit of setting and checking the film speed after unloading each exposed roll and again after loading each fresh roll. By canceling the automatic film speed setting feature, you'll be less likely to mark a roll of pushed or normal film incorrectly. If you do inadvertently mismark a roll, you'll be most unhappy with the results; as mentioned previously, color slide films are intolerant of one-stop exposure errors.

CHANGING FILM MID-ROLL

At times, it may be necessary to change film in the middle of a roll, usually because the ISO (or EI) of the film in the camera is not suitable for the current lighting conditions. To do this, first make note of the speed of the film in the camera and the frame counter number. (It's best to jot it down somewhere.) Let's say that you have ISO 50 film in the camera and the frame counter shows 14 (you've already taken 13 images). If possible, set your camera to leave the leader out after rewinding, then push the rewind button. If you can't set the camera to do this automatically, rewind manually and leave the leader out. If the leader ends up inside the canister, you'll need to extract it or have your camera store do this.

(Note that a 4 × 5/8-inch strip of sheet film with an inch of double-sided tape affixed to one end works well for extracting leaders and costs about two cents—far less than the film leader-retrievers that are sold in camera stores. And, the homemade leader retriever works about a thousand times better.)

After rewinding the film, write "ISO 50/adv. > 14" on the film cassette with a black felt-tipped marker. Place the roll back in a canister with a small slip of paper marked "ISO 50/advance to 14." (If you've set your camera to leave the leader out, don't forget to reset the camera so that it winds the leader in on other rolls, otherwise, you might confuse exposed, partially exposed, and unexposed rolls.) Then, when you want to reload the partially exposed roll that you removed, follow these steps:

1. In manual mode, set the fastest possible shutter speed, for example, 1/8000 sec.

2. Put a body cap on your camera and close the viewfinder shutter (or cover the viewfinder with your hand before advancing the film). These two steps ensure that no stray light strikes the film.
3. Note the ISO and the frame to which the roll should be advanced.
4. Load the roll and advance the film to the correct frame number.
5. Set the correct ISO (or EI) and you'll be ready to shoot.

RATING FILMS DIFFERENTLY

Some films perform best at their nominal ISO, that is, at the manufacturer's suggested ISO rating. However, because exposure control is so vitally important with color slide film, some photographers choose to rate some films at different EI values than those suggested by the manufacturer. They base these adjusted EIs on their personal taste, on the manner in which they determine their exposures and exposure compensations, and even on the idiosyncrasies of their individual camera's metering system.

People often ask me, for example, whether I rate Fuji Velvia at 50 or 40. I rate it at 50, the nominal ISO, and push it at EI 100. When I do this, I'm satisfied with my middle tones when the sun is shining (though if time permits, I'll usually make a few images at +1/3 stop). Plus, I'm satisfied with the way the film handles subjects of various tonalities, because my system of exposure compensation is based on my extensive experience with Fuji Velvia (and, thus, is slightly biased toward overexposure). When I first used Ektachrome 100SW, I shot it at its nominal ISO and found that my images were about 1/3 stop overexposed. Rather than revamp my entire system of exposure compensation, I now simply rate 100SW at 125 for normal shooting, and at EI 250 when pushing it one stop.

For years, I was puzzled by the fact that when I made images at a given exposure compensation with Fuji Velvia, I'd get a properly exposed image when the sun was shining but an underexposed one when a cloud covered the sun. Surprisingly, it took me several years to realize this and begin adding 1/3 to 1/2 stop of light across the board when photographing in low light. When I shoot with Velvia in low light, I prefer to add the extra light by using my exposure compensation dial rather than by changing the ISO setting.

Another film-related question that I'm asked frequently is, "Why do you prefer pushed Fuji Velvia to one of the 100 speed films?" The answer is that I like everything

ROSEATE SPOONBILL, Ding Darling National Wildlife Refuge, Sanibel Island, Florida. Canon FD 800mm F5.6L lens and T-90 body, Fuji Velvia pushed one stop, center-weighted average metering +1/3 stop: 1/180 sec. at f/5.6

Many photographers rate Fuji Velvia 1/3 stop lighter than the manufacturer's suggested ISO. I do not, opting instead to add light to my exposures when photographing in low light.

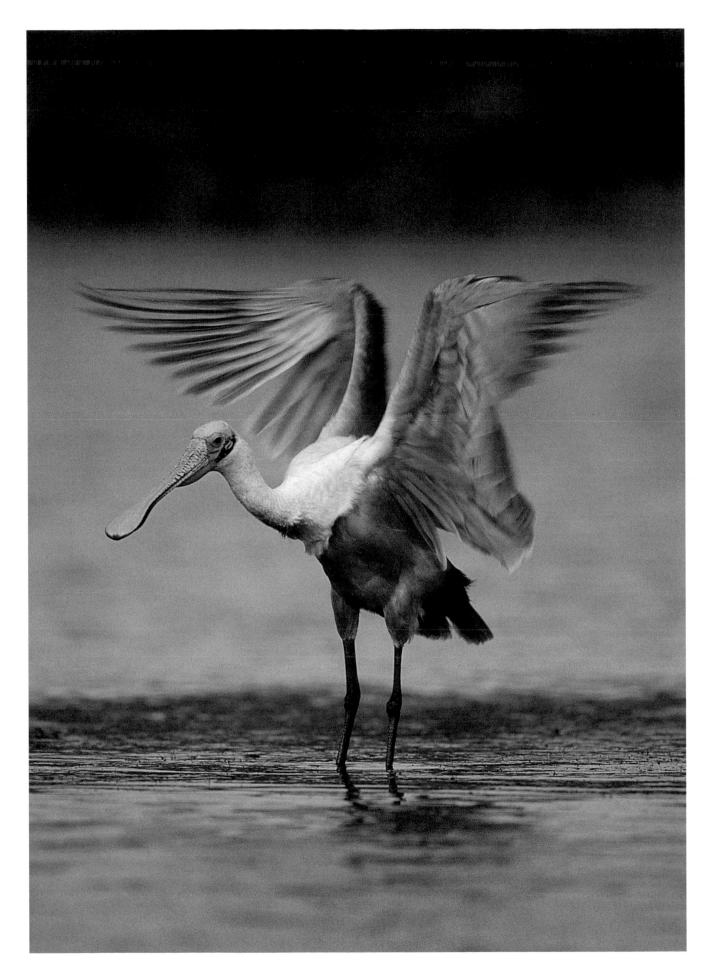

about Velvia, and aside from a very slight boost in contrast and an almost undetectable increase in grain, pushing has no effect on this film. Pushed or not, Velvia offers almost unparalleled sharpness and rich, vivid colors. I dislike Fuji Provia's greens, which seem to me to have a bluish cast. In addition, although Ektachrome 100S and 100SW are both excellent films, I still prefer Velvia's color palette. And besides, Velvia is much less costly than Ektachrome 100S or 100SW (when purchased from the large mail order houses).

During the early 1990s, I experimented very briefly with Fuji Sensia and Provia, and with Kodak's Lumiere (no longer in production), but was unhappy with each of them. I was looking for a 100 speed film that pushed well to EI 200, and each of these films exhibited a considerable magenta shift when pushed. In late 1996, I tried a few rolls of Kodak's

Ektachrome 100SW pushed to EI 250 and was happy with the results; the colors approached those of Fuji Velvia, the whites were clean and bright, and the film pushed well. It did, however, exhibit a bit of grain when pushed.

Recently, I tried shooting Ektachrome 100SW film at EI 200 and pushing it only 2/3 stop; as when pushed to 250, the exposures were perfect. The colors, however, seemed a bit richer, and less grain was evident. By shooting 100SW at EI 200 and pushing it only 2/3 stop, I'm still rating it 1/3 stop faster than the manufacturer does. When photographing warblers at Point Pelee in May 1997, I used Ektachrome 100SW as described above on dark days, when I was forced to use flash as main light, and was thrilled with the results. Others photographers report good results when pushing this film two stops! I can't wait to try it.

Top: **SNOW GEESE**, Bosque Del Apache National Wildlife Refuge, New Mexico. Canon EF 600mm F4L lens and EOS 1N body, Ektachrome 100SW (rated at 250) pushed one stop, evaluative metering at zero: 1/320 sec. at f/4

Bottom: **CANADA WARBLER**, Point Pelee National Park, Ontario. Canon EF 600mm F4L lens with 1.4X teleconverter plus 37mm of extension and EOS 1N body, Ektachrome 100SW (rated at 200) pushed 2/3 stop, ambient exposure set manually at a level of two stops of underexposure: 1/125 sec. at f/5.6, Better Beamer flash extender, flash as main light at -1/3 stop

Bird photographers need a 200 speed film. Ektachrome 100SW pushed 2/3 stop is the best that I've found. In the image of a flock of snow geese, the extra speed let me freeze the action in low light, while in the photograph of the male Canada warbler, the extra speed enabled me to properly expose the background.

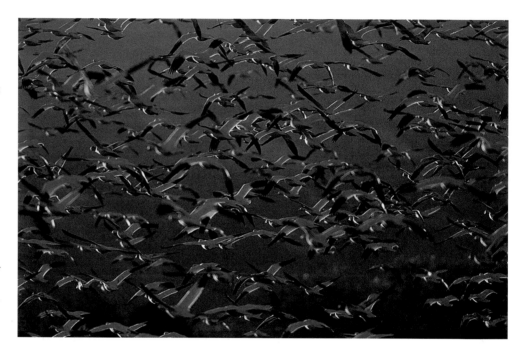

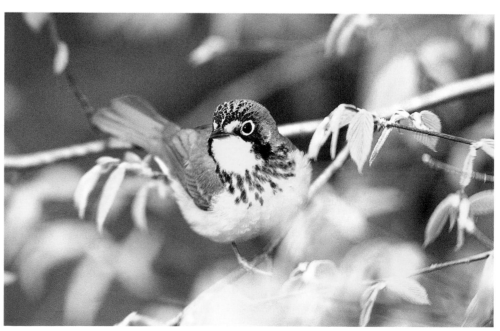

Film Care and Processing

Store your film in the refrigerator to extend its shelf life. Avoid leaving it in hot places for long periods of time. Avoid having your faster film x-rayed repeatedly at airports, especially overseas airports with outdated equipment. To prevent losing exposed rolls of film, always place them in deep or zippered pockets. Be sure to process the exposed rolls as soon as possible. Though it adds extra bulk when traveling with large amounts of film, keep each roll of film in its individual canister unless it is in your camera. This will prevent damage to the film, such as physical damage (if you were to drop the cassette you might pop the endcap), water damage (if you were to drop it in a lake), damage from high humidity when working in tropical climes, or scratches on the film when excess dust and grit get inside the cassette or onto the felt strips designed to keep dust and grit out of the cassette.

With regards to dust and grit, make a habit of cleaning the leader by pulling it between your thumb and index finger before loading a fresh roll; you can also do the same thing with the bottom edge of a T-shirt that you are wearing, if it is clean. This will prevent any grit from scratching the film as it leaves and enters the cassette. This is important, because scratches from dust and grit will appear on your processed slides as fine, straight scratch lines parallel to the top and bottom of the horizontal frame. These scratches often appear on only the first few or last few frames of a roll, when tension caused by autoloading or auto-rewind is greatest.

Other preventive measures include thoroughly cleaning the inside of your camera body with a good blower brush every other roll or so and opting, if possible, to use a slower rewind speed; some camera bodies offer a choice of fast and slow auto-rewind. Lastly, many photographers (myself included) disregard the manufacturer's instructions and clean the film pressure plate (located on the inside of the camera back) with alcohol and a soft cloth.

For processing, I ship my exposed film to Chelsea Professional Color Labs in New York City, by either U.S. Priority Mail/Return Receipt Requested or Federal Express. Both provide sturdy boxes at no charge. Though it adds to the cost of shipping (due to the extra weight), I always ship each roll in a canister, lest one or more rolls arrive with popped endcaps (which would ruin at least a few frames on each roll). The strong shipping boxes add an extra measure of protection, and my slides are returned in the same manner.

Chelsea Labs and its sister lab, Baboo, have processed my film for the past six years. Chelsea's processing, although very inexpensive, is consistently excellent. My transparencies are always clean and bright, and both normal and pushed rolls are processed to exacting standards. When you think (or know) that you've screwed up the exposure of a given roll of film, Chelsea offers excellent clip testing; a few frames are snipped off at either the beginning or end of the roll, processed, and examined so that the rest of the roll may be processed correctly. Service is fast; if film is received in the morning, the slides are usually shipped to you the same day. Chelsea uses only cardboard mounts, which I much prefer to plastic mounts for a number of reasons: cardboard mounts are easier to handle and label (the labels stick better), and they won't scratch the film when it is removed from and returned to the mounts when you have scans or color separations made from your slides. Plastic mounts will.

I have had a very few small mishaps with Chelsea Labs but no major disasters. My biggest complaint, usually, is that I find one or two scuffed slides in every 60 or 70 rolls. In addition, Chelsea has duplicated hundreds of my select images without putting so much as a tiny scratch on any of the valuable originals. Realize, of course, that the longer you deal with a lab, the greater the chance that disaster will strike. Fortunately, the technicians at Chelsea make far fewer mistakes than I do. But, we're all human. If you do give Chelsea a try, tell them I sent you. If, however, they trash your 200-roll shoot from a once-in-a-lifetime trip, please don't call or write me.

When shipping a large number of rolls from a big trip for processing, some photographers send the film in several batches believing that at least they'll get something back in the event of a loss or a processing disaster. To my mind, though, doing this *increases* the chance of loss or mishap. Regardless of which lab you use regularly, try to keep things in perspective in case of a major processing accident; there are lots of more important things in life.

I always store my film in a refrigerator, and whenever I set out on a trip in my micro-mini motor home, I make sure that the refrigerator is well stocked.

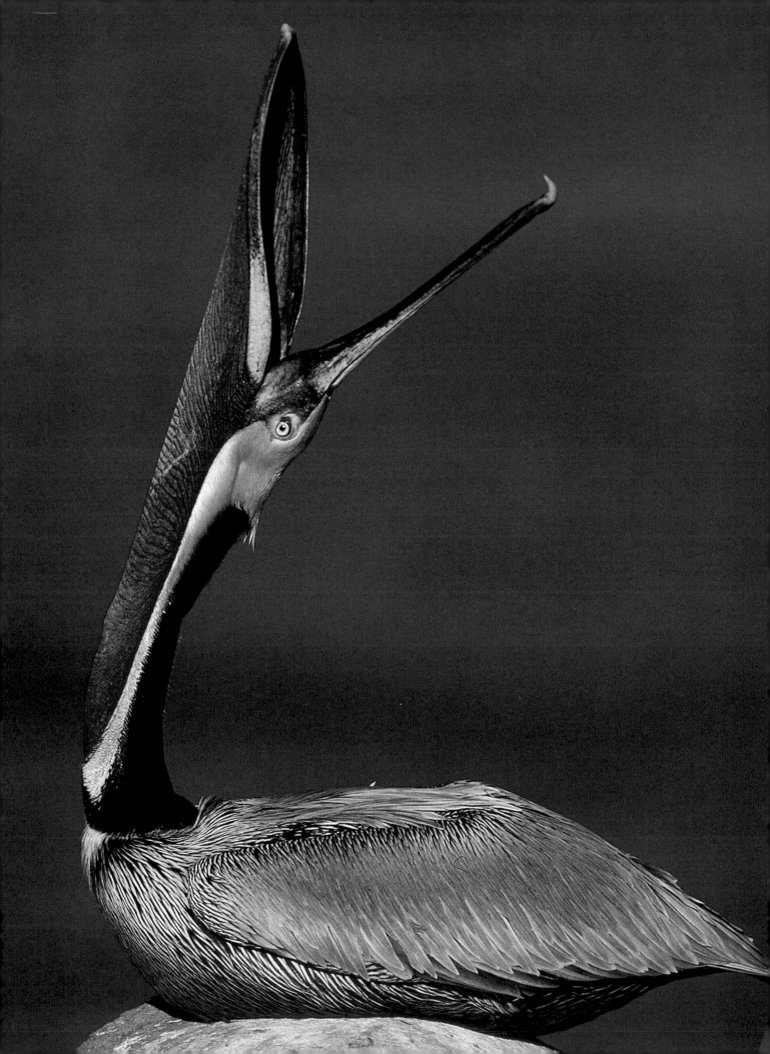

Chapter Six

PRODUCING SHARP IMAGES

Pleasingly composed, well-lit photographs of strikingly beautiful birds are, in most cases, nothing, if the image of the bird isn't sharp or, better yet, razor sharp. Photographs of moving birds taken at slow shutter speeds can, at times, yield highly artistic blurred results. If you wish to be a successful bird photographer, however, you must be able to make critically sharp images on a consistent basis. Sharpness is not an option.

Image sharpness is largely a function of six factors: lens and teleconverter quality and condition, focusing accuracy, shutter speed, subject movement, aperture, and equipment shake (usually due to a flimsy tripod, an inadequate tripod head, poor technique, or a combination of all these things). Making sharp images consistently with big lenses and teleconverters is a difficult task. However, by correctly using a sturdy tripod and by constantly honing your shooting technique, your results will improve. And, by studying your photographs on a light box with a quality loupe and learning to judge your work for critical sharpness, making razor-sharp images will soon become second nature.

BROWN PELICAN, La Jolla, California. Canon EF 600mm F4L lens and EOS 1N body, Fuji Velvia pushed one stop, evaluative metering at zero: 1/2000 sec. at *f*/4

Quality lenses, big tripods, fine-grain film, good technique, and fast shutter speeds all make for extremely sharp images. In order to make this photograph, I had to frame the pelican with its head and bill nearly out of the picture and then wait for it to do its thing. Head-throws like this are thought to be a form of intraflock communication.

Lens Quality

All other factors being equal, the higher the quality of a telephoto lens' glass and construction, the sharper the resulting image—period. That goes double when using the lens with a matched teleconverter. (Using an off-brand teleconverter with an expensive lens is downright foolish.)

If lenses were constructed of only a single glass element, they'd suffer greatly from both distortion and aberration; so, additional lens elements, or groups of lens elements, are added until near perfection is achieved. Modern lenses, all designed by computer, usually feature 5 to 10 lens elements in 5 to 15 or more groups. Most glass reflects about four percent of the light striking it, so all lens elements need to be coated to improve light transmission, lest very little light at all reach the film. Each of the additional optical features in a lens improves the quality of the image, and each, of course, adds to the price of the lens. You simply will not be able to make sharp images with a 400mm lens that costs only $129.99.

Never use a filter to protect the front (glass) element of your telephoto lens; it will distort the image, sometimes severely, and can hinder autofocus performance, as well. Always protect the lens' front element by extending and locking the lens hood *whenever* you remove the lens from its case or trunk. Most lenses that are dropped hit the ground front end first. Having the lens hood extended may well result in damage to the hood, but in most cases, the front element will remain intact. Make sure, also, to keep the front element clean of dust and water spray, especially salt spray. Check the front element at the beginning and end of each shooting day, and several times during the day when working in adverse conditions.

On the topic of dropping lenses, always take extreme care when placing the quick-release plate in the clamp; many accidents happen during or after this seemingly simple procedure. Also, take extreme care when placing your tripod on the ground; make sure that you've spread the legs completely so that the rig is not unbalanced. I've seen many photographers put their tripods down so carelessly that a slight breeze would blow their rigs over. With Gitzo tripods, inspect and test the leg-lock mechanisms and clean the fittings and internal bushings regularly. Many smashing lens disasters occur when leg-locks or twist-locks fail and one leg inexorably begins to shorten. To prevent this, push down hard on the top of the tripod *before* mounting your big lens, and make sure that none of the leg sections slip. In addition, periodic replacement of the bushings is recommended.

If you regularly leave your tripod-mounted lens unattended, the lens will, eventually, hit the ground with a thud. I never dropped my 800mm lens, but my 600mm F4 was jinxed: it hit the deck three times in the first six months that I owned it. I was lucky, however—shipping and repairs totaled less than $2,000. If you're unfortunate enough to drop a big, expensive lens, make sure to have the manufacturer check the lens, even if there is no apparent damage. By keeping your long telephoto lenses clean and undamaged, they will make razor-sharp images for decades.

MARBLED GODWIT, San Diego, California. Canon EF 600mm F4L lens and EOS 1N body, Fuji Velvia, evaluative metering at zero: 1/320 sec. at *f*/5.6

Today's best telephoto lenses produce razor-sharp images even when you're shooting them wide open. By usually shooting my 600 F4 at f/5.6, I gain a bit of extra depth of field, and it is easier for me to mentally check my exposures against the sunny f/16 exposure rule. (The sunny f/16 values that I have stored in my head are all at aperture values of f/5.6.)

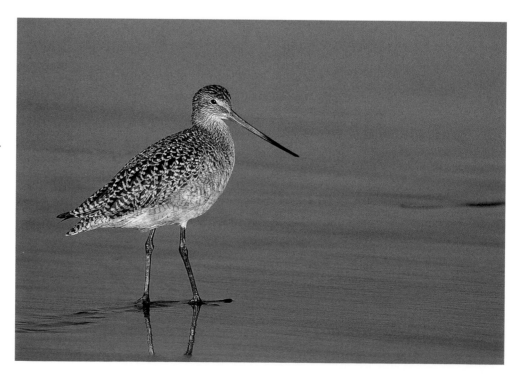

Accurate Focusing

If you don't focus your long lens accurately, you'll never make sharp photographs. Take your time and use extreme care when focusing. This is, of course, easier said than done. Many times, especially when rushed, even experienced photographers focus on a bird and take a few frames only to find out when they refocus that the previous images were *not* sharply focused. To avoid this, continue to turn the focusing ring *past* the point of focus and then back again. By using this simple technique, when time allows, you'll be able to create sharply focused images on a consistent basis.

The Canon EOS 1N offers a superb feature that makes focusing manually a snap; if you set the main switch to the "sound symbol" position when you turn on the camera, an electronic beep will be emitted when the subject is correctly focused. With practice, you'll learn to fire at the sound of the beep, rather than waste time trying to decide whether or not the image is sharply focused.

Always focus on a bird's eye and the feathers surrounding it. When viewing wildlife, or wildlife art, we tend to make immediate eye contact. Consequently, if a bird's eye is in sharp focus, it gives the photograph an impression of overall sharpness. Bright matte focusing screens make focusing easier, as do fast lenses. All modern lenses feature wide open viewing, so the same image will appear brighter through an F4 lens than through an F5.6 lens. The brighter the viewfinder image, the easier it is to focus.

If you have poor vision, you may benefit from using an eyepiece diopter. Most manufacturers offer these as accessories. Call your camera dealer to check on availability, then consult your eye doctor. Quite a few modern camera bodies (such as the Canon A2 and EOS 1N and the Nikon F4s and F5) offer built-in, infinitely adjustable viewfinder diopters as standard equipment. If your vision is poorer still, autofocus may be a necessity.

SANDHILL CRANE, Bosque Del Apache National Wildlife Refuge, New Mexico. Canon FD 800mm F5.6L lens and T-90 body, Fuji Velvia pushed one stop, evaluative metering at zero: 1/750 sec. at *f*/5.6

When working in vertical format, focusing manually while following a moving subject is extremely difficult; the tendency is to let the subject—even a slow-moving one such as this foraging sandhill crane—get too far forward in the frame.

Shutter Speed and Subject Movement

Fast shutter speeds, from 1/250 to 1/1000 sec. or faster, lessen the effect of both equipment shake and subject movement; the faster the shutter speed, the less image blur will occur. As a general rule for bird photography, you should choose the fastest possible shutter speed that the lighting conditions and film speed will allow *by working in aperture priority and choosing your lens' largest opening.* At 1/1000 sec. or faster, almost all motion will be frozen. At 1/750 or 1/500 sec., most movement will be frozen, but images of flapping birds may exhibit blurred wing tips. (At 1/500 sec. or faster, getting relatively sharp images with handheld 400mm F5.6 lenses and 100 speed film should be routine.) At 1/350 and 1/250 sec., some blurring of moving birds may result, and with shutter speeds of 1/125 sec. or slower, blurring due to subject movement will most surely occur.

With shutter speed a constant, blur due to subject movement decreases as the subject-to-camera distance increases. At 1/30 sec., photograph a single snow goose flying at 20 mph *at a distance of 50 feet,* and the image will be considerably blurred, often bordering on the surreal. But, at 1/30 sec., photograph a flock of snow geese flying at 20 mph *at a distance of 200 feet,* and the image of each goose in the flock will appear relatively sharp.

To create blurred images that accentuate motion, choose relatively slow shutter speeds of from 1/125 to 1/2 sec. This technique can work well, especially with birds in flight; however, producing successful images on a consistent basis is difficult, and experimentation is necessary. Intermediate and long telephoto lenses should be tripod mounted when attempting to produce intentionally blurred images.

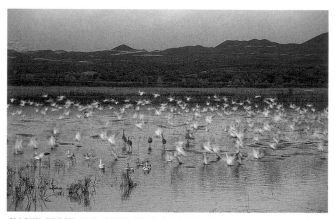

SNOW GEESE AND SANDHILL CRANES AT DAWN, Bosque Del Apache National Wildlife Refuge, New Mexico. Canon EF 400mm F5.6L lens and A2 body, Fuji Velvia pushed one stop, evaluative metering +2/3 stop: 1/10 sec. at *f*/11

I photographed the resting birds at f/11 so that the entire flock would be in sharp focus. When the geese took flight, I fired off two more images (using a cable release) and was pleased with those results, as well.

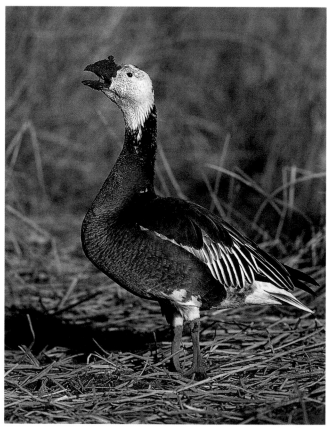

SNOW GEESE AT SUNSET, Bosque Del Apache National Wildlife Refuge, New Mexico. Canon EF 600mm F4L lens and EOS 1N body, Fuji Velvia, evaluative metering +1/3 stop: 1/30 sec. at *f*/4

Even though I made this photograph at 1/30 sec., the silhouetted images of the geese are sharp because the subject to camera distance was great. I took extreme care in framing the composition to ensure that no bird was cut in half by the edge of the frame.

SNOW GOOSE (BLUE FORM), Bosque Del Apache National Wildlife Refuge, New Mexico. Canon FD 800mm F5.6L lens and T-90 body, Fuji Velvia pushed one stop, center-weighted average metering +1/3 stop: 1/125 sec. at *f*/5.6

When in doubt, shoot; it's amazing how often a slow shutter speed can stop action. This calling goose was letting the world know how much it had enjoyed the last tuber that it had extracted from the mud.

Depth of Field

Depth of field is the area of reasonably sharp focus that extends in front of and behind the point of focus. Large apertures, or lens openings, (signified by small f-stop numbers, such as $f/2.8$, $f/4$, and $f/5.6$) minimize depth of field. When you use large apertures to photograph nearby birds, the foreground and background will be thrown completely out of focus. In most instances, this is desirable—your backgrounds will be soft and beautiful. Different parts of the same bird, however, may not be in focus, especially when you're photographing small birds that are large in the frame at point-blank range. Smaller apertures (denoted by larger f-stop numbers, such as $f/8$, $f/11$, $f/16$, and $f/22$) maximize depth of field. The higher the f-stop number, the greater the depth of field. Shooting at small apertures increases the range of sharp focus.

As a general rule, I recommend that bird photographers shoot wide open nearly all the time; the best modern telephoto lenses are designed to produce razor-sharp images when used wide open. Stop down (choose a smaller aperture) only when you have a good reason to do so. The number-one reason for stopping down is to ensure enough depth of field so that all parts of the subject are in sharp focus. Again, this is often most important when photographing small birds that are large in the frame.

At a given aperture, depth of field decreases as subject-to-camera distance decreases. So, when shooting wide open at point-blank range with a long telephoto lens, depth of field is measured in mere fractions of an inch. If a towhee, for example, is practically filling the frame, you'll need to shoot at an aperture of $f/8$ or smaller so that both the bird's eye *and* near wing will be rendered in sharp focus. Remember, however, that unless you're using flash as main light, choosing a smaller aperture necessitates the use of a slower shutter speed, and slower shutter speeds often result in a *loss* of sharpness, due to equipment shake or subject movement.

If a bird is facing the camera, I'll often choose a smaller aperture (to increase the depth of field) and make some vertical portraits. If the subject is at an angle to the axis of the barrel of the lens, the images can be quite striking. When including two birds in your composition, you may need to stop down for extra depth of field, unless the birds are on *exactly* the same plane. To check this, focus on the eye of one of the birds; if the eye of the second bird isn't also in sharp focus, you'll need to stop down at least to $f/8$ or $f/11$. When I'm desperate for additional depth of field, I'll shoot as slow as 1/90 or even 1/60 sec.

When photographing a large flock of birds 100 yards away with a long lens at the wide open aperture, *many* rows of birds would be in sharp focus, with the depth of field measured in feet. In this situation, I might select an aperture of $f/16$ or even $f/22$ and thereby have enough depth of field to ensure complete front-to-back sharpness. In this case, though, I'd be working at such slow shutter speeds that I'd need to use mirror lock-up and either the self-timer or a cable release to prevent blur due to equipment shake. Note: If your camera has a depth-of-field preview feature, activating it will allow you to *see* the changes in depth of field as you set smaller and smaller apertures.

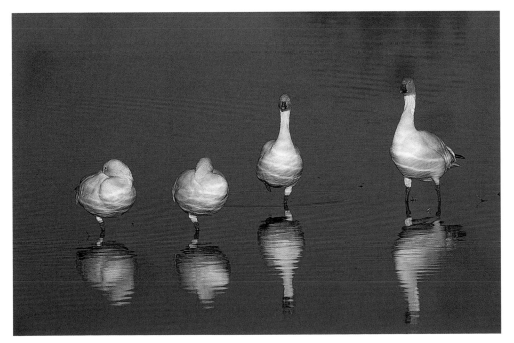

SNOW GEESE, Bosque Del Apache National Wildlife Refuge, New Mexico. Canon EF 600mm F4L lens and EOS 1N body, Fuji Velvia pushed one stop, evaluative metering -1/3 stop: 1/250 sec. at $f/8$

To capture this quartet of geese, I needed a bit of extra depth of field to ensure that both pairs of birds would be in sharp focus. Since the birds remained still for quite some time, I was unrushed and able to use my camera's depth-of-field preview feature to check that all the birds were in sharp focus.

Equipment Shake

It is a fact: long lenses quiver and shake. The longer the lens, the greater the vibrations. At shutter speeds of slower than 1/125 sec., these vibrations often cause soft (blurred or unsharp) images. When making exposures at very slow shutter speeds, the slap of the mirror as it snaps up and out of the way (to allow light to hit the film when the shutter opens) causes additional vibrations that can cause soft images. And while teleconverters greatly increase image magnification, they also magnify the effects of vibration, and again, all vibrations decrease image sharpness. (In addition, teleconverters rob you of valuable light, forcing you to use slower shutter speeds.)

Many beginning bird photographers feel that they'll be able to produce sharp images with their telephoto lenses mounted on a shoulder stock (a brace for the lens). And, shoulder stocks are lighter and far more portable than tripods. Others feel that monopods (one-legged camera supports) may be the answer.

When shooting birds in flight at shutter speeds of 1/500 sec. or faster, some photographers can produce sharper images with a shoulder stock than they can by simply handholding the camera. After much practice, when I use fast shutter speeds in these conditions, I feel completely comfortable handholding my intermediate telephoto lenses and am able to produce razor-sharp images on a consistent basis.

A recent technological development has led to the introduction of two image-stabilized (IS) lenses by Canon: a 75–300mm F4–5.6 IS zoom and the EF 300 F4L IS. When handheld, these image-stabilized lenses allow photographers to produce sharp images at relatively slow shutter speeds. The 75–300mm IS lens is a great travel lens but isn't very useful for bird photography; with the IS function activated, it isn't possible to photograph birds in flight because the lens causes the subject to "drag" in the viewfinder as you pan. The 300 F4 IS, on the other hand, would be a superb addition to the lens arsenal of any serious nature photographer, especially those who refuse to use a tripod or who work regularly from large boats, canoes, or kayaks.

Most importantly for bird photographers, this lens offers a choice of *two* IS settings: IS 1 and IS 2. The first eliminates lens shake in all directions, while the latter eliminates shake in one direction only—90 degrees to the axis of lens movement. You'd choose the IS 2 setting when photographing birds in flight, and panning would be a snap. Additionally, the 300 F4 IS works well with both 1.4X and 2X teleconverters. With the 1.4X teleconverter, you'll have a 420mm F5.6 lens with functioning autofocus and image stabilization. With the 2X, you'll lose autofocus, but image stabilization will function with Canon's EOS 1N, the Elan II series, and future generation EOS camera bodies.

WESTERN GULL, La Jolla, California. Canon EF 400mm F5.6L lens and A2 body, Fuji Velvia pushed one stop, evaluative metering at zero: 1/750 sec. at *f*/5.6

For most bird photography, it is best to shoot wide open; this ensures the fastest possible shutter speed. When shooting single birds in flight and using 100 speed film, I've never taken a single frame at anything other than the widest aperture.

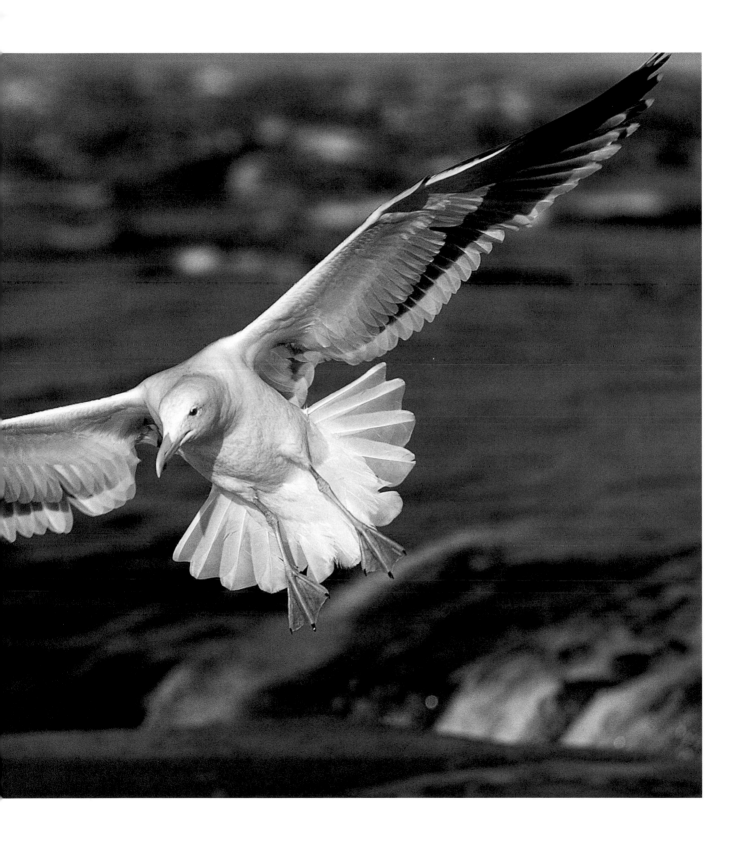

Tripods and Tripod Heads

The most effective way to reduce equipment shake when using long telephoto lenses is to use heavy-duty tripods and rock-solid tripod heads. When using my 600mm F4 lens, I use either the Gitzo 410R Pro Studex tripod or, more recently, the Gitzo 1548 carbon fiber tripod. My everyday tripod head is the Wimberley head; when photographing small landbirds, I use the Arca Swiss B-1 Monoball with quick-release clamp. It is routinely possible to obtain sharp images with long lenses at shutter speeds of as slow as 1/60 sec. with either of these heads.

Many expert photographers feel that the Arca Swiss B-1 is too small to handle the 13-plus pound lenses; they feel that the Arca Swiss B-1G (giant), the Arca Swiss B2 (bi-directional head), or one of the other large ball heads are necessary to support the 600 F4 lenses. However, I humbly disagree.

As far as tripods go, it is generally best to choose the heaviest and sturdiest one that you can carry afield. Your tripod should be taller than you are when it's set up with the legs extended so that you can work comfortably with the camera well above your head when photographing birds high in trees, or can extend the forward-pointing leg when working downhill. For maximum rigidity, your tripod should have three leg sections, not four. Standard advice for nature photographers is to purchase a tripod without a centerpost to allow for ground level shooting. For bird photographers working with big lenses, however, I advise always buying a tripod *with* a centerpost for a couple of reasons:

1. When you handle a large tripod-mounted lens with the tripod legs closed (as when you're preparing to hoist the rig onto your shoulder and move on), the centerpost will prevent an individual leg from folding under the tripod between the other two legs. If this happens and your tripod doesn't have a centerpost, there are two possible unpleasant outcomes: Either you may lose control of the entire setup, which then crashes to the ground, or you may badly pinch a finger as you attempt to right the unbalanced rig. I've had the latter happen to me more than once.

2. Contrary to popular advice, I will, on occasion raise my centerpost to maximum height. I'm willing to sacrifice a bit of stability for better perspective; the higher you get, the less it will appear that you're shooting the bird from below. And, when shooting at fast shutter speeds, you gain far more than you lose.

Gitzo tripods, such as the 320 or the 341, are adequate for lenses as light or lighter than the 500mm F4s, although these lenses will produce sharper images when supported by the Gitzo 410 (especially when they're used with teleconverters). When selecting a Gitzo 300 or 400 series tripod, always opt for the model that features upper *wing locks* rather than twist lock rings. The former are far easier to loosen than the latter.

Many of my photo-tour participants arrive with the inadequate Bogen 3021 or 3221 tripods to support their 400mm and 500mm lenses. In many cases, one piece or another has fallen off and disappeared; the tripods are thus rendered flimsy and useless. Many Bogen tripod users are forever having problems with the leg-locks, as well.

Gitzo tripod users need to be aware that the positioning of the leg tabs greatly affects tripod stability and, therefore, image sharpness. The leg tabs, currently made of a gray composite material (metal on older tripods), are located at the top of the upper leg sections. To ensure maximum stability, it is important that the top of the leg tabs (which are broad on the composite tabs, but too narrow on the older metal ones) are flush against the stops.

Recently, I tried the Gitzo 1548 carbon fiber tripod. Despite the fact that it isn't very heavy and has four leg sections, I liked it quite a bit and was able to make sharp images with my 600mm F4 lens, even at slow shutter speeds. The carbon fiber leg sections are extremely rigid,

Tripod Leg Pads

These foam pads fit snugly around each tripod leg and cushion the load when you're carrying tripod-mounted telephoto lenses. They lessen the pain you feel in the shoulder that supports your outfit. However, no matter how carefully you install them, they wind up sliding up and down the tripod's upper leg sections. The best leg pads, made by OP/TECH USA, are sized to fit various tripod leg diameters. Many photographers opt to make their own tripod leg pads with pipe insulation material and gaffer's tape.

The lightweight Gitzo 1548 carbon fiber tripod, with an Arca Swiss B-1 tripod head.

and the sizeable twist locks with their knurled surfaces are easy to grab and tighten; I did, however, have one twist lock freeze up on me. Whenever you adjust the leg length, you must make sure that all the twist locks are tight before beginning to shoot; the upper twist locks have a tendency to loosen when the lower twist locks are loosened.

It is worth it to tolerate and work around these minor difficulties with the Gitzo 1548, though, as the 3 1/2 pound savings in weight (as compared to the Gitzo 410R) can make quite a difference on long walks. Plus, the carbon fiber legs will never corrode, making the tripod ideal for use in water of up to several feet deep.

To increase sharpness when working on a tripod at very slow shutter speeds, I'll sometimes drape my vest (which is quite heavy) over the lens. Another trick (when using a ball head) entails tilting the ball gently to the side so that the stem of the ball rests against the top edge of the housing. Frame the image and lock the ball as tightly as possible. Then loosen the tripod collar, square the camera body to the world, tighten the tripod collar, and begin making sharp photographs. To square the camera to the world, rotate the lens so that the top and bottom *film frame edges* (inside the camera) are parallel to the horizon line (even if you can't *see* the horizon line). Some photographers can do this intuitively, even when working on slopes or at ground level. I can't, so I simply use a double bubble level at all times (see page 98).

As for tripod heads, pan-and-tilt heads operate on three independent directional axes, offer fine control over framing, and therefore, are often the choice of landscape photographers. In order to lock these heads completely, however, you need to tighten three knobs; this takes precious time. With my first 400mm lens, I used a pan-and-tilt head on an inexpensive tripod for many years, often loosening all three controls and using the tripod simply to support the lens. This approach worked well with fast shutter speeds and when I was following action.

THE BALL HEAD OPTION

Today, some nature photographers still prefer heavy-duty pan-and-tilt heads when using long telephoto lenses, but most opt for the speed and ease of operation of ball-and-socket type tripod heads. Ball heads have many advantages. They enable you to point your lens quickly and easily at your subject and to square the camera body to the world easily and almost instantly. Framing the image is a snap, and ball heads can be tightened completely by turning a single knob or lever-type handle.

For years I relied on the original Arca Swiss ball head. It was large, heavy, and very sturdy but not very smooth; setting the desired tension was difficult. When the tension screw wasn't touching the ball, the ball would be too loose. As soon as the screw touched the ball, it would be too tight. Unfortunately, many of the ball heads manufactured today perform in much the same manner. The Arca Swiss B-1 head is smaller and lighter, yet able to support even the 13+-pound lenses with pro bodies. It is rock-steady when locked up, yet smooth as silk at any tension setting (except in frigid conditions or when the ball itself gets wet).

With the B-1, making small adjustments in framing and following slowly moving birds is, after a bit of practice, not too difficult. You adjust the tension on the ball by turning

The Arca Swiss B-1 Monoball tripod head with quick-release.

CHESTNUT-SIDED WARBLER, Point Pelee National Park, Leamington, Ontario. Canon EF 600mm F4L lens with 1.4X teleconverter plus 37mm of extension and EOS 1N body, Fuji Velvia pushed one stop, evaluative metering at zero: 1/320 sec. at ƒ/5.6, Better Beamer flash extender: fill flash at -1 stop

When shooting warblers, setting the tension on the ball head is a tricky proposition. You want the ball to be relatively loose so that you can easily follow these tiny birds as they forage for bugs, yet tight enough to ensure sharp images.

a set-screw located in the main locking knob; it is easy to maintain fine control. Another advantage of the Arca Swiss B-1 is that there's no ball head creep—when you frame an image and then tighten the ball, what you wind up with is exactly what you saw through your viewfinder. Most other ball heads creep downward a bit when you tighten them. Don't buy a ball head without mounting your long lens on it and checking for ball head creep first.

The main drawback of the Arca Swiss B-1 is that it takes at least four or five full quarter turns to tighten the ball completely. In bird photography that's a long, long time. The FOBA ball head, though not quite as smooth as the Arca Swiss B-1, can be tightened almost instantly; it has a handle that locks the head with a less-than-one-quarter-turn twist of the handle.

Do you need to tighten a ball head completely before making an exposure? Theoretically, yes; in practice, absolutely not. Depending on the type of shooting I'm doing, I may completely lock the ball down from rarely to most of the time. When shooting small landbirds, even with shutter speeds as slow as 1/60 sec., I never even attempt to lock the ball head; these birds move too quickly and they rarely stay perched for more than an instant or two. When photographing larger birds, such as herons, egrets, ducks,

geese, pelicans, cormorants, raptors, and shorebirds, in flight or in action, I don't, of course, lock the ball down. However, when large birds like these are stationary, I do tighten the ball head—but only after taking a few insurance frames (lest the bird fly away while I'm tightening the ball).

When you shoot without tightening the ball completely, the tension setting on the ball is of utmost importance. If there isn't any tension on the ball, you'll have difficulty making any sharp images at all, especially when you're working at slow shutter speeds. You'll spend all your time, and quite a bit of energy, trying to prevent your big lens from flopping over. If, on the other hand, the tension is set too tightly, you'll have trouble following active birds. A moderate tension setting will allow you to handle your lens easily, follow slowly moving birds, and produce sharp images. The perfect tension setting is the tightest one that still allows you to easily follow birds in motion. (Do, however, set the tension a bit looser when photographing birds in flight.)

The Wimberley head is a bulky, heavy, gimbal-type tripod head ideal for use with the 13+-pound lenses—the 400mm F2.8s and the 600mm F4s. Balanced correctly, these heavy lenses are rendered practically weightless, and the neck and shoulder muscle fatigue that photographers often encounter during long flight shooting sessions with

BLIZZARD IN BLUE (SNOW GEESE), Bosque Del Apache National Wildlife Refuge, New Mexico. Canon EF 400mm F5.6L lens and A2 body, Fuji Velvia pushed one stop, center-weighted average metering +1/2 stop: 1/15 sec. at f/5.6

On the cold, gray morning that I made this image, I carefully adjusted the ball head tension in my motel room before I set out so that I was able to get right to work after arriving at Bosque Del Apache. This photograph was runner up in the Composition and Form category of the 1997 British Gas Wildlife Photographer of the Year Competition.

standard ball heads is eliminated. Following moving subjects, especially those in flight, becomes routine with a bit of practice. You need to tighten two controls, however, for locked-down shooting; and, unless you take the time to level the tripod, the camera body must be squared to the world *each time* that you set the tripod down (after first loosening the tripod collar).

When working with the Wimberley head (or with the Arca Swiss B-2 head), some photographers prefer to work

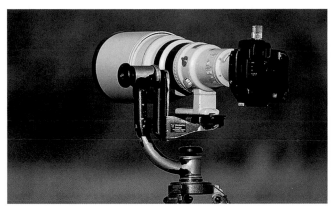

The Wimberley head, great for flight shooting, is now my everyday tripod head. It is shown here with my Canon 600mm F4L lens, A2 body, and double bubble level. (Note that the Gitzo leg tabs are flush against the stops for maximum stability.)

with the tripod collar loosened completely at all times, rotating the lens in the collar to square the camera when shooting both stationary and moving subjects. With most of the big lenses that I've handled, the lens doesn't rotate freely enough in the collar to allow you to do this easily. And, if the lens does rotate freely, you'll sacrifice sharpness if you work with a loosened tripod collar. To square the camera, simply loosen the tripod collar as you set the tripod in place and point the lens at the subject; then rotate the lens in the collar until the camera is square to the world. Tighten the tripod collar and begin making photographs.

After successfully photographing geese and sandhill cranes in flight with my 600mm F4 lens, 1.4X teleconverter, and Wimberley head for two weeks in New Mexico late in 1996, I was so thrilled with the results and the ease with which this specialized head handled the big lens that I began using it as my everyday head. Just as when using a ball head, I rarely take the time to lock the head down completely, but I do work with the controls kept fairly snug to increase stability.

LEVELING THE CAMERA AND TRIPOD
When following a moving subject, you may be forced to work with the tripod collar loosened, in order to keep the camera square to the world as you pan. If, however, you'll

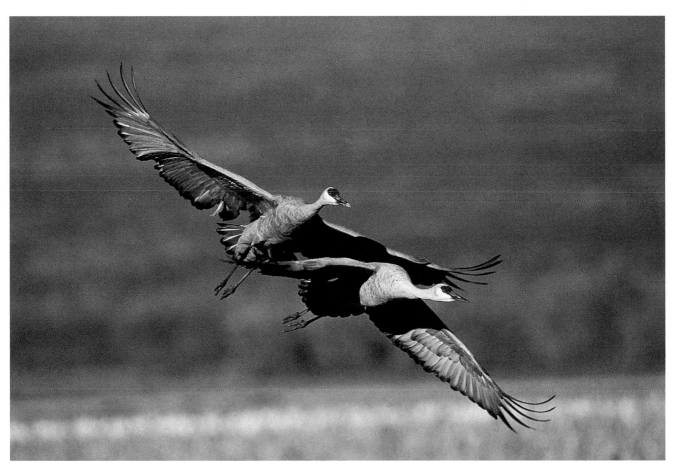

MATED PAIR OF SANDHILL CRANES, Bosque Del Apache National Wildlife Refuge, New Mexico. Canon EF 600mm F4L lens and EOS 1N body, Fuji Velvia pushed one stop, evaluative metering at zero: 1/750 sec. at *f*/5.6

For flight shooting with 13-pound lenses, the Wimberley tripod head is unsurpassed. It enables me to easily follow moving subjects.

Double Bubble Levels

This little plastic gizmo, which fits into the camera's hot shoe, allows photographers to be absolutely sure that their avian subjects are square to the world and that their horizons are level. The level works especially well when you're down on the ground with a big lens or working on a slope or hillside (especially when shooting verticals). The Hama spirit level is the most common double bubble.

Double bubble levels are, however, relatively expensive and fairly easy to lose. It is also possible to snap the level off at the base when you're loading or unloading equipment. For that reason, I always remove my level after shooting and keep it in the upper left pocket of my vest. If the fit of your level is a bit loose in the hot shoe, place a small square of paper tape on the bottom of the bubble to make the fit a bit more snug.

The centered vertical-format bubble on this double bubble level indicates that the camera is square to the world and helps you avoid making images of tilted herons and cockeyed cuckoos.

DOUBLE-CRESTED CORMORANT, Anhinga Trail, Everglades National Park, Florida. Canon EF 600mm F4L lens with 50mm of extension and EOS 1N body, Fuji Velvia pushed one stop, center-weighted average metering +1/3 stop: 1/250 sec. at ƒ/5.6

I'll admit to being something of a fanatic when it comes to keeping my camera body square to the world, but it only takes an instant to check the bubble level before locking the ball head or tripod collar. Using a bubble level ensures that your subjects won't appear tilted in the frame.

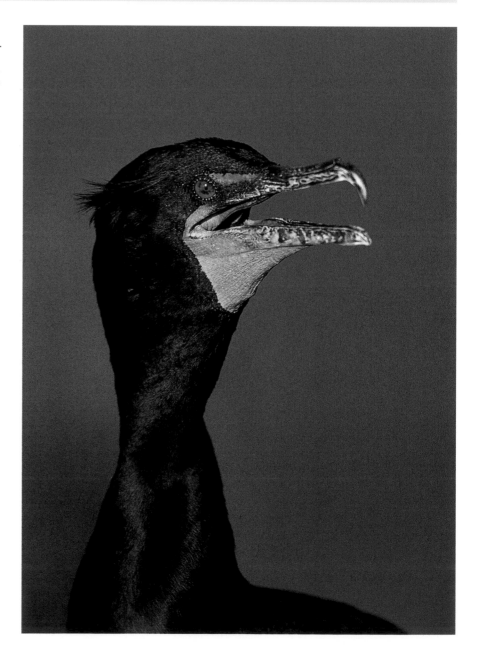

be taking flight or action photographs from a single spot for more than a few minutes, it is best to take the time to level your tripod. If you don't, the camera will become skewed to the horizon as you pan. Whether you're working in horizontal or vertical format, using a Hama Double Bubble—a two-way level that fits in the camera's hot shoe—will make squaring your camera to the world a snap.

You can level the Gitzo 410 and similar tripods that have bubble levels built into their mounting bases. Choose a fairly level spot on which to set up, and make sure that all the tripod legs are extended to the same length. Check the tripod's bubble to see if it is centered in the target circle. In most cases it won't be. If the bubble is nearly centered, you may be able to center it perfectly by splaying one or two legs out, or by pushing them in, slightly. If the bubble is well off center, you'll have to lengthen or shorten one or two of the tripod legs to achieve perfection.

Centering the bubble in the target circle is a tricky proposition at first, but after some practice, you'll be able to do it usually in less than a minute or so. After leveling the tripod head, rotate the lens in the tripod mount until the bubble level in your camera body's hot shoe indicates that the camera is square to the world. Why go through all this trouble? If your tripod head is not level, your camera body won't remain square as you swing your lens from side to side. Once your tripod head and camera body are level, you can point your lens in any direction and your camera body will remain square to the world.

MOUNTING SYSTEMS

To mount your camera body and lenses with tripod collars securely to your tripod head, you use what are called quick-release plates (see box below). At present, there are only two basic types of plates used: the Bogen system and the Arca Swiss system.

The Bogen system, which relies on a one-size-fits-all, hexagonal quick-release plate that fits into a fixed-cavity clamp, is completely unsuitable for bird photography for a variety of reasons. First, with only a single mounting screw, Bogen plates are incapable of holding large telephoto lenses securely in place. Second, the hexagonal plate fits directly into the fixed cavity clamp, making it impossible to shift long, heavy lenses forward and backward as needed for balance. And third, when used with heavy lenses, the system is inherently flawed; several of my instructional photo-tour participants who used the Bogen quick-release plates have relayed tales of long lenses mysteriously falling off tripods.

The only way to safely and sanely mount your long lenses (and your camera bodies, when working with short lenses) to your tripod head is to employ the Arca Swiss quick-release system. Its opposing jaws lock the mounting plate in an open-ended channel. This permits the use of customized plates designed for specific lenses and bodies. You can, therefore, use small unobtrusive plates for light loads and longer, larger, heavier plates for the really big telephoto lenses. The open-ended channel also allows the photographer to shift the plate forward and backward to balance your rig; fixed cavity systems don't allow for this.

Several manufacturers offer a variety of quick-release plates; many, however, aren't capable of handling big telephoto lenses. The best are those made by Really Right Stuff; each is designed to fit a specific lens, camera body, motor drive, or vertical grip. Plus, they incorporate silky smooth metal-to-baseplate designs with flanges that prevent the plates from twisting. And, whatever the number of

Lens and Camera Body Plates

The purpose of these plates is to safely and securely mount your equipment into the jaws of an Arca Swiss–style quick-release clamp. They come in a variety of sizes, and though there are several companies that sell them, only Really Right Stuff offers over 100 different Arca Swiss–style quick-release mounting plates. These model-specific plates are tailored to fit virtually all major brands of camera bodies and lenses.

Avoid universal plates that supposedly "fit" a wide range of bodies or lenses. Poorly designed, "five-sizes-fit-all" plates are heavy and bulky, and since they aren't made for specific pieces of equipment, the fit is generally poor; the very worst of them allow your lens or camera body to pivot on the mounting plate. Optimally designed, lightweight plates, such as those from Really Right Stuff, fit the bottom of your camera body, lens—and even your power winder or vertical grip—like a glove. These plates are not flat topped; they have flanges that eliminate pivoting.

Really Right Stuff quick-release plates.

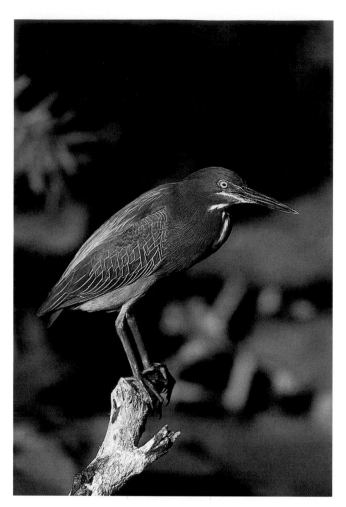

mounting screws on the foot of your long telephoto lens and whatever their configuration, Really Right Stuff plates are designed and manufactured to mate with them perfectly.

Sufficiently long mounting plates that are capable of supporting super telephoto lenses can be moved forward or backward in the jaws to balance the camera and lens. Balancing the load reduces vibrations. I balance my rig when I set up, and I rebalance it whenever I add accessories to, or remove them from, the mix. These accessories include teleconverters, extension tubes, and flash units. In addition, be sure when you're using a ball head, to move the plate back in the jaws when pointing the lens downward, as when photographing ducks off a dock, for example, and to move it forward in the jaws when pointing the lens upward, as when photographing birds high overhead in trees. The rig should be perfectly balanced *when the lens is pointed at the subject.*

In all cases, make *absolutely* sure that you retighten the clamp after balancing your rig, otherwise your big lens will take a tumble. Aside from ensuring sharp images, correctly balancing your rig reduces photographer fatigue, as well.

GREEN HERON, Anhinga Trail, Everglades National Park, Florida. Canon EF 600mm F4L lens with 1.4X teleconverter and EOS 1N body, Fuji Velvia pushed one stop, evaluative metering at zero: 1/400 sec. at *f*/5.6

In order to produce sharp images on a consistent basis, you must use long, quick-release mounting plates that allow you to rebalance your rig each time you add or remove accessories. Make absolutely *sure that you retighten the quick-release jaws each and every time you balance your rig.*

GREATER YELLOWLEGS, Jamaica Bay Wildlife Refuge, Queens, New York. Canon EF 600mm F4 lens with 2X teleconverter and EOS 1N body with cable release, Fuji Velvia pushed one stop, evaluative metering at zero: 1/180 sec. at *f*/11

Working at 120mm, I needed to do everything possible to eliminate lens shake. After mounting the 2X teleconverter behind the 600mm F4, I rebalanced the load by moving the plate forward in the quick-release jaws. Since the bird remained in one spot, I locked the head tightly and used a cable release.

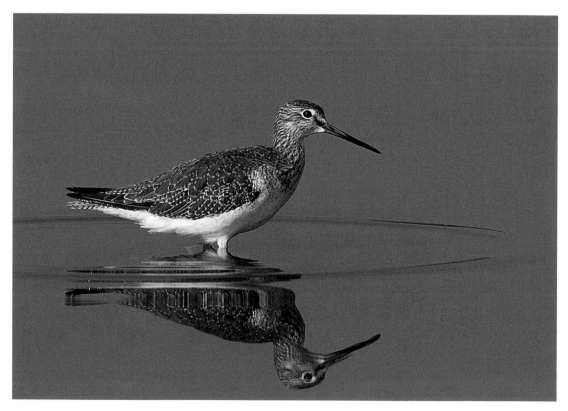

Releasing the Shutter

Many top professionals strongly recommend using an electronic (or, with older cameras, a mechanical) cable release to minimize camera body shake for all types of nature photography at all shutter speeds. When it comes to bird photography with long lenses, however, I strongly disagree. When you're working at 1/60 sec. or faster, it is absolutely best to depress the shutter button with your index finger.

There are several reasons for this. Even the sturdiest and most durable camera systems rotate a little between the camera mount and the lens mount. By holding the camera firmly in your right hand and pressing your cheek firmly against the camera back when depressing the shutter with your index finger, you'll reduce all movement of the camera body and dampen the vibrations from mirror slap, as well. You can gain added sharpness, especially when shooting

Cable Releases

These are devices that fire the camera's shutter, thereby eliminating camera shake or the vibrations that occur when you manually depress the shutter button with your finger. There both are mechanical and electronic cable releases; the former are primarily for older camera bodies, while the latter are for most modern cameras. Optional radio-activated shutter releases are available for some high-tech cameras.

The main disadvantage of using a cable release is that it doesn't allow you total control. You can't make tiny, last-minute adjustments in framing, and you can't dampen vibrations manually by placing your left arm atop the lens and pressing your cheek against the camera back. It is usually best to use a cable release only when working with stationary subjects and very slow shutter speeds (less than 1/60 sec.).

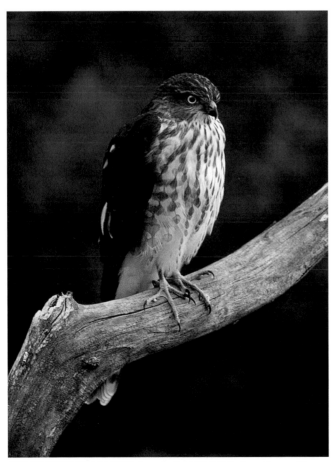

SHARP-SHINNED HAWK, Jamaica Bay Wildlife Refuge, Queens, New York. Canon FD 800mm F5.6L lens with 50mm extension tube and T-90 body, Kodachrome 64, center-weighted average metering at zero: 1/15 sec. at f/5.6

To make a sharp image at 1/15 sec., I used a cable release and a Kirk leg support. This is a sort of fourth leg that goes from one of the tripod's upper leg sections to the camera-body plate; it has a leg clamp at one end and a tiny ball head at the other. It takes quite a bit of care and time to set up and lock this accessory, but without mirror lock, you don't have many other options when shooting at this slow a shutter speed.

at relatively slow shutter speeds, by steadying the lens by placing your left hand and forearm atop the lens barrel directly over the tripod head. Alternatively, you could also support the lens from below with the thumb, pointer, and middle fingers of your left hand, while resting the heel of that hand on the mounting foot of the lens forward of the tripod head.

Both of these recommendations work because mass equals stability. By holding the camera, you'll be adding your mass to the mass of your camera, lens, tripod, and ball head. Sharper images will result. In addition, holding the camera body gives you more control, and a feeling that the camera and lens are an extension of your body. Birds are far too active to allow the successful use of cable releases—even when perched, birds are constantly shifting their position. By using your finger to release the shutter, you'll be far better able to get in tune with the rhythm of a bird's movements, and to make minute adjustments in framing and composition, while increasing sharpness at the same time.

Watching photographers using cable releases with long telephoto lenses makes me chuckle, especially on breezy days. They remind me of someone flying a kite. By holding onto your camera body and lens as explained above, you can also reduce or eliminate vibrations caused by the wind. Having said this, however, I do often use a cable release to fire the shutter when I'm photographing roosting birds with a long telephoto lens and a 2X teleconverter at shutter speeds in the 1/60 to 1/125 sec. range.

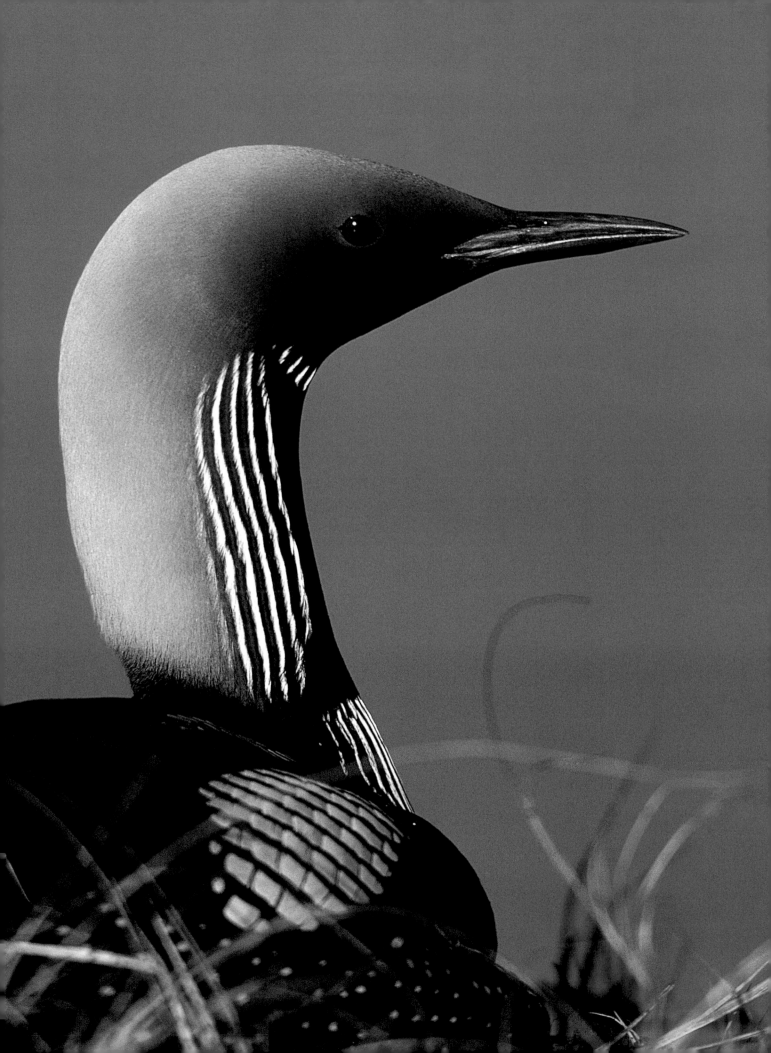

Chapter Seven

DESIGNING THE IMAGE

While being born with an artistic eye is a plus for all photographers, designing pleasing nature images is a skill that can be learned, and then developed and enhanced over time. When I began photographing in 1983, I plunked every bird dead-center in the frame. In early 1984, I signed up for an eight-session introductory nature photography course offered by the New York City Audubon Society. The instructor, Milton Heiberg, taught the basics of composition in just 15 minutes and did a superb job of answering my main question: "Where *do* you put the bird?"

When "putting" the bird in the frame, you don't, of course, actually move the bird—wouldn't that be nice? Simply shift your camera up or down, right or left. Shifting the camera up will reposition the bird lower in the frame; shifting it a bit to the right will reposition the bird more to the left in the frame, and so on.

The rules of composition are not hard and fast rules; they're only guidelines. Once you've established your basic composition, you can adjust the bird's placement slightly and then depress the shutter button. You are the artist. Of course, there'll be many times when you must compose, focus, and shoot in a matter of seconds. In these instances, you must rely on both your experience and your artistic instincts to come up with a satisfactory photograph.

PACIFIC LOON, Churchill, Manitoba. Canon EF 600mm F4L lens with 1.4X teleconverter plus 25mm extension tube and EOS 1N body, Fuji Velvia pushed one stop, evaluative metering at zero: 1/640 sec. at *f*/5.6

Over the course of seven sunny mornings, I made over a thousand images of this beautiful, cooperative loon; this is one of my favorite compositions.

Horizontal Composition

If you thumb through a field guide, it is easy to see that most birds, such as loons, grebes, ducks, geese, swans, gulls, terns, rails, sandpipers, some birds of prey, and most songbirds, are horizontally oriented. Most are two to three times longer than they are tall. If you get close enough to these birds to fill more than half the frame with them, you should almost always choose to work in horizontal format.

THE RULE OF THIRDS FOR HORIZONTAL COMPOSITION

When the image of the subject, in this case the bird, is small in the frame, divide the frame in thirds both horizontally and vertically. Place the bird at one of the four points of intersection created by these invisible lines. By placing the bird at one of these four points, you give it room in the frame. A visit to any art museum will reveal that this principle has been guiding artists for centuries. Placing the bird in the center of the frame may be fine for field-guide portraits, but it yields static compositions.

As you move closer and closer to a bird, it will take up a larger and larger portion of the frame. It quickly becomes impossible to follow the rule of thirds. To achieve a pleasing composition in these situations, simply *keep the bird out of the center of the frame*. In most cases, you should leave more space *in front of the bird* (between its

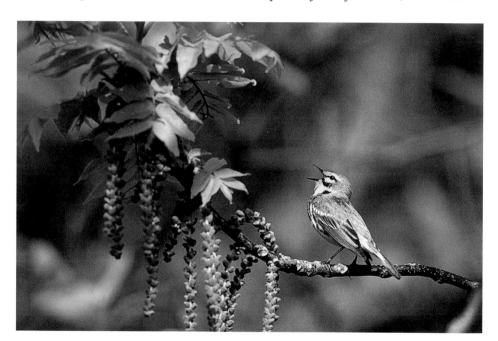

MALE PRAIRIE WARBLER, Higbee's Beach Wildlife Management Area, Cape May, New Jersey. Canon FD 800mm F5.6L lens with 50mm extension tube and T-90 body, Fuji Velvia pushed one stop, center-weighted average metering at zero: 1/500 sec. at *f*/5.6

The rule of thirds works perfectly when photographing subjects that are small in the frame and in an attractive habitat. Good images of birds in full song with their heads thrown back are hard to make but easy to sell.

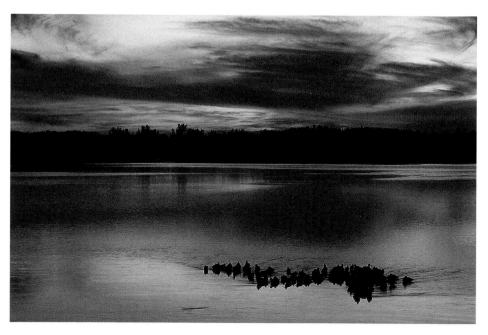

WILLETS AT SUNSET, Ding Darling National Wildlife Refuge, Sanibel Island, Florida. Canon EF 28–105mm F3.5–4.5 zoom lens at 28mm and A2 body, Fuji Velvia pushed one stop, evaluative metering +1/2 stop: 1/60 sec. at *f*/8

The rule of thirds works well with horizontal birdscapes. I made this photograph with mirror lock and a two-second timer.

bill and edge of the frame) than behind it (between its tail and the edge of the frame). By giving the bird this room, you'll be able to have your photograph depict more of the bird's world as the bird sees it.

Realize, also, that there's a difference between centering the bird—a poor compositional practice—and placing the bird's eye in the center of the frame. If a bird occupies about half the frame, centering its eye will yield a pleasing composition because the bird's tail will fall fairly close to the frame edge behind it and its bill will fall a good distance from the frame edge in front of it. As for top-to-bottom placement of the bird in the frame, anywhere from a third to halfway up in the frame usually works well. This positioning also depends on the foreground and background elements, as well as on the photographer's personal style.

When photographing large subjects, such as gulls, terns, or herons, you may get close enough to some very tame birds to make head-and-shoulder portraits, or even head shots. These opportunities present difficult compositional problems. As a starting point, center the bird's eye and place it from halfway to two-thirds of the way up in the frame. Then, depending on the length of the bird's bill and the size and shape of its head, fine-tune the composition until it looks pleasingly balanced.

Pay special attention to the negative space in the photograph. Negative space refers to the space not taken up by the bird's image. When making head-and-shoulder portraits, it is important not to let the negative space overpower the bird's image; there should be balance in the composition. This principle is true for other types of images, as well; the negative space shouldn't dominate the photograph.

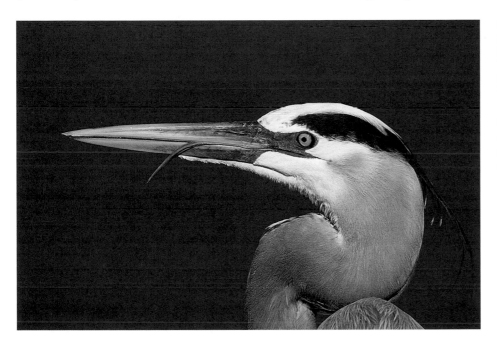

GREAT BLUE HERON, Venice Rookery, Florida. Canon FD 800mm F5.6L lens with 75mm of extension and T-90 body, Fuji Velvia pushed one stop, center-weighted average metering at zero: 1/500 sec. at f/5.6

Composing pleasing images is difficult when you're making horizontal head shots of birds. As a starting point, make sure to place the bird's head on or above the horizontal centerline.

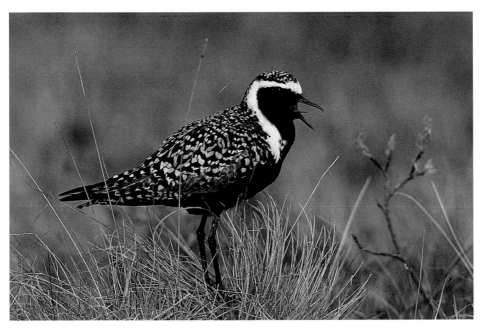

AMERICAN GOLDEN-PLOVER, Churchill, Manitoba. Canon EF 600mm F4L lens with 1.4X teleconverter plus 25mm extension tube and EOS 1N body, Fuji Velvia pushed one stop, evaluative metering +1/3 stop: 1/250 sec. at f/5.6, Better Beamer flash extender, fill flash at -2/3 stop

By keeping a bird even just slightly out of the center of the frame when you're working in horizontal format, you'll create compositionally interesting photographs. Here, the small plant balances the composition.

Vertical Composition

Years ago, shooting verticals was far more difficult than shooting horizontals; the single shutter button was in the wrong place. This made shooting in vertical format unnatural. Properly aligning the camera body was (and still is) difficult. However, many modern camera bodies do offer vertical grips as either standard or optional features. Vertical grips make shooting in vertical format easy. And, using a double bubble level mounted in the camera's hot shoe will help you avoid any alignment problems.

Families of birds that are tall, rather than long, are best handled in vertical format; cormorants, herons, egrets, bitterns, some long-legged shorebirds, woodpeckers, flycatchers, and most perched raptors all fall into this category. But since horizontals are so much more convenient to shoot, novice photographers often try to stuff these tall birds into horizontal frames, rather than fitting them easily—and pleasingly—into vertical ones. In addition, for photographers hoping to market their work, shooting verticals is even more important; by making images of the same subject in both formats, you give editors a choice. And, there's always a demand for well executed verticals as cover art.

More than 90 percent of the vertical photographs that you make will feature vertical-portrait compositions; they'll be your vertical bread-and-butter shots. To design a pleasing vertical-portrait composition, simply position the bird on the vertical centerline, equidistant from the top and bottom of the frame. You may want to move the bird down a bit in the frame if the image has "cover potential," to provide room for a magazine or book title, or, occasionally, either up or down a bit to include other compositional elements (see the lefthand photo opposite).

JUVENILE BLACK-CROWNED NIGHT-HERON, Jamaica Bay Wildlife Refuge, Queens, New York. Canon FD 800mm F5.6L lens with 25mm extension tube and T-90 body, Fuji Velvia pushed one stop, center-weighted average metering +1/3 stop: 1/90 sec. at *f*/5.6

When working in vertical format, it is often best to place the subject on the vertical centerline. Here, however, I chose to place the bird well off the vertical centerline. Though this young night-heron was resting peacefully, and I was well concealed in a permanent blind, it never took its eye off me for an instant.

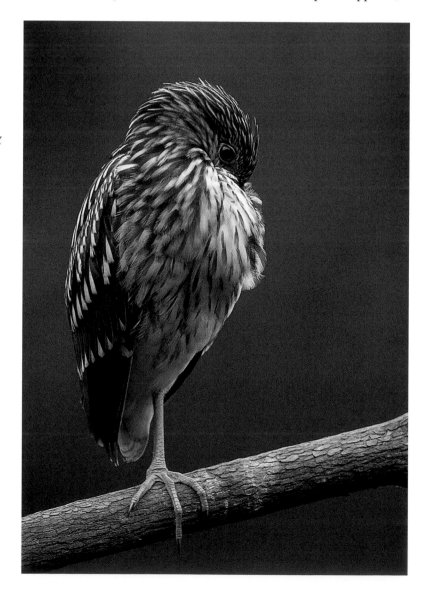

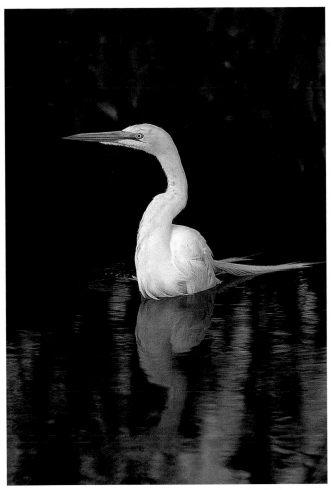

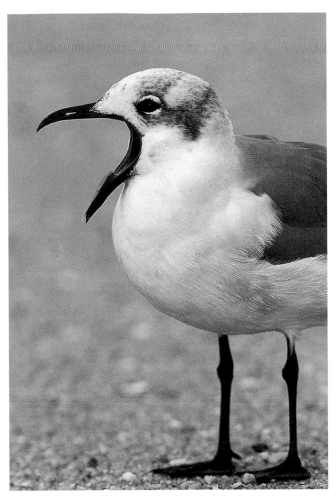

GREAT EGRET, Anhinga Trail, Everglades National Park, Florida. Canon EF 600mm F4L lens and EOS 1N body, Fuji Velvia pushed one stop, evaluative metering -1/3 stop: 1/500 sec. at f/5.6

Choosing to work in vertical format is generally best when photographing herons and egrets. Here, I placed the bird on the vertical centerline and made sure to include the complete reflection in the image.

LAUGHING GULL (WINTER PLUMAGE), Sunset Beach, Cape May, New Jersey. Canon EF 600mm F4L lens with 25mm extension tube and EOS 1N body, Fuji Velvia pushed one stop, evaluative metering at zero: 1/1000 sec. at f/5.6

When framing vertical front-end compositions such as this, fit the whole bird from top to bottom into the frame, then cut off the rear of the bird just behind the legs. And at all times, strive to capture the peak of action.

At times, you may choose to alter the composition by moving the bird off the vertical centerline.

When shooting tight vertical close-ups of a bird's head, put the bird's eye or eyes on the vertical centerline about a third of the way down in the frame. Whether the bird is facing you or looking to the side, this will yield a good, basic composition. If the bird, however, has a long, straight bill, you may be forced to move the bird off the vertical centerline toward the frame edge behind it, so as to include the bird's head and entire bill in the frame. In any case, you may, depending on the shape of the bird's neck and upper body, have to do some fine-tuning to ensure that your composition is balanced.

Sometimes, when you're close to a fairly large bird that is roughly parallel to the film plane, you may wish to use the vertical format to show fine details in the bird's plumage— even though it means cutting off part of the rear half of the bird. You may be able to create a pleasing image by

choosing what I call a *vertical front-end composition*. To do this, you place the bird's eye on, or slightly forward of, the vertical centerline, a quarter to a third of the way down in the frame; then, adjust your side-to-side framing, making sure that you leave some space behind the bird's legs.

THE RULE OF THIRDS FOR VERTICAL COMPOSITION

When a bird, whether it be tall or long, is small in the frame and you want to use vertical format, divide the frame in thirds both from side to side and from top to bottom, as you would for a horizontal composition, and place the subject at one of the four points of intersection. In over a decade of photographing birds, I've taken less than a handful of vertical images featuring small-in-the-frame subjects; I've always found it easier to work in a horizontal format (although I may have missed some good opportunities for making cover photographs that include lots of attractive habitat in the background).

Background

If the subject is positioned against an uncluttered background or if there's a cluttered background well behind the subject, telephoto lenses—with their narrow angles of view—and the shallow depth of field that comes with the use of wide apertures, will produce lovely soft, out-of-focus backgrounds. I'll take still blue water or well-lit green foliage every time.

Shooting wide open (at your lens' widest aperture) heightens this effect; with image size constant, it is the size of the aperture, rather than the length of the lens, that determines depth of field. Large apertures, such as $f/2.8$, $f/4$, and $f/5.6$, minimize depth of field and reduce background detail. Conversely, small apertures, such as $f/16$ and $f/22$, maximize depth of field and increase background detail.

When there are leaves and branches or other background elements on the same plane as, or just behind, a bird, they become integral background components. Depending on the configuration of these elements, and their position relative to the subject, they can either ruin or enhance an image. The colors and intricate patterns of stalks and leaves can certainly add to the beauty of your photograph, and in addition, they depict the bird's natural habitat. You can frequently maximize these positive effects by altering your composition, or by increasing your depth of field to ensure that these additional elements are in sharp focus.

It is, however, always best to avoid photographing birds against severely cluttered backgrounds, even if those backgrounds are some distance behind the subject. The best example of a cluttered background would be a jumble of twigs and branches, some dark and others white, without bark. In some cases, you can eliminate distracting elements by changing your position, moving left or right or up or down. For example, if you see a bright white seashell in your viewfinder just above the back of the gull that you're photographing, you could "hide" the shell behind the bird by lowering your tripod. If you're unable to clean up the background by changing *your* position, you'll have to wait for the bird to move slightly and hope that it doesn't fly away.

With a cluttered background immediately behind the bird, you have big problems. At times, it is best not to take any photographs at all. Note that dark shadows on an otherwise well-lit background can also ruin an image, especially if they fall directly behind the bird's head and the bird has a dark or black bill; you may lose the bill, which merges with the dark background and cannot be seen. You may be able to improve your results in these situations by shifting your position slightly.

Patches of light sky can also ruin otherwise pleasing images, as the viewer's eye tends to be drawn to the lightest section of a photograph. You can sometimes eliminate these light areas by raising or lowering your tripod in an attempt to get the sky completely out of the frame. Training yourself to really see the background when you're focusing on an incredibly beautiful bird just yards away is a difficult task. However, by doing so, you'll greatly improve the quality of your work.

If a bird is at rest, you can see the background as it will appear in the photograph by utilizing your camera's depth-of-field preview button or stop-down mechanism. (Remember: If you're shooting wide open, what you see, depth-of-field-

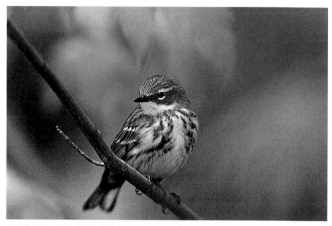

YELLOW-RUMPED WARBLER, Comber Woods, Ontario. Canon EF 600mm F4L lens with 1.4X teleconverter plus 37mm of extension and EOS 1N body, Fuji Velvia pushed one stop, evaluative metering at zero: 1/90 sec. at $f/5.6$, Better Beamer flash extender, fill flash at -1 stop

The softly focused green canopy of leaves framing this female warbler contributes greatly to the image's artistic success.

WATERFOWL AND WORLD TRADE CENTER AT SUNSET, From Jamaica Bay Wildlife Refuge, Queens, New York. Canon FD 400mm F4.5 lens and A1 body (handheld and supported by beach debris), Kodachrome 64, center-weighted average metering +1/2 stop: 1/500 sec. at $f/4.5$

I've made many wildlife images that incorporated the Twin Towers as another element of the composition. This, the most artistic of them, has also been the best selling.

wise, is what you'll get.) When shooting at small apertures, you can actually *see* how much of the photo is in sharp focus by activating the depth-of-field preview feature. Distracting background elements are much more obvious when you view the image stopped down. When checking depth of field at very small apertures in this manner, the image will at first appear very dark, so give your eye 10 or 20 seconds to adjust, and you'll easily be able to pick out the distracting background elements.

OTHER ELEMENTS OF COMPOSITION

The more you photograph birds, the more you'll find yourself including various pebbles, rocks, boulders, blossoms, lily pads, leaves, logs, limbs, fences, fence posts, pilings, and an assortment of other objects (both natural and man-made) in your images. By giving thought to the positioning of these elements in the frame and to the spatial relationship between these objects and your subject, you can use them to add to the compositional strength of your slides—rather than detract from it.

The spatial relationship between a bird and a stationary object can change only if the bird shifts its position. You, however, can make the object *appear* to change its position relative to the bird by changing your position left or right or up or down. For example, if a distracting twig appears several inches behind the head of a perched landbird that is facing to your left, you can "move" the twig from behind the bird's head by moving to your left.

Interesting and significant photographs can be made if an object that is included in the frame relates to some aspect of the bird's natural history. Consider, for example, a dunlin standing next to a horseshoe crab, a crossbill on a pine cone, or a warbler drinking from freshly dug sapsucker wells. It is always best to focus on the bird; if the object isn't on the same plane as the bird, it is the *object* that is slightly out of focus, not the *bird*. On some occasions, it is possible to frame your subject with foreground compositional elements. If you're shooting through a small opening in a tree, for example, the out-of-focus leaves will form a green halo around your subject—provided that you've carefully lined up the shot and ensured that your line of sight to the subject is unobstructed.

SNOWY EGRET CHICK, St. Augustine Alligator Farm, St. Augustine Beach, Florida. Canon EF 500mm F4.5L lens with 37mm of extension and EOS 1N body, Fuji Velvia pushed one stop, evaluative metering at zero: 1/125 sec. at ƒ/4.5, Better Beamer flash extender, fill flash at -1 1/3 stops

Most newborn heron and egret chicks look alike. To help the viewer identify the species of this chick, I chose to include the black legs and diagnostic yellow feet of the adult snowy egret in the composition.

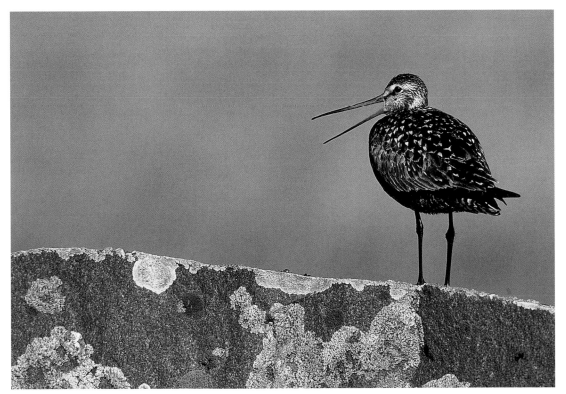

HUDSONIAN GODWIT, Churchill, Manitoba. Canon EF 600mm F4L lens and EOS 1N body, Fuji Velvia pushed one stop, evaluative metering at zero: 1/640 sec. at ƒ/5.6

I was eventually able to make large-in-the-frame photographs of this bird. However, it was the wider shot shown here— taken while I approached— that proved to be the most artistic, because it included a good portion of the lichen-covered boulder.

Perspective

In photographic terms, perspective refers simply to the position from which you view the subject through your lens and the way the image looks to you from that position. Though it is generally best to photograph birds from their eye level, I work most often standing behind my tripod, even when I'm photographing birds on the ground. Remember, however, that I'm usually working at 840mm, and the longer the lens, the shallower the viewing angle.

While working from a standing position, a photographer with a 400mm lens might be shooting down at the bird at an angle of 30 degrees. On the other hand, a photographer with an 800mm lens working with the same bird (at the same image size) would be shooting downward at an angle of only 15 degrees. In the image made with the 400mm lens, from a higher perspective, it would appear as if the photographer were shooting down at the subject; the image made with the longer lens would be much more pleasing, because it would seem as if the image had been made from just above the bird's level.

As a general rule then, the shorter the lens, the more important it is to get low down when you're photographing birds on the ground; the lower your position, the shallower the viewing angle. There are several ways to lower a tripod. The fastest and simplest way is to release the leg tab on the forward leg and pull up on that leg, moving it forward and reducing the angle between it and the ground; by lowering the tripod head even a foot or so, you'll significantly

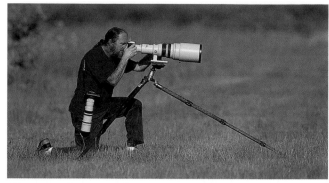

Shortening the two rear legs on your tripod and then pulling the forward-facing leg further forward is a good way to reduce your shooting angle by roughly half. The chiggers present at this site made sitting in the grass an unattractive proposition. (Photo courtesy Joanne Williams)

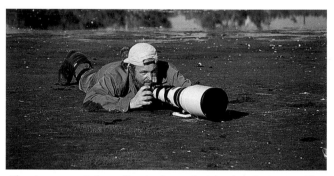

If you've never tried crawling in the mud with a long lens, try it. You may not like it, but your photographs will improve. (Photo courtesy Milton Heiberg)

SEMIPALMATED SANDPIPER (JUVENILE PLUMAGE), Jamaica Bay Wildlife Refuge, Queens, New York. Canon EF 600mm F4L lens with 1.4X teleconverter and EOS 1N body, Fuji Velvia pushed one stop, evaluative metering +1/3 stop: 1/500 sec. at ƒ/5.6

Getting down on the ground with a telephoto lens and shooting wide open can make for surreal images. Both the foreground and background will be completely out of focus, and only the bird will be sharp.

reduce the viewing angle. You can get even lower by shortening all three tripod legs so that you can kneel behind your camera; or, shorten them even more so that you can sit behind the tripod. Shortening the tripod legs will give you a more stable platform than keeping them long and splaying them.

To get right down to ground level, you'll need a tripod with either a very short center post or no center post at all. Few tripods are designed for extreme low-level work. My preference with long lenses is to place them *directly on the ground.* I simply take my camera and lens off the tripod and rest the lens on the sand, dirt, grass, or mud, supported only by the mounting foot and the attached mounting plate. Images taken from ground level are most pleasing. Both the background and the foreground are thrown completely out of focus, and the resulting images often border on the surreal with the sharp image of the bird bathed in a soft-focus halo. Always keep in mind, however, that you are the artist and can also, at

times, create unusual images by shooting straight down at your subject, or choosing to photograph from other unusual perspectives.

In general, photographing birds that are high above you won't yield pleasing images. By standing well back, and using your most powerful optical set-up, you can reduce the viewing angle. To gain an even better perspective, shoot from as high a position as possible; look for small mounds or rises on which to set up your tripod and then extend the legs so that your tripod is at maximum height. Do this even if this means you'll be working on tiptoe. Standing atop a small step stool can also help. As a last resort, raise the centerpost.

It is also possible, on rare occasions, to completely change the background by changing your perspective. To find a completely new perspective, it isn't necessary to compose through the lens. By simply taking a few steps to either side, or getting down on one knee, you can often find new shooting angles.

 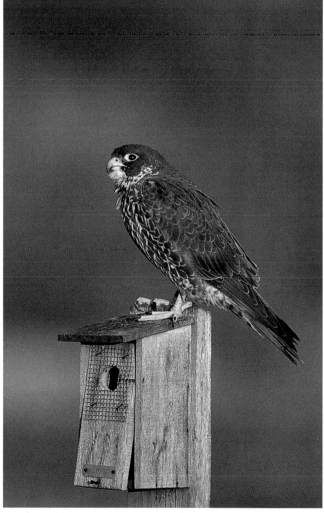

IMMATURE PEREGRINE FALCON, Jamaica Bay Wildlife Refuge, Queens, New York. Canon FD 800mm F5.6L and T-90 body, Fujichrome 50 pushed one stop, center-weighted average metering at zero: 1/250 sec. at *f*/5.6

I made the image on the left, with the predominantly blue background, while standing behind my Gitzo 410 tripod. By lowering the tripod and then kneeling behind it, I was able to change my perspective and come up with the background of out-of-focus reeds in the righthand image. Golden, late-afternoon light added drama to each photograph.

Less Is More

Though I have no formal training in art, I have, over the years, learned a lot about designing pleasing images of natural history subjects. Basically, what I've learned is that less is usually more. The nature photographer's task is to make order out of chaos. Most of my favorite photographs feature just a bird, a perch, and a background of pure color.

Careful framing is vitally important, as well. Always avoid cutting off a bird's feet with the frame edge when the whole bird can fit comfortably in the frame. Almost always leave some room at the edge of the frame around both the subject and the other elements of composition. When shooting small flocks of birds, strive to include the entire group in the frame; avoid cutting individual birds in half unless you're photographing a section of a huge flock as a pattern. Avoid including unusually bright or dark areas, especially behind the subject's head and on the edge of the frame.

Photographs of individual birds must feature balanced compositions. When working in vertical format, be sure not to leave too much negative space at the top of the frame. Sometimes, it is possible to place the subject on one side of a horizontal frame and balance the composition with another element, such as a bush, a rock, or even just a block of color. You must balance photographs of two birds, as well, with a bird on either side of the frame; you can achieve this balance even if one bird is entirely out of focus.

Straight or curved lines can either enhance an image compositionally or ruin it. You can use them to frame or set off your subject, to lead the viewer's eye around the photograph (angled lines often do this best), or to divide the frame pleasingly. When shooting birdscapes, you shouldn't place the horizon line in the center of an image unless the top and bottom portions of the photograph are equally interesting or dramatic. Horizon lines are generally best placed from a quarter to a third of the way up or down in the frame. Lastly, straight lines that cut through the subject or protrude from it can be absolute image killers.

BELTED KINGFISHER, Anhinga Trail, Everglades National Park, Florida. Canon EF 600mm F4L lens and EOS 1N body, Fuji Velvia pushed one stop, evaluative metering +1/3 stop: 1/500 sec. at *f*/5.6

The angled line of the perch leads the viewer's eye straight to the bird. Keep in mind that simple compositions are often best and that less is often more.

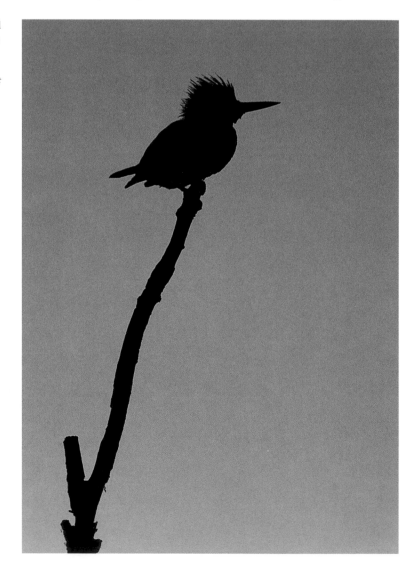

Choosing Subjects Wisely

When you're just getting started in bird photography, you'll be eager to make photographs of each and every bird that you can approach closely. But, as your work improves, you'll begin to notice that not all birds of a single species are equally beautiful. Most noticeable will be differences in the condition of birds' plumages. Most adult birds wear two sets of feathers each year: breeding plumage and nonbreeding plumage. Juvenile birds have a different, distinctive set of feathers for the first few months of their lives.

When feathers are newly grown, a bird is said to be in fresh plumage. New, unworn feathers will appear brightly colored, and the feathers of birds in fresh juvenile plumage will exhibit a warm, evenly patterned look. Birds in fresh plumage make ideal subjects, but as time goes by, feathers

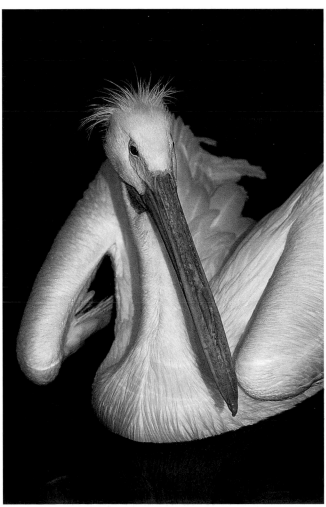

WHITE PELICAN, Placida, Florida. Canon EF 400mm F5.6L lens and A2 body (handheld), Fuji Velvia pushed one stop, evaluative metering at -1/2 stop: 1/500 sec. at ƒ/5.6

The pelican's bill, angled as it is against the lines of its partially raised wings, makes this vertical composition a powerful one.

are subject to wear and become bleached by the sun. In addition, birds that are molting may look particularly disheveled. Dull, shabby individuals generally make less-than-desirable subjects, but if a field-guide publishing project requires an image of a worn, molting second-winter herring gull, it wouldn't hurt to have a sharp, well-composed image of one in your files. Most artistic images, however, usually feature birds in fresh plumage.

Many species of birds, especially ducks, wading birds, shorebirds, and some songbirds, are more attractive in breeding plumage, which is brightly colored and patterned, than they are in winter plumage. At the height of breeding plumage, the soft parts (bill, lores, feet, and legs) of many herons and egrets also become brightly colored. Birds at the height of breeding condition make excellent subjects. In any plumage, though, individual birds that have dirty, soiled feathers or stains, mud, crud, or bits of food on their bills (or any other unsightly imperfections) won't make good subjects. At certain times of the year, for example, some herons and egrets exfoliate (peel off) the horny sheaths that cover their bills, making them unattractive subjects. As you gain experience in bird photography, birds with these types of imperfections will become more and more obvious, and you'll strive to photograph only birds in excellent condition.

The beauty and condition of the bird, however, are not the only factors that determine the success of an image. A stunning bird in perfect feather photographed with impeccable technique by someone with an artistic eye would seem to guarantee a great image, but it doesn't. There are a host of factors that can ruin sharp, perfectly exposed, well-composed photographs of beautiful birds:

1. The light is coming from the wrong direction.
2. The quality of light is poor.
3. The bird's face is poorly lit.
4. There are shadows falling on the subject's face.
5. The background is cluttered or contains distracting elements.
6. The background, or the perch on which the bird is sitting, is grossly unattractive.

Always strive to find an attractive bird in nice light in an attractive setting. The most difficult lesson to learn in nature photography is when *not* to take a picture. It is something you learn only with experience, though even then, not easily. As photographers, we travel to faraway places and carry long lenses. And, we want to shoot lots of film. But, we must learn to recognize poor situations and walk away from them.

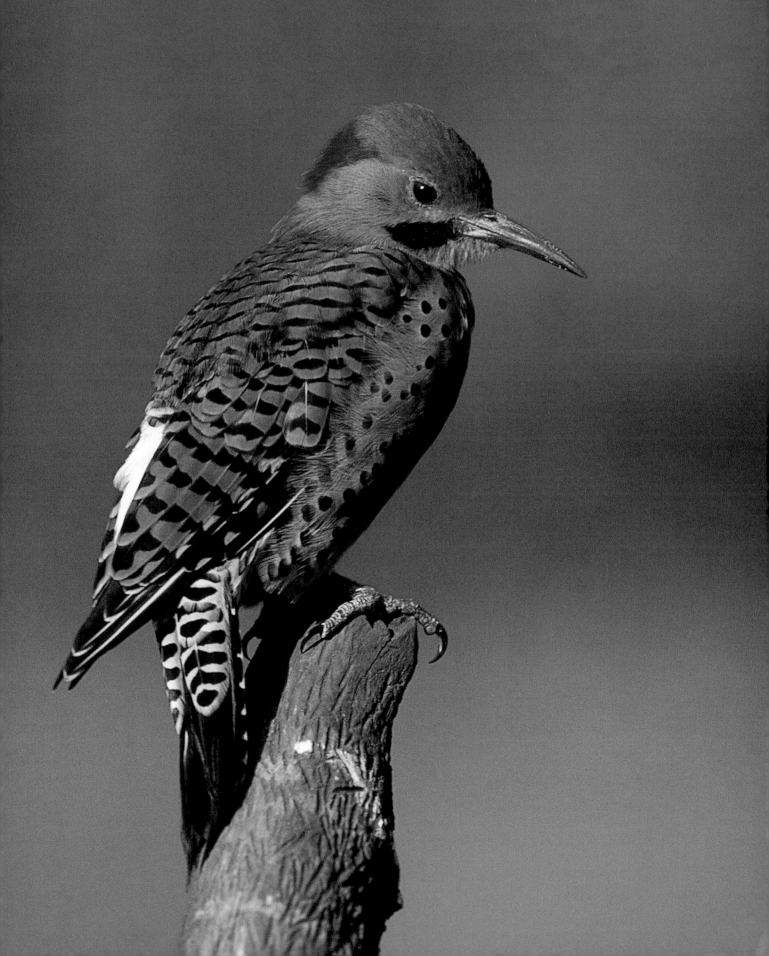

Chapter Eight # GETTING CLOSE

In 1983 I decided to become a bird photographer. I knew even then that spending hours, even days, in cramped blinds—the classic approach to bird photography—was not for me. I also knew that birds are wary, jittery, jumpy creatures not easily approached. Undaunted, however, I set out with my first telephoto lens (the Canon FD 400mm F4.5). I knew nothing about photography, but with six years of intensive birding under my belt, I did know a lot about birds and bird behavior. My initial photographic attempts were pathetic at best; those dots on the slides, were they birds?

Nevertheless, I was determined to succeed. I soon found myself laying on my belly in black muck, no-see-ums covering the backs of my hands, crawling toward a young least sandpiper. More than a decade and one major spinal surgery later, I find myself back on my belly in the mud (only this time with the state-of-the art Canon EF 600mm F4 lens) crawling toward yet another juvenile least sandpiper.

By spending lots of time in the field, observing, thinking, getting low to the ground, and moving slowly, I was soon able to get close to my subjects without using a blind. Modern birders, armed with the finest in optical equipment, are able to study feather edgings, lateral crown stripes, and even eye-ring colors at considerable distances. Wildlife photographers, however, don't enjoy this luxury; they must often make approaches inside of 20 or 30 feet. I'll do just about anything to get close enough to make a good photograph, as long as I don't unduly stress the bird that I am approaching. There are a variety of techniques to use for getting close to free, wild, and unrestrained birds.

NORTHERN FLICKER, Jamaica Bay Wildlife Refuge, Queens, New York. Canon FD 800mm F5.6L lens with 50mm extension tube and T-90 body, Fuji Velvia, center-weighted average metering at zero: 1/250 sec. at f/5.6

During late August and September, I've spent hundreds of hours in the permanent blind at Big John's Pond. After the passage of cold fronts, southbound migrant songbirds and accipiters often join the usual cast of immature and adult night-herons.

The Slow Approach

This sounds simple, and it is. It works best with birds that are preoccupied with feeding, preening, bathing, or even sleeping. After spotting a subject in an attractive setting, lift your tripod-mounted telephoto rig off your shoulder prior to beginning your approach; bend at the knees and ease the tripod onto the ground. Do this slowly; slinging a tripod-mounted super telephoto setup off your shoulder is the surest way I know of to spook most birds. Next, grasp your tripod's two rear legs and lift the entire rig so that the upper sections of the rear legs rest against the right side of your upper chest. Take a few slow steps, pause, then take a few more. Slow down even more as you get closer to the bird.

If the bird adopts its alert posture or sounds its alarm call, freeze. Continue your approach only when the bird becomes accustomed to your presence—when it resumes preening, feeding, bathing, or sleeping. I cannot stress enough the importance of moving ever-so-slowly, quietly, and carefully. (I pride myself on almost always being able to approach my photo-tour participants so soundlessly from behind when they're in the field that they're often startled when they finally perceive my presence.)

It is an excellent practice to stop and take a few frames during your approach. Photographs taken at intermediate distances serve two purposes: they allow the bird to become accustomed to the sound of the shutter and winder, and they depict the bird's habitat far better than tighter shots. As you get closer, take only a step or two at a time, firing off a few frames each time you pause. Under the right conditions, a slow approach can result in head-and-shoulders portraits of your quarry. On bad days, though, most birds will flush (fly away) as you take your first step.

If you carry a short zoom lens in your vest pocket, you'll be able to take wide habitat shots that include the bird, or birds, in the frame *after* making tight shots with your long lens. Handhold the camera for these shots. Make absolutely sure that you lock the tripod head before taking your camera body off the telephoto lens; if you don't, your now unbalanced long lens might wind up on the ground or in the water.

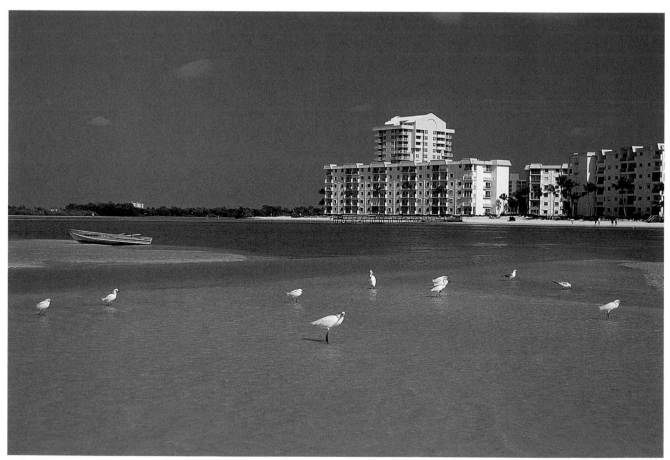

REDDISH EGRET (WHITE PHASE) WITH SNOWY EGRETS, Little Estero Lagoon, Fort Myers Beach, Florida. Canon FD 50mm F3.5 macro lens and T-90 body (handheld), Fuji Velvia pushed one stop, center-weighted average +1/3 stop: 1/250 sec. at *f*/11

After getting the close-up photographs that I want (opposite), I sometimes remember to make a few wide images, as well.

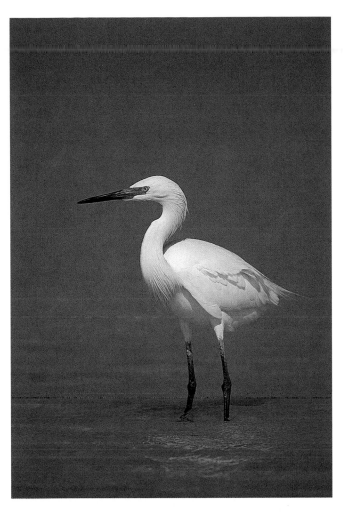

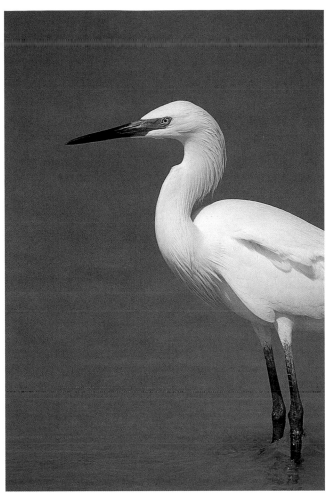

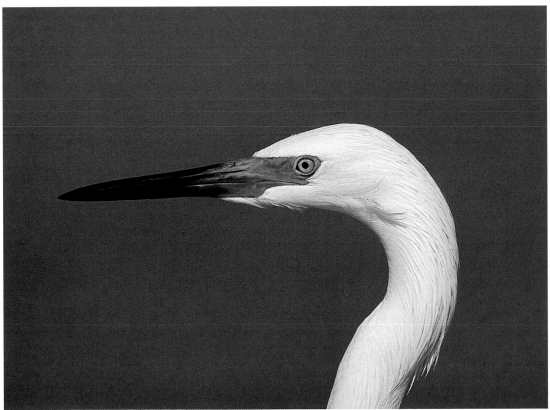

REDDISH EGRET (WHITE PHASE), Little Estero Lagoon, Fort Myers Beach, Florida. Canon FD 800mm F5.6L lens with 0mm, 25mm, and 75mm of extension respectively (clockwise from top left) and T-90 Body, Fuji Velvia pushed one stop, center-weighted average metering at zero: 1/1000, 1/1500, and 1/1000 sec. respectively at f/5.6

Close, closer, and closer still. I'm usually so anxious to get close to a beautiful bird that I rarely make any wide shots at all until after I've gotten the tight shots that really excite me.

The Low Approach

The lower (and slower) your approach, the better. With its legs suitably adjusted, carefully maneuver your tripod in front of you while walking on your knees or waddling like a duck. When on rocks and jetties, or when going down a slope, advance while seated. When I'm working low on grass, sand, or mud, I prefer—because of my bad knees—to advance while seated. If you're on level ground, it may be best to crawl on your stomach toward the subject.

You can mount any telephoto lens on a tripod with a short center post for ground-level shooting, but I find this setup cumbersome. With my manual focus 400mm lens, I used to mount the rig in reverse on a Slik pan-tilt tripod head and shove the locking handle into the mud for stability. With my two monster lenses, the 600mm F4 and the 800mm F5.6, I simply remove the lens from the tripod head, place the foot of the lens—mounting plate and all—in the sand, dirt, or mud, and begin advancing.

Crawling on your belly can be wondrously effective with gulls, terns, and shorebirds, and often works well with other birds in flat, open areas. You can use elbow and knee pads to lessen the discomfort sometimes encountered when working on sand, gravel, or pavement. Top grade rain pants ("skins" to a fisherman) effectively keep mud off clothing while working around ponds, creeks, or marshes. In most instances, the images you'll attain shooting at the bird's level are far more pleasing visually than those taken from above or below.

When you're on the ground fighting to get your eye to your viewfinder, leveling your camera can be nearly impossible, so using a double bubble level in these situations can make your life a lot simpler.

In the sand with sanderlings at Sunset Beach, Cape May, New Jersey. Getting low usually means getting closer; the birds will often approach you. (Photo courtesy Debbie Pankonin)

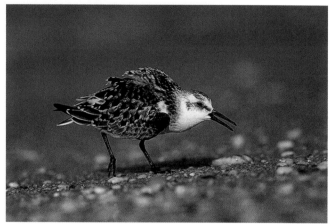

JUVENILE SANDERLING DEFENDING FEEDING TERRITORY, Sunset Beach, Cape May, New Jersey. Canon EF 600mm F4L lens with 25mm extension tube and EOS 1N body, Fuji Velvia pushed one stop, evaluative metering at +1/3: 1/640 sec. at f/5.6

I spent four hours on each of eight consecutive September mornings photographing sanderling behavior. As many as a dozen sanderlings fed along a gentle surf, with the more aggressive individuals defending their temporary feeding territories against others of their species. As long as I was seated, the birds ignored me completely.

Ethical Considerations and Field Behavior

Bird photographers need to be aware that their actions can have adverse effects on both the birds they're attempting to photograph and the environment their subjects inhabit. You must study your subjects and come to know them well. Learn their body language. Learn their tolerances. Approach a bird once, twice, three times. If your attempts are unsuccessful, find another subject.

Take extreme care when photographing birds at rest or at the nest. Nesting birds will sometimes abandon their eggs if approached too closely or if disturbed repeatedly. Breaking branches or otherwise removing vegetation to get a clear shot may expose the nest to the heat of the sun or to predators. Even tying back branches temporarily will leave the human scent at the nest site,

and this may attract predators. For these reasons, my personal and ethical preference is to avoid searching for and photographing nesting songbirds; I've photographed only one active songbird nest in my life.

In parks and refuges, know and follow the rules. Stay on the path if so indicated, be careful when traversing fragile habitats, and respect the rights of other photographers and birders. To further ethical considerations, initiate discussions of field practices and ethics at camera clubs, photographic associations, and natural history societies. Talk about these subjects at length with photographer friends. And, in the field, always ask yourself the following question before you act: How will my actions affect the birds, the environment, and others?

Shooting from Blinds

While I prefer to approach my subjects unconcealed and on foot, there are times when it is desirable, even necessary, to use a blind. Permanent blinds, usually fixed wooden structures, are often built adjacent to ponds or feeding stations, or at strategic locations in seabird colonies. In many cases, they offer consistently good, if not consistently spectacular, photographic opportunities. It is often impossible to photograph notoriously shy and skittish birds, such as ibises, grouse, larks, and longspurs, without being hidden in a blind. Using a blind can also reduce stress on nesting birds.

Many photographers, working on their own property, or with permission to photograph on privately owned land, build semi-permanent blinds in order to photograph birds at feeders, at water, or at the nest. There are nearly as many types of blind constructions as there are photographers building blinds. The most spectacular examples may be the 60- or 70-foot high scaffold blinds sometimes erected near owl, hawk, or eagle nests. Though I've never even set foot in a semi-permanent blind, I do hope, one day, to spend a few winters in Michigan photographing cardinals and titmice in the snow from a blind that I've constructed.

Also available from several suppliers are portable blinds made from tear-proof fabric on foldable frames. They can be carried fairly easily into the field and set up quickly in desirable locations. They usually require the use of a small stool or folding chair inside and are most always quite cramped. I haven't had much luck with my portable blind; it seems to scare birds away! I've used it, though only in public areas where it isn't feasible to leave a blind in place for several days to allow the local birds to become acclimated to it.

This is the view from the permanent blind at Big John's Pond at Jamaica Bay Wildlife Refuge in Queens, New York. The two-pronged perch that you see in the center of the photo lasted two years and was my absolute favorite. Fellow photographer Johann Schumacher and I spent an hour setting it in place and lining it up so that we'd have beautiful green backgrounds; the whole tree trunk must have weighed more than a hundred pounds.

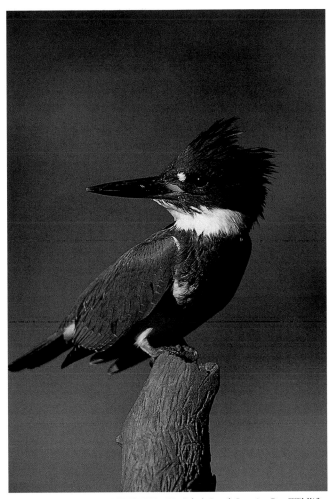

FEMALE BELTED KINGFISHER, Big John's Pond, Jamaica Bay Wildlife Refuge, Queens, New York. Canon FD 800mm F5.6L lens with 50mm extension tube and T-90 body, Fuji Velvia, center-weighted average metering at zero: 1/180 sec. at *f*/5.6

With my surgically repaired back and type-A personality, I much prefer permanent blinds to cramped portable ones, in which you must sit, confined. At Big John's Pond, it may, at times, be hours or even days between good photo opportunities.

On the other hand, I find drop-cloth or bag blinds to be quite effective. These are large cloth covers with eyeholes and a lens cutout or sleeve. You can sew one yourself from several square yards of camouflage cloth or purchase one; Rod Planck Photography and DB Design both offer excellent models. When you find a spot where roosting birds fly away no matter how carefully you approach, but then quickly return when you back off, you'll want to use a bag blind. You can try draping the blind over yourself and your outfit and maneuvering slowly into position, but I've found that just walking up to your preferred spot and getting under cover works just as well. In some situations, the birds have returned even before I've had time to make myself comfortable.

You can, in a pinch, jury-rig makeshift blinds from a great variety of materials, including large appliance boxes (you can stand in a refrigerator carton), canvases, drop cloths, tents and tent poles, ladders, broom handles, steel rods, broken branches, and dead vegetation. You can use gaffer's tape, rope, wire, or even vines to hold everything together.

On occasion, it is possible to conceal yourself behind naturally occurring features. Possibilities include, for example, hiding behind the trunk of a large fallen tree to photograph a family of baby owls, or nestling down between huge boulders to photograph gulls, terns, or shorebirds roosting on a jetty. Many years ago, on a blustery fall day at Jones Beach State Park on Long Island, New York, I noticed that migrant northern flickers kept landing in a small, bare tree. Setting up less than 40 feet away, I concealed myself behind a bayberry bush among the tall phragmites (reeds) and waited. Not only did the flickers continue landing, but they were soon joined by a merlin. Both of these species are usually extremely wary, but on this day, they were unaware of my presence.

Using Your Car as a Blind

Using your car as a blind can be a great way to get close to birds and other wildlife. This technique is especially productive when visiting national wildlife refuges or other locations that have auto-tour routes on which the birds are accustomed to vehicles. This approach can also work well anywhere that birds congregate regularly along the edges of dirt or paved roads, lanes, streets, avenues, or even interstate highways (thank you very much, officer).

There are several options for steadying your camera outfit when shooting from a vehicle. The simplest method entails resting the front end of your telephoto lens on a partially raised window; however, because a lens is round and the edge of a window is flat, it is difficult to keep the lens from rotating. Resting the lens on a pillow, large beanbag, or even a folded towel or sweatshirt placed on the partially raised window is far more effective. For additional stability, tuck your left arm against your body, bracing it against your thigh, if possible, and wedge your right elbow against the steering wheel.

This technique offers great maneuverability; it is easy to point the lens at subjects well ahead of (or behind) the car and to follow the action. And, by raising or lowering the window, you can easily photograph birds that are considerably above or below eye level. When you must travel long distances between photo opportunities, or at speeds of greater than 10 miles per hour, simply place your outfit on the passenger seat atop a pillow. Be sure to uncouple the camera body from the lens to prevent damaging the lens mount.

A somewhat unusual, but very effective, method of supporting your lens involves setting up a tripod inside your vehicle on the driver's side. I've even used the massive

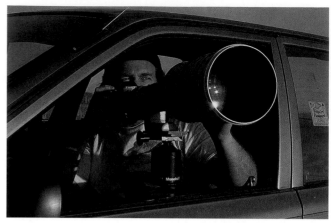

At times, you can use your car as a blind as I did here at the gull colony in Captree State Park on Long Island, New York. I'm in my first Toyota Corolla with my 800 F5.6 lens, the old Arca Swiss ball head, and a Groofwin Pod. (Photo by Elaine Belsky Morris/BIRDS AS ART)

Gitzo 410R tripod inside my Toyota Corolla. It takes a bit of doing, but it's well worth the effort; the convenience of working on a ball head is a real plus. When working this way, you can avoid the real pain of arm muscle fatigue that occurs when you're supporting a good part of the weight of your outfit. To set up your tripod in the car, follow these (not-so-simple) steps:

1. While seated at the wheel, with the driver's side door open, slide one leg of your tripod into the back seat by inserting it between the left edge of the driver's seat and the driver's-side door post.
2. Lower the window and close the door gently; then, position the tripod head just above the completely lowered window.
3. Extend the tripod leg in the back seat as necessary before locking it. Also extend and lock the leg that points toward the front of the car; this leg should be as close to the driver's-side door as possible and rest on the floor, well to the left of the brake pedal.
4. Release the third tripod leg and raise it so that it is parallel to the floor of the car, and position it so that it is roughly parallel to the dashboard. Extend it until it presses firmly against the passenger-side door. On some vehicles it is possible to brace the leg in that door's handle recess.
5. Now lock this last leg, mount your camera and lens onto the tripod, and proceed slowly in search of a suitable subject in good light. Note that, at this point, if you've correctly followed these directions, you'll be trapped in the driver's seat.

Another excellent (but simpler) way to support your outfit solidly in your car and still enjoy the convenience of using a ball head is with a heavy-duty window mount. Several models are available. I use the Groofwin Pod (ground/roof/window-pod), offered by L. L. Rue Enterprises. Others prefer the Kirk Enterprise window mount.

The Groofwin Pod is a versatile, sturdy, and stable platform which has a 9 × 1-inch lip that grabs either the window groove or the top of a partially raised window. It can be adjusted to fit virtually every automobile on the road and can be set up with the platform either inside or outside the vehicle. When you use the Groofwin Pod in conjunction with a quality ball head, you'll be able to make consistently sharp images. In addition, fatigue is sharply reduced, because the mount, not you, supports the lens during long shooting sessions. With your lens suitably supported, drive slowly up to your subject and turn off the car engine to eliminate vibration; then frame, focus, and fire away.

When photographing from you car, always observe all traffic laws, rules, and regulations. Don't drive so fast as to scare wildlife from the roadside. Respect the rights of birders and other photographers, and never leave your vehicle if others are observing a bird, or birds, at close range from their vehicles; this will most likely scare away the birds. Do scout a new location; a quick survey of the tour route when the sun is high in the sky can alert you to various photo opportunities so that you can take advantage of them when the quality of light improves in the late afternoon. Try to use your knowledge of bird behavior, habitat preference, and lighting conditions to anticipate the great opportunities that may lie just around the next bend in the road.

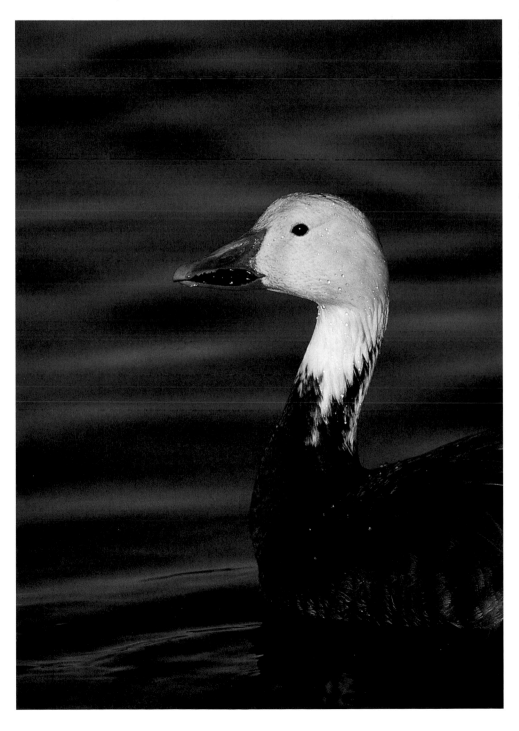

SNOW GOOSE, Bosque Del Apache National Wildlife Refuge, New Mexico. Canon FD 800mm F5.6L lens with 50mm extension tube and T-90 body, Fuji Velvia pushed one stop, center-weighted average metering -1/3 stop: 1/125 sec. at *f*/5.6

Cars make great movable blinds, especially at refuges with auto-tour routes. Here, I was able to make a head-and-shoulders portrait of a bird that is usually very difficult to approach.

The Thinking Photographer

By making careful field observations, and by being patient, determined, imaginative, and creative, you can take advantage of countless photographic opportunities that others overlook. Birds flushed from their roosts inadvertently, or while being approached, will at times quickly and repeatedly return to preferred perches, roosting sites, feeding areas, rainwater pools, abandoned prey, or partially scavenged carcasses. Don't lament when a bird shows you its tail feathers. Position your tripod, get as low as possible, and remain motionless; in a matter of minutes, you may be rewarded with a great photographic opportunity.

If you persevere, good photographic opportunities will eventually present themselves. I was in the middle of the vast Pawnee National Grasslands in Colorado at dusk one rainy day, peering at a common nighthawk resting on a fencepost and thinking about what might have been had the sun been shining. I drove two hours back to my motel in Ft. Collins, slept a few hours, and drove the two hours back to Pawnee. When I arrived at dawn, on what was a perfect morning, I found the same fencepost, amid thousands of others, with the same nighthawk sitting on it. Now that's a preferred perch! I walked right up to the bird and photographed it to my heart's content.

There are hundreds of situations that are tailor-made for bird photographers. For instance, flocks of shorebirds roosting in the lee of a dune, or crouching in fear of falcons overhead, may refuse to fly. Boats returning to fishing stations and commercial fish docks in late afternoon may attract hundreds of gulls and terns as the day's catch is cleaned or processed. Drakes of various wild species often mingle with eager mallards at duck-feeding ponds in winter. Gulls, terns,

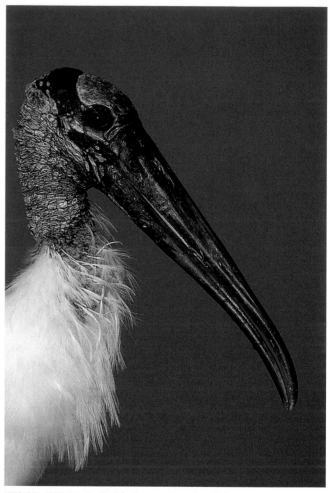

WOOD STORK, Red's Fish Camp, Lake Tohopekaliga, Florida. Canon FD 800mm F5.6L lens with 75mm of extension and T-90 body, Fuji Velvia pushed one stop, center-weighted average metering +1/3 stop: 1/500 sec. at ƒ/5.6

Images such as this leave most photographers wondering how I was able to get so close to a normally wary species. Obviously, they've never visited Red's Fish Camp, which boasts a good number of relatively tame wild birds.

I first found Red's Fish Camp while scouting the Kissimmee/St. Cloud area of central Florida. The crappie fishermen usually clean their catches during mid-morning hours. On weekends, there are always lots of fishermen and, therefore, lots of tame birds. Aside from the wood storks and great egret seen here waiting for a handout, many other bird species, including bald eagle, visit the generous anglers at various seasons.

shorebirds, and cormorants often become accustomed to the presence of humans after hundreds of dog walkers, surfers, tidepooling tourists, sunbathers, shell collectors, and fishermen walk by them each day without causing undue havoc. Hawks carrying nesting material will frequently fly the same route, back and forth, for hours. Warblers will feed unsuspectingly at active sapsucker wells, as will flickers at anthills, and tanagers at beehives. And, small landbirds singing from exposed perches will defend their territories even against 500mm lenses. My advice is to always look, see, think, and shoot.

It is generally best to approach single birds, or small groups, rather than large flocks; in most cases, if you scare or flush one bird and it sounds its alarm call, you'll flush them all. When approaching large flocks of roosting birds,

always work one end of the flock; you can often pick off individual subjects one at a time as the birds shift position in response to your approach. Likewise, when approaching tame groups of roosting birds, such as gulls, terns, or shorebirds, you may at times need to get the birds to reposition themselves; do this by approaching a bit more boldly than usual—but not so boldly as to scare the birds off.

Small birds often feel more secure when roosting with much larger birds. Greater yellowlegs are extremely wary birds that often roost in large, nervous flocks; they're usually very difficult to approach. Recently, however, I came across some greater yellowlegs roosting among a small flock of Canada geese. The much larger geese must have given the shorebirds a sense of security; I was able to get much closer than I ever had before.

WAYS TO INCREASE IMAGE SIZE

It is obvious, of course, that the closer you are to your subject, the larger its image size (the area covered by the subject) will be in the final photograph. Why, then, do I constantly see other bird photographers in the field failing to get as close as possible to relatively distant subjects? Why, while leading photo-tours, am I always the closest one to a completely tame bird, even though I have the longest lens? When you're fighting for image size, *always get as physically close to your subject as you can.* Getting even a single step closer will result in a considerable increase in image size. By learning to read the body language of ridiculously tame birds, you'll know when you can approach a subject more aggressively than usual.

It is also obvious that when you're shooting from a given position, the longer your lens, the larger your image size will be. What isn't so obvious, though, is the large increases in image size that come with relatively small increases in focal length. Consider two photographers shooting side by side, one with a 400mm lens and the other with a 500mm lens. It's obvious, one would think, that the 500mm lens would produce an image 1/4 (or 25 percent) larger than the 400mm lens. Well . . . not exactly. Image size is a function of the *square of the focal length;* 500/400 = 5/4, so 5 squared divided by 4 squared = 25/16. Since 25 - 16 = 9, the increase in image size is 9/16, or 56 percent. So, switching from a 400mm lens to a 500mm lens results in an image that is 56 percent larger—not 25 percent larger as originally thought.

It is also interesting to note that adding a 1.4X teleconverter to a 500mm lens results in a 96-percent increase in image size—nearly double! If you use a 2X teleconverter on any lens, the image will be four times larger. (To better visualize this, imagine a rectangular bird and double its length and height; the area covered by the subject will be quadrupled.) Lastly, few photographers realize that, even when they're photographing birds beyond the minimum focusing distance of their lens, they can attain significant increases in image size simply by mounting an extension tube between the lens and the camera.

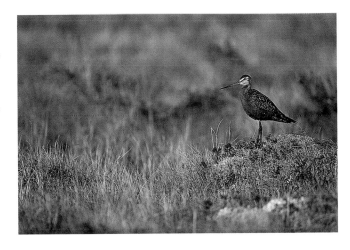

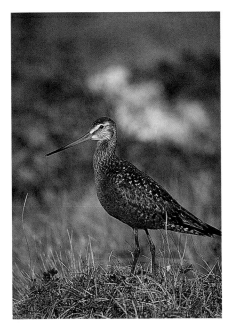
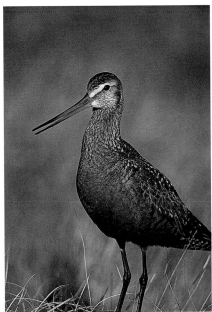

HUDSONIAN GODWIT, Churchill, Manitoba. Canon FD 800mm F5.6L lens with 0mm, 25mm, and 50mm of extension respectively (counterclockwise from top) and T-90 body, Fuji Velvia pushed one stop, center-weighted average metering +2/3, +1/3, and +1/3 stop: 1/500, 1/500, and 1/350 sec. respectively at ƒ/5.6

This handsome male godwit steadfastly stood its ground on its breeding territory and eventually allowed my close approach.

The Tame Ones

At times, a particular bird may allow you great freedom in approaching, as if it were a model being paid by the hour. The possible explanations for such cooperative behavior are many; understanding them can improve your photographic chances immeasurably. Most juvenile birds make good subjects; some are astoundingly tame. (Young birds of many species are easily distinguished by their evenly patterned upper parts, each feather distinctively fringed buff or white.) Newly arrived migrants from arctic regions may never have seen humans before, so they, too, often make wonderful subjects.

Weary, hungry migrants (their occurrences often storm related) are often so intent on resting, or feeding ravenously, that they're oblivious to all else. Birds summering far to the south of their breeding ranges can also be what I call "sitting ducks" (or loons, or grebes. . .). Though sick or injured birds are often easily approached, the resulting photos are usually—although not always—disappointing. (When photographing dead or dying birds, I try to make the images a tribute to both the beauty of the bird and to the fragility of its life.)

The images of countless cooperative birds often flash through my mind. The male hooded warbler that I followed for two hours through knotweed in New York City's Central Park tried to land on me several times! The juvenile stilt sandpiper on the East Pond at Jamaica Bay Wildlife Refuge preened, scratched, stretched, and just plain posed; when it finally flew away, I got up from the mud, glanced skyward, and thought what a privilege it was to have photographed that bird. The snowy owl that I had dreamed of finding in the dunes of Long Island flew away at my cautious approach; my heart sank, but it landed nearby and allowed me to photograph it until it was harassed by a gull and fled.

More recently, my memorable encounters have included the spectacular brown pelicans in breeding plumage at La Jolla, California; the great white heron on the causeway at Sanibel Island, Florida; the male cerulean warbler at Point Pelee National Park, Ontario; and the splendid female Pacific loon on her nest in Churchill, Manitoba. This remarkably tame and beautiful bird allowed several tour participants and their excited leader to photograph her at close range as she sat on her eggs, the picture of tranquillity.

Do's and Don'ts for Getting Close

The following do's and don'ts can help when you're in the field trying to approach wild, free, unrestrained birds.

- Do wear a cap on windy days; at close range, blowing hair can scare birds.
- Do wear your scroungiest attire; you will get dirty.
- Do remove the camera strap to prevent camera-strap flap (on windy days).
- Do, if possible, keep trees, bushes, utility poles, and even buildings between yourself and the bird while making your approach. When you pass such objects, keep them directly behind you to help break up your silhouette.
- Always be prepared; you never can tell when a photogenic bird will decide to sit down right in front of you for no reason at all!

- Don't feel that it's necessary to wear camouflage clothing.
- Don't forget to hose yourself down before going into the house after you've been crawling in black muck.
- Don't leave home without extension tubes; you'll soon be getting so close to birds that you'll need the tubes to reduce your lens' minimum focusing distance.
- If you take your vest off before beginning your approach, don't forget to put several rolls of extra film in your pockets.
- Never lift your tripod-mounted long lens quickly off your shoulder when you're close to a bird; for some reason, to most birds this is as threatening as if you were raising a shotgun.
- Never make rapid movements.

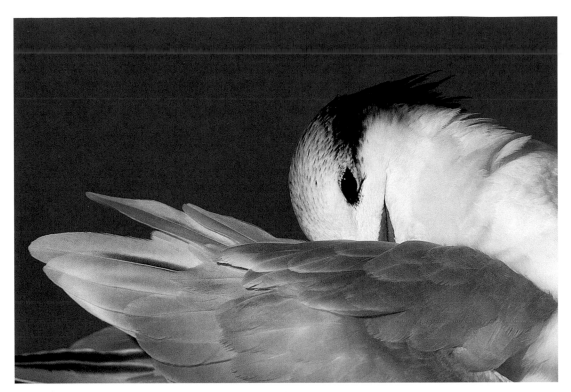

ROYAL TERN, Blind Pass, Captiva Island, Florida. Canon FD 800mm F5.6L lens with 100mm of extension and T-90 body, Fuji Velvia pushed one stop, center-weighted average metering +1 stop: 1/750 sec. at *f*/5.6

The 800mm F5.6 lens focuses only to 45 feet, so I needed a lot of extension to make this image. Hundreds of beachgoers are on the beach every day, and they acclimate the birds to human presence; with a careful approach, it is easy to get within yards of roosting gulls and terns.

WHOOPING CRANE, Lake Kissimmee, Florida. Canon EF 600mm F4L lens with 25mm extension tube and EOS 1N body, Fuji Velvia pushed one stop, evaluative metering at zero: 1/640 sec. at *f*/8

In the mid-nineties several dozen captive-bred whooping cranes were introduced into the wild at various central Florida locations. Most avoided humans, but one pair, defending a territory on the shores of Lake Kissimmee, was completely oblivious to fishermen, boaters, and bird photographers.

Attracting Birds in the Field

Nearly all my efforts afield are directed at getting close to the wild birds that I photograph, but there are a variety of ways to bring the birds closer to you. At Merritt Island National Wildlife Refuge near Titusville, Florida, I once placed a road-killed water snake on a crushed limestone dike in sight of several turkey vultures. I spent four hours in a hot car staring at the dead snake before giving up. The idea, though, was a good one, as food is the obvious number one choice in avian attractants.

On numerous springtime visits to southern Ontario, I've never had a good opportunity to photograph Baltimore orioles, despite the fact that they're a commonly seen species. During a phone conversation with photographer Tom Vezo, he suggested setting up an orange feeder. Bird feeding is, however, prohibited at Point Pelee National Park, so I tried Tom's idea at Comber Woods, about 25 kilometers north. The first orioles fed on my halved oranges less than 10 minutes after the setup was complete. They were soon joined by gray catbirds, rose-breasted grosbeaks, and several warblers as well.

I've also scattered packaged birdseed to attract a variety of sparrows and finches, and spread cracked corn for turkeys and ducks. I've tossed bits of white bread to gulls, handfed live bait fish to snowy egrets, and thrown thawed sardines to entice white pelicans. Some photographers smear peanut butter on tree trunks for woodpeckers and magpies, attract bluebirds with mealworms, put out grape jelly for wintering orange-crowned warblers, and feed bug-zappered bugs to a variety of insect-eating species (some photographers even freeze them for cold-weather use). Though I realize that some birders and ornithologists might disagree, I have no ethical problems with any of the above techniques, as all are commonly practiced by non-photographers and none are harmful to the birds.

I have, however, heard of a professional photographer who tied down live anoles with some monofilament fishing line in order to get some action shots of a red-shouldered hawk; I cannot, on a humanitarian (or it is reptilian?) basis, condone this or similar techniques. Such actions serve only to further damage the image of photographers in the eyes of both refuge managers and the public.

You have to be creative when setting up perches near feeders. Always select an attractive perch, and position it so that you can make the shot without *including the feeder in the image. It is generally best to use only a single perch, especially when attempting to photograph fast moving birds, such as orioles. Here, I put the large log in place because it made a much more attractive perch than the rusty metal railing on which it rested.*

BALTIMORE ORIOLE, Comber Woods, Ontario. Canon EF 600mm F4L lens with 1.4X teleconverter plus 37mm of extension and EOS 1N body, Fuji Velvia pushed one stop, evaluative metering +1/3 stop: 1/320 sec. at *f*/5.6, Better Beamer flash extender, fill flash at -1 stop

I had action within minutes of setting up my orange feeder (above) and spent several mornings photographing the orioles at this spot. They're very quick birds, and though I made lots of great images of orioles eating the oranges, I managed to get only this single frame of an adult male on my carefully erected perch above the orange.

On a short-term basis, you can attract a variety of landbirds to water, especially in dry regions or during droughts. These birds will come to drink or to bathe, so if you'll be in a given location for several days, it often pays to put out some water. Before doing so, however, always check out park or refuge regulations; providing water for wildlife is prohibited at some locations. If you get the go-ahead, simply hollow out a small pool—no more than two or three feet across at most—line it with some type of plastic sheeting, and fill it with water. It is best to completely cover the plastic with soil to prevent unsightly reflections and to make sure that the plastic sheeting doesn't appear in the photograph. Set up a perch above the pool; most birds will pause on it for a moment before going into the water, and after bathing, many birds will sit on your perch and preen, often for a few minutes or longer.

To bring in even more birds, many photographers set up water drips above their pools. Suspended from a limb above the water, a plastic two-liter soda bottle with a pinhole in the bottom can work well, but portable, outdoor camping showers are far better. They hold much more water and the drip rate can be controlled easily. It is the sound of the dripping water that, under the right conditions, will have birds lined up waiting to use your pool.

Many birds are attracted by human-made sounds as well. Birders regularly make squeaking sounds through pursed lips in the hopes of arousing the curiosity of secretive birds. Photographers can do the same by making any variety of squeaking or sharp peeping noises. If you see a bird skulking around in a deep tangle of branches and twigs, you must set your tripod down *before* making any noises; if birds respond at all, most will pop up only once. Friends have told me that I do a pretty good screech owl imitation (to which a variety of songbirds are supposed to respond vigorously).

I've tried it hundreds of times and never had a single bird pay any attention to my efforts, but still I keep trying. Screech owl tapes are also purported to work well, but I've never tried them.

Using bird sounds on audio tape or compact disc to lure birds into camera range is, however, a controversial subject. The use of species-specific recordings of bird songs does work, and it does work well. An increasingly large assortment of bird sounds are available on tapes and CDs. And there's also the option of recording the song of the very bird you're attempting to photograph and then playing the tape back in the field.

Cliff Beittel, a skilled photographer and oft-published student of mine, opened my eyes (and ears) to the use of prerecorded songs on a photo-tour to Churchill, Manitoba, several years ago. We were frustrated in our attempts to photograph Savannah sparrows around the Granary Ponds just west of town. Cliff whipped out his CD player, cued up the species' song, set the player down alongside an attractive perch on which we had previously noted several singing male Savannahs, and pushed the play and repeat buttons. We sat on the ground just 18 feet from the song-perch, and almost instantly a territorial Savannah sparrow came in to challenge the "rival male"—the CD player. Several other male Savannahs took their turns singing and posing on the post and on a lichen-covered rock nearby. After 20 minutes of superb opportunities, the action fizzled; the birds had tired of our antics.

In many parks and refuges, the use of sound recordings is not permitted. In addition, the use of tapes or CDs to attract endangered species is prohibited by law in all locations. Many biologists feel that using prerecorded bird songs on the breeding grounds should be taboo. Although, on the other hand, most have no problem at all with the

SAVANNAH SPARROW, Churchill, Manitoba. Canon EF 600mm F4L lens with 1.4X teleconverter plus 25mm extension tube and EOS 1N body, Fuji Velvia pushed one stop, evaluative metering at zero: 1/640 sec. at *f*/5.6

Many species of songbirds will respond almost instantly to recordings of their own songs. By placing the playback device near an attractive perch, such as this lichen-covered rock, you can make some lovely images of otherwise difficult-to-photograph birds.

use of this technique to attract *migrant* songbirds. In part, these concerns have arisen over the past two decades as small populations of rare or locally rare birds have been subjected to daily doses of their song by groups of birders eager to observe the species on territory; it is believed, by some, that male songbirds waste energy by defending their territories against tape recordings, rather than against intruding males of their own species.

I have no ethical problem at all with the judicious use of tapes or CDs to draw breeding songbirds into camera range; perhaps such use actually sharpens a bird's territorial defenses. Before you try it, however, be absolutely sure that you're not violating any local, state, or federal laws and that you're working in an area that is not visited regularly by other tape-toting birders or photographers; repeated use of tapes on breeding grounds *may* disrupt the birds.

JUVENILE COOPER'S HAWK, Cape May, New Jersey. Canon EF 600mm F4L lens and A2 body, Fuji Velvia pushed one stop, center-weighted average metering +1 stop: 1/320 sec. at ƒ/5.6

At Cape May in autumn, southbound migrant raptors will respond, often aggressively, to plastic owls mounted on antenna poles. This young accipiter was upset with Hootie, my plastic great-horned owl that is adorned with goose feathers.

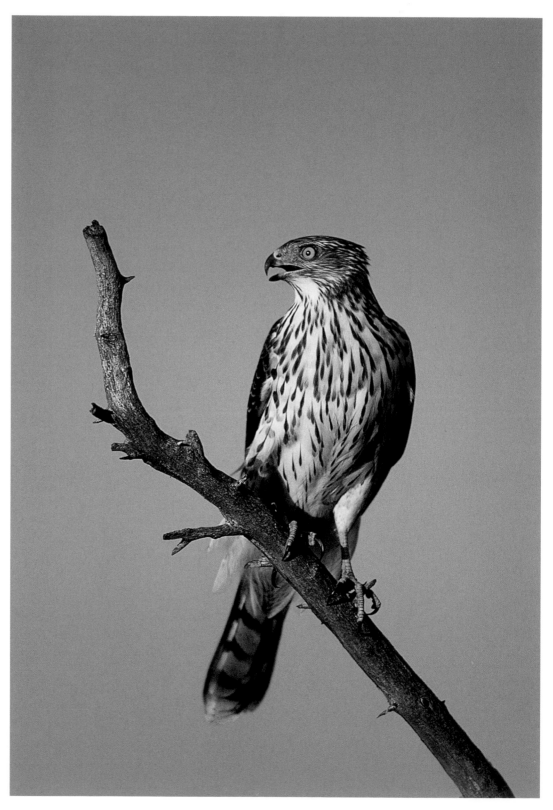

In Your Backyard

If you're clever, photographing birds in your backyard allows you far more control over subject position, lighting angle, foreground and background elements, and even the bird's choice of perch than you could ever hope for in the wild. If your backyard isn't blessed with bountiful, berry-bearing bushes, thick tangles of brush, and a small, noisy stream, you can easily introduce food, shelter, and water into the open spaces around your home.

In setting up your backyard for bird photography, planning is the key. I've seen countless feeders rife with birds that were practically useless for photography. Deep shade is usually the chief culprit. You should place feeders (or bird baths and water drips) so that they're lit by morning or afternoon sunlight. If possible, position a single feeder or water feature so that it is lit by both morning and afternoon light. Or, you can simply move hanging feeders or water drips from one spot to another to take advantage of better lighting conditions. If you have platform feeders or bird baths in various spots, you can cover the ones that get only morning light at around noon and then uncover the afternoon feeders and baths. Making these changes on a daily basis will help the birds to quickly adapt to the pattern.

Before determining the exact location of a feeder, it is important to consider where and how *you* will be positioned. You should consider the following questions: How long a lens will you be using? What is its minimum focusing distance, both with and without extension? Will you be standing, seated, or prone? Will you be shooting from an open house window or concealed in a blind? (There's a lot to be said for just remaining still in plain sight, as most feeder birds quickly become accustomed to the presence of humans.)

It is routinely possible to take (and successfully market) attractive photographs of birds on either store-bought or homemade feeders, but I much prefer to photograph them on natural perches. If you erect a perch in a sunny location near a feeder, or attach one to the feeder itself, incoming avian visitors will often alight on it. It is usually best to set up only a single perch; by prefocusing on that one perch, you increase your chances of making dramatic photographs.

Many well-lit, well-composed photographs of birds taken in backyards are ruined by harsh backgrounds. Take care to position perches and feeders against pleasing backgrounds; avoid clotheslines full of laundry and aluminum siding (among other things). If the birds ignore your perfect perch and persist instead in landing on an obstructed natural perch at the edge of your yard (most birds have a favorite), feel free to clip a few branches here and there to get a better view. In a national wildlife refuge this is a federal offense, but in your own backyard it's called pruning and is perfectly legal.

When photographing birds at window feeders, or birds such as hummingbirds that show little or no fear of humans, a short telephoto lens can be the right tool for the job. But, for general backyard bird photography, intermediate and long telephotos (often with 1.4X teleconverters) are best. There's no doubt about it: specifically tailoring your backyard to fit your photographic needs will present you with a great many opportunities to produce quality images.

Getting close to wild birds with a camera and a long lens can be difficult. It can be frustrating. It can be deeply disappointing. But, the rewards are sweet. Natural moments from the lives of wild creatures preserved on film can be enjoyed in solitude or shared with others. Photographers share not only these frozen moments in time, but also—in a very personal way—the lives of the birds they photograph, their environment, and their beauty.

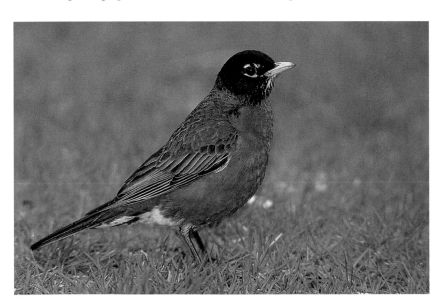

AMERICAN ROBIN, Point Pelee National Park, Leamington, Ontario. Canon EF 600mm F4L lens with 1.4X teleconverter plus 25mm extension tube and EOS 1N body, Fuji Velvia pushed one stop, evaluative metering at zero: 1/250 sec. at *f*/5.6, Better Beamer flash extender, fill flash at -1 stop

Making beautiful bird photographs is immensely satisfying, whether you're photographing in your own backyard or at wildlife refuges or national parks.

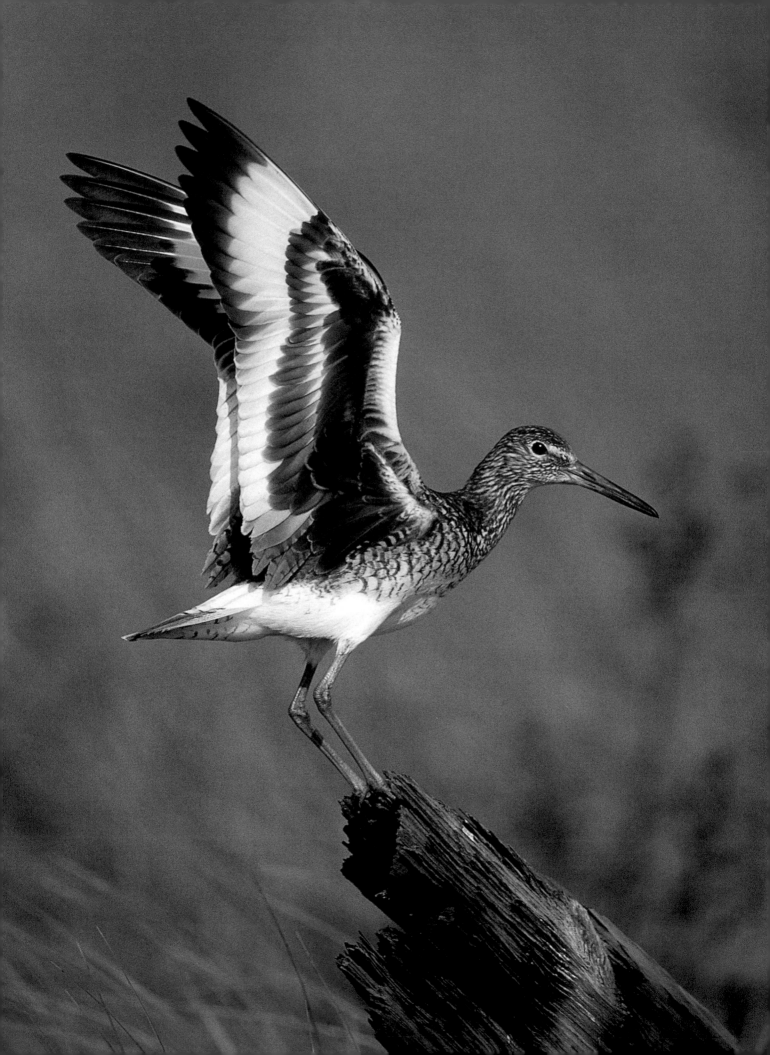

Chapter Nine

CAPTURING ACTION AND BEHAVIOR

Though a well-composed, technically perfect portrait of a perched bird doing absolutely nothing at all may make a fine image, a photograph of the same bird singing, calling, yawning, tipping forward, ruffling its feathers, crouching in fear, stretching a wing, landing, taking flight, flapping, soaring, staring at its toes (gulls and terns do this quite often—I have no idea why), feeding, or even just sleeping, will almost always be more interesting. The interest of viewers piques when they're provided with glimpses of a bird's daily routines. Furthermore, images depicting action and behavior reveal more about the subject than do static portraits, and implied motion adds excitement to any photograph.

It is obviously far more difficult to compose pleasing images when working with moving subjects than with stationary ones. Birds that are swimming, walking, running, or flying directly toward you often look best in the dead center of the frame. If a single bird is flying from right to left, put it on the right side of the frame (and visa versa); this gives the subject room to move into the frame. When photographing flocks of birds in flight, such as ducks, geese, and shorebirds, pan with the flock as you focus, just as you would when shooting a lone bird.

WILLET, Jones Beach State Park, Long Island, New York. Canon FD 800mm F5.6L lens with 25mm extension tube and T-90 body, Fuji Velvia, sunny $f/16$ -1/2 stop: 1/500 sec. at $f/5.6$

Don't try to conserve your film budget when photographing bird action and behavior. This oft-published image was the best in a long series of more than 20 exposures.

Anticipate the Action

There are countless instances when a knowledge of bird behavior can help you to anticipate the action. Sleeping birds, for example, often yawn on awakening and, after ruffling their feathers, often stretch a wing. A bird that has stretched one wing will almost always stretch the other wing next. And, birds that tip forward will often stretch both wings elegantly overhead and then take flight.

When photographing feeding birds, you should try to capture as many steps in the process as possible: foraging, grazing, picking, plucking, dabbling, diving, stalking, attacking, capturing, holding, subduing, and swallowing prey. Great egrets sway their necks in cobra-like fashion before grabbing a lizard or large insect. Most large herons and egrets take a drink immediately after downing a fish; like most birds, they must first dip their beaks into the water and then tilt their heads back to ingest it, so don't relax after an absolutely huge fish is finally swallowed—keep on shooting. Shorebirds often glance skyward to check for predators. After photographing this behavior, look up, and you might get a flight shot of a falcon. Be ready to shoot on cue.

When photographing flying, swimming, or foraging birds, using autofocus is, of course, a huge advantage. However, whether you're using autofocus or not, keep the tension on your tripod head rather loose so that you are easily able to follow the action and frame the image.

When shooting moving birds off a ball head, it is generally best to keep the horizontal pan locked; you'll make sharper images this way, because there's usually play (movement) between the ball and the housing when the horizontal pan screw is loosened. Some photographers, though, opt to loosen this control so that they can pan more easily as a bird walks, swims, or flies by. If you choose to do this, don't loosen the screw completely; keep it fairly snug.

When photographing flocks of flying birds, watch the flock expand, contract, and change its shape; when the birds create an interesting pattern, make the photo. When photographing small flocks, try to avoid making images when one bird blocks another; wait until the blocked bird comes clear. And, unless you're shooting part of a huge flock, avoid cutting off parts of birds at the edge of the frame.

Photographing birds that are swimming or flying directly at the camera with manual focus equipment is a real challenge at best. Rather than trying to keep up with the subject by constantly turning the focusing ring, some photographers attempt to prefocus at a given distance, then frame and follow the bird, and depress the shutter button an instant before the image becomes sharp. Good luck!

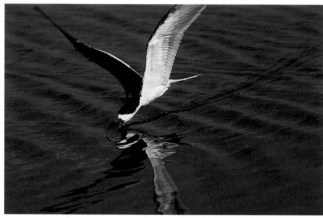

BLACK SKIMMER, Merritt Island National Wildlife Refuge, Titusville, Florida. Canon EF 400mm F5.6L lens and A2 body (handheld), evaluative metering at zero: 1/750 sec. at ƒ/5.6

One of the most difficult aspects of handheld flight shooting with autofocus equipment is panning fast enough to keep up with the subject. Failing to do so usually results in the subject being too far forward in the frame, as it is here. In this case, however, having the bird flying out of the frame left room for its wake and made for a well-balanced composition. Sometimes, it is better to be lucky than good.

BELTED KINGFISHER, Anhinga Trail, Everglades National Park, Florida. Canon EF 600mm F4L lens with 2X teleconverter, 12mm extension tube, 1.4X teleconverter, and EOS 1N body, Fuji Velvia pushed one stop, center-weighted average metering +1 stop: 1/1000 at ƒ/11

I have no memory of making this particular image, but I did push the shutter button when the unexpected action occurred.

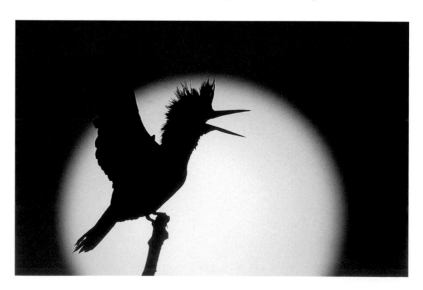

BE READY FOR THE UNEXPECTED

If you zero in on a bird and unexpected action occurs, *fire the shutter immediately*. Don't attempt to change your aperture or shutter speed; the action will be over before you finish making your adjustments. By shooting when the action occurs, you give yourself a chance to capture it on film. If your ball head isn't locked when the unexpected action occurs, you can reframe the image as the action occurs. Even if your tripod head is locked, you still have some flexibility in the setup; you can often make minute adjustments in framing by gently pressing on your camera body as needed. I call this "bending the lens" and do it quite often, even when shooting static portraits. It can save the day by allowing you to fit the entire bird into the frame rather than cutting off a wingtip or some tail feathers.

When photographing unexpected action without autofocus, you'll simply need to do your best to maintain focus. But with or without autofocus, it pays to make lots of images when photographing action; if you wait for the perfect shot, you'll often wind up not taking a single frame. When that gull yawns, a heron raises its crest, or a second bird flies into the frame, don't hesitate. Shoot fast and often.

Gull and tern nesting colonies offer wonderful opportunities to photograph unusual behaviors and birds in action. (To avoid stressing the birds excessively, work from a blind or from your car.) You'll learn a lot about the birds' breeding behavior, and what you learn will help you make better, more interesting images. When I lived in New York City, I regularly visited the gull colony at Captree State Park on Long Island from March through August. Hundreds of pairs of herring gulls and several pairs of great black-backed gulls nest annually in the area surrounding the auxiliary parking lot.

During March, the birds set up and defend their territories; violent confrontations are fairly common. In April, the interesting behaviors include nest building, courtship, and mating. Eggs are laid and incubated in June, with the first nests hatching at the end of the month. In July, the adults are busy protecting and feeding their fuzzy young. They're not, however, averse to eating their neighbors' chicks should the chance arise. Toward the end of the month, and throughout early August, the handsome fledglings begin spending more and more time away from the nest and more and more time testing and strengthening their wings.

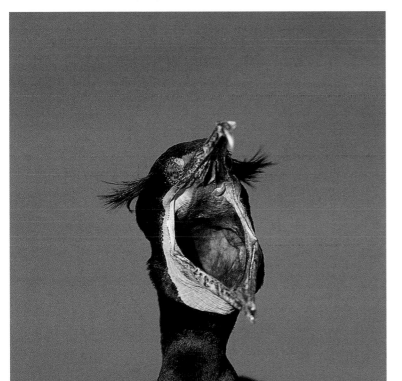

DOUBLE-CRESTED CORMORANT, Anhinga Trail, Everglades National Park, Florida. Canon EF 600mm F4L lens with 50mm of extension and EOS 1N body, Fuji Velvia pushed one stop, center-weighted average metering +1/3 stop: 1/320 sec. at ƒ/5.6

Using autofocus in this situation was not feasible; no matter which sensor I had selected, it would most likely have picked up the tip of the yawning bird's bill rather than its eyes. I was forced to "grip it and rip it," that is, to focus manually as best I could and then pray.

Selecting the Best Shutter Speed

To freeze the movement of a bird or birds in flight or in action, it is generally best to use the fastest possible shutter speed that lighting conditions and film choice will allow. By working in aperture-priority mode and selecting the widest lens opening, the camera will automatically set the fastest shutter speed. Shutter speeds of 1/1000 sec. and faster will freeze most action; at 1/500 sec., images of fast-flapping birds will show blurred wingtips.

When photographing behavior, however, you can choose slower shutter speeds; the smaller apertures that result will provide additional depth of field. So, when photographing bird behavior, you face a dilemma: Should you shoot at the fastest available shutter speed (by selecting the widest aperture) and attempt to freeze all movement, or should you stop down (and shoot at a slower shutter speed) for more depth of field? If a bird is at an angle to the film plane or if it stretches a wing, it is best to make the image at f/8 or f/11 and attempt to get enough depth of field to cover the whole subject and render the entire bird in sharp focus.

It is surprising to learn how often the relatively slow shutter speeds that result from choosing smaller apertures are fast enough to freeze motion. This is especially true when a bird's movements aren't quick. I've gotten some wonderful photographs of birds preening, even singing, at shutter speeds of as slow as 1/60 sec. And, if a bird ruffles its feathers, scratches itself, or takes off while you are

shooting at a slow shutter speed, take several frames. You may get one or more wonderfully blurred images, with the blurring accentuating the motion.

When using flash in conjunction with slow shutter speeds to photograph moving birds, two images will be recorded on the film: a sharp one, the flash exposure, and a blurred one, the image made by the ambient light. The

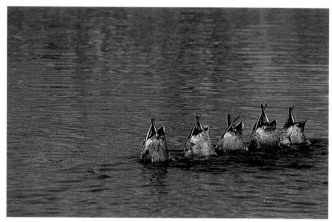

NORTHERN SHOVELERS TIPPING UP, Bosque Del Apache National Wildlife Refuge, New Mexico. Canon EF 600mm F4L lens with 1.4X teleconverter and EOS 1N body, Fuji Velvia pushed one stop, evaluative metering at zero: 1/500 sec. at f/5.6

Anticipating and capturing the peak of action is of utmost importance when photographing action and behavior. Here, I was following these five ducks as they paddled around haphazardly; suddenly, they were all in a line tipping up.

HERRING GULL (WINTER PLUMAGE) WITH SURF CLAM, Stone Harbor Point, New Jersey. Canon EF 600mm F4L lens with 1.4X teleconverter and EOS 1N body, Fuji Velvia pushed one stop, evaluative metering +1/3 stop: 1/800 sec. at f/5.6

When I photograph action, I work in aperture-priority mode and set the widest lens opening more than 95 percent of the time. This ensures the fastest possible shutter speed.

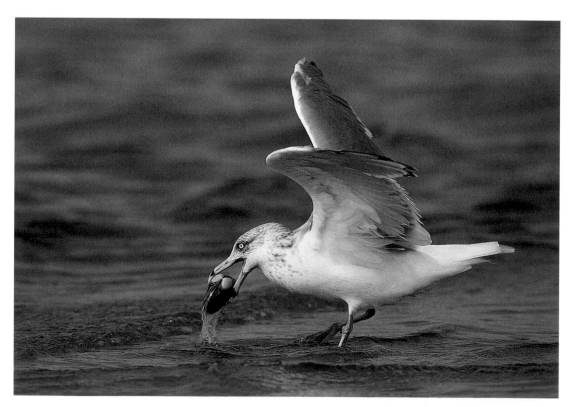

effect of the sharp image superimposed on the blurred one is called *ghosting*. In these situations, be sure to choose the rear-curtain synch setting, if your flash offers it; the blur of the moving subject will be *behind* the sharp image rather than in front of it, and the resulting photograph will look more natural.

You may want to try to make some surrealistic images by photographing birds in flight or action with shutter speeds in the 1/30 to 1/2 sec. range. Note that as subject-to-camera distance increases, blur due to subject movement decreases. In extremely low-light conditions, I like to think of surrealistic blurs as "necessary" if you're shooting at the fastest available shutter speed, and "intentional" if you're stopping down at all. You can even produce intentional blurs on sunny days by shooting at *f*/22 or *f*/32; using film that's slower than your normal film can also increase the blur and the surrealistic look.

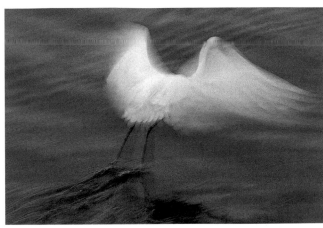

SNOWY EGRET, Ding Darling National Wildlife Refuge, Sanibel Island, Florida. Canon EF 400mm F5.6L lens and A2 body (handheld), Fuji Velvia pushed one stop, evaluative metering at zero: 1/30 sec. at *f*/11

I could have made this image at 1/125 sec. at f/5.6 but chose, instead, to shoot slower to increase the blurring.

GREAT BLUE HERON FEEDING NESTLINGS, South Venice, Florida. Canon FD 800mm F5.6L lens and T-90 body, Fuji Velvia pushed one stop, center-weighted average metering -1/3 stop: 1/125 sec. at *f*/5.6

Early morning light added drama to this image and mandated the use of a relatively slow shutter speed, which, however, was still fast enough to freeze the action. (Remember that blur due to subject movement decreases as camera-to-subject distance increases.) Of a long series, this image showing the pink mouth lining of one of the chicks was the best by far.

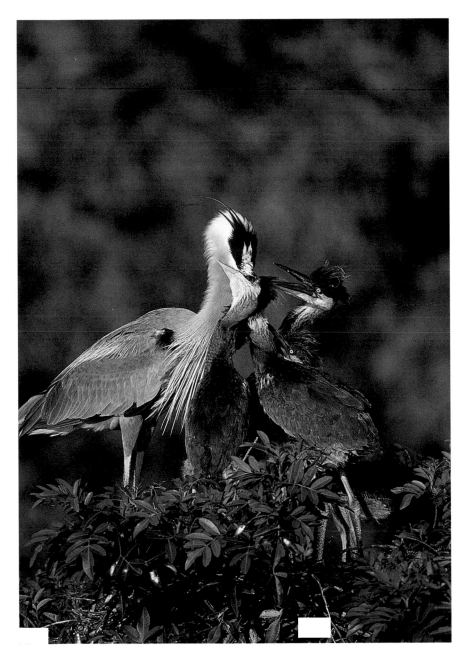

Keep Your Distance

When attempting to photograph bird behavior or birds in action, it is very important not to get *too close* to your subject. If you do, and the bird changes its position or stretches a wing, some part of the bird's body may become cut off by the edge of the frame. Even when making a portrait of a perched or standing bird, it is best not to get too close; I rarely have my subjects take up more than 3/4 of the frame. A bird must have some room in the frame—and so, for cropping purposes, must photo editors.

When photographing birds involved in territorial disputes, it is especially important to give yourself enough working room; their movements are often rapid and violent. Gulls often engage in brutal battles; even the victors often emerge with bloodied heads and broken feathers. Migrant shorebirds often squabble while defending small feeding territories on crowded mudflats. Both godwits and dowitchers, with their long bills, are especially well-equipped for such matches.

By resisting the urge to get closer while photographing aggressive behaviors, you'll find it easier to follow the action, to keep the birds in the frame, and to focus. Select one of the combatants and focus on its eye. If you're using autofocus, it is best (if possible) to choose an outside focusing sensor and attempt to maintain focus on one of the subjects, or to activate all the sensors. Remember to loosen the necessary tripod head controls so that you can follow the action easily. In these instances, a tripod will give you the vertical support you need. With short or intermediate telephotos, however, it is far easier to follow birds in flight and in action while handholding your outfit.

Be Patient

In late November more than a decade ago, I stood thigh-deep in frigid water in Long Island's Zach's Bay with my Canon FD 400mm F5.6 mounted on a Slik U212 tripod. On a wooden railing just 10 feet away, a western sandpiper slept peacefully. To increase my depth of field on this cloudy-bright day, I shot at 1/60 sec. at $f/13$ to ensure that the whole bird would be in sharp focus. When the bird awoke; I shot. When it scratched, I shot. When it preened its back, I shot. As it shook out its feathers, I shot. When it warily eyed a hunting peregrine, I shot. And I even changed film twice.

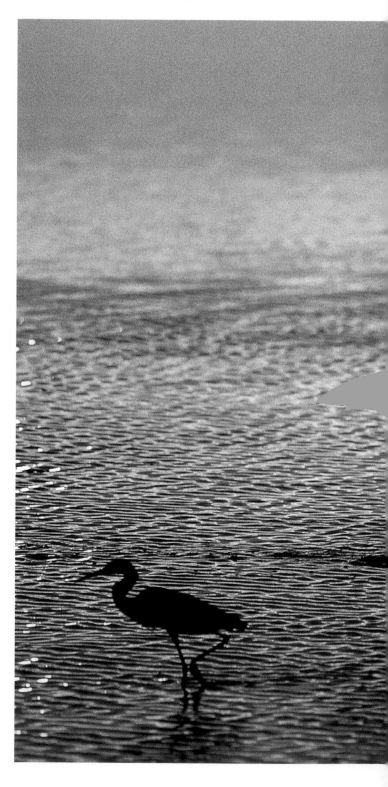

Young shorebirds can be ridiculously cooperative subjects. When you get close to a wild bird without disturbing it, you'll often be able, as the example below shows, to photograph it for an extended period of time. Remain still and keep your eye glued to the viewfinder; be assured that the instant you glance elsewhere, the bird

REDDISH EGRETS AND LITTLE BLUE HERON. Canon FD 400mm F4.5 lens and A1 body (handheld), Kodachrome 64, center-weighted average metering at zero: 1/500 sec. at $f/4.5$

I can remember my reaction after seeing this photograph for the first time as if it were yesterday; I jumped for joy. The image became my first Audubon Calendar credit and, years later, the logo for my business, BIRDS AS ART.

will do something spectacular. By being patient, you'll be able to make an interesting series of photographs depicting a variety of behaviors.

Taking good photographs that depict behavior, birds in flight, and birds in action is difficult. Many, if not most or even all, of your slides may wind up in the trash can. Yet, aside from the occasional astonishing image, there are many other rewards. Moments spent with a preening peep or a heron struggling to swallow a huge fish are not soon forgotten. You will witness some behaviors that many ornithologists would have trouble explaining and others that may never have been seen before by anyone.

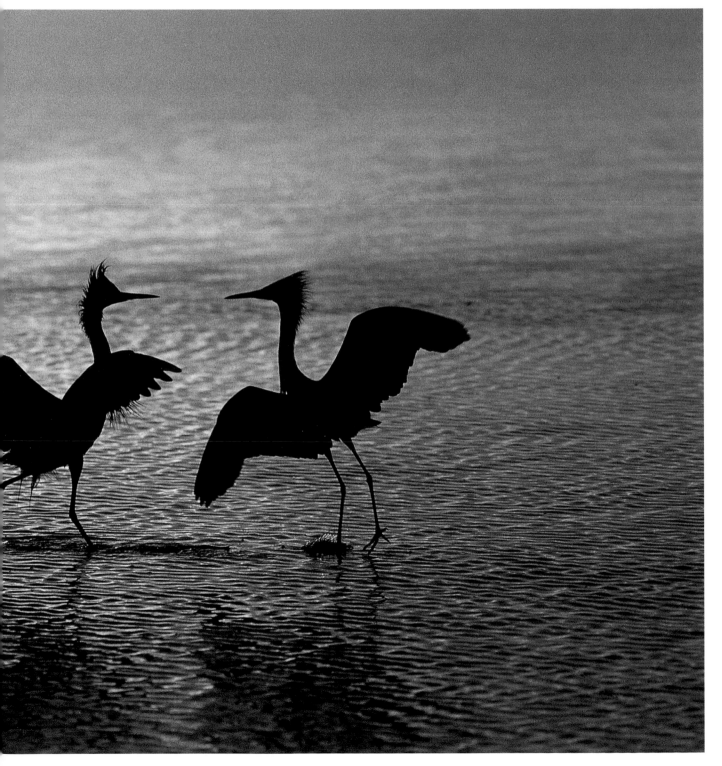

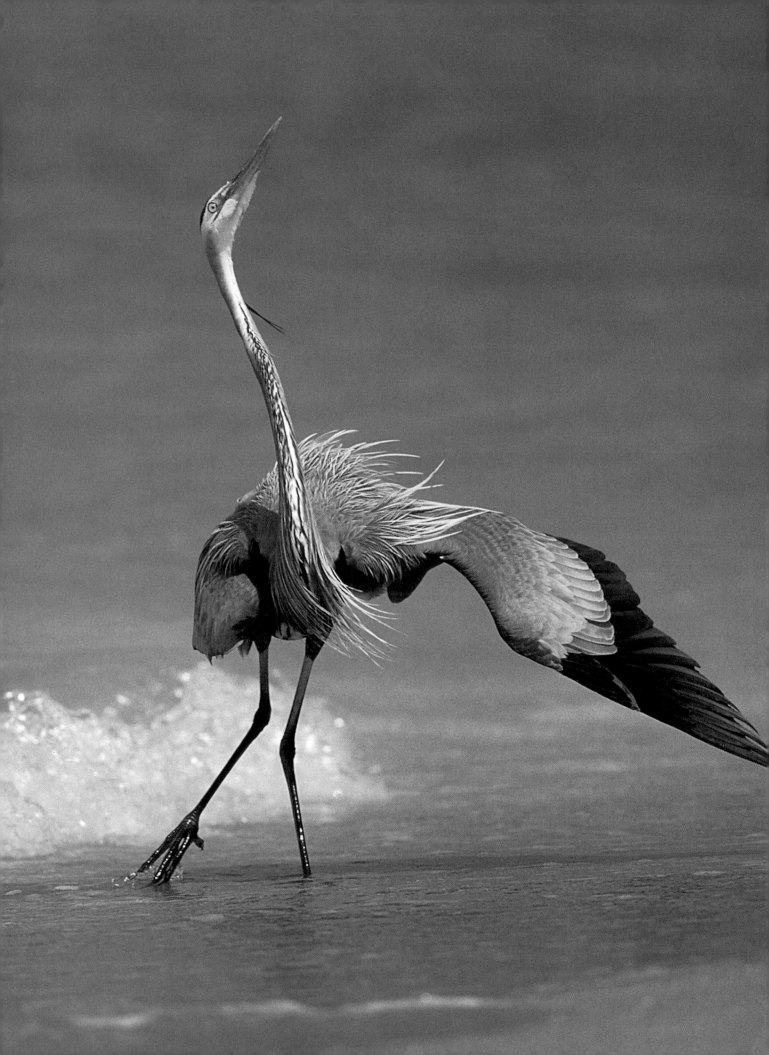

EVALUATING AND SELLING YOUR WORK

To effectively evaluate your work, you must have the proper tools. It is best to view your processed slides with a loupe while seated at a light box, rather than by projecting them onto a screen or a white wall. Projected slides can be severely scratched by slide projector mechanisms or damaged by the intense heat from projector bulbs; some may fade over time. In addition, it is extremely difficult to judge the sharpness of projected images; almost everything looks sharp on a screen.

A light box is simply a box with a translucent top (almost always Plexiglas) and an internal fluorescent light source; ideally it has a 5000-degree Kelvin lightbulb inside, which is balanced for color daylight (meaning that the light is closest to natural daylight). Light boxes come in a variety of sizes. Portable ones range in size from about 6 × 9 × 2 inches to 14 × 18 × 4 inches. Larger ones, also called light tables, can be as large as 48 × 16 × 6 inches and weigh 20 pounds or more. Handy photographers often build their own.

Loupes are handheld magnifiers. The Schneider Kreuznach Universal Lupe 4X is the industry standard. It is lightweight, provides image sharpness from edge to edge, and can be focused by turning a ribbed focusing ring. Like all 4X loupes, it allows viewing of the entire image. Some photographers use 8X loupes to better check for image sharpness; however, with most 8X loupes, you can only view a section of the image at a time. Photo editors use only 4X loupes, and so do I.

GREAT BLUE HERON, Blind Pass, Captiva Island, Florida. Canon EF 400mm F5.6L lens and A2 body (handheld), evaluative metering at zero: 1/750 sec. at *f*/5.6

Images that depict rarely seen behavior, that are dramatic as well as technically perfect and artistically designed, and *leave lots of room for type placement often cause photo editors to drool. This great blue was performing a threat display while defending a winter feeding territory against another of its kind. This image was highly commended in the 1997 British Gas Wildlife Photographer of the Year Competition.*

How to Edit Slides

In bird photography, even top professionals will, on average, discard (or edit out) 30 to 70 percent of the images that they make. The decision to keep or discard a picture is made at the light box. To begin editing, I first remove all 36 slides (or however many there are) from the box and place them in a stack on my light box; spreading them out exposes all 36 slides to potential damage. I always place the slides emulsion-side down. The chemical grains are on the emulsion side of the film, as is the lab's logo, so you should be left looking at a blank white—preferably cardboard—slide mount.

It is important to get into the habit of working with your slides emulsion-side down so that any inadvertent damage will occur on the non-emulsion side (which should be face up). You should never eat or drink anywhere near your slides, but damage can occur if you accidentally drop your loupe onto a slide, or if, when conversing, tiny bits of spittle escape one's lips. (Now, when you see one or more tiny translucent circles on your slides, you'll know where they came from.) It is, therefore, best to remain silent or turn away from the light box when speaking, especially when working with valuable originals. In any case, you can, at times, get away with marring the non-emulsion side of a slide, while damage to the emulsion side will almost always be fatal.

To view a single slide with a loupe, place the image on your light box. Place the loupe over the slide, and then look through the loupe by leaning forward and placing an eyebrow against the frame of the loupe. You don't have to place the slide directly against the light box, however; when I'm viewing hundreds of slides, I'll often hold my loupe in my right hand (near my eye) and raise each slide to my eye with my left until it touches the loupe. The light from the light box still shines through the slide and illuminates it, while back fatigue is reduced. I use my left eye, just as I do when looking through my camera's viewfinder. Use whichever eye feels most natural to you.

I use a Schneider Kreuznach 4X loupe and Logan portable light box. In addition to putting my slides in plastic slide pages, I also use Kimacs, 2 × 2-inch individual protective sleeves, which you can see to the right in the photo. These provide additional protection.

REDDISH EGRET (WHITE PHASE), Little Estero Lagoon, Fort Myers Beach, Florida. Canon EF 400mm F5.6L lens and A2 body (handheld), evaluative metering -1/2 stop: 1/1500 sec. at *f*/5.6

During an initial picture edit, I carefully set aside select images like this one. The very best, which I call "family jewels," will practically leap off the light table and grab you by the throat.

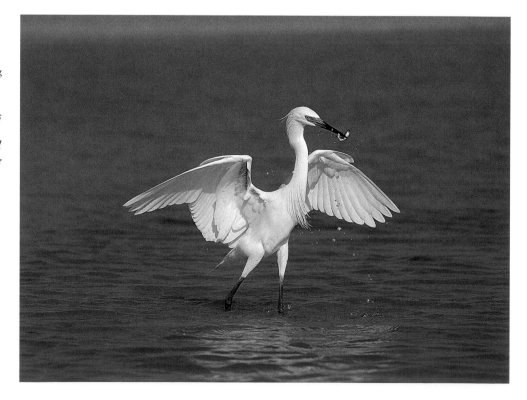

Generally, I find it best to do an initial edit by going quickly through all the slides from a shoot, which can be as many as 100 rolls at a time. I discard only the very worst images (those that are unfocused or poorly exposed) and set aside only the very best. Some of these select images may be one-shot wonders—single frames or grab shots of birds in flight or in action that have succeeded beyond my wildest dreams. However, even when I'm viewing long sequences of nearly identical images, one slide almost always stands out as the best, the one in which the light strikes the feathers on a bird's face just so or captures the absolute peak of an elegant wing stretch.

After I label these select images and affix a stick-on copyright label, I place them immediately in 2 × 2-inch plastic individual slide protectors and send them to Chelsea Professional Color Labs in New York City to be duplicated. I usually make either six, twelve, or eighteen 70mm reproduction-quality duplicates and six 35mm duplicates of each select image. I've had great success marketing the larger dupes (duplicates); they enable me to show my very best work in several places at once. I use the 35mm dupes mainly for slide lectures. After I finish looking at each roll during the initial edit, I make sure to

mark the top of the box with a felt-tipped marker, indicating the species photographed and the location. If an editor calls in search of a newly photographed species, this saves me many hours of searching through my slides.

Doing an initial edit gives me an overall idea of how I did with various species and prevents me from selecting borderline images for labeling from the first roll while an entire box of perfect transparencies rests elsewhere on the light box. After a quick look, I'll put all of the slides aside

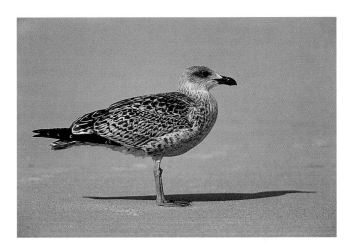

IMMATURE GREAT BLACK-BACKED GULL, Cedar Beach, Long Island, New York. Canon EF 600mm F4L lens with 1.4X teleconverter and EOS 1N body, Fuji Velvia pushed one stop, evaluative metering at zero: 1/1000 sec. at ƒ/5.6.

In the smaller photograph above, the young gull's head is turned slightly away from the light, and the image is lifeless. In the larger photograph, the bird has turned its head a bit so that the feathers on its face are impeccably lit. The bird, and therefore the image, seems vibrant and alive.

for a day or so and then do the main edit. At this time, I look at the slides more carefully than I did during the initial edit, inspecting each for technical excellence and artistic merit. I discard virtually all that aren't razor sharp or that are a bit too light or dark, though I do keep some as photographic teaching aids.

I either discard or place in my reference pile others that are technically perfect but artistically weak. This latter group also includes images that are not good enough to be published but not bad enough to throw out, as well as images that reveal seldom-seen details of a bird's plumage or depict unusual behaviors or postures. I set aside the technically perfect, artistically pleasing images be to labeled. After waiting a few days, I run through the reference pile one last time to make sure that I haven't missed anything good.

As time goes by, your work will improve and your editing standards will become more stringent. Both the slides that you keep and those that you discard will be of higher quality. You'll begin to notice and appreciate the fine points that make one image superior to another. You'll learn the difference between *sharp* and *breathtakingly sharp*. You, like me, will become a background madman, striving only for backdrops of pure color, discarding images if even a single distracting element has crept into the frame. When there are two birds in the frame, you'll search for the one image in which the head positions of both birds are absolutely perfect. You'll berate yourself for shooting three rolls of an obviously disheveled bird. Unimaginative compositions and harsh midday light will bore you, and only well-designed photographs made in rich, warm light will interest you.

SAVING IMAGES WITH ERIE CROP MOUNTS
For years, I regularly discarded some spectacular images that had distracting elements on or near the edge of the frame. Then, I learned about Erie Color Slide Club crop mounts. The openings in these heat-sealable cardboard mounts are of various sizes and proportions. By selecting and using the perfect crop mount, I was (and am) able to eliminate the unwanted section (or sections) of an image and improve the compositional balance, as well.

I prefer the mounts with rounded corners; they are offered with eight different window openings. My favorites are those that offer the most extreme crops: the no. 3 (a low horizontal of 32 × 17mm) and the no. 8 (an almost square 23 × 20mm). I've marketed many images mounted in Erie Color Slide Club crop mounts, including one of a snowy egret in a no. 8 mount for an Audubon Engagement Calendar. And, these are images that I would have thrown away just a few years ago. To use Erie mounts follow these steps:

1. Remove the transparency from its original mount by using your thumbnail to rip the mount apart starting from the top inner frame-edge. (If you choose to open the mount with a razor blade, be careful not to slice off the tip of your finger). Work slowly and carefully, taking care not to rip the transparency. Once you free the film from the mount, handle it only by the sprocket-hole edge.
2. Select a suitable Erie crop mount. Fold it in half and smooth the inside frame edges with your index finger to eliminate most or all of the cardboard fuzz.
3. Position the film meticulously in the mount and secure it with a tiny piece of Scotch tape.
4. Seal the mount with either an iron or the electrically heated hand press available from Erie. Since I use lots of these cropped images in slide shows, I invested in the hand press, which seals the mounts flat. If you iron the mounts, they may warp and refuse to drop into slide trays.

To me, the thrill of photographing birds is threefold: the thrill of spending time with wonderful creatures in wonderful places, the excitement of getting my slides back from the lab and reviewing them on a light box, and the joy of sharing my work with friends or with others on the published page. Of the three, however, I get the greatest joy from viewing my work for the first time at the light table.

Cleaning Dirty Slides

Even photographic slides stored in archival-quality slide sheets get dusty. To brush off dust or fuzz, I use a 2 3/4-inch Staticmaster brush, making sure to brush lightly.

Though it should never happen, slides and transparencies used for publishing are often returned with solvents, tape residue, fingerprints, and even ink marks or other stains on the them. In these cases, I'm often able to clean the slides myself with either lighter fluid or 91-percent isopropyl alcohol, which is the only thing I know of that removes dried ink. To do this, wet a folded section of a lint-free darkroom glove with a small amount of solvent, and work very gently, applying little pressure. (Do not use a Q-Tip; it may scratch the slide.) If you can't tell whether the problem is on the emulsion or non-emulsion side of the slide, it is always best to try the non-emulsion side first, as the emulsion side is more easily damaged.

Erie crop mounts allow you to easily crop your images. Start with the original slide (top left) and essential cropping gear (bottom left): a stack of mounts, the Erie heat press, and Scotch tape. After repositioning the piece of film in a mount (top right), close the mount to reveal the newly cropped image (bottom right).

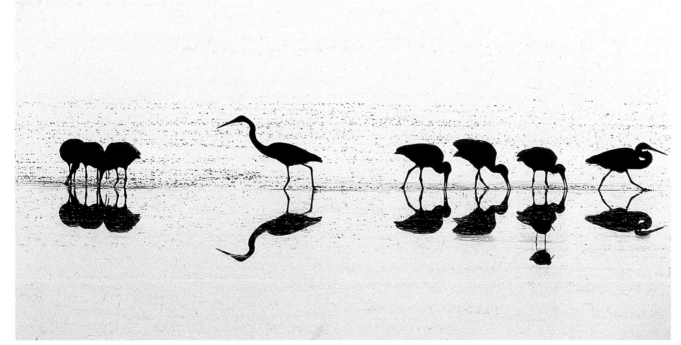

EGRETS AND WHITE IBISES, Merritt Island National Wildlife Refuge, Titusville, Florida. Canon FD 800mm F5.6L lens and T-90 body, Fuji Velvia pushed one stop, center-weighted average metering +1 stop: 1/500 sec. at ƒ/5.6

This is the low horizontal image that I had visualized before depressing the shutter button. It is ridiculous to assume, as some photographic purists do, that only the 3:2 proportions of a standard 35mm slide mount are artistically correct.

Marketing Your Work

The first photographs that I ever sold—to *Bird Watcher's Digest* in the mid-eighties—were the shorebird images used with an article I wrote entitled "Muddy Recollections." There are many important points to be learned from the details of the simple tale of this sale.

First, don't quit your day job . . . yet. I taught elementary school in New York City for 23 years beginning in 1970. Like several other prominent North American nature photographers, I honed my photographic skills and began selling my work while still teaching. Having a "real" job allows aspiring photographers to survive financially while getting their feet wet in the business.

Next, one of the best ways to sell your photographs is to write articles. Selling a single image to a national magazine is a major coup. Selling an article illustrated by half a dozen of your photographs, however, may actually be an easier task. If you succeed, you get paid for six images *and* the article. Many books on marketing your written work recommend writing query letters to editors to excite them about your proposed article and to get them to agree to publish it.

If you're just breaking in, however, I feel it is best to submit an interesting, informative, well-written piece accompanied by no more than 20 carefully edited, original images with suggested captions for each. (Many believe that sending good dupes—especially good 70mm reproduction-quality dupes—is a better choice than sending original slides.) By placing an entire package in front of an editor without querying first, you'll have a reasonably good chance of getting your article published; it is my strong belief that unknown photojournalists writing query letters will be rejected more than 99 percent of the time.

And finally, photograph (and write about) subjects you've come to know on an intimate basis, subjects that thrill you. The shorebird family was my avian first love. I studied these birds, counted more than half a million of them at Jamaica Bay Wildlife Refuge, New York, and adored them for their delicate beauty and their fantastic migratory flights. This love resulted not only in my first published article, but in my first full-length book, *Shorebirds: Beautiful Beachcombers* (North Word Press, 1996).

If you're thinking of becoming a professional photographer to get rich, forget it. The lifestyle is great, but the competition is fierce, and in nature photography, editorial-use fees are often low, while the cost of film, cameras, lenses, accessories, extensive travel, and office supplies and machines is high. If after a few years, you're breaking even, you will have performed a small miracle. Determination, marketing skills, and business creativity are more important than the technical excellence or artistic merit of your work. There are lots of fabulously talented nature photographers who've tried to make it as full-time professionals and have found it difficult to sell more than a handful of images, let alone even come close to supporting themselves.

On the other hand, there are more than a few professional nature photographers who make a wonderful living primarily because of their strong will to succeed, their ability to find or create new markets for their work, and their skill at marketing and self-promotion. The artistic and technical quality of their work ranks a distant fourth in the list of

I was very excited to have my image of a pair of great blue herons on the cover of this issue of Wildlife & Nature. *Inside was my article on the Venice Rookery, accompanied by 11 additional images. Often, creating a package with your photographs and a related article that you've written is a great way of getting published.*

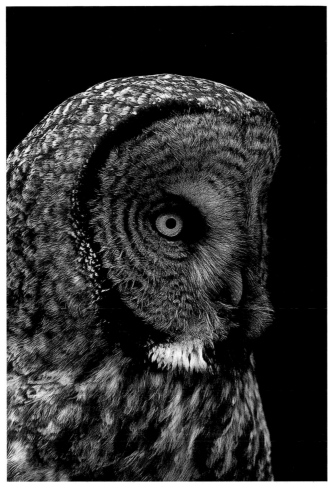

GREAT GRAY OWL, Yellowstone National Park, Montana. Canon FD 800mm F5.6L lens with 50mm extension tube and T-90 body, Fuji Velvia pushed one stop, center-weighted average metering at zero: 1/60 sec. at *f*/5.6

Owls sell well, as do any avian subjects that remotely resemble humans.

factors that determine their success. Several years ago, in an article in *Outdoor Photographer,* Galen Rowell wrote of "the size of the rat gnawing at the photographer's belly to succeed." As a classic type-A personality, I've always had a very large rat in my belly, and you'll also need one to succeed in the business of nature photography.

It is important to realize that professional nature photography is a business and, despite the allure, a difficult one. I enjoy the time spent working in my home office, but I do routinely put in 10-, 12-, and even 14-hour days when I'm not on the road. And that's seven days a week.

GETTING STARTED

Networking is important in any business, and it is vitally important to those trying to make a living selling images of the natural world. Networking is simply a matter of who you know and who knows of you and your work. For aspiring nature photographers, there's no better way to gain exposure than to do slide programs for local Audubon, birding, natural history, and photography groups. The first few slide shows I did were freebies. Then, for a while, my standard fee was $25. Despite the lack of money involved,

those first slide shows were important stepping stones. They gave me confidence both as a speaker and as an artist and helped me to polish my act. Those early audiences told me with their "oohs" and "ahs" that I could excite people with my photography. Plus, at each program, I'd sell a few prints and notecards, and develop leads for additional slide programs and, at times, for photo sales.

Today, I routinely receive offers to do one-hour shows for $400 plus expenses, which usually include airfare and dinner. I like good food, so if my schedule permits, I try never to turn down these offers. In addition to lots of exposure, these appearances help to promote my instructional photo-tour business and allow me to sell my books, prints, and photographic accessories, as well.

Another way of getting exposure is to arrange to hang mounted prints of your best images at local libraries, clubs, or businesses—even at your own workplace. The career of photographer Milton Heiberg was given a jump-start when he hung some 30 prints around the building in which he was doing freelance work for a major publishing company. Several art directors and designers approached him when they needed stock photography, and others stopped by for advice on camera equipment. He soon began making some sales and teaching mini-seminars to his coworkers. The editor of another publishing house saw his prints while visiting the building and asked if he'd like to write a photography manual; he wound up doing five books for that publisher.

Once you've sold a number of photographs, networking starts to take care of itself. An art buyer may see a published image and get in touch with you. Magazine editors with whom you've worked successfully will recommend your work to inquiring photo editors. Likewise, contest-winning images may generate sales. When I'm away from home, I always carry a set of 70mm reproduction-quality duplicates;

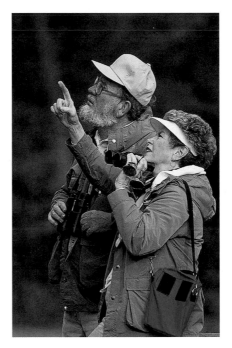

BIRDERS, Crane Creek State Park, Ohio. Canon EF 600mm F4L lens and EOS 1N body, Fuji Velvia pushed one stop, evaluative metering at zero: 1/250 sec. at *f*/8

Good photographs of people birding or otherwise enjoying nature sell. Notice, however, that this image is sharp, well-composed, and also captures an interesting gesture. You should take as much care with your images of people as you do with your wildlife images.

there's no telling who I may run into. I love sharing my work with others, and many times, chance encounters wind up generating income in one way or another. And of course, I'm never without my 70mm dupes and a stack of business cards when I attend the annual forum of the North American Nature Photography Association (NANPA) or the annual conference of the Outdoor Writers Association of America (OWAA). A great amount of networking takes place at these and similar events.

DEVELOPING SALES LEADS

Spending hours browsing in a bookstore that has a good nature section may not seem like a good practice, but it should be standard procedure for those just beginning to try to sell their nature photographs. *Seeing* lots of great nature images is a prerequisite for *making* great nature images. Get your hands on and study every book, magazine, and calendar that contains images of the subjects you photograph regularly. Critique each image. Note the composition and the format (horizontal or vertical). Ask yourself why a particular image excites or bores you. Lastly, ask yourself how your work compares with what's being published. Answer honestly.

When visiting bookstores, always have a notepad with you. Jot down the names and mailing addresses of book and magazine publishers, and of calendar and greeting card companies. If possible, get the name of an editor, a photo editor, or an art director at each organization. Seek guidance from friends, other photographers, workshop leaders, seminar instructors, and, best of all, from any photo editor willing to review a small selection of your best work.

Another good source for developing sales leads is the *Guilfoyle Report* (see Resources). This newsletter, issued four times a year, includes a "Happenings" section that lists the current photographic needs of a variety of nature photo buyers. However, since thousands of competent professionals subscribe to GR, the chances of making a sale are slim. The newsletter does, though, contain a wealth of photo sales leads. In addition, each issue contains at least one major article describing a specific market in detail; topics have included overviews of the calendar, birding magazine, and greeting card markets, as well as more specific pieces dealing with prestigious publications, such as *National Wildlife* and *International Wildlife*. Additionally, the *Guilfoyle Report* includes a great deal of business-related information.

To develop sales leads, first request (by mail) the photographer's (and writer's) guidelines from various publishers and publications; be sure to include a stamped, self-addressed envelope with your request. Next, as samples

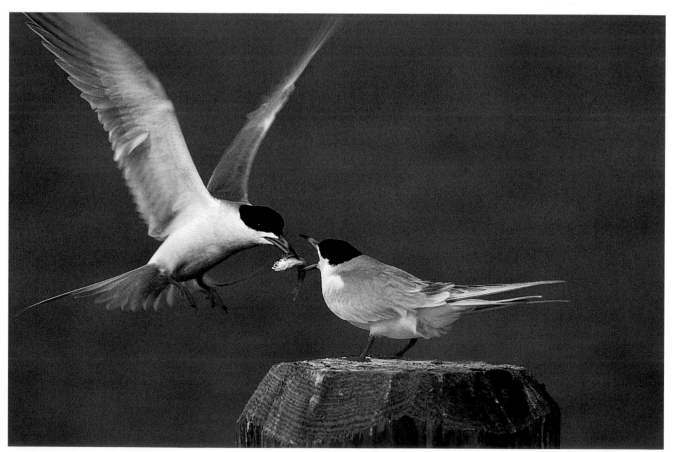

FORSTER'S TERNS (COURTSHIP FEEDING), Bunker Pond, Cape May Point State Park, New Jersey. Canon FD 800mm F5.6L lens with 25mm extension tube and T-90 body, Fuji Velvia pushed one stop, center-weighted average metering at zero: 1/350 sec. at *f*/5.6

Single images that tell a story—in this case, a love story—are rare. And when they show two creatures interacting, making eye-to-eye contact, they're easy to market. This image has been used in several calendars and on a book cover, as well as in several magazine articles.

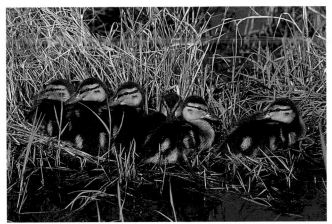

MALLARD DUCKLINGS, South Cape May Meadows, Cape May, New Jersey. Canon EF 100–300mm F4.5–5.6 zoom lens and A2 body with pop-up flash, Fuji Velvia pushed one stop, program mode: 1/200 sec. at $f/8$

Cute sells. These baby mallards were paddling around with their momma when they suddenly hauled themselves out onto a grass bank and lined up in a row.

of your work, send 20 or 40 of your very best slides to each photo editor or art director who responds to your requests. If an individual publication regularly issues a "want list," ask to receive it if your work meets their technical and artistic standards. If you're just starting out, it is best to send originals; you want to make a great first impression. (Duplicates are never as sharp as originals.) If your work is good, and you're persistent, you'll begin to make a few sales.

WHAT SELLS

I'm often asked which type of bird photograph sells best. My answer is always the same, "The one on the light box of the person who is willing to pay for it." By this I mean that photo buyers purchase only the images that fill their immediate and specific needs. If an art director wants a photograph of a mockingbird pecking at someone's head, he or she will not buy your drop-dead gorgeous image of a mockingbird holding a juicy red berry. Before the printing of this work, fewer than half of *my* favorite images had ever been published, and mind you, over 5,000 of my images have appeared in print.

For editorial use, portraits of individual birds against clean backgrounds sell well. Birds in flight and action shots sell well, also, as do images depicting bird behavior. Photographs showing two birds interacting are especially good sellers and are often in demand for book covers and calendars. For the far more lucrative advertising market, think *concepts:* images that depict unity, power, love, togetherness, teamwork, discipline, and determination are consistent sellers.

Photo editors often voice two major complaints: that photographers don't shoot enough verticals, and that wildlife subjects are too large in the frame. By shooting lots of verticals, you'll give editors a choice of format and also have a lot of images with cover potential. And, by resisting the urge to fill the frame with your subject, you'll give

editors the opportunity to crop or to position type as they desire. Whether you generalize, as do photographers Joe and Mary Ann McDonald, Darrell Gulin, John Shaw, and Art Wolfe, or specialize, as I do, you'll increase your chances of making a sale by having large files of technically perfect, pleasingly designed images that depict a wide variety of subjects. Diversity sells.

Though I've shared my thoughts on the basics of marketing natural history images with you, a complete description of business practices in the field of nature photography is far beyond the scope of this work. You could, in fact, write an entire book on the subject, and John Shaw has done just that superbly in *John Shaw's Business of Nature Photography* (Amphoto Books, 1996). If you're serious about marketing more than just a handful of your images, this book will quickly become your bible.

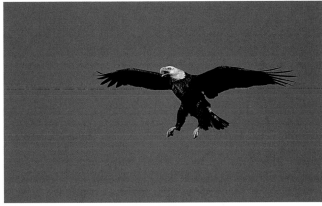

BALD EAGLE, Cape Coral, Florida. Canon EF 600mm F4L lens with 1.4X teleconverter and EOS 1N body, Fuji Velvia pushed one stop, evaluative metering +1/3 stop: 1/640 sec. at $f/5.6$

Concepts sell. Eagles say "power." I made this image, taken as the bird flew into its perch tree, at a distance of approximately 110 feet. Using my Wimberley tripod head made it easy to track the bird and fire off six frames before it landed.

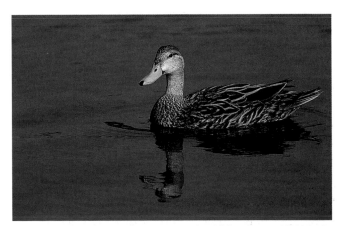

MOTTLED DUCK, Ding Darling National Wildlife Refuge, Sanibel Island, Florida. Canon EF 600mm F4L lens with 1.4X teleconverter and EOS 1N body, Fuji Velvia pushed one stop, evaluative metering at zero: 1/500 sec. at $f/5.6$

Though editors clamor for action shots and images that depict interesting behaviors, more than 80 percent of the images I sell are straight portraits. They are, for sure, well-made portraits, but they are, in fact, just plain, simple portraits.

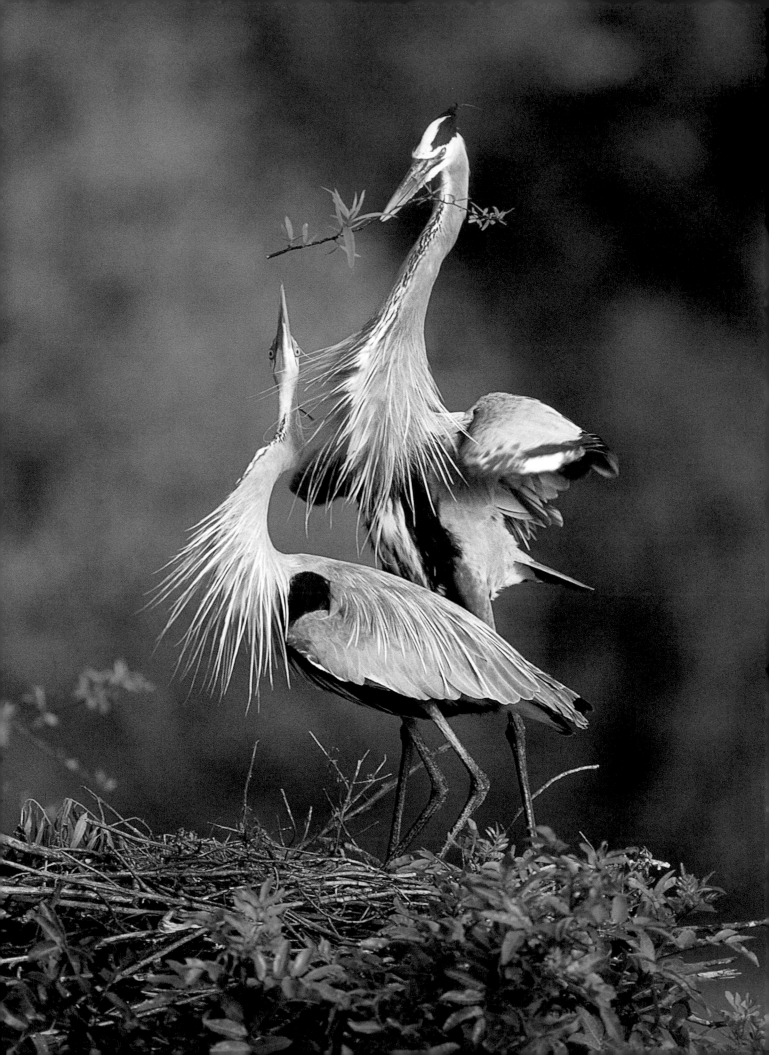

Appendix NORTH AMERICAN HOT SPOTS

For the past decade, I've had the pleasure of visiting many of the very best North American bird photography hot spots—locations where beautiful, sometimes uncommon or hard-to-find birds can be photographed without much effort, spots with great light and wonderful backdrops. These outstanding locations are situated over the entire length and breadth of the continent. At many of these spots, you'll often find yourself shooting 5 to 10 rolls or more per day. Here are my very favorites.

THE VENICE ROOKERY
South Venice, Florida

On a small island in a small lake in a small park in southwestern Florida, just blocks from a WalMart and a Burger King, is the Venice Rookery. It is a thriving mecca for nature photographers from around the world, who can be found, queued up each morning from November through March, making images of the many great blue herons and great egrets that nest there. In February and March, the variety of behaviors and nesting activities that you can witness in a single morning can be astonishing.

Great blue herons, which dominate the site, can be seen gathering nesting materials, adding to their nests, displaying, mating, incubating and turning eggs, flying to and from the colony, foraging, feeding, or flying around the island for no apparent reason at all. Even with a complete clutch of eggs, or with young in the nest, male great blues constantly bring in vines, twigs, or leafy sprigs for their mates, and an elaborate sequence of behaviors occurs each time they do.

Adult great blues usually forage away from the colony. They swallow fish, frogs, and snakes whole and partially digest them for their young on the return flight to the nest. When the young are just little fluff balls, they don't beg for

VENICE ROOKERY. Canon EF 28–105mm F3.5–4.5 zoom lens at 55mm and A2 body (handheld), Fuji Velvia pushed one stop, evaluative metering at zero: 1/125 sec. at *f*/9.5
It is a rare day without a breeze at the Venice rookery, so I jumped at the chance to make this carefully framed image on what was an absolutely still morning.

food readily. So, the returning parent holds its bill above the chicks' heads; this stimulates the chicks to beg.

When young herons are nearly fledged (fully grown and feathered, and ready to leave the nest), a different scenario unfolds as an adult returns to the nest with food. The instant the parent arrives, it is mobbed—almost attacked—by three or four very hungry juvenile herons, which yank on the parent's beak relentlessly while vying for the best position. All this activity makes for incredible photographic opportunities.

The great egrets nest a bit later in the season than their larger cousins; it is rare to see their fluffy white chicks before March. Throughout the winter months, the beautiful adults can regularly be seen displaying to their mates. As they do this, they raise the breeding plumes on their backs into a beautiful fan of intricately patterned feathers—a delicate latticework reminiscent of a fine bridal gown. Great egrets also often engage other great egrets in mid-air territorial battles, or squabble with neighboring great blues herons.

To reach the Venice Rookery from Interstate 75 in Florida, take Exit 35 (Jacaranda Boulevard) and follow it southwest about five miles to the traffic light at US 41; the WalMart will be diagonally across the highway on your

GREAT BLUE HERONS, South Venice, Florida. Canon FD 800mm F5.6L lens and T-90 body, Fuji Velvia pushed one stop, center-weighted average metering -1/3 stop: 1/500 sec. at *f*/5.6
A male great blue heron, performing an age-old courtship ritual, offers his mate a fresh sprig for the nest.

left. At this intersection, make a right turn and then take the *first left* at the Florida Highway Patrol station. Follow this winding road for a few hundred yards and the lake and the rookery will appear, almost magically, on your right.

EAST POND, Jamaica Bay Wildlife Refuge, Queens, New York. Canon 50mm F3.5 macro lens and A1 body (handheld), Fuji Provia, center-weighted average metering +1/3 stop: 1/125 sec. at *f*/11

The water level at East Pond in Jamaica Bay Wildlife Refuge is lowered each year in late spring to provide habitat for thousands of southbound migrant shorebirds.

BOSQUE DEL APACHE NATIONAL WILDLIFE REFUGE
San Antonio, New Mexico

Take 40,000 snow geese and 10,000 sandhill cranes, add mountainous backdrops and spectacular sunrises and sunsets, stir in a highly skilled, visitor-friendly refuge manager in the person of Phil Norton, and you'll have the recipe for one of the premier bird photography hot spots on the planet. Bosque is located 90 miles south of Albuquerque and 20 miles south of the small, eco-tourist–friendly town of Socorro.

The geese and cranes, which in some years remain within yards of the refuge's roadways, visit Bosque from November through early March. You'll need all your lenses at the refuge, from your wide-angle to your telephoto. Arrive well before dawn and photograph sunrise from the road that lies east of the main impoundment and north of the entrance booth. After sunrise, drive the farm loop road. Stop at the Chupadera Deck where you may find sandhill cranes and ducks close by. Continue north to the Willow Deck or the farm fields where flight shooting is often excellent, especially on mornings with southerly winds.

As winter progresses, the geese and cranes are joined by large numbers of raptors, including several races of red-tailed hawk and both bald and golden eagles. Raptor photography is often best from the marsh loop road in the afternoon, but you can often find Cooper's and other hawks perched in the trees surrounding the visitor center.

On sunny afternoons, sandhill cranes often fly low over the farm loop road a few hundred yards past (south of) the Farm Deck. On clear evenings, sunset photography can be excellent from this location as thousands of geese and cranes

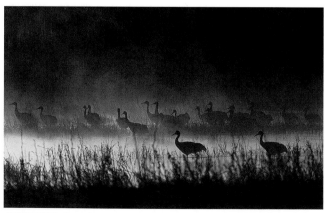

SANDHILL CRANES, Bosque Del Apache National Wildlife Refuge, New Mexico. Canon EF 600mm F4L lens with 1.4X teleconverter and EOS 1N body, Fuji Velvia pushed one stop, evaluative metering +2/3 stop: 1/320 sec. at *f*/5.6

Bosque is truly a beautiful and inspiring place. While photographing there, I feel like an artist in a huge warehouse filled with oil paints and canvases. These cranes in ground fog were backlit by the rising sun.

fly south over the low mountains to the west. Whenever there are some clouds on the western horizon, however, it is best to return to the Chupadera Deck in hopes of catching a blazingly colorful sunset.

JAMAICA BAY WILDLIFE REFUGE
Queens, New York

When nature photographers think of great places to shoot, few think of New York City, but Jamaica Bay Wildlife Refuge, part of Gateway National Recreation Area and just 10 minutes from John F. Kennedy International Airport, offers excellent bird photography year-round. Late summer and early fall can be superb. In late August, more than a thousand juvenile sandpipers and plovers stop at the East Pond on their way to South America. Less than six weeks old, most are unafraid of humans, even those with long lenses. Work the south and east shores of the East Pond in morning and the northwestern shore in afternoon.

The permanent blind at Big John's Pond offers great photographic opportunities: ducks in the fall, early winter, and spring; egrets and juvenile night-herons in the summer and fall; and hawks and songbirds in the fall and winter. Late fall, early winter, and early spring offer excellent flight shooting around the West Pond when mallards, black ducks, lesser and greater scaups, American wigeons, red-breasted and hooded mergansers, Canada and snow geese, and thousands of brant fill the skies. Opportunities to photograph barn owls or peregrine falcons are best in fall.

During the coldest winters, birds are sparse, but there's always a chance to see and photograph a short-eared or snowy owl near the old tern nesting area. Warbler photography can be good in the North Garden if you're lucky enough to hit a wave day in May. The refuge hosts many breeding species. Easy-to-photograph species include tree swallow, song sparrow, and red-winged blackbird.

POINT PELEE NATIONAL PARK
Leamington, Ontario

Colorful, hyperactive landbirds are very difficult to photograph, but there's no better place in North America to see and photograph these avian jewels than Pelee. In late April and May, exhausted after crossing Lake Erie on spring migration, many warblers, vireos, tanagers, grosbeaks, orioles, thrushes, and sparrows stop at the tip of the Point Pelee peninsula to rest and feed on the sandy beach or in the low, still-bare trees and bushes.

Take an early tram from the visitor's center, and work your way south along East Beach to the Tip. Many of the birds are either tired or so busy feeding that you'll need to mount an extension tube behind your telephoto lens to enable closer focusing. During the day, the birds usually fan out into surrounding woodlands; spots such as Sanctuary, Northwest, Pioneer, and Tilden's Woods can all be productive. The parking lot at DeLaurier Trail hosts a variety of sparrows; white-crowned is most common. And, the lot at Marsh Boardwalk can be good for American robins, common grackles, and red-winged blackbirds; you can also find thrushes and warblers here on wave day afternoons.

The warblers, and other landbirds and their offspring, stack up at Pelee in early fall before continuing south and are followed in late September and October by large numbers of sharp-shinned hawks in search of easy songbird meals. You can also photograph migrating gulls, terns, ducks, mergansers, and cormorants in both the spring and fall. And in late fall, the lucky photographer might find a tiny saw-whet owl roosting in groves of evergreens.

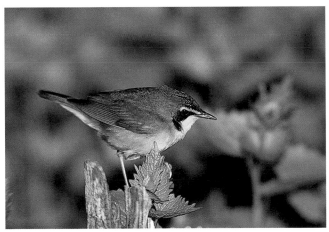

KENTUCKY WARBLER, Point Pelee National Park, Ontario. Canon EF 600mm F4L lens with 1.4X teleconverter plus 37mm of extension and EOS 1N body, Fuji Velvia pushed one stop, evaluative metering at zero: 1/200 sec. at *f*/5.6, Better Beamer flash extender, fill flash at -1 stop

Having a chance to photograph a migrant male Kentucky warbler on a clean perch in early morning light is the bird photography equivalent of winning the lottery. I was so nervous that half the images I made were unsharp. This species is a southern breeder, but part of the beauty of Point Pelee is that just about any bird species might show up there.

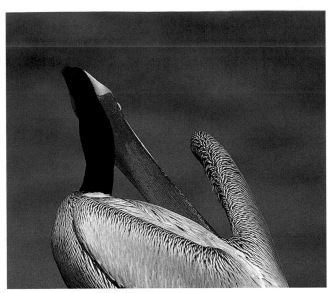

BROWN PELICAN, La Jolla, California. Canon EF 600mm F4L lens and EOS 1N body, Fuji Velvia pushed one stop, evaluative metering at zero: 1/800 sec. at *f*/5.6

Access to the cliffs above the main cove at La Jolla, formerly the best spot in the world at which to photograph California brown pelicans, is now restricted. This is a real shame and is typical of the increasing restrictions and closures that I've encountered in my travels.

LA JOLLA CLIFFS
La Jolla, California

La Jolla, California, is a chic, wealthy, seaside town located north of San Diego. In the windows of posh shops, dresses and suits carry four-figure price tags, but La Jolla's true treasures are to be found roosting and preening on the sandstone cliffs that lie just down the hill from Prospect Avenue. The brightly colored California race of brown pelican is my favorite subject here, and these birds are at their brightest in early January.

Although winter is the best season here, you can find Brandt's cormorants, plus western, Heerman's, and California gulls, and a variety of terns and shorebirds (especially whimbrels) throughout the year. (Note that most shorebird species are absent during June.) Because the cliffs are visited regularly by surfers and dog walkers, the birds are accustomed to humans and are often ridiculously tame. About a mile south of the main cove, long stretches of flat rocky shelves host hundreds of easily photographed gulls, terns, and shorebirds except during storms and unusually high tides. Mornings offer the best lighting conditions.

CAPE MAY
New Jersey

On the East Coast, all flyways lead to Cape May. Although this location at New Jersey's southern terminus is not a great place to photograph birds, it is a place where you can make great bird photographs. Many tens of thousands of both northbound and southbound migrant birds stop in or

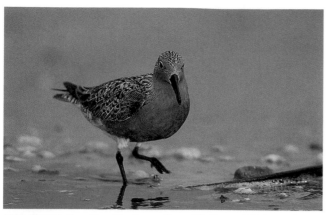

RED KNOT, Cape May, New Jersey. Canon EF 600mm F4L lens with 25mm extension tube and EOS 1N body, Fuji Velvia pushed one stop, program mode, evaluative metering at zero: 1/250 sec. at *f*/9.5, Better Beamer flash extender, programmed fill flash

There are usually so many red knots on Delaware Bay beaches in mid-to late May that it is difficult to make a photograph of just one bird.

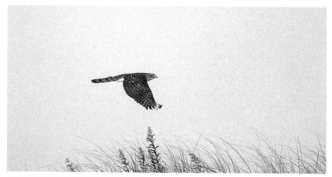

IMMATURE COOPER'S HAWK, Cape May, New Jersey. Canon EF 400mm F5.6L lens and A2 body (handheld), evaluative metering +1/2 stop: 1/750 sec. at *f*/5.6

On cool mornings in early fall, dozens of sharp-shinned and Cooper's hawks can be seen flying low over the dunes at Sunset Beach.

fly over Cape May annually, but their appearances are often weather related, and landbirds, which often predominate, are difficult subjects to photograph.

For decades, more than one million shorebirds have gathered each spring on the shores of Delaware Bay to feed on billions of tiny horseshoe crab eggs; numbers of red knots, ruddy turnstones, and sanderlings normally peak at some time during the last two weeks of May. This varies, though, so if you'll be traveling great distances to get to Cape May to photograph this phenomenon, it might be advisable to call the Cape May Bird Observatory (ph: 609-884-2736) first to check on conditions.

Black-crowned and yellow-crowned night-herons, glossy ibises, and a variety of other herons and egrets nest in the dune vegetation at Stone Harbor Point during late spring and summer. In June, you can photograph laughing gulls on their bulky, stick nests at the overflow colony on Nummy's Island, and 30,000 pairs nest on nearby Ring Island. (Be sure to work from a portable blind to minimize disturbance.)

In the late summer and fall, hordes of southbound migrant songbirds, hawks, gulls, terns, herons, egrets, and

shorebirds visit Cape May Point State Park, South Cape May Meadows, Higbee's Beach Wildlife Management Area, Sunset Beach, Stone Harbor Point, and countless other Cape May locales. You can find thousands of sanderlings and young laughing gulls on the beaches, and Forster's and royal terns and ospreys dot the skies, while both sharp-shinned and Cooper's hawks hunt low over yellowing dune grasses. In the winter, you can photograph sea ducks and purple sandpipers on and around the Second Avenue jetty.

LITTLE ESTERO LAGOON
Fort Myers Beach, Florida

This little-known, mile-long lagoon that lies next to the Gulf of Mexico is filled with tame birds 12 months a year; the winter months, however, are best. Wear clothing and footwear that will allow you to wade waist-deep in water, and you'll have no trouble making close approaches to great blue herons; great, snowy, and reddish egrets; American oystercatchers; double-crested cormorants; black skimmers; piping, Wilson's and snowy plovers, plus a variety of sandpipers. Thousands of herring, ring-billed, and laughing gulls winter at the lagoon as well. Opportunities for shooting flying birds are also good. Likely subjects include gulls; black skimmers; royal, sandwich, and Forster's terns; brown pelicans; gulls; ospreys; and, on rare occasion, both young and adult bald eagles.

The lagoon is about half an hour from Sanibel Island, if there's no beach traffic. Take San Carlos Boulevard over the bridge into Fort Myers Beach, then turn left (east) and go about five miles. Just beyond the Holiday Inn on your right, there'll be a strip mall on your left. Park in the lot; cross the street and make your way through the Holiday Inn parking lot, and you'll discover the western end of the lagoon.

In early morning, another option involves walking east on the main road and then entering the lagoon at its eastern

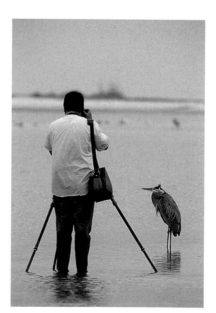

At Little Estero Lagoon, a BIRDS AS ART Instructional Photo-Tour participant approaches a typically tame great blue heron.

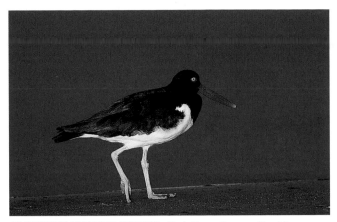

AMERICAN OYSTERCATCHER, Little Estero Lagoon, Fort Myers Beach, Florida. Canon FD 800mm F5.6L lens with 25mm extension tube and T-90 body, Fuji Velvia pushed one stop, center-weighted average metering +1/3 stop: 1/250 sec. at *f*/5.6

In some years, oystercatchers are both abundant and relatively tame at Estero. Photographing them in late afternoon sunlight can yield dramatically lit images.

end. This enables you to walk west and photograph with the sun at your back. I always enter the lagoon at the eastern end in the morning and the western end in the afternoon.

SANIBEL ISLAND
Florida

Sanibel Island—particularly Ding Darling National Wildlife Refuge—is *the* top site in North America at which to photograph large wading birds. At Ding Darling, it is not uncommon to see a thousand great and snowy egrets, a hundred white ibises, and dozens of roseate spoonbills herding schools of small baitfish across a shallow bay. Often joining these huge feeding aggregations are numbers of double-crested cormorants, red-breasted mergansers, brown and white pelicans, little blue and great blue herons, wood storks, and several reddish egrets.

At Ding Darling, you can do most of your photography, which is best from December through March, within yards of your vehicle. At present, unfortunately, the refuge doesn't open to vehicular traffic until 7:30 A.M. When you enter the refuge in the morning, the sun will be on your right for the first two miles, and you'll come to three large impoundments on your left. As you proceed slowly in search of a feeding spree, be sure to search the roadside mangroves for perched red-shouldered hawks.

Check out the first two impoundments on your left, and if a spree isn't developing or in progress, continue on to the Cross Dike. There, exit your car and check the far end of the Tower Pool to the north. A walk along the Cross Dike can often yield anhingas, double-crested cormorants, yellow-crowned night-herons, tricolored and green herons, American coots, mottled ducks, and blue-winged teals.

If Ding Darling is uncharacteristically unproductive, you can exit the refuge and make a *right* turn onto Sanibel-

Captiva Road. (A left turn will bring you back to the refuge entrance.) Cross the bridge at Blind Pass, and park your car in the small lot (where spots are at a premium after 8:30 A.M.). In the morning, photographic opportunities abound on the beaches on both the Sanibel and Captiva sides of the bridge. Royal, Forster's, and sandwich terns all roost on the beach, often in large groups, with a few black skimmers.

You may be able to photograph brown pelicans on the jetty, on the beach, or in flight as they enter and leave the inlet or dive for fish near shore. Cooperative snowy egrets, great blue herons, black-bellied plovers, willets, and groups of white ibises often forage on the edge of the gentle surf. (A similar assortment of birds may be found along the causeway between Sanibel and the mainland.) Visits to either Blind Pass or the causeway *before* entering Ding Darling can yield profitable results for early-rising photographers.

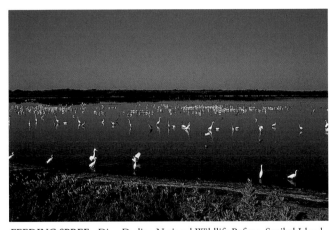

FEEDING SPREE, Ding Darling National Wildlife Refuge, Sanibel Island, Florida. Canon EF 28–105mm F3.5–4.5 zoom lens at 40mm and A2 body (handheld), Fuji Velvia pushed one stop, evaluative metering -1/2 stop: 1/180 sec. at *f*/13

Being at Ding Darling during an early morning feeding spree is something to dream about.

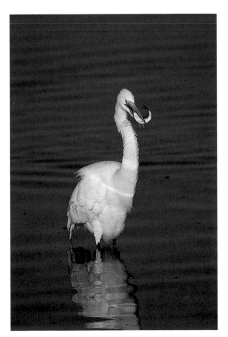

GREAT EGRET WITH FISH, Ding Darling National Wildlife Refuge, Sanibel Island, Florida. Canon FD 800mm F5.6L lens with 25mm extension tube and T-90 body, Fuji Velvia pushed one stop, spot metering of white +1 1/3 stops: 1/1000 sec. at *f*/5.6

Great egrets usually fish the edge of the near-shore channel, while snowy egrets fly over it, fishing on the wing (while flying).

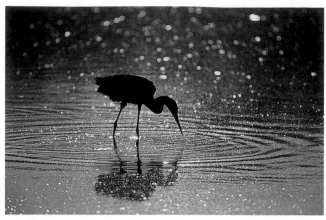

REDDISH EGRET AT SUNSET, Ding Darling National Wildlife Refuge, Sanibel Island, Florida. Canon EF 600mm F4L lens with 1.4X teleconverter and EOS 1N body, Fuji Velvia pushed one stop, evaluative metering +2/3 stop: 1/500 sec. at f/5.6

The Tower Pool at Ding Darling may be the best location in North America at which to photograph wading birds in silhouette at sunset. Some years, there's lots of algae, and this ruins many photographic opportunities; there are no reflections off algae.

After lunch, visit the fishing pier near the old lighthouse at the eastern end of the island. This spot is ideal for photographers with short telephoto lenses, as the birds are completely tame. Return to Ding Darling no later than 4:00 P.M. and park just past the Cross Dike. Dozens—even several hundred—roseate spoonbills can often be observed and photographed here in flight or roosting on either side of the road. At times, flight shooting from the tower itself can be excellent.

The area from just past the Cross Dike to the Mud Bar is my favorite spot in all of North America for creating sunset silhouettes of large wading birds. Large numbers of spoonbills, frequently joined by a big flock of willets, often wind up roosting on the Mud Bar. Be sure not to leave too early; on some evenings the afterglow doesn't light up the sky until 30 minutes or more after the sun has set.

ANHINGA TRAIL
Everglades National Park, Florida

Though there are several good photography spots in Everglades National Park, Anhinga Trail consistently offers superb opportunities for visiting bird photographers. The livin' is easy: the birds are close, and they are tame. You can walk the entire trail in under 10 minutes. The straight, paved main portion of the trail runs roughly east/west and abuts Taylor Slough, which lies just a few yards north of the trail. This layout allows photographers to utilize direct frontlighting pretty much from dawn till dusk. When water levels are low, the large numbers of fish concentrated in the slough attract hordes of hungry birds.

Photography at Anhinga Trail is generally good from early winter to early spring; February, March, and April can be spectacular. Great blue herons and American alligators

spend most of each day remaining perfectly still. Common moorhens and purple gallinules forage atop spatterdock or in the short grass that borders the slough. White ibises, snowy egrets, and tricolored herons forage along water's edge, while double-crested cormorants fish nearby. Green herons, defending their breeding territories, chase each other around like kids in a school yard. And, American bitterns may pose like statues in the sawgrass alongside the boardwalk.

Ospreys and belted kingfishers hover above the two large pools. In March and April, swallow-tailed kites swoop low over parking lot treetops snatching bits of hanging moss with which to line their nests. You can photograph turkey and black vultures dropping down to land on the roof of the visitor's center.

Perhaps by now you're wondering, "Why the Anhinga Trail moniker?" Well rest assured, the trail *is* aptly named; anhingas pose on the low railings for point-and-

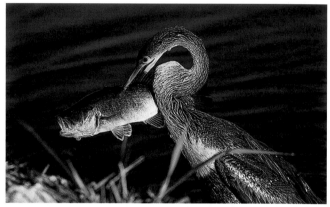

FEMALE ANHINGA WITH LARGEMOUTH BASS, Anhinga Trail, Everglades National Park, Florida. Canon EF 400mm F5.6L lens and A2 body (handheld), Fuji Velvia pushed one stop, evaluative metering at zero: 1/500 sec. at f/5.6

Fishing is usually great along the Anhinga Trail; handheld 300mm or 400mm autofocus lenses are extremely useful.

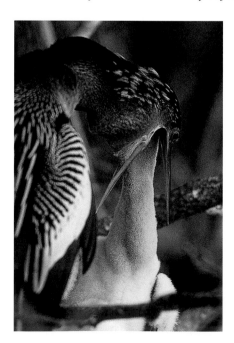

FEMALE ANHINGA FEEDING YOUNG, Anhinga Trail, Everglades National Park, Florida. Canon FD 800mm F5.6L lens with 75mm of extension and T-90 body, Fuji Velvia pushed one stop, center-weighted average metering +1/3 stop: 1/90 sec. at f/5.6

Hurricane Andrew knocked out all the anhinga nests that were close to the boardwalk, but in 1997, several pairs nested within yards of the rebuilt boardwalk. This is a pre-Andrew image.

shoot–camera toting tourists. They spear bluegills with their pointed yellow-orange bills, and they raise their young in stick nests.

Observers accustomed to seeing anhingas in their drab nonbreeding plumage will be dazzled by the colors of the birds at the height of breeding plumage; both male and female anhingas have bright, kelly green eye rings surrounded by turquoise facial skin. Courtship and nest building generally take place in mid-winter, and by February, most females are incubating eggs. If you visit in March, you'll see nestfuls of creamy yellow or white young of varying sizes.

CHURCHILL
Manitoba

Rightfully know as the "Polar Bear Capital of the World," Churchill, Manitoba, is located on the shores of Hudson Bay just below the arctic circle. In October and November, hundreds of nature photographers in all manner of tundra-traversing vehicles spend tens of thousands of dollars for the privilege of photographing the magnificent bears at this spot.

For those interested in photographing birds, however, a mid-June visit will better provide a lifetime of memories and boxes full of transparencies. The Churchill River, the deep waters of Hudson Bay, miles of rocky shoreline, large lakes, small ponds, sub-arctic tundra, extensive marshes, and boreal forests attract a variety of nesting bird species. Many individuals are resplendent in full breeding plumage.

Minutes from town, Arctic terns nest at the Granary Ponds, and horned grebes, greater scaup, northern shovelers, and northern pintails float peacefully on its icy waters. Red-necked phalaropes—the females brightly colored, the males dull—pick tiny prey from the surface of the water. Other possibilities at this site include Bonaparte's, herring, glaucous, and Thayer's gulls, and the rare Ross' gull.

At nearby Cape Merry, white-throated and savannah sparrows sing from rocky perches, as huge flocks of scoters

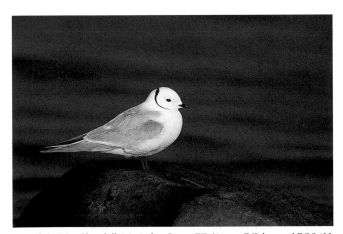

ROSS' GULL, Churchill, Manitoba. Canon EF 600mm F4L lens and EOS 1N body, Fuji Velvia pushed one stop, evaluative metering at zero: 1/640 sec. at f/5.6
While stalking some Bonaparte's gulls, I looked to my right and was amazed to see that a rare Ross' gull had landed nearby.

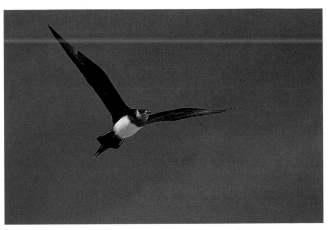

PARASITIC JAEGER, Cape Merry, Churchill, Manitoba. Canon EF 400mm F5.6L lens and EOS 1N body (handheld), Fuji Velvia pushed one stop, evaluative metering at zero: 1/640 sec. at f/5.6
There's usually something interesting to photograph at Cape Merry. Reflected light from an iceberg illuminated the undersides of this jaeger.

and small groups of common eiders navigate the river mouth. Harlequin ducks feed near the tip, and a variety of gulls (including little, Iceland, and Ross') rest atop icebergs. Parasitic jaegers, joined occasionally by migrant long-tailed jaegers, chase Arctic terns relentlessly in an effort to steal their main prey, capelin.

In the wet tundra alongside the road to the airport, Hudsonian godwits court, stilt sandpipers nest, and Smith's longspurs sing from stunted spruce trees. The ponds at Akudlik (just five minutes southeast of town) harbor oldsquaws, Bonaparte's gulls, stilt sandpipers, and several nesting species, including Arctic tern, semipalmated plover, and Pacific loon. In the marshes just east of Akudlik, the concentration of bird life can be amazing. Nesting species can include short-billed dowitcher, dunlin, least sandpiper, American golden-plover, whimbrel, Canada goose, and Arctic tern.

Continuing east along Launch Road past the airport, all of the aforementioned tundra-nesting species can be found. The nests of whimbrels, and American golden-plovers and semipalmated plovers can usually be found quite easily. In addition, willow ptarmigan are common and will almost always respond to prerecorded tapes of their own calls.

At the research station, the road turns due south toward Twin Lakes, first slicing through a huge marsh and then through the boreal forest itself. The marsh hosts many nesting shorebird species, including American golden-plover, short-billed dowitcher, lesser yellowlegs, and Hudsonian godwit.

The nesting birds of Churchill have seen more than their share of nature photographers and many are far more accustomed to humans than those in wilder regions. As a result, you can photograph many species at the nest by simply sitting down and remaining motionless. If an incubating bird doesn't return to its nest within 10 minutes, leave the area and try again later in the day. Another option would be to set up a portable blind. In either case, be aware that if

your presence keeps a bird off its nest for an extended period of time, the eggs may become chilled beyond saving. And, the Arctic summer is so short that re-nesting is not possible.

Although the boreal forest is a birder's paradise, I've had no luck photographing the many specialty species found there. Birds that I have seen, but not photographed, there include pine grosbeak, rusty blackbird, slate-colored junco, bohemian waxwing, and boreal chickadee. The following species can also sometimes be seen: boreal owl, hawk owl, spruce grouse, and three-toed woodpecker.

Even though Churchill consistently offers great bird photography, it may not be for everyone. When deplaning for the first time, I was greeted by fierce winds and hail; the temperature was 33 degrees. The weather in June is quite variable. Over the years, I've lost several complete days to rain. The tundra is wet and finding nests is a difficult job, as is carrying long, heavy lenses over soft, boggy earth and through icy-cold tundra pools. As the weather warms up, mosquitoes and black flies often hinder your photographic efforts. In some bad years (and even on some mornings in "good" years), the bugs may be virtually intolerable. Churchill, however, does offer the serious, determined nature photographer modern lodging, good food, and unparalleled access to a variety of arctic-nesting species in their finest spring dress.

BOLSA CHICA LAGOON & NEWPORT BACK BAY
California

Less than an hour by freeway from Los Angeles, these sites (about 10 miles apart) offer consistently spectacular bird photography from November through March. Bolsa, the scene of numerous and continuing environmental battles, is the premier location on the continent at which to photograph bufflehead; surf scoter; Pacific loon; as well as eared, horned, western and Clark's grebes.

Bolsa, which is best in the morning, is located on Pacific Coast Highway three miles northwest of the coastal town of Huntington Beach. A small footbridge crosses the lagoon at its narrowest point, and if you look straight down from the bridge, you'll usually see huge schools of small baitfish paving the bottom. As a result, dozens of loons and grebes fish within yards of the bridge.

On sunny mornings with winds out of the south or east, flight photography can be excellent as well; brown pelicans and a variety of ducks, cormorants, and shorebirds often fly directly over the bridge. The pelicans often dive for fish within yards of the walkway. In the afternoon, walk northwest on the path parallel to this oceanside lagoon to photograph a variety of ducks and other waterbirds. In late spring and early summer, a walk to the tide gates at the northwestern end of the lagoon in early morning or late afternoon will find numbers of terns hovering above the churning waters and diving for fish. Although not a

necessity, autofocus equipment is of great help here. Elegant terns predominate, with good numbers of Forster's and a sprinkling of royal, Caspian, and least terns, as well.

To reach Newport Back Bay from Bolsa Chica, make the forced right turn out of the parking lot and then a quick U-turn. Head southeast down the Pacific Coast Highway about 10 miles. Make a left turn onto Jamboree Road, and then turn left again on Back Bay Drive into the Upper Newport Bay Ecological Reserve. In general, it is best to time your visits to Back Bay so that they coincide with high tide—when large flocks of shorebirds are forced off the extensive mudflats to roadside roosts and ducks can be found paddling by close to the road. Marsh wrens and clapper rails (the endangered "light-footed" race) are also most visible at high tide. Eurasian wigeon is often seen at this location.

Driving on, you'll soon come to the bottom of San Joaquin Hills Road where you may find room to park; the basin to your left is often chock-full of tame duck species, including American wigeon, Northern pintail, mallard, and green-winged and cinnamon teals. Northern shoveler, gadwall, and blue-winged teal are also seen here frequently.

Several hundred yards down the road you'll come to the second and last parking lot (again, on your left). The adjacent dirt beach and the marsh just to the north are primary roosts for large flocks of wintering and migrant shorebirds. Hundreds of marbled godwits, willets, and American avocets join thousands of western sandpipers to roost at these two locations during high tide. Other regularly occurring shorebird species include dowitcher, least sandpiper, dunlin, red knot, and long-billed curlew.

Cross the road to the small freshwater pond, where you can photograph all the regular ducks in afternoon light. In addition, this pond often shelters soras, hooded mergansers, and black-crowned night-herons. You can photograph these birds by working from or below the small wooden bridge, and you can find the endangered California gnatcatcher on the brushy hillside south of the pond.

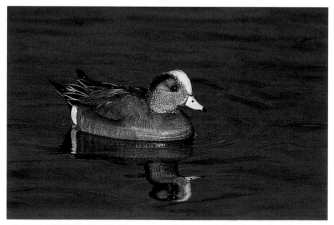

AMERICAN WIGEON, Newport Back Bay, California. Canon EF 600mm F4L lens with 1.4X teleconverter and EOS 1N body, Fuji Velvia pushed one stop, evaluative metering at zero: 1/500 sec. at *f*/5.6

You can photograph many types of ducks at close range at Back Bay.

More Bird Photography Hot Spots

North America is a huge continent. The sites described previously are ones that I've visited on many occasions, always with success; but there are, obviously, countless locations that offer superb opportunities for bird photography. The following is a list of additional bird photography hot spots by state, along with the likely species at each location and the best times to visit. I've been to some of these locations and have heard rave reviews about others from friends and colleagues.

You will also, however, be able to find lots of great sites on your own. Visit nearby parks, refuges, and other natural areas. If you can, travel to distant birding hot spots, but realize that not all great birding locations will be excellent for photography. Wherever you go, keep your eyes open and don't be afraid to follow your instincts. It has been said that there's a good spot at which to photograph every bird species, no matter how rare or secretive it may be.

ALABAMA
Fort Morgan
spring migrants, including indigo bunting, blue grosbeak, Baltimore and orchard orioles, summer tanager, ruby-throated hummingbird
April

ALASKA
Kougarok Road, Safety Lagoon, and Woolley Lagoon (Nome)
western sandpiper, yellow wagtail, bluethroat, bristle-thighed curlew, black-bellied plover, ruddy turnstone, Pacific golden-plover
June through early July

St. Paul Island, in the Pribiloff Islands (access by air only)
red-faced cormorant; red-legged kittiwake; parakeet, least, and crested Auklets; tufted and horned puffins; rock sandpiper; snow bunting
June through early August

ARIZONA
Patagonia
broad-billed, black-chinned, and violet-crowned hummingbirds; vermilion and sulphur-bellied flycatchers; thick-billed kingbird; white-winged dove; great-tailed grackle; gray hawk
summer

CALIFORNIA
Carrizo Plains
red-tailed (including dark phase), ferruginous, and rough-legged hawks; bald and golden eagles; California condor (reintroduced)
November through February

Klamath Basin (on the California/Oregon border)
Ross' and greater white-fronted geese; ducks; tundra swan; bald and golden eagles; barn, short-eared, and northern pygmy owls
December through February

Lee Vining Canyon
red-breasted sapsucker, hairy woodpecker, brown creeper, western wood-pewee, mountain bluebird, pygmy nuthatch
June through July

Point Pinos, Monterey (Pacific Grove)
black oystercatcher; wandering tattler; black turnstone; surfbird; western, glaucous-winged, and California gulls; loons; cormorants; seabirds
November through March

COLORADO
Pawnee National Grassland
mountain plover, Brewer's sparrow, lark bunting, Swainson's and ferruginous hawks, McCown's and chestnut-collared longspurs, common nighthawk
June through July

FLORIDA
Dry Tortugas National Park (access by boat or plane only)
northbound migrant warblers, including Swainson's, hooded, Kentucky, yellow-throated, prothonotary, and worm-eating; other migrant songbirds, including blue grosbeak, indigo bunting, summer tanager, and gray kingbird; sooty tern; brown and black noddies; magnificent frigatebird
April through early May

Lake Kissimmee State Park
Florida scrub jay, blue jay, rufous-sided towhee, bobwhite
late winter, early spring

INDIANA
Muscatatuck National Wildlife Refuge (Seymour)
least bittern, sedge wren, Henslow's sparrow
May through August

MAINE
Machias Seal Island (access by boat only)
Atlantic puffin, razorbill, Arctic tern
June through early August

MASSACHUSETTS
Newburyport to Cape Ann
harlequin duck, red-breasted merganser, Iceland gull, snowy owl
December through February

MINNESOTA
Agassiz National Wildlife Refuge (Middle River)
American bittern, sedge wren, sora and Virginia rails, great horned owl, waterfowl, grebes (including red-necked)
May through June

Hawk Ridge (Duluth)
broad-winged, sharp-shinned, Cooper's, red-tailed, and rough-legged hawks; goshawk; bald and golden eagles
September through November

MISSOURI
Squaw Creek National Wildlife Refuge
300,000 snow geese, one million blackbirds, bald eagles
October, November, early December (for eagles)

MONTANA
Benton Lakes National Wildlife Refuge (Great Falls)
marbled godwit, upland sandpiper, Wilson's phalarope, willet, short-eared owl, Savannah sparrow, various waterfowl
April (for sharp-tailed grouse), May through July

Bitterroot Mountains (south of Missoula)
spruce and blue grouse, pileated woodpecker, wild turkey, red-breasted nuthatch, rufous-crowned sparrow
July through August

Bowdoin National Wildlife Refuge (Malta)
American avocet, yellow-headed blackbird, lark bunting, cliff swallow, chestnut-collared longspur
May through June

Freezeout Lake
marbled godwit, American avocet, American bittern
May through July

Medicine Lake National Wildlife Refuge (Medicine Lake)
western grebe, marbled godwit, sharp-tailed grouse, white pelican, western kingbird, chestnut-collared longspur, waterfowl
May through June

Yellowstone National Park (Montana and Wyoming)
great gray owl, gray jay, American dipper, raven, yellow-headed blackbird, tundra and trumpeter swans
spring, summer, fall

NEBRASKA
Platte River (Grand Island)
500,000 sandhill cranes
mid-March

Rainwater Basin (Clay County)
four million ducks and geese
March

NEW JERSEY
Barnegat Inlet lighthouse and jetty (Barnegat)
purple sandpiper, ruddy turnstone, harlequin duck, Ipswich sparrow, red-throated and common loons, oldsquaw, red-breasted merganser
January through March

NORTH DAKOTA

J. Clarke Salyer National Wildlife Refuge (Upham)
American bittern, sora, sedge wren, LeConte's and sharp-tailed sparrows, grebe, duck
May through June

Kidder County
several species of grassland sparrows, white pelican, American avocet, willet, upland sandpiper, black tern, ferruginous hawk
May through early July

Lostwood National Wildlife Refuge (Kenmare)
Baird's, clay-colored, vesper, and grasshopper sparrows; Sprague's pipit; bobolink; sharp-tailed grouse; upland sandpiper; northern harrier; horned and eared grebes
May through June

OHIO

Crane Creek State Park
spring and fall migrants, including warblers, kinglets, vireos, orioles, thrushes, grosbeaks, tanagers; American robin; Canada goose (with goslings); American woodcock; killdeer
late April through May; September and October for southbound songbirds

SOUTH CAROLINA

Huntington Beach State Park
brown pelican; gulls; terns; shorebirds, especially short-billed dowitcher, greater yellowlegs, and western sandpiper; herons; egrets; bald eagle; migrant songbirds
spring, fall, summer

TEXAS

Bentsen Rio Grande Valley State Park
green jay, plain chachalaca, golden-fronted woodpecker, long-billed thrasher, bronzed cowbird
February through April

Big Bend National Park
desert nesting birds, migrant songbirds
April through July

Falcon State Park
pyrrhuloxia; Altamira oriole; Cassin's, olive, and black-throated sparrows; verdin; greater roadrunner; long-billed thrasher
winter

Galveston Island
reddish egret, neotropic cormorant, black-necked stilt and other shorebirds, black skimmer, gulls, terns
January through April

High Island
spring migrants, including warblers, vireos, orioles, thrushes, grosbeaks, tanagers
April through early May

Little Bay (Rockport)
waterfowl (including black-bellied whistling duck), white pelican, clapper rail
winter

Santa Ana National Wildlife Refuge (near Harlingen)
green jay, great kiskadee, olive sparrow, Altamira oriole, least grebe, green kingfisher
February through April

UTAH

Bear River Migratory Bird Refuge (Brigham City)
American avocet, black-necked stilt, Wilson's phalarope, black-crowned night-heron, western and Clark's grebes, cinnamon teal, snowy plover, California gull, white pelican, yellow-headed blackbird
May through August

CANADA

Last Mountain Lake (Saskatchewan)
sandhill crane, Swainson's hawk, white pelican, tundra swan, LeConte's and Baird's sparrows
spring, summer, fall

Stanley Park, Vancouver (British Columbia)
Barrow's goldeneye, scoters, loons, western grebe, canvasback, wood duck, gulls, a variety of landbirds
November through March

Resources

PHOTOGRAPHY EQUIPMENT

Arthur Morris/BIRDS AS ART
PO Box 7245/ 805 Granada Dr.
Indian Lk Est, FL 33855
www.birdsasart.com
Instructional photo-tours, Better Beamer Flash Extenders, Double Bubble Levels

Beattie Systems, Inc.
2407 Guthrie Avenue
Cleveland, TN 37311
ph:(800) 251-6333
Beattie Intenscreens (bright focusing screens)

B. Moose Peterson
P.O. Box 3628
Mammoth Lakes, CA 93546-3628
ph: (619) 924-8632
Lowepro Pro Trekker AW Super Telephoto Backpack, photography tours and books

Bogen Photo
565 East Crescent Avenue
Ramsey, NJ 07746
ph: (201) 818-9500
Bogen, Manfrotto, and Gitzo tripods, photographic accessories

Canon USA
1 Canon Plaza
Lake Success, NY 11042-1198
ph: (516) 328-5000

Chelsea Professional Color Lab
159 West 27th Street
New York, NY 10001
Manager: Sheetal Kumar
ph: (212) 229-2929
E-6 processing, 35mm and 70mm reproduction-quality duplicates

DB Design
P.O. Box 1571
Forestville, CA 95436
Portable blinds, Progrips for Nikon 8008 and 8008s

Erie Color Slide Club
P.O. Box 672
Erie, PA 16512-0672
ph: (814) 456-7578
Cardboard crop mounts

FotoQuote
145 Tyee Drive #286
Point Roberts, WA 98281
ph: (800) 679-0202
Software for pricing and selling stock photographs

Franklin Distributors Corp
P.O. Box 320
Denville, NJ 07834
ph: (201) 267-2710
Archival storage materials

Kirk Enterprises
107 Lange Street
Angola, IN 46703
attn: Mike Kirk
ph: (800) 626-5074
Photographic accessories, quick-release plates and collars, leg supports, window mounts

L. L. Rue Enterprises
136 Millbrook Road
Blairstown, NJ 07825
ph: (908) 362-6616
Photographic accessories, Groofwin Pods, vests, nature and photography books

M & M Photo Source, Ltd.
1135 37th Street
Brooklyn, NY 11218
ph: (800) 606-6746
Cameras, lenses, tripods, ball heads, film

Nikon Inc.
1300 Walt Whitman Road
Melville, NY 11747-3064
ph: (800) 438-8782

Op/Tech USA
304 Andrea Drive
Belgrade, MT 59714
ph: (800) 251-7815
Tripod leg pads

Really Right Stuff
P.O. Box 6531
Los Osos, CA 93412
attn: Bryan Geyer
ph: (805) 528-6321
Photographic accessories, quick-release plates, flash brackets

Rod Planck Photography
P.O. Box 169
Paradise, MI 49768
ph: (906) 492-3444
Bag blinds, reflectors, diffusers, workshops, nature and photography books

The Slideprinter
P.O. Box 9300
Denver, CO 80209-9969
ph: (303) 698-2962
Prints from slides

Staticmaster
NRD Inc.
2937 Alt Boulevard
Grand Island, NY 14072
ph: (800) 525-8076
Slide cleaning brushes

The Stock Solution
307 West 200 South #1003
Salt Lake City, UT 84101
ph: (800) 777-2076
*Fold mats for 70mm duplicates,
self-sealing 35mm slide mounts*

Sun Precautions, Inc.
2815 Wetmore Avenue
Everett, WA 98201
ph: (800) 882-7860
Sun protective clothing

Wimberley Design
974 Baker Lane
Winchester, VA 22603
ph: (540) 665-2744
Wimberley tripod heads

MAGAZINES AND NEWSLETTERS

*The Biological and Technical
Journal for Wildlife Photographers*
Wildlife Research Photography
P.O. Box 3628
Mammoth Lakes, CA 93546-3628
ph: (619) 924-8632

Birder's World
11 East 8th Street, Suite 410
Holland, MI 49423-3502
editorial ph: (800) 424-2473
subscription ph: (800) 446-5489

Birding
American Birding Association
P.O. Box 6599
Colorado Springs, CO 80934

Bird Watcher's Digest
P.O. Box 110
Marietta, OH 45750
ph: (800) 879-2473

Guilfoyle Report
AG Editions
41 Union Square West, #523
New York, NY 10003
ph: (212) 929-0959

Living Bird
Cornell Laboratory of
Ornithology
159 Sapsucker Woods Road
Ithaca, NY 14850
ph: (607) 254-2473

National Wildlife
National Wildlife Federation
8925 Leesburg Pike
Vienna, VA 22184

Nature Conservancy
1815 North Lynn Street
Arlington, VA 22209

Nature Photographer
P.O. Box 2019
Quincy, MA 02269-2019
ph: (617) 847-0095

Nature's Best
Image Hunter Publishing
1130 Bellview Road
McLean, VA 22102
ph: (703) 759-6575

Outdoor Photographer
12121 Wilshire Boulevard,
Suite 1220
Los Angeles, CA 90025-1175
ph: (310) 820-1500

Petersen's PHOTOgraphic
6420 Wilshire Boulevard,
6th floor
Los Angeles, CA 90048-5515
editorial ph: (213) 782-2000
subscription ph: (800) 800-3686

Shutterbug
Patch Publishing
5211 S. Washington Avenue
Titusville, FL 32780

*Shutterbug's Outdoor & Nature
Photography*
Patch Publishing
5211 S. Washington Avenue
Titusville, FL 32780

The Natural Image
George Lepp & Associates
P.O. Box 6240
Los Osos, CA 93412
ph: (805) 528-7385

WildBird
3 Burroughs
Irvine, CA 92718
ph: (714) 855-8822
subscription ph: (303) 666-8504

*Wildlife & Nature: Florida's
Outdoor Magazine*
P.O. Box 240
Largo, FL 33779
ph: (813) 587-0343

ORGANIZATIONS

American Birding Association
P.O. Box 6599
Colorado Springs, CO 80934
ph: (800) 850-2473

American Society of Media
Photographers (ASMP)
14 Washington Road, #502
Princeton, NJ 08550
ph: (609) 799-8300

Cornell Laboratory of
Ornithology
159 Sapsucker Woods Road
Ithaca, NY 14850
ph: (607) 254-2473

National Wildlife Federation
8925 Leesburg Pike
Vienna, VA 22184

North American Nature
Photography Association
(NANPA)
10200 West 44th Avenue,
Suite 304
Wheat Ridge, CO 80003-2840
ph: (303) 422-8527

Outdoor Writer's Association
of America (OWAA)
2155 East College Avenue
State College, PA 16801

Bibliography

Cooper, Jerry A. *Birdfinder: A Birder's Guide to Planning North American Trips.* Colorado Springs: American Birding Association, 1995

Ebbers, Bert C. *Nature's Places: Photography by Rod Planck.* Paradise, Michigan: Hawk-Owl Publishing, 1992

Erlich, Paul R., David S. Dobkin and Darryl Wheye. *The Birder's Handbook: A Field Guide to the Natural History of North American Birds.* New York: Simon and Schuster, 1988

Finlay, J. C. *A Bird Finding Guide to Canada.* Edmonton: Hurtig Publishers, 1984

Lepp, George D. *Beyond the Basics: Innovative Techniques for Nature Photography.* Los Osos, California: Lepp & Associates, 1993

Lepp, George D. *Beyond the Basics II: More Innovative Techniques for Nature Photography.* Los Osos, California: Lepp & Associates, 1997

Mangelsen, Thomas D. *Images of Nature: The Photographs of Thomas D. Mangelsen.* New York: Macmillan Publishing Company, 1989

National Geographic Society. *Field Guide to the Birds of North America.* Washington, D.C.: National Geographic Society, 1987

Peterson, B. Moose. *Nikon Guide to Wildlife Photography.* Rochester: Silver Pixel Press, 1993

Peterson, B. Moose. *Wildlife Photography: Getting Started in the Field.* Rochester: Silver Pixel Press, 1997

Riley, Laura and William. *Guide to the National Wildlife Refuges.* New York: Macmillan Publishing Company, 1992

Shaw, John. *John Shaw's Business of Nature Photography.* New York: Amphoto Books, 1996

Shaw, John. *The Nature Photographer's Complete Guide to Professional Field Techniques.* New York: Amphoto Books, 1984

Terres, John K. *The Audubon Society Encyclopedia of North American Birds.* New York: Alfred A. Knopf, 1980

West, Larry, and Julie Ridl. *How to Photograph Birds.* Harrisburg: Stackpole Books, 1993

Wolfe, Art, and Martha Hill. *The Art of Photographing Nature.* New York: Crown Publishers, 1993

Index